T0345892

A Municipal Mother

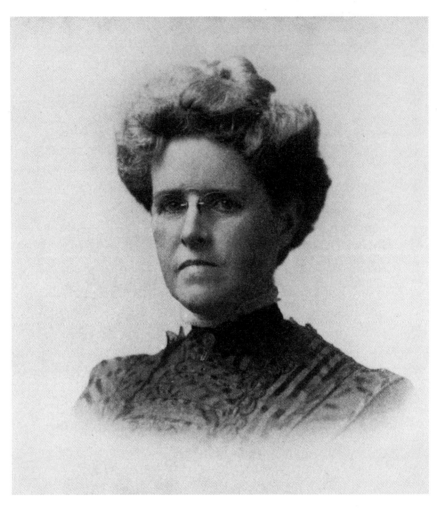

Lola Baldwin. Photograph from Sunset magazine, September 1912

A Municipal Mother

Portland's Lola Greene Baldwin,

America's First Policewoman

Gloria E. Myers

Oregon State University Press

Corvallis, Oregon

For my parents, John and Mary Kowal

The paper in this book meets the guidelines for permanence and durability of the Committee on Production Guidelines for Book Longevity of the Council on Library Resources and the minimum requirements of the American National Standard for Permanence of Paper for Printed Library Materials Z39.48-1984.

Library of Congress Cataloging-in-Publication Data
Myers, Gloria E.
A municipal mother : Portland's Lola Greene Baldwin, America's first policewoman / Gloria E. Myers.
 p. cm.
Includes bibliographical references and index.
ISBN 0-87071-386-8
 1. Policewomen—Oregon—Portland. 2. Baldwin, Lola Greene. 3. Feminism—Oregon—Portland.
HV8023.M94 1995
363.2'082—dc20 95-16780
 CIP

Contents

Preface

 T his work began as a History M. A. thesis based on a local case study of Lola Greene Baldwin, a Portland, Oregon, woman who claimed to be the first American urban policewoman, early in the twentieth century. A preliminary review of recent secondary and certain older primary sources, however, revealed that her contention was frequently disclaimed, discounted, or completely ignored. I decided to proceed anyway, as my original concept was to determine what historical and social factors led to the *need* for paid female municipal law officers in Portland at that time. The historiographical question became an intriguing subplot to my general purpose of providing a detailed, unromanticized portrait of the day-to-day work of at least *one* of the pioneers in women's policing. The volume of information begged something beyond the scope of my initial project, and encouragement from several quarters resulted in this manuscript.

I was pleased to find a wealth of primary material in public records and contemporary newspaper and journal coverage. After gleaning as much as I could from published accounts, I followed with a thorough survey of the local government correspondence available at the Portland City Archives. These documents were filed according to the methodological whim of a succession of Progressive Era clerks and secretaries, necessitating a complete "A to Z" search of the years 1905 to 1922. This mining activity turned up scores of letters written by Baldwin in her capacity as head of what became known as the Women's Protective Division. In many instances I was able to locate companion answers, which aided greatly in balancing the interpretation of some events. The best find, however, proved to be Baldwin's 1908-1913 daily activity logs, discovered at Portland's Police Historical Society Museum. I spent several months in a storage room filled with mothballed uniforms scanning hundreds of these pages to inform my narrative.

I placed my findings in the context of Progressive Era reform through an examination of recent scholarly works. I was especially inspired by Estelle B. Freedman, whose study of women's historical roles in penology and law enforcement enabled me to fix Baldwin's place in a continuum. The works of Robyn Muncy, Karen Blair, William L. O'Neill, and J. Stanley Lemons reminded me that early twentieth-century feminism encompassed much more than suffrage, and helped label Baldwin as a so-called "social feminist." The efforts of Allen Davis, Joanne Meyerowitz, Mina Carson, Don S. Kirschner, David J. Pivar, Eric C. Schneider, Kathy Peiss, Lary May, Lewis A.

Erenberg, Barbara M. Hobson, Ruth Rosen, and John C. Burnham, among others, aided my grasp of the social, cultural, class, and gender complexities of the period. Peggy Pascoe's exploration of "female moral authority" helped me to understand Portland's first policewoman as a distinct type of post-Victorian transition figure. As Baldwin's area of interest proved to be so broad, I might have overlooked some germane secondary material, despite an intention to be thorough. I apologize for any oversights, and take complete responsibility for any errors in interpretation or fact which may appear in this work.

Numerous wonderful people assisted me as this book evolved. First and foremost, I owe David Horowitz more than I can ever repay. His special support, cajoling, and confidence in my subject matter pushed me forward through periods of self-doubt, and times when life got in the way! Others offered their help and welcome advice at various points in my research and writing process. Robert D. Johnston and I spent many dizzy hours reading microfilm at adjoining machines, and shared bits of local "Progressiana" stumbled upon in the void beyond the newspaper index. Portland historical writer Harry Stein provided several useful leads, as did David Peterson DelMar, whose writings on late-Victorian domestic violence touch on the issue of women and the police power. David was also kind enough to read an incomplete text and affirm the worth of pursuing it as a larger work. Portland State University historians David A. Johnson, Lois S. Becker, Gordon B. Dodds, and sociologist Robert C. Liebman all critiqued the M. A. thesis version of this study, and have since encouraged its expansion. Pat Wesson, Edith Beach, and especially Sybil Plumlee, all retired members of the Women's Protective Division, were gracious in answering my questions about Baldwin's influence on Portland policing.

As anyone who has ever attempted primary research can attest, there is a special place above reserved for archivists, librarians, and their staffs. Steve Webber, who managed the Portland City Archives when I began my quest, was infinitely patient with my determination to turn up "everything." He pulled out what seemed like an endless succession of boxes, and explained the quirks of the Progressive Era filing system. His successor Marcus Robbins has also been helpful and enthusiastic about this project. I owe a great debt to then-director Ralph O'Hara of the Portland Police Historical Society Museum, who produced Lola Baldwin's daily activity logs from the depths of a storage vault. His successor Verne Rohrbach was equally magnanimous and forthcoming with valuable insights into Portland police history. Alternate curator John Leckman cheerfully filled in the blanks when the others were absent. I wish to thank the personnel of the Oregon Historical Center Library, Multnomah County Library, and Portland State University Library. Whether in

tolerating my overtime use of microfilm readers or in hauling "just one more" journal volume from storage or the closed stacks, this effort could not have been completed without their cooperation. Finally, I must not forget Jeffrey Grass and Jo Alexander of the Oregon State University Press, who have given me the writer's ultimate compliment by publishing this manuscript.

The complexity of Lola Greene Baldwin's career as a policewoman produced a study of equal intricacy. It proved impossible to examine her activities through a single historical lens. She shaped her job in reaction to contemporary social, cultural, gender, political, and professionalization issues. With a dual purpose of providing a readable history and an informative piece of scholarship, I have consciously constructed this work as a synthesis informed by those varied forces. Although societal conditions were relatively similar in U. S. cities which hired policewomen during the Progressive Era, this work speaks mainly to the situation in Portland. As the first documentable paid female police agent, however, Baldwin emerged as *the* historical transition figure for women's direct involvement in municipal law enforcement. Her story mirrors the general reform dilemma of Progressive Era urban America: how best to maintain traditional moral norms in the modernizing city.

This work explores the link between the conservative "social feminism" which dominated the women's movement during the Progressive Era and evolving "female protective" institutions. It also exposes the influence of the so-called "social hygiene" ethic on much of the period's remedial ideology, including the role of the urban policewoman. The antiprostitution and venereal disease control aspects of that movement appear as a persistent force in the evolution of the policewoman idea in Portland. Through the words and actions of a contentious, culturally conservative, yet remarkable woman, Baldwin's story details the era's major social battles on a local, regional, and sometimes national level. It proved difficult, unfortunately, to gather extensive information about Baldwin's private life. As a result, this work is presented as an account of her public career. As such, it is based on documentation from newspaper and archival sources. Wherever available from reports of birthdays, anniversaries, family obituaries, official biographical information, or reminiscences of others, the facts pertaining to her personal history are included in the manuscript.

Introduction

In February 1911, pioneering American juvenile court judge Benjamin Lindsey, speaking before a mass meeting of suffragists in Albany, New York, stated that he believed that women who worked as police and probation officers "each had done more good than forty men would or could have." In 1913, Chicago social worker Louise de Koven Bowen impressed national readers of *The Survey* with the need for what she termed "policewomen." Only females with full police power, she asserted, could "cope with certain dangerous situations with which private organizations have tried in vain to deal." By 1920, police reform expert Raymond B. Fosdick wrote that the policewomen's movement was already "of supreme significance" in the evolution of law enforcement in the United States. Although the profession was only a dozen years old, he noted that women police had proved especially successful in the active investigation and prevention of female vice crime. This work traces the emergence of the policewoman idea through a case study of the career of Lola Greene Baldwin of Portland, Oregon, the first woman hired by an American municipality to carry out regular enforcement duties.[1]

In late 1907, under pressure from a coalition of local women's interest groups and antivice forces, the Portland city council agreed to fund several positions for women in the police department. It directed the civil service commission to add the category of "Female Detective" to its classified examinations list, and subsequently passed an ordinance that specified police budget monies "to provide for the expenses of affording protection to young women and girls." On April 1, 1908, Lola G. Baldwin, aged forty-eight, was sworn in "to perform Police Service" under the direction of the chief of police. She was not, however, the passive beneficiary of a job concocted by the male civic hierarchy. She had forged the role herself and, with the aid of women's organizations and male sympathizers, successfully convinced authorities that it was a necessary adjunct to Rose City policing.[2]

The infant municipal policewomen's movement was an outgrowth of several impulses which coincided during the Progressive Era. The foremost of these was a redefinition of the role of women in society. The nineteenth century's "cult of true womanhood," which confined women as civilizing and purifying agents within the home, began to give way to more public reform opportunities at the end of the century. By the 1890s, many elite and middle-class women began to organize to effect social change in the civic sphere.

These "social feminists" chose issues which were consistent with their traditional nurturing roles and supposed moral superiority. In the cities, educated women began settlement houses in poverty-stricken immigrant working-class sectors. Rather than dispense charity at arms length, they lived among the less fortunate as neighbors, and began programs to Americanize recent arrivals and uplift the native-born poor. Settlements offered classes in everything from citizenship and English language to health and occupational training. Vice-conscious workers tried to divert the locals from the traditional recreation options of the saloon and the prostitute. Other socially concerned women, observing the success of places like Chicago's Hull House, joined in a nationwide campaign to improve urban conditions through what one historian referred to as an "imposition of middle-class culture and values on the lower classes."[3]

Insisting on a legitimate right to be municipal housekeepers, various women's civic reform, literary, and improvement societies banded together in 1890 as the General Federation of Women's Clubs. The Federation subsequently cooperated with existing organizations like the Women's Christian Temperance Union (WCTU), Young Women's Christian Association (YWCA), the new urban settlement workers, and others. The result was a powerful consortium which, in the period between 1890 and World War I, addressed diverse problems affecting women, children, and families. Together, they called for school improvements, public health codes, women's suffrage, the hiring of women as police officers and jail matrons, measures against juvenile delinquency, protective laws for minor and female workers, prostitution abatement, policing of amusements, alcohol restriction, and other issues which touched directly upon American home-life. They became part of a female dominion within social reform which endured for years.[4]

The urban policewoman appeared in response to distaff concerns for the moral safety of transient women and girls. Initially, under a temporary special police authority, Lola Baldwin was commissioned by a Travelers' Aid board dominated by social feminists to watch over females who came as visitors or to find work at Portland's 1905 world's fair. Three years later, under permanent police powers, her emphasis shifted to protecting those enticed by new employment opportunities. Low-skilled, unmarried young women were flocking to expanding cities like Portland to find blue-collar, white-collar, or domestic jobs. Many of these "women adrift" lived independently in boardinghouses or housekeeping rooms. Both young native-born and immigrant women, away from the controlling influence of family for the first time, were felt to be imperiled by seductive vice elements. Urban reformers were alarmed by an immigrant culture they considered immoral, ubiquitous saloons, and rampant prostitution. Although working girls were especially

vulnerable, the reformers thought the cities held pitfalls for females of all ages and classes. The municipal policewoman was but one of the "maternal" responses initiated by the social-feminist reform coalition.[5]

The study of Baldwin's career reveals a culturally conservative, gender-specific policing strategy. Through measures designed to preserve traditional standards as the norm, she and others labored to *codify* the Victorian model of female moral purity, and make it relevant to the post-Victorian city. She and her reform cohort evolved an elaborate institutional apparatus of social control to deal with *what they defined* as deviant behavior. They targeted the female "sexual delinquent" as the antithesis of their ideal of a standardized social morality ethic. Government and private preventive and corrective activities consumed their attention. In Portland, between 1905 and 1918 alone, Baldwin and other social feminists, in cooperation with male reformers, helped found the municipal policewomen's division, juvenile, morals, and domestic relations courts, a citizen vice commission, a state institution for sexually delinquent girls, a city venereal detention hospital for prostitutes, and pushed a variety of state and local protective legislation for women and children.[6]

Baldwin's active policing years (1905 to 1922) coincide with the rise and gradual decline of the progressive ethos in the United States. An analysis of her work offers a look at the response of one individual and her supporters to that impulse over time. The period's major social battles over juvenile delinquency, censorship, prohibition, amusement reform, prostitution, and venereal disease all affected the first policewoman's agenda. As a "Municipal Mother," as contemporary Louise Bryant described her in a *Sunset* magazine piece, Baldwin benefited from the Progressive Era belief that women could ameliorate urban evil as they had earlier civilized the household. Although not without difficulty, this ideology allowed her to establish a lasting and legitimate employment niche for her sex within law enforcement. She embodied the American woman's transition from Victorian seclusion to post-Victorian acceptance as a traditionalist, nurturing, morally conservative activist in the public sphere. Her story, set in Portland, evokes the flavor of urban life in ragtime America, when the police power increasingly became the watchdog of social morality.[7]

The vogue for women's civic activism caught fire in Portland after 1900, when the city began experiencing exponential growth, although a strong female reform element was already present prior to that time. Frances Willard, president of the national organization, personally delivered the charter to the Portland branch of the Women's Christian Temperance Union (WCTU) in 1883. Like its parent, the local WCTU involved itself in much more than the alcohol question. From its inception, for example, it championed "equal

rights at the ballot box." One of its first projects was a program to educate children on the evils of alcohol. In 1888, it opened a foundling's home for orphaned or abandoned babies in East Portland. In the early 1890s, it began an industrial home for women and girls in the working-class section of the North End which included a kindergarten, a day nursery, and a sewing school. Several years later, it operated a home for unwed mothers. After 1900, the WCTU actively campaigned for child labor laws, raising the age of consent for sexual relations from fourteen to eighteen years, women's protective legislation, city policewomen, jail matrons for female prisoners, and tobacco and alcohol restrictions.[8]

The patrician Portland Woman's Club was founded in 1895. It supported women's education efforts, specialized social service aid programs, suffrage, vice prevention, and protective legislation. Noted member Abigail Scott Duniway led the fight for the women's franchise in Oregon. Sarah A. Evans began nutrition and cooking classes for working women, and discovered filthy conditions in the city's food markets. When she initiated a public campaign for sanitary laws and inspection, she was appointed market inspector by Mayor Harry Lane. Millie Trumbull, who lived as a settlement worker at Chicago's Hull House for a time, was secretary of the Oregon chapter of the national Conference of Charities and Corrections. She inspired the organization of Portland's juvenile court, and became head of its probation department. Eleanor F. Baldwin wrote a column, "The Woman's Point of View," in the *Evening Telegram* which highlighted women's reform concerns, including the need for policewomen. Writer Louise Bryant, most noted for her suffrage activities, also boosted the women's police idea in the *Oregonian* newspaper and *Sunset* magazine.[9]

The more egalitarian Portland Women's Union enjoyed a broader membership who shared an interest in moral reform, vice prevention, and women and children's protection through both public and private means. Its representatives were found on boards and as practical workers for institutions like the Florence Crittenton Home, Children's Home, Travelers' Aid, Boys and Girls Aid Society, and the Albertina Kerr and Fruit and Flower day nurseries. It had a number of well-to-do affiliates, but also drew from the ranks of the solid middle class, without regard to social pedigree. As one of its more successful projects, it ran homelike boarding houses for single female workers. A number of its members were instrumental in beginning Portland's first genuine settlement house.[10]

In 1904, "The People's Institute Settlement Work" was established in the heart of the working-class residential North End. Although begun as a Presbyterian Mission project, it soon became a secular enterprise substantially

backed by Helen Ladd Corbett of the Women's Union. It patterned itself after Jane Addams' Hull House in Chicago, accepting volunteer workers and contributions from all quarters. Valentine Pritchard, a kindergarten teacher and trained settlement worker, served as director. After visiting homes in the neighborhood, Pritchard provided services to meet the most pressing needs. She organized a kindergarten, a class for disabled children unable to attend regular school, an outdoor playground, and an indoor gymnasium program. She added a bathing and laundry room which local mothers could patronize with their children twice a week. Citizenship, hygiene, sewing, cooking, and mothering classes instructed immigrant women in expected cultural norms. An employment bureau for women and a free medical clinic were also provided.[11]

With a long tradition of self-sufficiency, the Rose City's Jewish women responded to the needs of the Eastern European Jews who began to settle in South Portland in the 1890s. In 1896, the wives of Abraham Meier, Alex Bernstein, Ben Selling, L. Altman and others (their own names have not been preserved) organized the Portland Council of Jewish Women. One of its primary concerns was the moral safety of young female immigrants, few of whom could speak English. Its philanthropy committee sponsored a sewing class which was open to all, regardless of religious background. When Reform Rabbi Stephen S. Wise accepted a position at Portland's Temple Beth Israel in 1900, his wife Louise joined the council. She convinced the women to begin a Visiting Nurse Association to serve all the city's poor. With Rabbi Wise's blessing, the women established a Neighborhood Guild, which opened a settlement house in 1905. "Neighborhood House," as it was called, provided much the same programs to South Portland residents as the People's Institute did in the North End. It offered citizenship, cooking, sewing, drawing, crafts, and manual training classes. The complex also housed a gymnasium, kindergarten, library, medical services, and group meeting facilities.[12]

The Portland Young Women's Christian Association (YWCA) was organized in 1900 as a haven for young women who moved to the city to find work. It provided safe low-cost rooms, meals, employment advice, enlightening lectures, and practical arts classes. In 1904, under president Jessie M. Honeyman, it began a Travelers' Aid department with funds from the National Exposition Travelers' Aid Association of New York. The aim of the program was to offer material help and guidance to young women arriving for the city's 1905 Lewis and Clark Exposition, and prevent them from being seduced or otherwise morally compromised while in the city. The Travelers' Aid idea had originated with the YWCA, which began one of the first programs in Chicago in 1888 "to outwit evil agents who would deceive the innocent." The

nonsectarian National Travelers' Aid, however, welcomed purity advocates from all women's groups for ad hoc vice prevention in cities hosting large expositions. In keeping with this female ecumenism, Honeyman appointed Lucia F. Addington of the Woman's Club and WCTU, Josephine Hirsch of the Women's Union and Council of Jewish Women, and Mrs. C. R. Templeton, also of the Women's Union, to serve as officers. Lola G. Baldwin of the Florence Crittenton Home board was chosen as program director.[13]

Other religious and ecumenical organizations were also a vital part of the vice-control and social-service network. Urban missions served a clientele often ignored by more fastidious workers. The women's auxiliaries of the Olive Branch, Peniel, and Salvation Army missions aided the most downtrodden of society from locations in the heart of the vice district. They provided refuge for abused prostitutes with no questions asked, for example, and dealt with women ravaged by alcohol and drug addiction. The Olive Branch Mission worked with the municipal policewomen by visiting prostitutes in the neighborhood and handing out cards directing them to the Women's Protective Division for help in leaving prostitution if they desired. The Volunteers of America ran a boardinghouse for working-class women on the east side's Union Avenue. The Catholic Women's League, besides serving the needs of their own, supported worthy outside causes. Of note was their financial sponsorship of an additional Travelers' Aid matron at Union Depot. They began a free employment bureau, and took probationed Catholic girls under their wing to ease the burden on the city's policewomen. The Catholic Sisters of the Good Shepherd operated what was for years the city's only detention home for delinquent minor females remanded by the courts or their parents as incorrigible.[14]

The municipal policewomen's movement was also heavily influenced and aided by the ideals of "social hygiene," a reform avenue often utilized by the social-feminist coalition. Inspired by medical germ theory, social hygiene principles dominated many of the attempts to bring rational order to America's urban areas at the beginning of the twentieth century. The goal was to cleanse and uplift the evil city, and make it morally and physically safe for families, single working women, and children. Advocates believed that the police power should be utilized to attack a broad range of concerns. Under pressure from social hygienists, many of whom were physicians, municipalities initiated sanitation and public health programs, venereal disease control, vice and prostitution abatement, commercial amusement reform, and other correctives for situations perceived as dangerous to the public welfare.[15]

Portland Mayor Harry Lane, a practicing physician, was the city's first public officer who could be called a social hygienist. He ran for mayor in 1905 after Mayor George Williams rebuffed his proposal for a meat inspection code

to regulate practices in local packing houses. He was equally incensed with the sexual vice and venereal disease in the North End. As mayor, he reorganized the city health department, and appointed Dr. Esther Pohl Lovejoy as Health Officer to fill a position which had simply been a political plum in the past. Like Lane, Lovejoy believed that prostitution and venereal disease were public health threats as well as moral issues, and should be controlled by the police power. Lane's appointment of Sarah Evans as market inspector furthered his approval of women as "municipal housekeepers," but his advancement of the policewoman idea was undeniably his most important gesture to include women in his plan to cleanse Portland of corrupting vice.[16]

Oregon Governor George Chamberlain, who served at the same time as Lane and shared his antivice zeal, was considered a pioneer social hygienist by the national movement. In 1908, both Lane and Chamberlain endorsed Portland physicians L. W. Hyde, Calvin White, and Norman Pease, who followed the lead of New York's Dr. Prince Morrow and formed a Social Hygiene Society to gather evidence on sexual vice and related issues and lobby for remedial actions. Dr. Hyde invited new policewoman Lola Baldwin, juvenile court judge William N. Gatens, and juvenile probation department head Millie Trumbull to join as charter members. In 1911, at the urging of Harvard-trained president of Reed College Dr. William T. Foster, the Portland society affiliated with the American Federation for Sex Hygiene and changed its name to the Oregon Social Hygiene Society. Its expanding male and female membership was instrumental in initiating statewide sex and venereal disease education, a vice commission to study prostitution and venereal disease in Portland, and state and local vice reform and health legislation.[17]

These two impulses, then—organized social feminism and the social hygiene ethic—became the most important guiding influences on the municipal policewomen's movement. Female interest in these issues was based in traditional concerns for family, and the welfare of women and children. As avenues for reform became increasingly secular, or at least secular-sounding, the principles of social hygiene enabled women to advocate use of the government police power to gain social change. Fearing prostitution and disease for the young woman who remained unprotected in the city, "municipal mothers" like Baldwin sought female-to-female preventive solutions. Social hygienists' insistence that prostitution was a public health problem opened up the legitimate use of the police power to fight urban vice in general, as most forms of it could be linked in some way to the "oldest profession." Both the women's organizations and the social hygiene element proved to be faithful supporters of Baldwin's policing agenda over time.

*My "beat" has been from Oregon
City to St. Johns, and from Portland Heights to the North End. The
policemen always know where to bring a girl whom it is not right to lock
up in the jails. They have even brought them to my home at night.*

—Lola G. Baldwin, December 1907

1

A Municipal Mother

In May 1905, Portland Police Chief
Charles H. Hunt distributed a letter to the newspapers warning citizens to be
wary of the criminal element during the upcoming Lewis and Clark Centennial
Exposition. Burglars, grifters, pickpockets, and every shade of con man, Hunt
reminded his readers, were developing clever schemes to "rob the green-
horn." He carefully outlined ways the public might protect itself and its
valuables. With more than a million visitors expected during the next six
months, he concluded, the regular city police would be "put upon their metal"
just to maintain order. In response, some businesses banded together to
sponsor numbers of special police who roamed commercial districts to
prevent customers from becoming victims. Yet for some Rose City residents,
property crime was only part of the imminent protective dilemma. Women's
groups and their antivice male allies prepared to provide other special police
to keep female visitors safe from the taint of immorality which usually
accompanied such world's fairs.[1]

Oregon's largest city went forward with plans for its great commerce and
development fair at a time of significant social change. Victorian-era restraint
was giving way to America's so-called ragtime period, and an emerging
"anything goes" attitude in the industrializing cities produced anxiety among
traditional moralists. In the minds of many, this laxity was somehow
connected to contemporary waves of foreign immigrants. One of their fears
manifested in a belief that shadowy aliens operated a worldwide "white slave"

traffic in young women. Urban events like the coming exposition were magnets for young unchaperoned females, and it was assumed that procurers would seek every opportunity to snatch them up. Rumors circulated that over eleven hundred girls had disappeared during world's fairs in the previous decade.[2]

In 1902, such stories prompted Mrs. William Shaw Stewart, Helen M. Gould, Florence Blanchard, and other eastern-based social purity advocates to form the National Exposition Travelers' Aid Committee. Using strategies developed by the Young Women's Christian Association in Chicago a decade earlier, this group sponsored ad hoc preventive and protective campaigns for females in cities hosting large exhibitions. Dr. Kate Waller Barrett, national head of the Florence Crittenton homes for rescued prostitutes and unwed mothers, coordinated its first Travelers' Aid program at the 1904 St. Louis Exposition. After what it considered good results in Missouri, the national committee contacted Jessie Honeyman, Women's Union member and president of the Portland YWCA, and offered surplus funds to help begin a similar effort for the Lewis and Clark Centennial.[3]

In the nonsectarian spirit of the national sponsor, Honeyman gathered a coalition board from among the city's secular and religious women's groups. The governing body included Lucia Addington of the Woman's Club and WCTU, Josephine Hirsch of the Women's Union and Council of Jewish Women, Mrs. C. R. Templeton of the Women's Union, and Honeyman herself for the YWCA. The board asked William R. MacKenzie of the Chamber of Commerce to act as treasurer. Rabbi Stephen S. Wise of Temple Beth Israel became an enthusiastic booster of the idea, not only for its needed preventive and protective mandate, but because it promoted an ecumenical spirit among the city's women. "This work should succeed," Wise told the *Oregonian*, "for the work of the Travelers' Aid Association spells sisterhood, and there are no lines of division in the realm of sisterhood." Furthermore, the rabbi asserted that the vice preventive program would "survive the Exposition and prove a permanent good to the city and the state."[4]

To supervise the female-protective and vice-preventive work for the fair, the national association recommended former eastern social worker and new Portland resident Lola G. Baldwin. Born of Protestant Irish heritage in Elmira, New York, in 1860, Baldwin had moved with her family to Rochester while she was still quite young. She began her early formal education with several years at Rochester's Christ Church Episcopal School for Girls. Founded in the wake of the great religious revivals which swept the area in the 1830s and 1840s, such institutions taught pupils not only reading and writing, but also the proper moral standards to dissuade them from "the highways and resorts

of dissipation" later in life. She completed her final elementary grades in the public schools, but only managed to finish three years at Rochester High School, when in 1877, she was forced to withdraw when her father died unexpectedly. From then on, as the eldest of three girls, she found herself obliged to earn her own living. She acquired all her further education, she emphasized later, "solely by personal effort."[5]

Choosing one of the few employment paths open to females, the bright, determined girl opted to become a teacher to support herself. Baldwin reported that she "studied diligently" to overcome her high school deficit and pass the New York State pedagogic certifying exam. She then taught for several years in what she once described as a "cobblestone school" in Monroe County near Rochester. In 1880 the adventuresome twenty-year-old decided to answer a call for teachers in the west. She traveled to Lincoln, Nebraska, where she passed the state accreditation exam "with a 98% average." Baldwin taught for the next three years in Lincoln's Preparatory High School under the direction of Professor J. M. Scott. She clearly took the experiences of these formative years to heart. Throughout her later life, she insisted that her own venturing "out into the world at an early age to face temptations and discouragements" prepared her in a very personal way "to understand the problems of other young girls."[6]

In early 1884, she met Vermont-native LeGrand M. Baldwin, a Lincoln dry-goods merchant. The two married in December of the same year, traveling back to her family home in Rochester for the wedding. When the couple returned west, the new wife was forced by custom to give up her teaching job. Yet she resisted becoming a cloistered housewife, and looked for other work. Public Lands Commissioner A. G. Kendall hired her as a statistical clerk in his Lincoln offices, and she continued in his employ until she and LeGrand started a family. Two sons, Myron and Pierre, were born while the couple lived in Nebraska. Even then, her teacher-bred interest in the welfare of the young led her into volunteer social service work with what were then called "wayward" girls.[7]

As a product of western New York's famed "burned over district" (so named because the effects of the fiery Protestant religious revivals of the 1820s and 1830s had there proved lasting and deep), Baldwin was inculcated from her youth with the zealous female reform impulse which seemed to be a definitive local trait. An above-average number of women from that region became involved in the most important social reform movements of the nineteenth century. Operating at first within the confines of church-based "moral reform" societies, middle-class women began to attack the vices which they felt were threatening the home. A Jacksonian-era focus on male alcohol

and vice temperance was replaced by ante-bellum concern for slavery abolition, which was replaced in turn by a post-bellum emphasis on women's rights and the "new abolitionism" of the antiprostitution crusade. This last movement proposed to rescue women from the "white slavery" of prostitution by "re-forming" their lives in special homes. A related effort sought to prevent the moral "fall" of young women thought to be at risk. By the mid-1880s, Lincoln, Nebraska, had copied its eastern counterparts and offered a number of such institutional programs. Baldwin spread her volunteer hours between the Nebraska Rescue Home and the Home for the Friendless, interviewing inmates to determine the best course for their moral salvation, and earning her credentials as a "new abolitionist."[8]

The Baldwins left Lincoln in 1893. Over the next ten years, LeGrand pursued his trade in Boston, Yonkers, Norfolk, and Providence. His wife continued her volunteer moral purity work among women and girls at each stop, developing a reputation as a diligent and caring worker. While in Providence, she became an accredited nonsectarian hospital visitor, volunteered at the Rest Cottage Home for wayward girls, and served on the boards of two Florence Crittenton rescue homes. The "chain" concept employed by the Crittenton institutions was similar to the strategy being adopted in retail circles at the time. Just after the turn of the century, LeGrand Baldwin joined the E. P. Charlton Company of Fall River, Massachusetts. One of the first multi-outlet merchandisers, Charlton's had over fifty so-called "variety" or "dime" stores spread throughout the east and midwest. In 1904, the company sent LeGrand to Portland, Oregon, to open its first northwest operation. His wife worked for him in the firm's business office, yet continued her interest in the moral welfare of young women and girls by serving on the board of the local Florence Crittenton Home. When Jessie Honeyman approached Baldwin to direct the Travelers' Aid work for the city's upcoming exposition, she found a woman well qualified and eager for the task.[9]

To compensate Baldwin for her time and lost wages, the Portland Travelers' Aid organization offered her $75 a month for the duration of the fair. She readily accepted, and began honing a plan to protect young female exposition visitors from what she called moral "pitfalls." With local pledges from fraternal lodges, individual businessmen, church service groups, and women's clubs, plus the $200 surplus from St. Louis and a personal gift from New Yorker Helen M. Gould, the Portland Travelers' Aid anticipated a budget of $2,500. Baldwin lost little time in identifying problem areas. Morally safe housing became a primary concern, as even saloon buildings and brothels offered scarce rental rooms. Baldwin worried that "respectable young ladies, not knowing the difference" might engage such lodgings, and be "ap-

proached by men who would try to force their attentions on them." When Baldwin learned of any such case, she made sure the girl in question was "at once removed by the association and sent to decent quarters." The YWCA, the Christian Endeavor Society, the Sisters of Mercy, the Council of Jewish Women, the Women's Union, and the Volunteers of America all helped in securing safe rooms. As a preventive measure, Baldwin ordered that all potential rooming facilities be catalogued and indexed as to their class and reputation. This list was made available free to arriving visitors at the docks and train depot.[10]

Many girls came to the exposition for temporary employment. Fairgrounds employers sought attractive young women to fill low-skilled but highly visible positions in concessions, sideshows, and exhibit halls. The exhibit halls were staid structures, filled with examples of agricultural produce and manufactures from the states or regions they represented. They were magnets for serious-minded adult fair-goers, but spelled boredom for younger attendees. Many of these eased away from parental grip at the first chance and made their way to the exotic enticements of "The Trail," the exhibition's amusement corridor, where they mingled with working-class youngsters and others who had no desire to sample the fair's more highminded attractions. The darkened, interactive experiences of the "Haunted Swing," the "Haunted Castle," and the "Mirror Maze" competed for custom along the boardwalk. Tucked in between were restaurants and a beer garden, a shooting gallery, an exotic animal show, the "Glimpse of the Harem" sideshow, and a booth devoted to human infants in incubators. Baldwin's Travelers' Aid workers diligently patrolled this area as they went to and from the YWCA Women's Pavilion. The national YWCA, for the first time at any exposition since assessing needs in St. Louis, sponsored a spacious building at Portland's world's fair. It offered restrooms, sleeping cots, light dining, sitting lounges, a nursery, and a children's playroom.[11]

The Rose City's existing leisure spots prepared to entice the overflow crowds. A full-scale mechanized amusement park, "The Oaks," opened in the southern Sellwood district to counter the attractions of the fair. Saloons, nickelodeons, dance halls, pool rooms, skating rinks, and shooting galleries all put a premium on pretty young females to attract business, and often promised high wages for easy work. Baldwin viewed these places as intolerable lures into the world of sexual vice. To thwart this practice, her volunteers clipped and investigated suspicious help-wanted advertisements, and exposed cases of bogus or morally dangerous employment in the press. Her May 1905 exposé of massage parlors operating as fronts for prostitution gave due warning to others not to follow suit. As an additional measure,

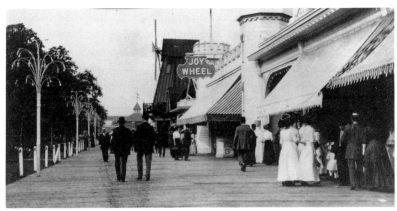

"The Oaks" Amusement Park, 1911.
Photograph: Oregon Historical Society (negative OrHi 84659)

Baldwin obtained promises from reputable businesses to employ girls referred by the Travelers' Aid.[12]

Baldwin generally assessed Portland as "more open in its vice" than the eastern cities she had lived in. This fact, in her estimation, "served the purpose of making it easier to deal with." For example, she won surprising pledges from some of the local saloonmen and brothel keepers to report or discourage under-age girls who sought work in their establishments. "There are those proprietors," Baldwin remarked at an April 1905 Travelers' Aid board meeting, "who are helping me in my quest, who furnish me information and lend me great assistance." Her direct approach won the respect of many in the saloon sector, who agreed to cooperate with the understanding that Baldwin "would never betray a confidence." Such pragmatic compromise helped Baldwin fulfill her ad hoc agency's purpose of preventing young women from falling into prostitution during the exposition period. "We do not expect to eradicate the social evil in Portland," she said on one occasion, "but we do expect to improve it."[13]

Concurrent with the Travelers' Aid preparations for the fair, Baldwin and Millie Reid Trumbull became the only women on a committee to organize a juvenile court in Portland. Trumbull, the secretary of Oregon's Conference of Charities and Corrections and a member of the Woman's Club, had experience as a settlement worker under Jane Addams in Chicago, and was familiar with that city's new juvenile court. Both Baldwin and Trumbull impressed upon the committee a need to consider girls as well as boys in its plan. The few juvenile courts in existence were overly preoccupied with young male delinquents, and the two women knew from experience that urban girls also needed the guidance of such an institution. As a result of their

input, when the court began operation in June, Judge Arthur Frazer named Trumbull as head of its probation department, and appointed Baldwin as an unpaid probation officer for transient girls. This enhanced Baldwin's status as a vice-preventive agent. [14]

On June 1, 1905, President Theodore Roosevelt officially opened the fair by telegraph signal from the White House. Well in advance of that date, Baldwin had stationed dozens of orange-ribboned Travelers' Aid volunteers from the ranks of the women's clubs and private charities at the train depot and docks to intercept early arrivals. Her workers were prepared to offer almost any kind of help to the female traveler. In addition to lists of approved lodgings and employment opportunities, Baldwin had arranged for free medical aid through Good Samaritan Hospital, vouchers for meals and temporary shelter, and the cooperation of the transportation companies on ticket problems. Local mothers applauded the group's thorough surveillance of the fairgrounds and other amusements, and police officials were pleased that some of the pressure was taken off their hard-pressed personnel. Baldwin's antivice measures for the fair soon won her further recognition in law enforcement and judicial circles.[15]

With the Lewis and Clark Exposition in full swing in the summer of 1905, the Travelers' Aid's success was quite evident. By the end of July, hundreds of women and girls had sought the agency's assistance at the fairgrounds or elsewhere. At the train depot, the Travelers' Aid workers never left a girl alone "for an instant," as they had noted that the "agents of disreputable houses met every train, and waited about the station for chances to entice country girls to go with them." Baldwin located many young women whose anxious relatives had reported them as missing. She shepherded those who broke the law through the courts, and kept close watch on them afterwards through an informal probation system she called "after care." [16]

Mayor Lane's office received nationwide congratulations for the female protective work being done in conjunction with the fair. He added his personal appreciation at the July Travelers' Aid meeting, where he unveiled his own extensive plans to clean up the city's vice district. By Baldwin's own account, the new mayor presented her with a police star to carry as a symbol of his recognition and approval of her vice-prevention work for the fair. Representatives of the municipal court and the local Boys and Girls Aid Society at the gathering expressed similar approval of Baldwin's work. When she penned a note to Lane thanking him for his remarks, she lauded what she termed his "rousing" antivice speech. "It was," she wrote, "*exactly* what we wanted."[17]

With the statistical skills she had learned as a land office employee, Baldwin recorded her case data in a special cross-referenced card file system. For both publicity and information's sake, she made periodic statements to the press concerning the number and type of incidents her workers handled. These published reports were necessarily of a general nature. Unless specifically requested by the police or courts, personal information about the subjects was never released. By early fall, Baldwin's figures confirmed a trend which she had suspected for weeks. The majority of her vice-related cases concerned resident women and girls, not temporary visitors. These alarming observations now led her, Mayor Lane, Police Chief Carl Gritzmacher, and some court officials to echo Rabbi Stephen Wise's prediction that the effort would have to continue once the fair ended.[18]

When the Exposition closed in mid-October of 1905, the local newspapers published what was supposed to be Baldwin's final report. Pre-fair budget projections had been overly optimistic, she explained, and only $1,600 of the expected $2,500 had been realized. Nonetheless, the Traveler's Aid had served 1,640 women and girls in one way or another, a third of whom had been placed in safe employment. Mayor Lane, Chief Gritzmacher, and many of the city's court officials agreed that the organization had "had a restraining influence upon procurers and other men of evil classes" during the fair. Baldwin's relentless pursuit of males who seduced young women in violation of a number of existing state laws had produced several forced marriages and well-publicized prosecutions. She asserted that such legal action not only punished the wrongdoer, but served as a warning to other men "to leave Portland's girls alone." However, she concluded, if the agency ended its preventive work, conditions would soon be "as bad as ever."[19]

In reality, circumstances for the city's young working women deteriorated even further than Baldwin expected. Fair-related employment evaporated, leaving large numbers without means to return home or develop qualifications suitable for other jobs. Safe unskilled positions were rare, and even "good" young women soon looked for work in the city's drinking dives and cheap amusements. Baldwin, alarmed, made a public plea for the $100 per month needed to keep the Travelers' Aid solvent. She cited precedent that YWCAs and their supporters in eastern cities like Chicago and Boston had funded permanent female protective departments since the late 1880s. The Portland agency's funds were drying up, as half its original budget had come from eastern sources, and most local pledges had been for the exposition period only.[20]

Seeking to convince Portland that a solid program of protective vice policing was an ongoing necessity, Baldwin decided to make a study of the

ways in which other cities handled the "girl problem." With a letter of introduction from Mayor Lane, she departed on an extensive fact-finding tour in late 1905. According to Baldwin, she visited "all the principle [sic] cities from Washington, D.C. to the Canadian line, and from the Atlantic to the Pacific," meeting with a variety of urban officials and social workers. She visited religious missions, settlement houses, female detention facilities, and YWCAs with permanent Travelers' Aid departments. One highlight of the trip was a day spent with Dr. Kate Waller Barrett at the Florence Crittenton National Training Center in Washington, D. C.[21]

On her way home, excited by her findings, Baldwin wrote to Mayor Lane from Chicago in late December. She hinted at a much broader vice-preventive campaign for Portland. Laced with "Stumptown" boosterism, the letter asserted that in all her travels she had not found any place she preferred over the City of Roses. "Why, if you could hear me answer questions and boom Portland," she wrote, "you would think that I was a native webfoot." A long discussion of the white slavery problem with a woman Travelers' Aid worker on Boston's busy immigration docks had convinced her, she told Lane, that Portland should pay greater attention to the ships entering its harbor. "In fact," she continued, the "greatest work for girls would be upon the outgoing, rather than incoming ships." In all, she claimed to have recorded "much valuable information" on her journey. "I hope," she concluded to the mayor, "that I shall find you in a mood for taking up all my new schemes for the betterment of girlhood in our beloved city."[22]

When she returned in January 1906, Baldwin discovered that her plans were in jeopardy. The Travelers' Aid was on the brink of disintegration. Despite the initial ecumenical optimism of supporters like Rabbi Wise, the governing panel found itself at an impasse due to its inability to obtain continued funding. Adding to the rancor, the YWCA element generally wished the work to continue, but only on condition that board members who were not evangelical Christians be removed. Unable to resolve these differences, the agency declared its exposition-related mission accomplished, and dissolved itself after voting Baldwin an extra week's salary to settle accounts. Fortunately, Baldwin's trip data, plus her promise of "unrelenting" fund raising, convinced the YWCA to accept sole sponsorship. With Baldwin continuing as director, the agency reorganized in early February as the Travelers' Aid Department of the YWCA, under the motto of "Protection for Girlhood."[23]

Much as Baldwin had originally designed it, the new entity remained a vice-preventive agency and a social work clearing house. The director continued her vice investigations as before, and coordinated assistance

among public and private institutions to help women and girls who were in "morally dangerous" situations. Her 1907 handling of "Caroline," a young unwed pregnant woman, well illustrates the process. Baldwin first contacted Portland's Associated Charities, which provided emergency food and rent money for the destitute girl. She then called the Visiting Nurse Association, which summoned an examining physician. When the doctor determined that the young woman had tuberculosis and would probably need a Caesarean section, Baldwin arranged for her free admittance to Good Samaritan Hospital, and asked Associated Charities to furnish baby clothes. In the meantime, she took the girl to the district attorney to swear out a complaint against the man responsible for her pregnancy. After the birth, the mother and child were transferred to the Florence Crittenton Home. When the girl developed complications from the birth, Baldwin had her moved to the county hospital for treatment. She later found her a domestic job, and suitable childcare for her infant.[24]

Baldwin once wrote that she and the YWCA financed her work by "going out into the business houses and elsewhere begging the money." She stretched her hard-won budget by utilizing charitable facilities available in the community and by arranging free or low-cost housing, medical services, and transportation. She developed a local reputation for frugal yet fair-minded competence. Apparently sharing Baldwin's maxim that "a fence around the top of the cliff is better than an ambulance down in the valley," salmon packer James W. Cook augmented her 1906 budget with a $500 gift. He reportedly told the Travelers' Aid director that her work was "the most practical and far-reaching social effort for girls that he had ever seen." In April 1906, William MacKenzie of the Chamber of Commerce asked Baldwin to help disburse its large relief fund for victims of San Francisco's great earthquake, who were arriving in Portland in large numbers. Because the disaster to the south absorbed so many of the donations usually made to the Travelers' Aid, its own contributions totalled only $1,470 for the year. Although severely financially limited, the organization still managed to aid 2,555 women and girls during that time.[25]

But, despite continual solicitation, the Travelers' Aid budget could not keep up with the demands made upon it. Besides Baldwin, it now paid Caroline Barnum as an assistant investigator, and Helen Hutchinson as employment secretary. Matters became worse as Portland experienced the repercussions of the national financial panic of 1907. As joblessness in the low-wage sector rose, the agency's employment service could find positions for only one-third of the young women who applied. Baldwin feared that the remainder would be forced to seek "easy money" in crime and prostitution.

She reported that the sexual vice investigations she dubbed her "special girls" or "police cases" more than doubled in 1907. She vigorously pursued both men and women she believed were "preying upon innocent girls." If she thought a given fine or jail term too light in cases she turned over to police authorities, she published the offender's name and occupation in her Travelers' Aid reports to the newspapers. In one six-month period alone, Baldwin claimed she had successfully pushed eight morals cases through the courts, each resulting in a heavy fine or jail time.[26]

Portland Mayor Harry Lane paid close attention to Baldwin's vice-preventive tactics. A respected local physician, Lane had entered the 1905 mayoral race over the vice and public health issues he felt were being ignored by then-mayor George Williams. Although he was the grandson of an Oregon governor and son of a congressman, Lane was not a professional politician. Instead, he was best described as a professional who brought his particular expertise to government. Elected by a coalition of reform-minded Democrats and Republicans, he represented the so-called "social hygiene" impulse of Progressive Era politics. Beyond obvious concerns such as food and water safety, improved sanitation, and disease control, reformers like Lane also addressed vice and other urban pathologies by adapting medicine-inspired "preventive" philosophy to the "body politic."[27]

As a champion of social hygiene, Lane repeatedly emphasized that he wished to make Portland "America's healthiest city." Conforming to Progressive Era vogue to utilize women as "municipal housekeepers," he appointed Dr. Esther Pohl Lovejoy as head of the city health department. Portland Woman's Club cofounder Sarah A. Evans, who started a school to teach sanitary food preparation to working-class women, became alarmed over unclean practices by the city's provisioners. She and other clubwomen lobbied the mayor to appoint a public food market inspector with police powers. He obliged by giving Evans the job, making her the first woman market inspector in the nation. His physician's experience complemented his approach to a fully healthful urban environment. Having pursued postgraduate medical studies in Europe at a time when the Continent pioneered new attitudes about the dangers of venereal infection, Lane became one of a new generation of public officials who viewed prostitution and its related vices as a public health issue as well as a moral problem. Just as preventive medical practice sought to eliminate the source of disease, Lane could justify his campaign to eradicate Portland's vice district as a public health measure tied to overall municipal reform.[28]

Early in Lane's first term, inherited conditions dampened his zealous crusade against vice. He discovered that reform intentions in the mayor's

office did not translate into immediate change elsewhere. He faced en-
trenched reticence in the city bureaucracy, and ambiguous public feelings
about the vice district. It was an open secret that many wealthy Portlanders
reaped high rents from buildings housing so-called "disreputable busi-
nesses," and that these same owners influenced selected public officials to
minimize prosecutions. In fact, many of the clubwomen who supported
Baldwin's Travelers' Aid antivice work were the wives and daughters of some
of those landlords. Baldwin's 1906 benefactor James W. Cook, for example,
whose daughters were Women's Union members, was later exposed as a vice
property owner. This collusive system repeatedly frustrated Lane in his
attempts to combat prostitution. Although he ordered increased police raids,
significant convictions eluded him.[29]

Defiant North End proprietors like Tony Arnaud, Fred Fritz, Julius Kutner,
and August Erickson "seemed to think that the ordinances have been
suspended," Lane's hand-picked police inspector Captain Philip Bruin wrote
in early 1906. Bruin reported seeing open prostitution solicitation in all the
district's saloons, yet the police vice squad rarely reported it. Suspecting graft,
Lane fired the entire vice detective force. Still the city courts rarely handed
down convictions. Too often, even with what Captain Bruin called "evidence
that would convince any intelligent man," Lane's replacement officers saw
their cases come to nothing. Bruin himself noted that he had made "many
personal enemies amongst the prominent citizens" by simply applying the
law. While Lane's efforts stalled at every turn, Baldwin's Travelers' Aid cases
often yielded meaningful results. Baldwin, in her own words, possessed an
"Irish" temperament and "relished a good fight." A coworker later remarked
of the tenacious Baldwin that "she couldn't be bought, she couldn't be
influenced, and she couldn't be intimidated." As a result, her relentless pursuit
of those preying on innocent girls brought admiration from the hamstrung
mayor.[30]

By late 1907, other officials were publicly commending the YWCA
Travelers' Aid director as well. Juvenile court jurist Arthur Frazer had been
Baldwin's supporter since 1905. Municipal court judge George Cameron
similarly approved of her vice-preventive attitude and prosecutory successes.
Oregon State District Attorney John Manning and Assistant United States
Attorney James Cole praised her thorough investigative work on cases which
came within their jurisdictions. Many of the city's regular patrolmen had
begun calling on her at all hours of the day and night to handle "the cases
where a woman was needed." Acting on tips, Baldwin described herself as
"going alone times without number into the saloons and dives" to retrieve
endangered females. The high praise coming from judicial agencies and

others sparked a belief in Baldwin and her supporters that it would be in the public interest for the city to assume financial responsibility for her services. By the end of 1907, "police cases," as she dubbed her sexual vice investigations, were the most expensive yet most necessary aspect of the Travelers' Aid agenda. If she could separate out the vice work, and somehow put it under public funding, the rest of the organization's program could survive within its current budget. Although no American municipality had ever paid for a female morals investigator before, Baldwin followed her impulse. In December of 1907, she packaged herself as a three-year *de facto* member of the police department and lobbied the city to pay for her vice crime work.[31]

After canvassing selected officials to test the possibility of allies, Baldwin reported hopefully to Mayor Lane that "not a man had said but what I might have something from the city." The only exception had been city councilman Dan Kellaher, who objected to the monetary outlay but who, she wrote, "was not opposed" to the basic principle of her work. Encouraged by her straw poll, Baldwin typed a lengthy report of her accomplishments of the past three years, much of which emphasized her vice policing role. She delivered copies to Lane, the police board, the civil service commission, and the ways and means committee of the city council. Couching her plea in respectful but assertive language, the Travelers' Aid director proceeded to attempt the conversion of Portland's civic government.[32]

"I beg to submit to you a few facts," Baldwin began, "in regard to the work of the Travelers' Aid for the protection of girlhood in Portland." Describing her activity as neither frivolous nor a part-time endeavor, the director pointedly emphasized that her "*entire time*" was engaged in it. "For three years," she continued, she had "worn a star like any member of the police department." Yet, she submitted, the city had "never paid anything for the service" despite the fact that she "handled police cases almost every day." In 1906, she reported, her office had worked with 230 "special girls," as she referred to her vice-related instances. Through the end of November 1907, she had already handled 322, with no end in sight. That fact alone, she contended, was clear proof that the city's police department "needed the services of a woman."[33]

"For three years," Baldwin reiterated, Oregon's most populous municipality had "enjoyed the services of a diligent officer by night and by day without the cost of one cent." The quality of her work could not be questioned, she attested, as it had always been handled to the satisfaction of all the officials who had requested her aid. The time had come, she pleaded, "when Portland, as a city, should acknowledge the work, as three years of everyday

demonstration given free of charge ought to be a fair test." The program's benefit to the area's young women and girls was obvious, she told the city fathers. "We are asking," the Travelers' Aid director explained, "that some provision be made in the 1908 police budget whereby this protective work for girls may be carried on." She deferred to the men and did "not ask to handle the money," although she had a reputation as a capable disbursing agent. "Place it where you will," she pleaded, "but let it be used for girls needing protection."[34]

Near the end of a so far very restrained and rational plea, Baldwin bared a side of her character which would confound her opponents for the rest of her public life. With an irony few could miss, she sprang a subtle trap. "We notice," she remarked almost mildly, "that there was $5,030 used this year for the dog pound, and an additional thousand is asked for 1908." Unblinkingly, she begged the authorities "for half that sum for practical, positive protection for the growing girlhood of the city of Portland." The amount she asked was miniscule, she inferred, compared to the $219,450 estimated for the police department for the next budget period. Her intended meaning was quite clear. Did the men in power care as much about the city's straying daughters as they did about its straying dogs? Certainly, they would be marked for ridicule if they disallowed Baldwin half what they spent on the pound. "Will you," she concluded pointedly, "place $3,000 to be used for the *girls* of Portland?"[35]

The animal shelter ploy had the desired effect, and Baldwin and her supporters received an early Christmas present. On December 23, 1907, the ways and means committee of the city council recommended appropriating $3,000 to fund positions for three women in the police department. The *Oregonian* item reporting the decision made no mention of the dog pound. It merely stated that the city had taken the action consequent to "recognizing the excellent results accomplished by the Travelers' Aid during the past three years, and after listening to a detailed report from Mrs. Lola G. Baldwin." The YWCA's Travelers' Aid director would seek the top position, the report continued, competing for it via civil service exam. There was little doubt as to whether she would succeed, the item related, as she came "highly recommended by Chief Gritzmacher, Judge Cameron of the municipal court, and others who have to do with police business." The new women police agents, the newspaper concluded, "would be under the supervision of the Chief of Police, but would undoubtedly be allowed great latitude in their special line of duty." Several days later, however, a reconsideration by the council's police committee limited the initial appointments to two women. Within six weeks, city ordinances specifically authorizing the appointment

and remuneration of "one female detective and one female clerk, to perform police service" were ready for a final council vote.[36]

The police committee recommended a $150 monthly salary for the female detective. As specific divisions within the police department were normally headed by officers of captain's rank, the committee set pay to that standard, even though it did not reconcile with the civil service designation of a "female detective" to head the unit. The sum was twice Baldwin's Travelers' Aid stipend, and $35 more than that of a male detective—a fact which brought some criticism from certain males of that rank. Baldwin quelled discussion of the disparity by reassuring Mayor Lane and the city council of its appropriateness. "You, as men," she prodded, "know what perils confront the young girl who is obliged to be out in the world to earn her living." The woman who filled the detective's position, she argued, "must be a trained worker," and thereby would be "entitled to the salary named." Her own efforts of the past three years, she reminded them unabashedly, had "accomplished more than could have possibly been done by a dozen regular patrolmen." Appealing simultaneously to their civic chauvinism and characteristic paternalism, Baldwin slyly volunteered that other cities had written for information about her work. If Portland took the initiative in funding her vice policing program, she asserted, it would "be known from east to west as the city which believes in protecting and cherishing pure, sweet, young womanhood."[37]

The city council voted unanimous approval of the women's police ordinances in mid-February 1908. In early March, Baldwin scored a top 95 per cent on the civil service board's new "female detective" exam and clinched the position. A young woman named Lucy May Sargent qualified for the job as her assisting clerk. On the morning of April 1, after posting the $1,000 security bond required of police department candidates, Lola Greene Baldwin, age forty-eight, took her oath of office at city hall. With the official title of Superintendent of the Women's Auxiliary to the Police Department for the Protection of Girls, she began duty as the nation's first municipally paid policewoman.[38]

After Baldwin's swearing-in ceremony, Chief Carl Gritzmacher invited her to his office to discuss her new duties. At her suggestion, he and the mayor agreed to let her continue renting her old space at the YWCA. In her experience, she told them, few young women would come forward with problems if they had to go to the station house. "Women and girls naturally shrink from publicity," she explained, and many would "endure great wrong before signing a regular complaint." She then ordered basic office supplies, including the letterhead stationery which proclaimed her municipal authority. Her famed budgetary parsimony would remain a necessity, however. Beyond

salaries for herself and Sargent, only $480 had been appropriated for annual expenses. Yet the certainty of that amount was better than the often-broken donation promises of the past. Few who encountered the five-foot-three-inch matron in steel-rimmed glasses as she returned to her office realized the change she had brought to law enforcement that morning. Although the files she opened were the same she had worked on the previous day, the oath she had spoken that morning empowered her as no woman had been before.[39]

On May 1, 1908, Portland's new policewoman sent her first monthly report to Chief Carl Gritzmacher. It was her understanding, Baldwin emphasized to her superior, that her department's "chief aim and purpose was to *prevent* downfall and crime among women and girls by investigation, timely aid, and admonition." She much preferred that, she continued, "rather than to defend them when they have transgressed the law." Her idea of preventive policing meshed perfectly with Mayor Lane's vice control priorities, yet her statement also articulated something quite new to law enforcement. It represented what one historian has described as "a distinct departure from the traditional police role." Baldwin was one of the first enforcement officers to add a preventive dimension to what was formerly a remedial profession. More importantly, she was not merely another woman reformer who urged male officials to use the police power to protect her sex; she actively promoted the direct use of female agents for such duties.[40]

Although Progressive Era reformers called for a purification of the cities to make them safe for women to enter the public sphere, Baldwin was the first to preempt the male prerogative in the field of municipal policing. She and her supporters had successfully argued that unaddressed concerns for the city's young women called for the immediate placement of what some have called a "mother-heart" into law enforcement. In a 1912 *Sunset* magazine piece on Baldwin, writer, suffragist, and Woman's Club member Louise Bryant described Portland's first policewoman as a "municipal mother" who could act as a surrogate parent to protect women and girls from the moral dangers and temptations of urban life.[41]

Baldwin's initial monthly report reflected traditional "maternal" concerns. After investigating ten rooming houses, she and her assistant Lucy Sargent were "not at all satisfied with the moral condition" of the places the working girls lived. In addition, they noted "a great many girls unemployed in the city," yet few safe jobs available. Continuing her former practice, the policewoman and her young assistant monitored the local help-wanted ads. They followed up on those having "the appearance of being fake advertisements offering large wages to girls for questionable employment." In three separate instances that first month, Baldwin stated, she was "satisfied girls were being procured for immoral purposes."[42]

To prevent unemployed girls from being enticed into vice, Baldwin explained to her superiors, she had found it necessary "to furnish a few meals and temporary shelter" for some who were usually "fully able to care for themselves." As frugal as ever, however, she asked for repayment when they were able. She called city health officer Dr. Esther Pohl Lovejoy in four cases of illness among young out-of-work women. "These girls," the policewoman's report continued, "were most of them from the lodging houses, all of them away from home." Baldwin located four of the five girls reported to her by others as having disappeared. In addition, she and Sargent accomplished thirty-two other investigations during their first month of duty. These included what they called "pitfalls alluring girls," and other instances in which the women police agents had been asked to furnish "reliable information to the courts, and otherwise assist where requested." Despite this impressive output, Baldwin prefaced her monthly summary with an apology that the time she had used for planning had made "the amount accomplished not seem to have been very great." She assured her chief that such time spent on strategy would pay off, and "not be lost in days to come."[43]

The more detailed records Baldwin left in her daily activity logs tell a story only touched upon in her report to her superiors. During that first month, she also received a crash course in federal immigration law. After the United States Attorney asked Chief Gritzmacher to lend Baldwin's services to him when needed, the policewoman spent parts of ten working days on one white slavery case. It included accompanying the girl in question by train to Seattle, where she was deported to Japan. In another investigation, the policewoman proved her detective skills were comparable to those of her male counterparts. After searching a young woman's room, Baldwin traced the laundry marks on a man's shirt she discovered in a closet. They yielded the name of the man the girl had been afraid to give as the father of her expected baby. The evidence led to his prosecution for seduction. On a more personal note, she had had to cope with the death of her father-in-law Myron H. Baldwin, who succumbed at the family home on April 18. With these additional facts in mind, it seemed overly modest when Portland's "municipal mother" reported at month's end that merely "a good beginning" had been made.[44]

The average working girl is
lamentably ignorant and innocent of the ways of the tempter, whether he
appears clothed in a dress suit or rough homespun.

—Lola G. Baldwin, September 20, 1911

2

Working Girls and Women Police

Detective Baldwin and her assistant Lucy Sargent maintained their office away from the police department in order to better serve the city's women and girls. Not wishing to frighten off potential clients, the new policewoman also declined to work in uniform, preferring plain dark street clothing . Baldwin's influence was so strong in this matter that women on the Portland force continued in plain clothes for fifty years after her retirement. In a similar vein, she kept her police badge hidden in her purse, and only presented it when necessary.[1]

Baldwin's jurisdiction included numerous young working women who lived in rooming houses, most away from the protective influences of home for the first time. They had gravitated to the city for various reasons: some full of hope, some running away from abusive homes, others simply seeking a fresh start after some major or minor life disappointment. The early female law officers hoped to instill a maternal influence into municipal policing to substitute for absent familial control or, in some cases, familial caring. In this way, most aspects of young working women's lives came under their scrutiny.[2]

Baldwin claimed that more than ten thousand of what she termed "business girls" lived in Portland and worked in its offices and retail stores. According to a contemporary source, 59 per cent of all young women between the ages of sixteen and twenty were engaged in some gainful occupation in the early years of the twentieth century. Many were trained in the business colleges which proliferated in the cities. These attracted numbers

of middle-class girls who thought that office or retail employment would be easier, cleaner, or more ladylike than factory or domestic work. In the policewoman's view, such young women were more prone to moral failure than either the rich or the poor. The affluent girl, Baldwin explained, was "chaperoned, and thus shielded from the dangers and pitfalls of the business girl's life." Poor urban-raised girls seemed instinctively "streetwise," although their country-bred cousins needed close supervision if they moved to the city. Wages for females in almost all occupations were generally low, and girls often felt pressured to keep up appearances. Tempted by the latest clothing fashions, for example, they might skip meals, or look for the lowest rents in order to afford a few articles of "fancy wear."[3]

Some fell victim to the easy credit offered by the large downtown Portland department stores such as Meier and Frank's, Lipman-Wolfe's, or Olds and King's. "A great many girls," Baldwin once told an interviewer, got into debt to "the firms who solicit charge accounts." The weekly installments seemed easy when pushed by some suave young salesman who appealed to the girl's desire to improve her wardrobe. Later, however, if she failed to meet the payments, she was often "hounded to distraction." Baldwin counseled numerous young women who found themselves in financial straits after buying even modest finery on time. Among those who made as little as eight dollars a week, the policewoman told *Oregonian* writer Louise Bryant, it was "not unusual to find girls $75 to $100 dollars in debt and absolutely discouraged." Baldwin at times intervened with creditors, negotiating smaller payments routed through her office to assure that no coercion was used against the girl. Yet some cases escaped the policewoman's notice, with unfortunate consequences.[4]

The policewoman related one tragic account to a lecture audience in 1911. She had been called to a lodging house where three young debt-ridden working women lived in a tiny housekeeping room. "All their stores," the policewoman recounted, "were contained in three baking powder tins." The closet was filled with the cheap dresses and "crepe paper gew-gaws" they wore to the public dance halls in the evenings. The only furniture in the musty cubicle was "a small bed, a shakedown quilt, and a chair with a broken leg." On the rickety bed, beneath a small window hung with torn and dirty curtains, a horrified Baldwin discovered "the bodies of two of the girls, who had chosen a death by suicide rather than a life of discouragement, misery, and sin."[5]

The essence of Baldwin's job was to avoid such morbid outcomes. Court officials and city health workers often tipped her off to perilous situations. Dr. Esther Pohl Lovejoy, the city health officer, advised the policewoman of one

shopgirl who she described as "both mentally and physically weak." To make matters worse, the doctor reported that the girl voraciously read "trashy novels," and often imagined herself one of their heroines. The young woman lived in a cheap rooming house which the physician thought was "unfit, as she would be an easy prey to men." She asked that the detective keep an eye on the girl's behavior. Baldwin had the girl enroll in a dressmaking class at the People's Institute settlement house, hoping that the discipline would help her face life more realistically. The basis of the policewoman's program was to prevent the sexual exploitation of such naive young women. The environment in which youthful females worked was of paramount interest to Baldwin.[6]

In 1903, Oregon's legislature passed a law which regulated certain working conditions for women. With the exception of domestic employment, it limited to ten the hours any female could work in a twenty-four-hour day. The law was disregarded by a Portland laundry owner in 1905. His conviction for the infraction was upheld in 1906 by the Oregon Supreme Court, which declared that any labor contract was subject "to such reasonable limitations as are essential to the peace, health, welfare and good order of the community." In 1908, the matter went on appeal to the U. S. Supreme Court. The National Consumers League retained Louis D. Brandeis to argue for the law's legitimacy. He engineered a new legal tactic when he submitted one hundred pages of sociological and legislative evidence, yet only three pages of court precedent. In his famed "Brandeis brief," he established the principle of "sociological jurisprudence" in a successful bid to uphold the Oregon law. Ironically, although touted as a victory for women's welfare, it legally characterized them as inherently "different," and subject to protection by the police power. This rebuked contemporary militant feminists who were seeking status equality for women on the political front, yet opened the door for social feminists like Baldwin who championed protective legislation.[7]

Baldwin's office provided a conduit to Oregon Labor Commissioner O. P. Hoff for excess hours complaints. One anonymous letter contended that three girls employed in a cafeteria were forced to work overtime on a regular basis. The young women "hesitated to say anything for fear of losing their places." The policewoman satisfied herself that the report was accurate, and forwarded it to Salem. Commissioner Hoff informed Baldwin that her tip resulted in a stern warning to the employer.[8]

The problem of inadequate pay was another matter. There was no legal minimum wage at the time, and the paltry amounts earned by many working girls were a grave concern to reformers. If girls were not paid promptly, or were shorted, Baldwin served as an advocate who would collect from

recalcitrant employers. She agreed with contemporaries like Jane Addams that a "living wage" for females would go far toward eliminating their sexual exploitation. Young women who could not make ends meet were often tempted to accept money, meals, and amusement "treats" from men bent on seducing them or luring them into the "easy money" of prostitution. Baldwin continually pushed to secure an urban environment in which a young woman, in her words, might safely "earn an honest and adequate living."[9]

Baldwin recognized the special dangers to the city's numerous "office girls." Each day, she reserved the noon hour to receive their complaints. By the nature of their work, lone young women might be isolated behind closed doors without contact with outsiders for hours. Relationships with male coworkers or superiors could easily get beyond the bounds of propriety. Often male perpetrators held positions of trust. In one instance, Baldwin helped prosecute a "business college principal for being too familiar with the girl students." In another case, a respected businessman in the Chamber of Commerce building had to answer an accusation that he was "too intimate with a girl in his office." Similar incidents involved a tailor, a dentist, a physician, a county judge from eastern Oregon, and a certain Portland councilman whom Baldwin identified only by his initials. Even jobs in more public places were not necessarily safer. A young clerk at Meier and Frank's told Baldwin that one of the firm's male buyers had "taken indecent liberties with her" when she was working in a stock room. A more serious case involved a young salesgirl at the Roberts Brothers department store, who was pressured into intimacy by a male clerk, became pregnant, and had an illegal abortion.[10]

Surprisingly, some reformers felt that young women who worked in factories were at less risk than those in other forms of urban employment. In places like the food canneries that dotted Portland's industrial area, older women often acted as protective surrogate "mothers" to young female employees. A work arena closed to the general public, plus the task discipline, helped make the factory atmosphere approximate that of the traditional family, where generational and gender pressure combined to keep girls in line. Jobs which entailed unrestricted contact with the public, on the other hand, posed a dilemma for those like Baldwin who wanted to maintain moral innocence among the city's young working women. There were few restrictions on the types of places which could employ young females, and this added to the early policewomen's burden. Restaurants, saloons, and many of the city's commercial amusements relied on the charms of pretty girls to improve their custom.[11]

The policewomen closely monitored restaurants which employed young females. Ethnic-run establishments came under surveillance because of elitist and nativist suspicions of Asians and the so-called "new immigrants" from Eastern and Southern Europe. A tip in one case suggested that an Italian cafe owner in the North End hired pretty white women or girls for unspecified "immoral purposes." Similarly, Greek restaurants were often arbitrarily accused of "harboring women." Some people simply objected to what they saw as breaches in proper female decorum. Three members of the Portland Woman's Club asked Baldwin to do something about restaurants with heavy kitchen doors that tray-laden waitresses were required to forcefully kick open. Three girls who worked at the Pekin Grille told Baldwin that a regular customer often "teased and insulted" them. The policewoman interviewed the offender and found that he was rather simple-minded but generally harmless. She then advised the young complainants to "throw the ink bottle at him next time, being sure that it reached its mark." Such assertiveness, Baldwin prompted them, went a long way toward keeping adventurous men in line.[12]

Baldwin especially objected to restaurants where girls served food and alcohol to men in private booths or "boxes." The waitresses were induced by the management to join the secluded diners in order to encourage their consumption, and sometimes found that *they* were the expected dessert course. In 1906, Baldwin's Travelers' Aid agency had supported Mayor Harry Lane's unsuccessful efforts to close up a number of such places, including the infamous Richards' Grille on Alder near the prestigious Arlington Club. In 1908, the new policewoman was dismayed when members of the city license board tried to revoke the liquor permits of the Chinese restaurants for promoting immorality while allowing the offensive grills to exist unimpeded. She visited the city's Asian eateries to see for herself. In a move uncharacteristic of the general anti-Chinese bias of the times, she defended the proprietors to the license panel. "I have repeatedly been in the places you call 'noodle joints,'" she told them, "and have never seen any boisterous nor unseemly conduct." She further admonished that "if the white men about town would run their places as well as the Chinese, we would not have nearly so much trouble as we do."[13]

Some young women tried to earn their way through self-employment, yet economic or traditional gender restrictions at times hampered their goals. Baldwin became concerned by a report that two female barbers were plying their trade in an area on the fringes of the North End vice district. The shop in question was run by a girl of seventeen and an older woman, and the policewoman worried that they might be offering more than haircuts to their

customers. She sent a male acquaintance over to have a shave and check out what she called the "moral character" of the place. The man reported that the barbers' behavior was impeccable, and that they "did not converse with customers in any way." Satisfied, yet worried for their continued safety, the policewoman visited them herself and asked why they had opened their business in such a disreputable area. They replied that they had yet to build up enough clientele "to pay the high rent prices in other localities," so they were forced to remain where they were.[14]

At times, rigid gender expectations drove young women to unusual measures to support themselves. In the fall of 1910, a girl who called herself "Joe" was apprehended on the streets in male clothing. Cross-dressing was considered a morals offense at the time, and she was placed under arrest. After hearing the girl's explanation of her bizarre behavior, Baldwin became more sympathetic to her plight. The young woman had lost her job in a restaurant, and was desperate for a way to feed herself and pay her rent. She was a trained musician, and looked for theater work. She found the managers reluctant to hire women. As a last resort, she donned male clothing and afterwards "discovered she could find work easier by passing as a man." Upholding the law, Baldwin was forced to order her to put on women's clothes. The whole matter was "unfortunate," the policewoman wrote in her log, as the girl "was a fine musician." Baldwin turned her over to the employment secretary at the YWCA with her personal reference.[15]

Women who set themselves up as fortune-tellers of any kind found a very cool reception in Portland. Baldwin's department had "a great deal of trouble" from occult science practitioners who hung out their shingles in the city. At times, they even appeared in the respectable neighborhoods. In late 1908, the policewoman took a pretty seventeen-year-old girl from a fortune parlor on 4th Street between Taylor and Yamhill. The girl said she was being restrained against her will, and was "forced to serve as a moneymaker" for the medium who ran the business. The policewoman went before Judge Calvin Gantenbein of the juvenile court to have the teenager legally removed from the place. The woman who operated it, who Baldwin described as a "Cherokee Indian gypsy," made a "desperate fight to keep possession of the girl." Indignantly, the policewoman informed Judge Gantenbein that the unfortunate child was illiterate, and in no way related to the medium. The woman had simply used the girl's looks to boost profits. The judge then ordered the fortune-teller to close her business, and placed the girl on probation to Baldwin, with the expressed stipulation "that she be taught to read and write."[16]

A worried middle-class mother reported another incident concerning a fortune-teller some months later. The woman's daughter, described by Baldwin as "a pretty fourteen-year-old," was engaged in conversation by two

women and a young man on a streetcar on her way home from school. She innocently told them her address, thinking they knew her family. The women fussed over her, telling her how pretty she was, and said she must "come visit them sometime." The girl told her mother about the incident. She became suspicious, went to the address given to her daughter, and discovered it to be "a fortune-telling establishment." The mother asked Baldwin to investigate, and said she was "nervous about letting the child ride the streetcars ever again." The policewoman wrote that she was treated very rudely by the two astrologers when she confronted them and accused them of bothering the girl and enticing her to their home. Several days later the son of one of the women, who had been with them when they first spoke to the schoolgirl, appeared at Baldwin's office to apologize for his mother's abruptness. To make up for it, he invited the policewoman over "to have her horoscope cast." In light of the mayor's recent directive for her to investigate the city's burgeoning palmistry industry, Baldwin seriously considered going.[17]

By July 1909, Baldwin had gathered enough evidence to convince the city council to ban such practitioners from Portland. A new ordinance forbade persons from giving any kind of advice to others "for or without pay" by means of occult or psychic powers. The code prohibited the use of clairvoyance, psychology, psychometry, spirits, mediumship, seership, prophecy, astrology, charms, potions, hypnotism, or "magnetized articles or substances, oriental mysteries, or magic of any kind or nature." The policewoman was breaking in a new clerk named Wilma Chandler at the time, as Lucy Sargent had resigned due to ill health. To test the code, Baldwin sent her new assistant on a week-long investigation under the ruse of "recovering a lost locket." Chandler was advised in her quest by a series of women "for fees ranging from $.25 to $1.00." As a result, seven illegal mystics were arrested, "fined $75.00 apiece," and put out of business. "Many of those who have been practicing occult science," a satisfied Baldwin wrote in August 1909, "have been leaving the city since the passage of this ordinance."[18]

Around the same time that the fortune-tellers were run out of town, discouraging reports about the city's massage parlors provoked Baldwin into action. She discovered that many of these places, which had been a thorn in her side since the early Travelers' Aid days, were again hiring young girls. At best, they were being employed to attract male trade; at worst, to provide customers with sexual favors. "The massage parlors, like the places of fortune telling and palmistry," the superintendent wrote in her log, were "blinds for assignation houses." In the spring of 1909, Mayor Lane directed Baldwin to make a comprehensive study of the massage operations. Remembering the conditions she found in such places at the time of the exposition, she set out with purpose "to get the proof against them."[19]

Baldwin began with a canvass of the thirty-plus massage businesses which were legitimately licensed by the city. She applied two investigative methods in her survey. During the daylight hours, she visited the establishments personally and demanded to inspect their records, licenses, and equipment. If she suspected something out of the ordinary, she sent a male investigator from the Social Hygiene Society back for an evening visit. On one such nocturnal mission, her informant reported that he was greeted by a very young woman in a silk kimono. As he waited his turn for a massage, he could hear male voices in nearby rooms. When the undercover agent asked his hostess if he could stay all night, she replied affirmatively and said that the cost "would not be over five dollars." The proprietor in question had been closed down at a different location by Mayor Lane at Baldwin's urgin g a year earlier, but had been allowed to open another shop by the license committee. The policewoman signed a complaint on her new evidence, but was dejected when the court found insufficient other grievances against the business at the current address to close it on a "common fame" basis. Baldwin then understood that the businesses could avoid prosecution if they relocated before enough remonstrances accumulated against them.[20]

Of the thirty-two licensed massage parlors operating in Portland in the spring of 1909, Baldwin gathered evidence that thirty "were either houses of assignation, or places of very shady repute." This overwhelming proportion convinced her that current licensing regulations helped perpetuate the disreputable businesses. Declaring a personal "war on the whole proposition," she rewrote the city ordinance governing massage parlors and submitted it to the mayor and council. To protect legitimate practitioners and guard against immorality, her revision stipulated that women could not give treatments to men unless a male attendant were present, and vice versa. This proviso effectively blackballed the city's dubious massage element. Baldwin's detailed testimony before the city council won their approval, and Mayor Lane signed the amended ordinance into law in the last week of his tenure. When new mayor Joseph Simon's administration took office the next week, the reformed ordinance was let stand, and the incoming chief of police offered Baldwin his "hearty approval" of her vice monitoring.[21]

Although the rewritten code cleaned up most of the trade, Baldwin soon discovered a number of newspaper advertisements for massage services placed by women who did not appear in the license rolls. When she visited the locations given, most of the practitioners hastily agreed to apply for proper credentials. At the request of the license committee, the policewoman reviewed their applications. She reported adversely on all of them, as each applicant had stated that it was her "intention to give massage to men,"

although none indicated the use of male attendants. Baldwin then expressed her true feelings about the whole issue. She told the city officials flatly that she disapproved of "the granting of *any* licenses to massage parlors," citing her past experience of them being "almost without exception places of immorality."[22]

The policewoman informed the license board that it was "*prima facie* evidence of something wrong" if males who could "obtain massages *by men* at reputable public bath houses in business locations" preferred to go instead to "the upper floors of hotels and lodging houses to be treated by a woman." Baldwin reiterated her strong opinion that "no right-thinking woman would desire or expect to give body massage to men." If such businesses were allowed to run, she continued, they invariably took young women as apprentices who "soon become immoral." It was, she concluded, impossible for her or anyone else to adequately control such places. "We should be very sorry," she pleaded in closing, "to see them reinstated in this city after we have succeeded once in closing them up." While not acquiescing to a ban, the license panel agreed to a more stringent oversight of the permit process.[23]

The probability of immoral conditions in much of the low-wage job sector troubled Baldwin from the beginning. In mid-1908, she voiced a particular concern over "a very large number of unemployed girls due to the financial depression." This made the policewomen's daily perusal of the newspapers imperative, and members of groups like the Women's Union and YWCA alerted Baldwin to ads she might have missed. The most questionable printed copy echoed some variation of "young girls wanted—good wages," with no indication of the place of employment. Many offers proved to be for work in amusement venues like shooting galleries, bowling alleys, and saloons. These all looked for pretty youthful females whose main function was attracting male customers. Such unabashed commercialization of young women was intolerable to Baldwin. Fears that the inexperienced girl would be unable to recognize or fend off the smooth vice procurer spurred Baldwin to action. As part of a preventive strategy, she advertised her office location and phone number in the "Help Wanted" columns, offering free employment advice.[24]

Misleading ads for housekeepers or nurses kept the policewoman and her staff busy. They were especially wary if the offers were placed by single men. A nurse who answered an advertisement seeking someone "to care for an invalid" became suspicious of letters she received in response to her reply. She handed the correspondence over to Baldwin. One note said that the sender "wanted a housekeeper who was matrimonially inclined," and asked the young woman to call on him at his place of business. Baldwin sent her young assistant Wilma Chandler, accompanied for safety by a male detective,

to contact the man and determine his motives. As her escort remained outside within earshot, Chandler went into the man's office alone. She talked to him for several minutes, and reported later that he wanted a woman to live with him, "and if she proved satisfactory after a given trial, he would marry her." He was apparently "quite willing" to take the attractive Miss Chandler on trial. Although he never attempted any undue familiarity, Chandler testified that he "was quite frank in his statement as to what he wanted with the housekeeper." Upon further investigation, Baldwin learned that he had made a career of seducing female domestics before the authorities were finally able to prosecute him.[25]

When Baldwin spied a suspicious item placed by a 3rd Street bowling alley, she sent one of her probationers as a decoy. According to Baldwin's own description, the nineteen-year-old girl, "Carmen," was not particularly attractive. She had been arrested some time earlier for "being on the streets in boy's clothes." Baldwin had remarked in her daily log at that time that she made "a much better looking boy than a girl." After appraising her appearance, the man who had placed the ad inferred that she was not exactly right for the job. He assured her that it was not that she was not good looking, but only because he "wanted a girl about sixteen years old." When he found the right one, he told Carmen, he "would pay her $12 a week, plus all she could make over that." As a further condition, the young woman reported back to Baldwin, the man "wanted a girl who would be his housekeeper after working hours. In other words, come over and stay with him." He had someone in that position at the moment, he had told her, "but she was too old." The policewoman used the girl's evidence to prosecute the alley manager for soliciting a minor for immoral purposes.[26]

Commercial amusements like bowling alleys and shooting galleries admittedly attracted their all-male clientele by employing pretty young girls. This practice frustrated urban moral reformers. "An America commercialized," Clifford Roe of the American Vigilance Association complained, had "commercialized its daughters." Baldwin stridently opposed any use of the female sex as an object of attraction, titillation, or display. She even balked when asked to arrange for girls to ride in the city's annual Rose Parade. "I find strong opposition in the minds of most people," she sniffed, "about placing young girls on floats for public display." If the yearly civic festival bothered Baldwin, businesses which purposely hired attractive young girls infuriated her. To her, the fact that girls were used in this manner, even if nothing untoward ever happened to them, seemed improper on its face. Partly as a result of this feeling, in May of 1909 the Portland policewomen began "a systematic investigation of all amusements, especially those employing girls."[27]

Baldwin initially targeted the shooting galleries which operated throughout the North End vice district. Some were quartered in the lobbies of lowbrow vaudeville or movie houses like Fritz's Theater at 2nd and Burnside, while others were accommodated in saloons. One entrepreneur rented the five-foot alleyway between two merchantile buildings. As Baldwin began her examination of these businesses, she enlisted the aid of juvenile court parole officer William MacLaren. Posing as a customer, he visited a number of the places in the evening. His subsequent report to Baldwin characterized most of them as "unsavory." One in particular featured two minor female employees who worked until well after midnight. He heard them spout vulgar language, and watched them throw their arms around drunken men and kiss them. They performed impromptu "can-can" dances, and generally behaved "in a disreputable manner." The male customers, MacLaren reported, took "all sorts of liberties with them." In his summary opinion, many of the galleries were "mere blinds for houses of prostitution."[28]

To confirm MacLaren's information, Baldwin toured a number of the enterprises in person. She soon corroborated his allegations. One of the first girls she interviewed admitted to the policewoman that she solicited men in the gallery where she worked. The young woman further asserted that she "had a different one every night, and took them to a nearby lodging house." If that were not proof enough, Baldwin wrote that she herself "was approached in a most questionable manner by an old gentleman" in another locale later that evening. Quite disturbed, she began a lobbying campaign to at minimum exclude under-age girls from working in the amusements. She impressed on the licensing authorities that the generally lewd atmosphere of the establishments put them at the least in violation of the spirit of the state law governing sexual conduct with minors. Her pressure on the city paid off, and her 1911 annual report noted that, due to the persistent efforts of the women's police section, shooting galleries could no longer employ girls under the age of eighteen.[29]

Although Baldwin had stopped the use of minors by the shooting galleries, she contended that Portland needed a blanket ban on *all* female employment in such venues. "Almost without exception," she complained to Mayor Allan Rushlight and the city council in 1911, "shooting galleries and the like are located in parts of the city adjacent to the lower class of saloons and such, and are kept open late at night." If respectable women took employment in such dives, she wrote, they would inevitably "be subjected to the severest insult and temptation." A woman already of "loose moral character," Baldwin believed, would simply commence to "solicit prostitution and make dates openly." In fact, she added, the proprietors of such amusements had

acknowledged to her that their businesses could not be conducted profitably without women. This, Baldwin reiterated, was prime evidence "that women ought not to be employed, as they are there for the one purpose of attracting men." It was impossible, she contended, for females of any age to expect proper protection in these places. "We appeal to you," she concluded, "not to grant licenses to any person who shall employ women or girls in shooting galleries."[30]

In late 1911, Rushlight appointed Baldwin to the city's new vice commission. This connection gave her the advantage of more "eyes and ears" as she worked for an absolute ban on female employment in the shady amusements. The vice investigative panel, which included religious leaders, physicians, and representatives of women's interest groups, was chartered to make a thorough survey of all suspected immoral businesses. By early 1912, it had accumulated a number of disturbing revelations about the shooting galleries. The commission submitted this information to the city council and the mayor in support of Baldwin's suggested code changes. The panel's lurid allegations made the moral danger to females abundantly clear to the city officials charged with regulating the amusement sector. On the whole, the report helped the policewomen's moral purity cause immensely.[31]

In one case, the vice commission reported that "two bright young girls, pupils at Washington High," had quit school after convincing their parents that they had secured jobs at the telephone company. In truth, they had moved their belongings to "a disreputable rooming house" in the city's North End vice district. They both lied about their age and began to work in a shooting gallery, where they were soon noticed by a certain gentleman customer who knew of their middle-class family backgrounds. The anonymous man informed on them to police authorities, and the girls were then reportedly "rescued by the Municipal Department of Public Safety for Young Women and returned to their homes." In this particular instance, the women police purportedly saved the under-age girls from sexual ruin, yet some others were not so fortunate.[32]

The investigators found a fifteen-year-old girl from a rural Oregon town working at one of the galleries in the central waterfront district. An older woman also employed there was believed to be "in the business of making appointments for men with this child." One of the vice committeemen dressed himself as a logger and approached this woman to confirm if she was in fact prostituting the minor. The woman agreed to secure the girl for the man if he would pay her a dollar in advance and "keep still about it." He paid her the money, but when she went to fetch the girl, one of the newsboys who hung around the place apparently "recognized the man in disguise, and warned the woman." She then hurried out the back door and disappeared into the night.[33]

In the southern part of the city, the vice surveyors discovered a large upstairs operation where "a number of girls worked under the most degrading conditions." The management expected them to engage in exotic dance routines as an added enticement. "The Houchi Chouchi dance given by these girls was but one of the diversions to attract custom and swell the profits of the proprietor," the investigators wrote. When an inebriated patron asked the manager if he could "get" one of the dancers, the man said that "he would find out." He further implied that the one the customer wanted was still "fresh," having been there "only two or three days." The girl in question appeared to the undercover agent to be a minor, so he tried to dissuade the man. He strongly admonished the tipsy stranger that he "should not rob the cradle." With visible irritation, the drunk replied: "Oh, hell! They all do it, and I might as well get it."[34]

A number of the shooting galleries reportedly hired young white girls as attendants to encourage the patronage of Greeks and Japanese. This practice was in clear violation of the accepted societal "color line" of the times, which tagged Asians and eastern and southern Europeans alike as inferior, nonwhite "races." In several cases, the vice investigators noted "public exhibitions of intimacy between Japanese patrons and these girls which were positively disgusting to all persons with a sense of decency." A young white woman who had worked at a place in the North End, the committeemen wrote, "became enamored of a Greek patron and ran away with him to another city, deserting her six-year-old daughter." Such examples bolstered the elitist suspicion of foreigners shared by many of the era's social reformers. They clung to a notion that alien males invariably wanted to sexually exploit white women, or steal them away from husbands and children.[35]

The vice commissioners learned that one shooting gallery manager ran four galleries in different sections of the city. He continually shifted his female employees from one establishment to another "in order that there might be a succession of new faces to attract patrons." The saloonmen nearby told a vice panel member that this man "preferred to employ girls who were young and green, as this class were looked upon as easy marks by the fellows who hung around the galleries." This especially alarmed the social hygienists among the vice investigators, who considered these amusements as veritable "centers for the dissemination of venereal disease." In one instance, a vice commissioner overheard a saloon habitue telling a bartender that he "got a dose" from a shooting gallery girl, "and she was only 16 years old at that."[36]

One of the places inspected by the commission was tucked into the five-foot alleyway between two buildings. The proprietor rented this space from the tenants on either side, who split the twenty-five dollars he paid each

month. The two young women who ran the place for him said that it usually had "receipts running about $25.00 per day." One of them had managed to protect her own virtue, she insisted, although she reportedly often "had to defend herself with a rifle" against drunken customers. "Most workers," she revealed, "were of necessity constantly subjected to improper advances and proposals from men patrons." Furthermore, she related, it was "generally understood" that the girls "were not to resent the advances of such men but must get the money." She noted that the daily earnings of the place, "when conducted by men, were only about $8.00."[37]

Baldwin and many of the other vice commissioners suspected that a system operated in the shooting galleries which produced young prostitutes. The case of a certain female North End gallery manager lent credence to that idea. The woman inserted advertisements in the city's daily newspapers offering jobs to young women. These never specified the kind of employment, but simply read: "Young Girls Wanted—Good Wages." The vice investigators obtained evidence that this woman placed girls who answered the job query in her shooting gallery for a few days, so that they "might become hardened and accustomed to the improper conversation and advances of men." After this initiation period, the citizen morals squad reported, the unfortunate young women "were graduated into a life of shame for purposes of mercenary profit."[38]

The vice commission ascertained that the girls in the shooting galleries were paid from $1.00 to $1.75 per day. This was hardly a large amount, but certainly more than a girl could make, for instance, as general household help. The "light character of the work," the panel concluded, made it attractive to women and girls and helped to "overcome any natural resistance they might have to engage in this class of employment." Work schedules ranged from eleven o'clock in the morning to midnight or later, but these hours were better than those of the average domestic. In addition, every morning free was preferable to the housemaid's customary Sunday afternoon off. Yet unlike work in the household, the vice commission concluded, this type of employment specifically seemed "to lead inexorably to moral ruin." The committee reported to the mayor and council that the conditions cited by themselves and the policewomen were "amply sufficient to urge the enactment of prohibitive restrictions." City authorities agreed, and in June 1912 a new ordinance banned all females from work in a variety of commercial amusements.[39]

Pragmatic enough to know at the outset that she could not change certain base elements of human nature, Baldwin hoped that the policewomen's constant vigilance would at least give pause to men who might "prey on

young women." She soon realized that she had a weapon much more powerful than the moral suasion relied upon by her reform predecessors: protective legislation. The United States Supreme Court's finding in the "Brandeis brief" case opened the gates for further laws designed to protect so-called "weaker citizens." If the principle of sociological jurisprudence could mandate women's *physical* work conditions, it could also be utilized to assure their *moral* welfare in employment. Given the evidence gathered about the Portland shooting galleries, for example, prohibition of female labor in such places was arguably "essential to the peace, health, welfare, and good order of the community." This new reach of the police power helped further legitimize the public role of social feminists like Baldwin. Her exposure of immorality in the massage parlors and occult businesses also aided the contemporary social hygienist campaign against medical quackery and other forms of pseudoscience.[40]

In Portland, the municipal policewomen's movement evolved as a melding of social feminist interests, the social hygiene agenda, traditional morality concerns, and the police power. It brought law enforcement sanction to reform efforts which sought to make the city a safe place for females to live and work without fear of sexual exploitation. This Progressive Era striving for a standard public morality became the "master symbol" under which urban areas were to be cleansed and rejuvenated through government intervention. In the years following its world's fair, Portland's commerce and population swelled, as did jobs available to young females. Baldwin and her department stood ready, in her words, "to make the path safe for the feet of the girl who desired to lead a clean, honest, useful life." Through the ordinance and licensing process, Baldwin had obtained some control over the city's employment environment. A more strenuous test, however, arose in the attempt to neutralize the moral threat from after-work amusements like the infamous ragtime dance hall.[41]

In seeking innocent recreation,
young people can hardly escape contact with amusements cunningly
designed to excite sex impulses, . . . especially dangerous are the dance-
halls.

—William T. Foster, Reed College, 1913

3

The Dance Hall as Moral Menace

The Progressive Era challenge to what was considered the "immoral" dance hall emerged from the breakdown of the nineteenth-century concept of amusement in which each race, class, and gender was expected to occupy a specific sphere. As a number of historians have shown, modern urban industrial society encouraged the disintegration of this paradigm. Workplace experience taught single women wage earners to expect recreation long allowed their male counterparts to reward daily drudgery. As part of what one writer terms a "shift from homosocial to heterosocial culture," working girls denied a Victorian heritage which prescribed sedentary, same-sex leisure activity. Girls who lived in boardinghouses, in particular, were not tied down to domestic chores still expected of young working women who lived at home. Regulated hours of production and independent status gave the benefit of several hours of freedom in the evenings. Males traditionally had filled this time with the masculine camaraderie of the saloon. Young women, however, preferred dancing and other lighthearted entertainment. This change helped spur an overhaul of urban amusements. Commercial dance halls, movie theaters, skating rinks, excursion boats, and amusement parks proliferated to meet a demand for mixed-gender pastimes. Like many of her contemporaries, Baldwin looked on in dismay as the working classes redefined public behavior between the sexes.[1]

Portland's early policewomen spent countless hours monitoring amusements frequented by the city's young working women. Reformers saw the proliferation of commercial resorts as symbolic of a breakdown of social and familial control within the working classes. Events like Portland's Lewis and Clark Exposition, however, helped blur the forbidden image of such activities by offering a central carnival midway, and gave sanction to amusement attendance by a wider segment of the population. After the fair ended, local entrepreneurs tried to perpetuate the excitement of its exotic strip. "The Oaks" amusement park on the city's southern edge expanded, and soon Council Crest hill was crowned by a roller coaster, an observatory, and a new dance hall. Downtown, other dance halls, restaurants, nickelodeon movie houses, vaudeville theaters, and similar businesses competed for a mix of working- and middle-class patrons. As the ragtime era dawned in Portland, a growing and prosperous commercialized pleasure sector provided Baldwin with a hydra-headed target.[2]

As the middle class began to embrace these so-called "consumer" amusements, fears grew that lower-class social mores would contaminate their daughters. Commercial resorts like dance halls attracted young people to a mixed-class, mixed-sex realm unknown in Victorian times. These places, which Baldwin described as "moral pitfalls," provided unrestricted social mingling. In the policewoman's worst-case scenario, an innocent girl might be plied with alcohol, then lured to a rooming house, the back seat of an automobile, or the dark arbors of one of the public parks and coerced into intercourse—with the subsequent possiblity of disease, unwed pregnancy, or prostitution.[3]

Baldwin's struggle with the urban dance hall exemplified the post-Victorian dilemma. Having already lost the battle to confine the sexes, races, and classes to their nineteenth-century amusement spheres, recreation reformers sought to define the terms of the new *status quo*. The starting point was less than encouraging. In 1908, Portland judge John Van Zandt attested that most of the delinquent girls who came before him blamed some dance hall as the place they "went astray." Public dances admitted anyone, and on any given night what Baldwin termed the "promiscuous crowd" might include drunks, known prostitutes, pimps, and procurers of both sexes, mixing freely with innocent young people. Young working women from the boarding-houses went to the dances, as one confessed to Baldwin at the Maple Pavilion, because they were "lonesome, and there was no other place for a girl to go." Their better-dressed sisters attended for the sheer adventure of it. Attractive young women, regardless of their financial circumstances, were always admitted free and "used as bait to draw trade."[4]

Policewoman Baldwin ranked the public dances as probably the worst traps in town for unwary young girls. In reputation, the halls carried a stigma from the nineteenth century, when single working men had paid for dances and other favors from professional prostitutes hired by the management. Although female dancing partners generally were respectable by the turn of the century, certain distasteful elements lingered. Nearby saloons offered cheap drinks to dance patrons and sometimes harbored prostitutes who mingled with the young crowd. Portland's Maple Pavilion at 17th and Washington stood on the same block as a saloon, and people drifted freely from one to the other. Merrill's Hall at 7th and Oak was located on the second floor above another bar, directly accessible by a back stairway. Baldwin observed under-age girls being served beer there, and herself received "unwelcome advances" from a drunken man on the stairway.[5]

The music favored in the dance halls explained much of the negative response from officials. After the turn of the century, so-called ragtime and jazz rhythms popularized by black musicians in the brothels and dives of Mississippi River towns migrated northward. In the industrial cities, working-class youth became attracted to its vitality as an antidote to the monotony of factory jobs. The music's beat, as one patron put it, "demanded a physical response." The inventive dances which accompanied the new tunes featured an emphasis on close contact and "suggestive motions of the pelvic portions of the body." Many of these so-called "tough dances" were blatantly imitative of human or animal sexual activity. It took little imagination to see the point of steps with names like "hug me close," the "shiver," the "hump-back rag," the "lover's walk," the "dip," the "slide over the wave," the "rough dance," the "turkey trot," the "grizzly bear," or the "angle-worm wiggle."[6]

The rapid popularity of such overt moves shocked elders reared on the chaste waltz. Even the waltz was subverted when dance managers turned the lights so low that partners had to grope for each other in the dark. Reigning over all was a fear that the ersatz sex of the dance floor would lead to the real thing. Adult concern over this risk of moral ruin was intensified because the girls who attended were so young. By 1910, a survey by a New York reform group found that the majority of female patrons were under twenty years of age, with a good number as young as twelve or thirteen. Whether poorly paid, simply lonely, or straining against the control of middle-class parents and home, the young of both sexes sought release in the energy and anonymity of the new dance palaces.[7]

Baldwin characterized Portland's twenty-odd dance halls as "unruly" at best. She often observed drinking, fighting, and even open soliciting. Unlike their earlier counterparts, many of the city's newer commercial dance halls

located outside the vice district. Otherwise-quiet residential areas like Sellwood, Lents, Mt. Scott, St. Johns, and Portland Heights all had such places by 1910. Some dances ran all night and, although nearby residents complained to the police, there seemed little effort by city licensing officials to remedy the situation. Baldwin soon concluded that the dance halls were vital to those who benefited from the largesse of what she called the "liquor interests." Although he recognized the dilemma, Mayor Lane had little power over the alcohol lobby, and even less success in fixing the problem. In June 1908, after several fruitless visits to the license committee, the frustrated Baldwin researched the matter herself. By state law, she discovered, all dance halls and like amusements had to be not only licensed but *regulated.* "There is not a question," she reported, "but that every poolroom, bowling alley, billiard room and dance hall are [sic] running in open violation of the Oregon statutes."[8]

Lane's successor and fellow social hygienist Joseph Simon was also adamantly opposed to the public dance venues. From the beginning of his tenure, he made it clear to everyone that he wanted them abolished. Baldwin agreed in principle, but was realistic about the problem, as she had found scant city cooperation in the past. If the city kept licensing the dance halls, Baldwin had little choice but to police them as best she could under the circumstances. This remained the *status quo* until early 1910, when the dance halls began to receive heavy public attention. In late January, the policewoman submitted some evidence which Mayor Simon had requested. Although he was concerned with the complete picture, he was especially interested in the activities of the so-called "5 cent dance halls." Also known as "taxi dance halls," these were venues where men of all stripes paid a nickel or a dime to cavort with pretty young girls who knew the latest steps.[9]

Baldwin's negative report triggered a more comprehensive investigation by male vice detectives. In mid-February, Chief Arthur Cox received word from one of his captains that surveillance in the dance halls had turned up some dismaying conditions. In particular, the Maple Pavilion at 17th and Washington and the Casino Dance Hall at 4th and Yamhill were allowing couples to indulge in steps "characterized by the police as shocking." The "turkey waltz," the "rag," and the light-dimmed "moonlight glide" were singled out as the most objectionable. The police ordered William Lilly, manager of the Maple Pavilion, to cut the dances out of his program. When he refused, the mayor and police chief requested that the city council license committee revoke the hall's operating permit. As in the past, the panel proved to be less than cooperative.[10]

As the *Oregonian* summarized the incident, Lilly made quite a melodramatic appearance before the three-member license board. As he stood in front of city councilmen Driscoll, Dunning, and Concannon, he reportedly "wept profusely, and said he had been badly used by the police and others." He felt that the terms of his permit were so ambiguous that he was "not to blame for any of the trouble that had befallen him." He easily won the sympathy of the committee, who refused the mayor's request and denied the revocation. By way of explanation, Driscoll said that it would not be "fair play" to close Lilly down because of certain dances when other places in the city permitted them. Mayor Simon was furious when he realized he lacked a legal remedy, as he firmly believed that the dance hall was immoral. Because the place was duly licensed, it was almost impossible for him to interfere—but he was not prepared to give up.[11]

Deputy City Attorney Frank S. Grant suggested to the mayor that there "should be an ordinance against the objectionable dances named, which would give the police power to suppress them." This way around the recalcitrant license committee appealed to Simon, who instructed Grant to write the measure up. The mayor was further incensed when he discovered that the license board had made a habit of marking "file" on written complaints from the police about the various dance halls, apparently never intending to act on them. Simon declared he would mount suppressive raids against the offending Maple and Casino dance halls. Until the license panel revoked permits or took strict regulatory action, the mayor hoped to make life miserable for the managers who refused to eliminate so-called "dirty" dancing.[12]

"I intend," Simon informed the *Oregonian*, "to raid these dance halls, and to have some of the men and women arrested and carted to police headquarters." He charged the city's vice detectives to "find out who they are and what they are doing in such places." The mayor's action, the newspaper summarized, was a direct response to numerous citizen and police complaints that known pimps, prostitutes, and their hangers-on frequented dances where "young boys and girls crowded nightly." Chief Cox declared to the morning newspaper that he had no sympathy for the proprietors. He joined in the condemnation, asserting that he was "no wise in favor of dance halls in which immature children are thrown in contact with persons of adventuresome character." Cox, like the deputy city attorney, publicly urged an effective controlling ordinance.[13]

Simon's vice raiders soon uncovered a situation that appeared to justify the mayor and his allies in pushing complete suppression of the public dances. Police arrested a woman on charges that she regularly made prostitution dates

for herself and her sixteen-year-old daughter in the Casino Dance Hall. The women were discovered "in the act" at the Elmwood rooming house after they were followed from the dance by detectives. Five young men who frequented the hall testified in secret to the municipal court, and confirmed that the mother had "aided in the downfall of her daughter." The woman was sentenced to jail "for a year and twenty days." The girl was taken in charge by Baldwin, who transported her to the county hospital for venereal disease examination and treatment, and then remanded her to the juvenile court for disposition.[14]

The incident proved noxious enough to force the license committee to grant the mayor's request to revoke the operating permits of the Maple and Casino resorts. Yet it was a victory in name only, as the panel soon allowed the Casino to reopen under new management. The new proprietor assured the board that the place would "conform strictly to the regulations of the police authorities." The Maple Pavilion remained closed, but only until it, too, might show a new face and vow to obey the toothless license requirements. Without a specific ordinance governing objectionable dances and other suspect behavior, the police could only watch for morals infractions covered by current law. Certain members of the city council reassured their constituents in the night life that things could still be resolved in their favor. As a result, policewoman Baldwin unwittingly found herself at the center of controversy in early 1910.[15]

In addition to his municipal position, councilman George L. Baker ran a Portland theater. As expected, he generally sided with the interests of the entertainment sector. With somewhat transparent motives, Baker instigated a feud between Baldwin and Simon, hoping this would allow the dances to escape abolition or stringent regulation for a time. He even held out the possibility that Simon might get rid of the morals policewoman. Baldwin's early pragmatic call for regulation had put her at odds with the abolitionist Simon. Baker now told the mayor that the dance hall proprietors were looking to Baldwin as a savior, and that she was seen "as favoring regulation." He gave Simon a copy of a letter Baldwin had written on city stationery to the Casino Dance Hall manager, openly complimenting the way the Casino was being run. The note was proof, the councilman maintained, that Baldwin stood in direct opposition to Simon's policy of suppression. Much chagrined at the charge, Baldwin adamantly defended herself in the next day's *Oregonian*.[16]

In a soliloquy that ran for several columns, Baldwin outlined the explanation for her apparent *faux pas*. "I have read with astonishment in the *Oregonian*," she began, "that I am quoted as opposed to closing the public

dance halls." It seemed impossible, she went on, that anyone who knew anything about the work she had performed in the past five years could believe such a thing. If the dance halls "had an arch enemy," she continued, it was her women's police unit. "We have fought them every step of the way," she insisted, "and by every method at our disposal." None knew better than they, she contended, that the halls were "recruiting stations for prostitution." If any person doubted the veracity of this claim, she invited them to accompany her to "visit the lodging houses next morning."[17]

In frustration, she reiterated the problems she had faced in recent years. "Dance halls," she asserted, were "an unmitigated evil, the threshold to the wineroom and the brothel." Her department records showed "more girls ruined through their influence than any other." This, she said, had recently been corroborated by a municipal court judge "who stated in open court that 90 per cent of the young women who came before him dated their downfalls to public dance halls." Even "the best regulated dance hall in the world," Baldwin offered, was "no place for an innocent girl." It was a societal shame, she intimated, that girls were "always admitted free, and used as bait to draw trade." In such an atmosphere, the detective went on, a young woman over eighteen was "no more able than a minor to protect herself from pernicious influences." It was not so much what occurred on the dance floor, she revealed, as it was "the results that followed." Even young men were not safe, as had been proved the previous week when "a woman of forty" was arraigned for soliciting "boys nineteen and twenty years of age" in one of the public dances.[18]

The policewomen had "constant trouble," Baldwin continued, "with girls going from dance halls to nearby saloons." Eighteen months earlier her department had been able to revoke the license of a saloon under Merrill's Dance Hall, "but it took a bitter fight and had to come before the whole council." The license committee had promised the policewomen at that time that in future no saloons would be licensed in locations near dance halls "for obvious reasons." Now, although her department was on record against it, Baldwin understood that a new saloon was scheduled to open close to one of the dance halls. It was in part such bureaucratic laxity, she suggested, that prevented Portland's reform element from eliminating the dance venues, or making them reasonably safe. The police, from the chief on down, had "done their best." Because the dances were "money makers," she continued, the police department effort had "not been supported as it should have been." Even a recent modest change requiring Sunday closures was generally disregarded.[19]

This last matter, Baldwin contended, was at the center of Baker's misrepresentation of her position on the dance halls, and the source of her supposed praise of the Casino management. In her heart, she insisted, she had always preferred suppression, and her department officially stood "for abolishment, not regulation." Yet past political conditions had made it impossible to completely eliminate the dances. A few grudging concessions were all the policewoman had been able to secure from the license committee. It was in the interest of one of those hard-won constraints that Baldwin had contacted the Casino proprietor in early February. Her letter, she explained further, had gone out *prior* to Mayor Simon's enthusiastic abolition crusade later in the month. Her investigation had disclosed that the Casino was ignoring the Sunday closing stricture imposed by the city in late January, and she had simply wished to encourage compliance.[20]

Anyone who read the letter, Baldwin insisted, would see for themselves that it did not sanction the dances in any way. What it reflected, she said, was that the policewomen were "always fair enough to note improvement," however limited. Her memo to the dance manager, in fact, had begun with a disclaimer that her department could not "in any sense endorse public dance halls." However, it was "very glad indeed" that the man had taken its suggestions and cleaned up some of the "objectionable features" cited in the past. "We are sorry," her letter to the manager had concluded, "that you have decided to open the dance hall on Sunday, for you had won some friends by your former attitude." It was this last statement, taken out of context, that had been misused by councilman Baker.[21]

"The best we have been able to do thus far is to insist upon a little more decency and some restrictions," Baldwin continued. "If the city authorities see fit to license these places," she jabbed at the permit committee, "then I have but one duty and that is to make them as safe as possible." In spite of the efforts of the police and the interest of groups like the YWCA, the Council of Jewish Women, the Woman's Club, Women's Union, and Mothers' Congress, Baldwin had never been able to eliminate the public dances. Besides perennial problems with the Casino, Maple, and Merrill's, she declared, the hall at Council Crest had been "a disgrace to civilized community ever since dancing was permitted there." Implicitly accusing the municipal councilmen, Baldwin added that Portland Railway Light and Power Company had taken her complaints seriously enough to close the dance hall at its Vancouver ferry terminal "although it was outside city limits." If the ferry owners could see the moral danger, why could not the license panel?[22]

Baldwin's printed diatribe ruffled more than a few feathers at city hall. The dance issue suddenly became a magnet for every complaint anyone had

against her. Her detractors had a field day resurrecting old sore spots. The contention that she was a "Lane appointee" without right of tenure resurfaced, as did accusations that her monthly salary of $150 should be in line with the $115 received by male detectives. She was scorned because her office was not in police headquarters and consequently she was not in touch with her superiors much of the time. Louis G. Clarke, chairman of the city executive board's police committee, said that she should be reprimanded for her letter to the Casino manager, and for her failure to ask Chief Cox's permission before making statements to the press. He alluded to other unspecified occasions when she had failed to "obey orders or to comply with the regulations of the department." As a result of the furor, Simon called Baldwin on the carpet.[23]

Although the mayor rejected much of the political backstabbing associated with the charges against Baldwin, he was still not convinced that she fully supported his suppressive mandate. The policewoman had included too many detailed regulation suggestions in the *Oregonian* story for Simon's comfort. Councilman Baker, police committeeman Clarke, and others who were troubled by Baldwin's growing influence in police matters urged the mayor to mount an investigation of the women's protective department. When called before the mayor to explain her position, Baldwin told him flatly that it had always been impossible to close the halls because of either municipal disinterest or intrigue. Therefore, she had simply recommended some new rules to councilmen Dunning, Concannon, and Driscoll of the license panel. Simon again stressed that he favored outright suppression rather than regulation. Although stinging from Baldwin's public slighting of his own effectiveness, Simon later reported that she had acquiesced to much of what he said, though he was disappointed that "she did not show the enthusiasm that was evidenced in the statement published in the *Oregonian* of Monday."[24]

Then, the *Oregonian* itself joined the debate. Its editors took the position that popular dancing was here to stay, so the city might as well make up its mind to effectively regulate it. There was "something, but not much, to be said in favor of public dance halls," its editorial began. Leisure-time amusement had become an "essential factor in life." Therefore, the paper acknowledged, such activity could not be "omitted safely from the existence of the poor any more than from that of the rich." For "a certain class of people," the piece continued, the halls provided "all the active amusement" their incomes permitted them to enjoy. The problem was that the dancing venues were "mingled and contaminated with vice." The lack of morally safe amusements, the editors suggested, was "a distinct defect in our civilization." Providing

such recreation was "a definite duty encumbent on Christian capitalists." Yet, the editorial concluded, this charge "need not be burdensome, for the resorts would pay huge profits." The opinion piece offered regulation as a positive, uplifting exercise, a view which was receiving support among urban reformers elsewhere in the country.[25]

At the height of the controversy, Baldwin wisely took the train to Seattle with an extradited female prisoner. Meanwhile, the attacks upon her intensified. The city's vice interests turned over more old ground in what they saw as a golden opportunity to rid themselves of their nemesis. Among the charges being aired were that Harry Lane had somehow "fixed" her civil service appointment, that she had always been uncooperative and mysterious about her work, and that she had failed to report regularly to city authorities. The committee on health and police asked to review her February expense report, and came up with several questions which held up her $67.50 reimbursement for the month. It wanted to know why she had asked for $1.90 of public funds for photographs, when as far as it knew she "had no rogues gallery." Also red-flagged were $6.90 "for transportation on the O. R. & N. lines" with no breakdown or explanation, and a bill of "more than $1 for messenger services." Fortunately for Baldwin, a washout on the Portland-Seattle tracks delayed her return for several days. In the meantime, her detractors failed to substantiate anything of significance. By the time she came back the flap had died out, and her job was again safe.[26]

The policewoman was mildly chastised by Chief Cox upon her return, and she promised to report her work in more detail. The chief was irritated by her frankness in the *Oregonian* piece, which had indirectly questioned his own diligence. Mayor Simon probably realized how close he had come to losing a zealous ally when the vice interests tried to persuade him to fire Baldwin. The working relationship between them was tentative at first, but within a few months the mayor demonstrated full confidence in Baldwin. In her report for the first half of 1910, she warmly thanked Simon for certain "personal encouragement which assisted materially in the work of the department." She reiterated that things had been less than smooth for a while, and that some of her actions had seemed to "call for explanations." She had refrained from such at the time, she told him, because, as the old saying went, "your friends do not need it and your enemies will not believe it."[27]

As 1910 progressed, the city seemed no closer to resolving its public dance hall dilemma. The ordinance drafted by City Attorney Grant at the time of the mayor's February raids did not seem to please anyone. It eliminated specific immoral dances by name, forbade alcohol on the premises, excluded those under eighteen, required separate dressing rooms for males and females, and

set a midnight closing time. Although she agreed with most of these strictures, the code contained too many loopholes for Baldwin's liking. First, it did not forbid Sunday operation. Second, the policewoman preferred that the halls close at 11 p.m., claiming this would allow the younger patrons to get something to eat afterwards, and still "send them home with the crowds from the theaters, instead of after midnight." Through this practice, Baldwin was confident she would "find fewer girls in lodging houses who were supposed to be staying with girlfriends." Third, the proposal did not eliminate darkened dance floors. Fourth, she wanted a complete ban on unaccompanied females, which would help dissuade cruising prostitutes. The health and police committee also had some reservations about the ordinance, and postponed consideration until a more agreeable formula was submitted.[28]

The problem received urgent attention in May 1910, however, when an elite segment of residents began to feel the effects of the rowdy public dances. Baldwin had warned about the Council Crest Dance Pavilion back in February, but few had paid attention amid the general uproar. The dance hall stood atop a steep hill in the southwest section, some "1200 feet above the city" according to advertisements. The streetcar serving it wound upwards through prestigious Portland Heights, where Brahmin families named Ainsworth, Thompson, Flanders, Holman, Dekum, and others resided in opulent tranquility. Their peace was shattered when the weather warmed, the Oregon rains ceased, and the cheap amusement crowd discovered the Dance Pavilion. The hall had been built against the wishes of neighboring home-owners, who belatedly discovered that their complaints had been among those stamped "file" and then forgotten by the license committee the previous year.[29]

In 1909, Portland Heights had learned that the license board was permitting the Council Crest Pavilion to operate at its doorstep. Almost seventy of the area's most prominent men signed a petition to the city stating a "vigorous and indignant protest" against the proposed amusement facility. Their neighborhood, they pleaded, was "purely residential, and the building of a dance hall would be an outrage upon the home life of the district." Yet the structure was built, and the crowds came. Transportation in the area became impossible, and some of the businessmen who lived on the Heights could not get home in the evenings because the streetcars were too crowded with dance-bound revelers. Patrons smuggled alcohol onto the grounds outside the dance hall, so that tipsy singing and boisterous behavior on the late streetcars kept householders awake. In a pivotal act of dismayed protest, a resident purposely derailed a crowded streetcar that refused to stop for him. The stir over this incident finally caught the city's attention.[30]

Residents assailed the character of the dance hall in general, and reported numerous instances of disorderly conduct on "their" streetcars. The dance hall manager declared that the whole attack was misguided and unjust. He railed against the city transportation network for "not being sufficient to accommodate one-tenth of the people who desired to reach the place." Furthermore, he explained, the overcrowded cars were not the result of his amusement venue, but of the "hordes desiring to see Halley's Comet." As for the rowdyism on the downhill cars, he failed to see how he could be held responsible for the behavior of persons who had already left his grounds. He said he had experienced no such trouble from people on his park premises, or within his dance hall. But once the city's better element had been "extremely discommoded," as one report read, it was only a matter of time before city hall responded. By the end of May, "on complaints of police and Portland Heights residents," the city pulled Council Crest Pavilion's license, and it ceased operation.[31]

With the genteel classes suddenly intimately acquainted with the problems posed by the open dances, public opinion moved the city in the direction of a regulatory ordinance. Taking advantage of the fresh wounds from the Council Crest battle and evidence gathered by Baldwin's police section, Mayor Simon asked for a total elimination of the dance venues. By the end of summer the city had enacted a stiffer conduct ordinance, but that did not fully satisfy the mayor. The council compromised with Simon by approving a moratorium on issuing or reissuing public dance permits under the new code. On one legal pretext or another, the mayor and his ally Baldwin succeeded in closing the remaining halls one after another, a result that was given prominent notice in the policewoman's 1910 year-end report. "Of one thing Portland should be especially proud," she wrote, "and that is that there is not a public dance hall now running."[32]

Despite Baldwin's sense of accomplishment, the licensing ban proved only temporary. By the summer of 1911 the Council Crest issue had faded, the moratorium was lifted, and permits were again issued to public dances upon promise to obey the city regulations. The policewoman soon received familiar complaints, several specifically about a dance conducted on the eighth floor of the Marquam Building. A visit there disclosed that "a number of the young men were under the influence of liquor, and several of the couples were dancing prohibited dances." In disregard of permit requirements, the policewoman reported, "the management was doing very little to preserve proper decorum." The Rosebud Dance near University Park also brought frequent protest. "We have had a number of girls," Baldwin wrote in her daily log, "who admit that their downfall began when they attended

dances at the Rosebud." In addition, she recorded "disgusting conditions" at other places, including ex-city councilman Fred Merrill's self-described "respectable dancing academy" at 7th and Oak downtown. But information gathered in Baldwin's investigation of the Oregon Dance Hall led to a confrontation in early 1912 that proved dismaying to the public dance centers.[33]

On January 4, 1912, Baldwin arranged a meeting of the license panel in the mayor's private office. The Oregon Dance Hall manager attended with his attorney. The head policewoman marched five young girls between the ages of fifteen and eighteen before the assembled men. In turn, each related a similar tale of having been sexually "ruined" by young men they met at the Oregon. "Their stories," the policewoman wrote in her log, "made quite an impression." To a man, the committee voted to recommend revocation of the licenses of *all* the public dance halls. "The city fathers," a *Sunset* magazine piece later reported of the incident, "were shocked when the facts were thus put before them." In fact, the periodical continued, "no amount of pleading on the part of the unscrupulous dance hall keeper could induce them to tolerate such a condition longer." Details of the meeting appeared in the *Oregonian* the next day. Baldwin came down strongly against the public dances. She said that she had been trying to look at the dance question "from an impersonal and rational standpoint: that there should be privileges for the poorer classes, just as for the upper." But the results had been "so terrible in the toll of young girls" that it was clearly in the public interest to ban such places.[34]

But again, a clear victory proved elusive. The public halls were closed, but Baldwin found that young women could still indulge in "their natural love for pleasure parties" if they made certain acquaintances or were in the right place at the right time. The city's fraternal organizations, for example, were allowed to hold dances whenever they wished. At the end of January, police apprehended a couple at the Rex Hotel who had attended a dance put on by the Woodmen of the World. The pair had met earlier in the evening, and the man, presumably a lodge member, had escorted the young woman to the dance. An officer saw them on the street after midnight, and "followed them to a hotel and arrested them in the room in bed together." The girl told Baldwin that the man had persuaded her to go to his room "to see a photo of his baby." He then "induced her to stay all night." The man received "sixty days on the rock pile," but the policewoman arranged for charges against the girl to be dropped, and she was "sent home to her mother."[35]

Baldwin also faced a perhaps more difficult challenge. "Since the closing of the public dance halls," Baldwin wrote in mid-April 1912, "a number of

supposedly private clubs have been organized, which are nothing more or less than public dances." The policewoman mused that these hybrids, which charged "dues" at the door in lieu of admissions, would "soon have to be regulated in some manner." A visit to the Minuet Club at the former Ringler's Dance Hall revealed "a large number of young girls, and the tendency of quite a few couples to rag." The Carnival Club, which opened in what had been Christensen's Dance Hall, posed the same difficulty. In June, the mother of a "dance-crazed" girl told Baldwin that the management sent "good-looking girls" into the streets with "membership tickets" which they gave free to other young women "who looked like they wanted to go to a dance." The informant swore to the policewoman that she knew of "one girl who was taken home by a prominent attorney in town."[36]

Despite such troubling incidents, attendance at the private dances swelled. In addition, charity functions frequently used dances to raise funds, hiring the large facilities where the public dances had been held. The owners scrambled to meet the needs of these more refined customers. When a former public hall manager applied to supervise such events at Oaks Park, the license committee referred his case to Baldwin, who immediately rejected him as "not a proper person to run a dance." Even the proprietor of the notorious Council Crest Pavilion, who had since converted his hall to a roller-skating rink, asked permission to install a dance floor to accommodate private "genteel" functions. The long memories of the nearby residents rebuffed him, however, and his request was refused.[37]

The hypocrisy of allowing elite groups to have dancing while the lower classes were excluded became a prominent issue by 1912. Baldwin took advantage of a deportation trip to New York in February to confer with recreation reformers in that city. Upon her return, she approached Portland's branch of the National Playground Association, whose president Dr. L. Hamilton Weir agreed to help Baldwin and the license committee formulate an ordinance which could satisfy all segments of society. Unlike Joseph Simon, new Mayor Allan Rushlight was generally ambivalent about the dance problem, and preferred to leave the matter with the head policewoman and the license panel. Weir's organization, together with Baldwin and the license committee men, formulated a plan to strictly regulate all dances except small affairs in private homes. The protection of young women and girls served as the guiding principle. As the act would allow the public halls to reopen, it had to provide for vigorous policing. The group surveyed recent ordinances from other cities for ideas.[38]

The ad hoc dance committee offered what it thought was a reasonable proposal. Dance halls and clubs would be licensed, with quarterly review,

and subject to monitoring by a police department dance inspector. Other groups, lodges, and service organizations would have to obtain city permits if they wished to hold a dance. There would be no alcohol sold or allowed on the premises of any dance, and no "return checks" to allow patrons to leave to find a drink and come back. There would be no Sunday dancing. The proposed ordinance generally prohibited "all forms of dancing out of the ordinary." But special provision was made against what the committee cinsidered the most obnoxious of the fad steps, including the "turkey trot," "moonlight waltz," "dip," "slide over the wave," "heads together," "walk back," "Texas Tommy," "bunny hug," and the "grizzly bear." Hall managers or sponsoring organizations were subject to fines of $5 to $250 for infractions, depending upon the type of violation.[39]

Policewoman Baldwin went on record in the *Oregonian* urging support of the proposal as it stood. The measure would, she said, "greatly strengthen the safeguards about young people frequenting dances." She was particularly pleased that one section eliminated the so-called "taxi" or "five cent" dances which had "been such a menace to the morals of the community." But public reaction revealed flaws in the plan. The private clubs and charity organizations bristled at "being treated the same as the public dance halls." The German and Swiss social clubs were upset that their traditional beer would be banned from their cultural events. The Jewish societies complained that the Sunday prohibition was insensitive to their needs: their Sabbath fell on Saturday, which only left Sunday for their weekend entertainments. Yet both Baldwin and Weir of the Playground Association dismissed such complaints, saying that the law was drafted in the interest of young women's moral well-being. "The clubs and societies should be willing," the pair declared, "to suffer some inconveniences for the benefit of the protection of innocent girls."[40]

The search for middle ground dragged on for months. In December 1912, Baldwin's side gave in a little by allowing for less strict regulation of dances held by social and religious societies. But these organizations wanted a total exemption from the law, especially for the fundraisers at which they charged admissions. Finally, after "many months of investigation," and pressure from all sides to get something on the books, Baldwin and the dance committee reluctantly agreed to a less stringent code. Just before the city council approved the act in April 1913, the *Oregonian* wrote that "the measure represented a compromise between the fraternal and charitable organizations on the one side, and the city department for the protection of girls on the other." The organizations got their exemption, and Baldwin got language added to eliminate the practice of admitting girls free at the now-legalized public dances. She was not pleased with the fraternal and social societies'

exemption, but declared her department "willing to experiment with the new plan to be able to bring about better dance hall conditions."[41]

Baldwin and her cohorts considered the April ordinance only a temporary measure to get the public halls open to allow working-class dancing once again. The dance code committee still met regularly. Its members, as Baldwin explained it, were "not Puritans," but "prominent citizens who were fond of dancing." Like the *Oregonian* three years earlier, they shared a common goal of uplifting dance amusement to make it a wholesome and moral form of recreation. One of the most difficult problems they faced was the prohibition of the latest "immoral" dance steps by name. These changed so quickly that an upgraded code might be obsolete before it returned from the printer. The solution was quite ingenious: the revisionists simply indicated that the only permitted dancing form would be the time-honored waltz position, regardless of the music. The panel also wanted a 9 p.m. dance curfew for all patrons under eighteen, and stiff restrictions covering appropriate escorts for young women. Believing that only an all-encompassing ordinance could be fair, they recommended rescinding the exemption for social and religious organizations. In August of 1913, with the aid of Portland's new mayor H. Russell Albee, the dance code was amended to suit the reformers' vision.[42]

Baldwin worked hard at getting support for the new ordinance. In early 1914, she fended off a move to reinstate the fraternal and religious exemption. She confronted petitioners with the statistic that they represented "more than 50,000 people," or roughly a fifth of the city's population. Excluding so large a number from the provisions of any ordinance, the policewoman admonished, "would be the rankest kind of class legislation." They listened to her protracted arguments about protecting girls. After consideration of the text of the code, Baldwin wrote, "even the Jewish members declared themselves in favor of the ordinance and opposed the movement for Sunday dancing." The policewoman was extremely pleased at the way the new regulations worked in practice. She reported to Mayor Albee that there had "not been a girl brought before the Municipal Judge from the dance halls" in the five months since the ordinance had been in effect. That, she told the mayor, was a "remarkable showing." She reported that her department had received numerous requests from other cities for copies of the new law. The Portland code was, she stated proudly, "conceded as the best and fairest ordinance ever drafted for the purpose of regulating dances."[43]

With a few minor changes, the code written by Baldwin and her cohorts governed dance behavior in Portland for many years. During World War I, the section covering the accepted dance form was amended to incorporate the exact description given by the American Association of Masters of

Dancing for the "waltz or closed position." Shortly before her retirement in 1922, Mayor George Baker asked Baldwin about an article which referred to a "drastic law" being proposed to curb obnoxious dancing in New York City. He wanted to know whether Portland's code might need revision. "While I am in no sense an advocate of dance halls," the head policewoman told her mayor, "Portland can truthfully claim that for years we have not allowed any form of vulgar dancing." That problem had been solved, she said, by a very specific" section of the city dance law. Baldwin ended by saying that the ordinance "enacted at the request of the Women's Protective Division in 1913" had regulated the problem that New York was confronting "during all this time."[44]

The 1913 Portland dance ordinance represented an attempt to uplift an amusement with roots in the lower classes and make it amenable to middle-class social mores. By championing the waltz position, it codified Victorian recreational norms in a contemporary commercialized leisure institution. Universal entry charges eliminated the free admission of young females as bait to attract business but also discouraged working girls from attending. The code further reduced the participation of boardinghouse residents by setting a nine o'clock curfew for those under eighteen who were not escorted by a parent or guardian. At least one historian argues that such measures were not merely protective, but were designed to curtail independent working girls' relative social freedom, which often "resonated uncomfortably" with the elite reform element. Portland's dance hall regulation movement was a civic endeavor to codify the private, middle-class sexual order of the past and make it relevant to the modern era. In Baldwin's ironic words, the new law undeniably *was* "the rankest kind of class legislation."[45]

Lola Baldwin's Portland dance regulation struggle echoed contemporary national efforts. She embraced the views of Chicago's Jane Addams and Louise de Koven Bowen and New York's Belle Israels that dance halls deliberately fostered immorality. Baldwin agreed with Portland's premier social hygienist William Foster of Reed College, who dubbed the dances "schools of sexual immorality, with clever and persistent teachers." For years, she could not make city licensing officials acknowledge any problem, and correctly surmised that powerful alcohol and night-life interests lay behind the reluctance. Like the national movement, the Portland effort proceeded in uneven stages. Mayor Lane was a heartfelt moral reformer who fell victim to persistent political conditions. Similarly, because a strong amusement lobby rejected Mayor Simon's call for abolition, little real progress occurred during his tenure. Only when broad-based reform organizations like the National Playground Association and united women's interest groups called for moral

uplift of the dances, and the *Oregonian* newspaper took a similar stand, did an arena for compromise arise. Baldwin, who had pragmatically adopted regulation as a second-best position, suddenly found herself on the consensus side of the issue. In pushing dance reform, she furthered the policewoman's role as societal censor, a function which touched the lives of many of the era's citizens.[46]

Many are wondering why we have so
much trouble with the young people. What can you expect when such
performances as this one at the Pantages have only one effect on the
public mind—that of debauchery and indecency.

—Lola G. Baldwin on Sophie Tucker, November 5, 1910

4

The Policewoman as Cultural Censor

In the Progressive Era context of an idealized urban society which operated in a "homelike" manner, the policewoman as a "municipal mother" performed a distinct function as censor. Baldwin and her cohorts used different forms of censorship to deal with moral problem areas. Sometimes an outright ban was tried, as in the case of the individual dances which they considered immoral. With other issues, such as concerns about young women and alcohol, cultural conditions demanded compromise. In their quest for moral safety, policewomen were called upon to identify and confront so-called "indecent" literature, dress, and behavior. As with the infamous dance halls, the offerings of the city's entertainment venues were often suspected of fostering immorality. Vaudeville houses and movie theaters, saloons and grills, swimming baths and amusement parks all received the close attention of the Rose City's female vice patrol. [1]

As part of a diligent survey of amusements, Baldwin and her assistants checked out the performances in the city's vaudeville theaters. By 1908, the genre had begun to shed its lowbrow nineteenth-century image. It had originated as entertainment for male saloon audiences who appreciated its smutty content, and that style still existed in some of Portland's North End dives on an amateur basis. As amusements in general democratized, the vaudeville form altered to accommodate family audiences. Old acts were toned down to attract mixed crowds and booked into legitimate theaters,

Pantages Theater, Broadway and Alder, 1910
Photograph: Wesley Andrews, Oregon Historical Society (negative OrHi 17606)

although a certain naughtiness prevailed. Like the "new" dance hall which embraced bordello music in rebellion against lingering Victorianism, "refined" vaudeville engendered the "ragtime ditty." These novelty songs were belted out by singers touted as "friendly entertainers," who guided patrons through fantasies of a new and liberating consumer culture. Rapport between audiences and performers exhibited an informal, often sexual banter. This feature in particular bristled the neck hairs of traditional moralists.[2]

Baldwin's greatest challenge in censoring the city's vaudeville and concert halls was her celebrated confrontation with Sophie Tucker, the star of the William Morris Circuit. In November 1910, the buxom young warbler brought her flashy song-and-dance revue to Portland's Pantages Theater for a week. After the first show, an anonymous male patron complained to Baldwin that the act was patently indecent and "grossly disturbed the public peace." Notebook in hand, the head policewoman and assistant officer Wilma Chandler attended the next performance. After scrutinizing the costumes, lyrics, and dance motions of the ample-bosomed songstress, Baldwin decided that Tucker's "Grizzly Bear" and "Angle-worm Wiggle" routines were "particularly objectionable." The policewomen then swore out a warrant for the singer's arrest on city indecency charges.[3]

After paying Tucker's $50 bail, Pantages manager Carl Walker somehow convinced the police court to postpone its preliminary hearing until after the engagement ended. He invited Police Chief Arthur Cox to review the performance. Cox found nothing wrong with the act and allowed it to continue. Infuriated, Baldwin publicly castigated Tucker in an interview with

the *Oregonian*. Among other things, she called the entertainer "a woman from the Barbary Coast of San Francisco," a pointed euphemism for prostitute. The irate policewoman swore out a second warrant, this time on state morals charges. Meanwhile, she described the singer's act in detail to Mayor Joseph Simon, and persuaded him to order Chief Cox to halt the show. Baldwin, however, had greatly underestimated the feisty Tucker. Incensed at Baldwin's public questioning of her moral character, the singer threatened to sue the city for defamation and vowed to "fight to the finish" to prove that she had "done nothing wrong."[4]

"I am earning an honest living," Tucker told the *Oregonian*, "and am sending money home to my folks." The policewoman's assertion that she was from the Barbary Coast was untrue, the Connecticut-born performer protested. "I cannot understand why Mrs. Baldwin should say these falsehoods about me." To Baldwin's charge that she had ridiculed her from the stage after the first warrant was waived, Tucker said she had simply inquired of her audience members whether *they* thought her act was "very immoral" or not. The singer remarked that she was affiliated with too many charitable organizations to condemn anyone else who was trying to do good. "I am not that kind of a woman," she reiterated, "and I am sorry Mrs. Baldwin thinks so badly of me."[5]

The next day, embarrassed city officials convened a hasty conference including Tucker, her attorney, Baldwin, and state and local legal authorities. The outcome proved a draw, with each side agreeing to drop charges against the other. Baldwin grudgingly provided a newspaper apology for the matter, saying she had "no personal animosity toward Miss Tucker." The policewoman defended her own actions, however, observing that it was her official duty "to know what is going on at the theaters where young people are attending in great numbers." The singer simply expressed relief that "the whole business had been taken out of the courts" and she could resume her tour on schedule. Although Baldwin forfeited the case, she did not conceal a personal sense of triumph for at least temporarily closing down "the last of the red-hot Mamas." In January 1911, she reported to Mayor Simon that she had read that Tucker had been "restrained from giving performances" at later stops. Furthermore, she wrote, the same musical numbers she and the mayor had censored had been "tabooed and criticized by the theatrical papers" in apparent vindication of their recent stand.[6]

The Sophie Tucker affair exhibited several cultural conflicts and contradictions central to the Progressive Era. Baldwin continued to associate vaudeville with its saloon roots, making no distinction between the bawdy barroom skits at North End vice dens like Fritz's Theater and the downtown variety shows

which were gaining middle-class support under her very nose. Although Tucker had agreed to "sing any song suggested, and wear street costume" if she could remain on the bill, Baldwin at first refused to back down, objecting to Tucker's general performance demeanor, which, she noted, had but "one effect on the public mind — that of debauchery and indecency." The singer's personal appearance probably had much to do with such impressions. Although quite young, she was large-busted, and loved to dress in tight, low-necked dresses and big feathered hats. Tucker moved her bulk with an unexpected sensuality, and belted out her songs in a big brassy voice. Whether she intended it or not, the singer evoked a devastating parody of the sacrosanct "Victorian aunt."[7]

Did Sophie Tucker deserve Baldwin's denigration? In sisterly irony, she, like the policewoman, had created a niche for herself as a new professional woman. In less than a year on stage, she had become, in her own words, "one of the biggest attractions on the William Morris Circuit." A daughter of Jewish immigrants, she saw the reformed theatrical venue as a legitimate vocation for young women like herself who struggled to provide for their families. In an interview with the *Oregonian*, Tucker spoke with pride of her 1903 graduation from Hartford's Morse Business College. She also recounted awards given her by the cities of New Orleans and Indianapolis, where she sang in the streets to earn over $1,500 for poor children at Christmas. Tucker berated Portland's first policewoman for arbitrarily terminating her ability to support her eastern relatives. In retrospect, the singer's core values of salaried independence, maintenance of family, and care for the unfortunate were little different from Baldwin's. Both women were professionals who sold their expertise. What most galled moral traditionalists like Baldwin, however, was the fact that performers like Tucker had found a way to sell their sexuality yet still remain "decent."[8]

The censorship criteria for performance dance during the Progressive Era were essentially the same as for recreational dancing. Morality monitors clung to Victorian definitions of what represented good taste. Exposed flesh, or even the appearance of it, could condemn a program as easily as suggestive body movements. For example, the policewomen panned a 1913 performance called "The Dance of Death" because "the woman danced in her bare feet, and the tights she wore were so nearly flesh color that it gave the impression that her limbs were bare also." Before an expected visit from the Navy fleet in 1919, the Portland policewomen issued complaints against a professional "shimmie dancing" couple who, in the quaint innuendo and euphemism of the times, "went to extremes in vulgar movements of their bodies, the man especially from the waist down, and the girl with her busts."[9]

Portland was certainly no backwater in regard to new types of entertainment. Early forms of the "movies" appeared in the city in the 1890s when Thomas Edison's coin-operated "kinetoscope" machines were installed in downtown arcades. Within a year of their development in 1896, "Electrograph Entertainment" offered Rose City audiences large-screen motion pictures. As entrepreneurs recognized the potential of this new form of amusement, makeshift storefronts gave way to whole buildings specially fitted for viewing. Because films were silent, they held a special attraction for recent immigrants, who could enjoy an American experience without a language barrier. Yet the movies were equally fascinating to people of all classes, and therein lay the reformers' dilemma. The first example of mass entertainment in America, "nickel madness" soon infected a vast cross section of society. Yet the prospect of diverse strangers arbitrarily seated together in dim caverns was most unsettling to society's moral watchdogs.[10]

Beginning in 1908, Baldwin and her assistant closely monitored the movies as part of their normal surveillance of all amusements. Marquees adorned with names like the "Bijou," "Lyric," "Majestic," "Globe," and "Oh Joy" beckoned Portlanders into dark, flickering interiors to view assorted "shorts." Ubiquitous coin-operated "picture machines" stood in the odd corners of small businesses, in downtown penny arcades, and in the waiting rooms of the railroad, interurban streetcar, and ferry terminals. Reformers' problems with the films were twofold: a discomfort with moral content, and concern about the conditions in which they were shown. Following an afternoon sampling slot picture machines, Baldwin judged that she would not allow her own children to view them, as "the general atmosphere of the whole thing was against good morals." In the large-screen exhibitions, however, she often found little objection to film content. Baldwin's main concern, in the context of her morality enforcement role, was that young girls often hung around the places specifically to meet boys.[11]

As the new medium proliferated, the police superintendent and her assistant lacked the time to scrutinize the content of all the city's film offerings. Yet Baldwin did make her services available on specific complaints. In 1911, for example, her review of *The Night Riders*, an early attempt to capitalize on Thomas Dixon's Ku Klux Klan novel, *The Clansman*, resulted in the arrest of the manager of the Majestic Theater. Although she made no specific reference to racial matters, Baldwin condemned the film because it "exploited hanging, outlawry, lynching, and incendiarism." The reel was turned over to Portland's grand jury, which cut what it considered the most objectionable parts, and then allowed the remainder to be shown. Soon thereafter, a number of concerned women from the city's Associated Charities, Woman's Club,

Council of Jewish Women, and Child Labor Commission formed an unofficial movie censorship committee to review all films before exhibition. This action relieved the policewomen of *ex post facto* responsibility. In 1915, the group obtained official sanction as the Municipal Board of Review, which functioned until its repeal in 1970.[12]

By 1913, 70 percent of an Oregon Social Hygiene Society sample of 2,618 Portland grammar school students reported going to movies once a week or more, 64 percent attending in the evenings. In 1912 the city had initiated a 9 p.m. curfew for unaccompanied minors. The curfew was a form of censorship in that it legally eliminated suggestible youth from the generally more risque late-evening performances. Yet, more than a year after the law went into effect, the Social Hygiene Society discovered 1,215 young violators during one two-night survey. The Oregon Congress of Mothers blamed the theaters for allowing unaccompanied children in their establishments after curfew, and blasted police authorities for not assigning more patrolmen to enforce the ordinance. Baldwin philosophically disagreed with the organization, however. It was not more police that were needed, she insisted, but more attention paid to children in the family. Wholesale violation of curfew, she reasoned, was simply another symptom of "a general lowering of standards in the American home." She complained of "large numbers of young girls still attending the night performances alone." She emphasized that until parents recognized the danger, her policewomen could "do but little to cope with the situation."[13]

As censorship agents sought to uplift the moral content of films in the 1910s, they realized that modern consumerism, not traditional producer values, dominated movie subject matter. Nevertheless, some reformers tried to turn the novel medium to moral uses. Baldwin applauded the Council of Jewish Women when it rented the Globe Theater in 1913 to show *The Evils of the Dance Hall,* one of the period's numerous "moral warning" films. In spite of constant vigilance, the policewomen continued to find unaccompanied girls loitering in lobbies, and to apprehend young males who took sexual advantage of them. In one case, Baldwin discovered a group of high-school boys who invited girls to the movies, but "took them instead to a house which they had provided for immoral purposes." To the policewoman's dismay, films rapidly became part of a modern youth culture in which all sexes and classes mingled without stigma. To her credit, despite her misgivings about the whole idea, Baldwin saw the potential for mass communication in the movie houses and arranged for lantern slides of missing girls to be shown at intermission.[14]

As part of her prevention program, Baldwin surveyed situations most likely to lead to delinquency among young females. Her case files showed alcohol as a culprit in many instances of immoral behavior. Saloons, roadhouses, taverns, restaurants, and grills all abetted the problem. By mid-1908, Baldwin had persuaded several members of the liquor license committee that the most effective way to protect women and girls from the corrupting effects of alcohol was to ban them from places where it was sold. As an element of the social hygiene ideal, Baldwin insisted, her proposal would "make safeguarding womanhood easier for those who make that part of their world's work." The policewoman stated that women or girls who entered saloons were of two types: either confirmed prostitutes, or innocents in danger of seduction, "neither of whom," she concluded, "should be there."[15]

The idea of excluding or censoring out the fair sex was an interesting compromise given the polarized contemporary sentiments on alcohol, including those in the head policewoman's own household. Baldwin's husband, LeGrand, ran for state and federal office several times as a Prohibition Party candidate. In much the same way that Portland suffragist Abigail Scott Duniway separated prohibition proposals from female voter legislation, Baldwin's tactic did not threaten male access to alcohol. By this concession, she hoped to increase chances of success with the all-male city government. Until she could engineer a local ban on women, the policewoman utilized a patchwork strategy based on Oregon's legal drinking age of twenty-one and its 1907 juvenile protective codes. The basic youth control law forbade anyone under eighteen from being in any setting where liquor was "sold, exchanged, or given away." The state's "age of consent" provisions made it a felony to seduce or procure females under eighteen for immoral purposes or allow them to enter any place, such as a saloon, frequented by pimps, prostitutes, or their customers. Under these acts, Baldwin initiated proceedings against several establishments notorious for alcohol sales to minors.[16]

In May 1908, the head policewoman succeeded in obtaining fines against the owner and bartender of the Signal Saloon for serving beer to an underage female. The two had even tried to thwart prosecution by sending the young witness to Chicago. Nevertheless, the incident by itself failed to convince the city council of the need for a ban on selling alcohol to all women, whatever their age. By summer, however, Baldwin had discovered a more viable test case. One evening she observed a large group of apparently underage females being served beer at the Club Cafe Saloon under Fred Merrill's dance hall at 7th and Oak. An inside stairway connected the second-floor hall to the back room of the bar, so that patrolmen on the street could not see who

entered. Alone or with male companions, girls came down for beer, then returned to the dance. Baldwin herself was propositioned by a drunken man on the stairway as she was leaving. The setup was just the kind of situation her proposed ordinance would correct.[17]

Baldwin persuaded three teenaged girls to testify against the Club Cafe after they were arrested in the place in early August. They swore that no one had asked their ages, or hesitated to sell beer to them. Their detailed descriptions of activities in the barroom prompted the police court to turn the matter over to the grand jury. Baldwin conveyed a transcript of the girls' private testimony to the city liquor license committee. On its strength alone, they revoked the saloon's permit. In mid-September the grand jury indicted both the proprietor and his bartender on state charges of serving minors. Armed with the transcript, the revocation, and the indictment, Baldwin confronted the city council. In late September, after a heated debate, the council passed an ordinance prohibiting all females from certain places within the city limits which sold alcohol. The code disappointed Baldwin by exempting restaurants and grills, many of which had reputations as bad as the worst saloon. Nonetheless, she still lauded the ordinance as "the greatest victory we have had since we began work."[18]

Despite her early feeling of triumph, Portland's new policewoman discovered that the strength of an ordinance depended upon enforcement from the bench. In March 1909, Baldwin prosecuted a test case against Franzel's Saloon, only to see the saloonkeeper and three women customers fined so lightly as to have little effect. Baldwin noted in her logs that almost all the cases brought before that particular judge that day resulted in acquittal or nominal action. "The police officers," she wrote, "had strong evidence against many, but little credence was given them by the judge." This was but one of many suspicious incidents of judicial inaction that plagued Baldwin. Undaunted, she began to follow judges to their chambers whenever her cases were belittled, demanding explanations for light sentences. Her persistence apparently paid off, for the Women's Protective Division soon reported "not having lost a case" in Portland's municipal court.[19]

Although the new alcohol ordinance was extremely helpful within the city limits, Baldwin continued to have problems with girls who traveled to outlying taverns and roadhouses. Although state law prohibited minors from being served, the rural taverns usually scoffed at the liquor codes. It is surprising how soon after its debut the automobile became involved in what Baldwin considered immorality. As early as 1908 she became aware that many of Portland's chauffeured car services were abetting the "ruin" of young women. These outfits drove parties of young people to out-of-town drinking

spas like Fred Merrill's Twelve Mile House east of the city, the Claremont Tavern near Linnton, or North End saloonman August Erickson's rural roadhouse on the Clackamas River. Obliging drivers bought beer or liquor for their under-age customers, and turned a blind eye to drinking and illicit sex on the "joyride" back to town. Although Baldwin could do little about the private autos, she was determined to check the taxi trade.[20]

In June of 1909 the policewoman decided to hold the hired-vehicle companies accountable for the behavior of their employees. She composed a letter of notice, citing the state codes and the "danger of allowing the chauffeurs to take out young girls and women unchaperoned." She delivered it to eighteen of the city's hired-automobile shops and garages. Soon, motorcycles gained popularity to the point that they, too, posed a danger. By 1915 Baldwin reported a "great deal of trouble with these machines." Some moralists feared that girls would be sexually stimulated by sitting astride these vehicles, and therefore prime targets for adventurous cyclists. Girls who enjoyed these rides were dubbed "motorcycle fiends," a term which inferred a type of addiction pathology. The women's police enlisted the aid of A. L. Welch, president of the Portland Motorcycle Club, who was most anxious to cooperate with Baldwin to stop such exploitation. He asked that two of his members be appointed as special police who would patrol the countryside, "weeding out and bringing to justice young men who abused their privileges as motorcycle riders."[21]

The late nineteenth and early twentieth centuries saw a concerted national effort to censor literature and art of supposed pornographic influences. One of the most widespread forms of this type of material was the so-called "French" postcard. These were mass-produced "penny" copies of classical nude art or contemporary salacious drawings or photographs. The cards were easily obtainable, and soon spread from their traditional hiding places in military barracks and men's wallets. When they began to turn up in the hands of young people, however, moralists became concerned. Although prohibitive legislation prevented their actual dispersal by mail, they moved with amazing speed. One of the places they appeared was among young girls in the workplace. Complaints to Sigmund Sichel of the police executive committee prompted him to ask Baldwin's office to investigate the issue. In one case, a supervisor at the Meier and Frank department store confiscated a quantity of "impure" art cards from some of its young female employees. The policewoman interviewed two girls about the incident, and upon admitting guilt they were fired by the store. Later the female detective discovered the source of the prohibited articles. A "postal and curio shop" on Alder Street opposite the department store maintained open displays of what

the policewoman described as "indecent and suggestive cards," which the manager removed after her complaint.[22]

The policewoman kept a vigilant eye out for pornography at all times. On a September afternoon in 1908, as she returned to Portland by train from some police business in Corvallis, she noticed an exchange between a young boy and a man hawking reading materials to passengers. The salesman urged the youth to buy what Baldwin termed "an obscene pamphlet." She watched as the boy accepted the literature and paid the agent "$2.00 in silver." The policewoman moved forward, sat next to the young man, and demanded the materials, explaining to him that they were unlawful "contraband." He turned them over to Baldwin, but only after she reimbursed his money. She alighted from the train temporarily at its next stop and wired the Portland police about the situation. When she arrived in the city, she persuaded the Barkelow Brothers Company, who employed the newsagent, to swear out a complaint against the man so she could arrest him.[23]

After the man's apprehension, Baldwin learned she would have to pursue her case in Polk County, where the incident had occurred. She traveled to the county seat of Dallas, and presented her materials to the district attorney there, who filed a case against the agent. The Dallas sheriff then came to Portland and arrested the man as soon as Baldwin obtained a dismissal from the municipal court. The policewoman took her evidence to the valley town and testified at the man's trial. During cross-examination of the defendant, he disclosed the name of his supplier. The agent was fined $150.00, and subsequently fired by his employer. The whole situation so upset the news agency and the railroad company that their representatives begged Baldwin to "make them as little trouble as possible." She manipulated their wish to discourage publicity to further her moral purity agenda, making them promise to display copies of the state law regarding obscene literature in all trains and stations, and to alert their personnel to the consequences of breaking the law.[24]

Newspaper advertising also revealed certain censorship problems. In the summer of 1909, the ad manager at the *Evening Telegram* asked Baldwin about the legitimacy of several introduction and matrimonial services which had opened in the city. She was well aware of them, she wrote, having "traced the source of trouble in the lives of several young women to the promiscuous acquaintance formed through these agencies." Some weeks earlier, when the policewoman had helped eliminate the city's shady massage and fortune-telling businesses, the papers had aided her cause by refusing ads from such establishments. It appeared that the introduction bureaus might need similar attention. Baldwin personally visited several of the places, and bought their

descriptive client lists. Some services distributed these very liberally "at 10¢ each," while others charged a $2.00 to $5.00 "membership fee" for the privilege. The availability of the circulars was widely advertised in the daily newspapers. Baldwin worried that this might tempt naive young women to buy them. In the name of protecting such girls, she began an investigation of the businesses then in operation.[25]

The Pacific Introducing Club at 229 1st Street was managed by a self-proclaimed "Christian woman" named Mrs. K. B. DeLin. There the police-woman discovered and described private booths where "men and women met promiscuously for evening basket suppers, etc." At the time of the visit, Baldwin's office was counseling an unhappy girl who was married "to a man much older than herself" through the auspices of DeLin's club. Baldwin then surveyed the Portland Introducing Bureau in the Alisky Building, which was operated by a Dr. T. J. Pierce under his wife's name. The policewoman learned that his other sources of income were money lending and selling abortive pills. Baldwin's background check on Mrs. H. C. Wilbur of the Confidential Matrimonial Bureau at 146 1st Street found that the woman had been barred from opening a similar place in Seattle. L. B. Osborne of the Guarantee Bureau on Park Street protested that his agency was simply helping to facilitate the Bible's injunction "to multiply and replenish the earth." Baldwin was not impressed. "In spite of all the Scripture quoted by Mrs. DeLin and the others," she wrote to Mayor Simon, "I am still of the opinion that God did not intend matches should be made through brokerage firms."[26]

Baldwin's inquisition of the "lonely hearts clubs" was based on possible moral danger to unsuspecting young women. The agencies' pamphlets contained descriptions of male and female clients. All were seeking some form of companionship from the opposite sex: mail correspondence, company, or marriage. If a man, for example, discovered an interesting placement, he paid $2.00 to $5.00 for the woman's address. The woman who submitted the ad had to pay a $5.00 "membership fee" to have her copy included. The agencies received money on both ends of the transaction, yet always disclaimed any responsibility for what might result from the "introduc-tion." The policewoman most objected to the lack of screening of men who answered inserts like: "This charming young lady lives in a town suburban to Portland. Would like to meet gentlemen her own age." In early September 1909, Baldwin presented her evidence and a proposed ordinance she had drafted with the aid of the city attorney. She hoped the city councilmen would agree that such concerns were not legitimate businesses, especially since they made little or no effort to discover the moral character or true intentions of

their ad respondents. On September 22, the council approved the code. It banned marriage brokers within the city limits, and forbade the publication or circulation of any brochures generated outside of Portland.[27]

The Progressive Era social hygiene ethic legitimized any government censorship effort designed to clean up the image of the "teeming city," including the demeanor of persons within public view. Urban purifiers concentrated at times on the beggars and other "street people" of the day. Reports of anything which might upset the delicate sensibilities of the female stroller usually ended up on Baldwin's desk. In 1911, the Mother's Congress and the Portland Woman's Club became agitated over the issue of pencil-selling "cripples and deformed persons appearing upon the streets." The groups wanted these people banned from the sidewalks because they fully believed that pregnant women viewing such individuals would give birth to defective babies. Baldwin took this complaint to several of the city's physicians for their opinions. Without exception, those she consulted concluded "there was danger of prenatal deformity being caused by this means."[28]

Some of the disabled appeared with children or minor females. "There can be no doubt," the policewoman wrote to the mayor, "but that the effect of such street work upon children and girls is most pernicious." The protesting clubwomen claimed that they did not intend "to deprive anyone of an honest effort to earn a living." However, they rejected city tolerance of the "floaters," as they called the drifters who turned up every year at Rose Festival time. They expressed compassion only for the unfortunates among the city's permanent residents. Although the clubwomen and the policewoman preferred that the physically deformed be "tenderly cared for elsewhere than on the public streets," they were willing to compromise in certain cases. There was one man, for example, who sold "small merchandise" at 3rd and Alder. Although he was "very much afflicted," Baldwin noted, he pushed himself around in a cart without assistance. This man, she conceded, "would not be at all objectionable if something light were used to cover his deformed legs." He deserved a concession because he was "a reputable man and a good citizen, and had been there for a long time." Yet, "on behalf of the prospective mothers of Portland," the policewoman begged the city to ban all nonresident disabled merchandisers.[29]

Although almost too obvious a symbol, water played an important role in the urban purity movement. Temperance advocates pushed for the installation of water fountains on public streets so that people would be less likely to frequent saloons to quench their thirst. In Portland, lumber baron Simon Benson provided the city with ornate cast metal "bubblers" which still grace

the business district. The municipality was fortunate in being able to tap the pristine watershed of the nearby Cascade range, which needed little or no chemical purification. At a time when bathtubs in private homes or rooming facilities were still rare, public "hygienic baths" proliferated with an eye toward encouraging health and civic morality. Reformers reasoned that if people learned to be clean, they would learn other temperance habits. The public baths would also form good citizens by "teaching obedience to health laws." But by the early 1910s, deteriorating conditions in the city's bathing facilities aroused concerns. Reports of "males and females bathing together," inadequate dressing facilities, and obvious sanitary violations led to an investigation by policewoman Baldwin.[30]

In September 1913, the often-maligned Portland Swimming Baths at 4th and Yamhill defensively claimed to the city that "the Multnomah Club and other places were allowing men and women in the water at the same time." After Mayor H. R. Albee asked Baldwin about the validity of this charge, she spent a week visiting bathing and swimming venues throughout the metropolitan area. The city offered an amazing variety. The bathing beaches on the Willamette River consisted mainly of crude dressing facilities and roped-off swimming areas, but the river also boasted floating bathing barges with raft dressing rooms. Downtown, the huge indoor pools of the elite clubs contrasted with numerous small Russian, Turkish, and Scandinavian ethnic bath-houses. In addition, the policewoman visited the hydropathic medical clinics and other places which provided mineral treatments. The city's transient hotels often had large tub rooms, but Baldwin referred that area to a male officer, as she did "not consider it proper" for a woman to check up on such features. When her quest was complete, she addressed the results to Mayor Albee.[31]

The policewoman began her report with the assertion that there was "no truth" to the allegations made by the Portland Swimming Baths of intersex swimming at the city's most elite private pool. "The Multnomah Club, of course," she smugly announced, had "the finest equipment." Their 115,000-gallon tank was "filled every fourth night." They provided a female attendant on "woman's day," when men were forbidden entry. Not even very young children of the opposite sex were allowed in the water together, and admission was limited to "club members only." On the other hand, Baldwin wrote, the Portland Swimming Baths paid "very little attention" to sanitary or moral conditions. The pool was used by almost a thousand members of the general public each week, yet the water was "changed but twice" in that period. Women and girls, the policewoman charged, were often seen "running indiscriminately among men and boys, and dressing in adjoining

booths." Boys were heard cursing, with no regard to their audience. Conditions were "altogether bad," Baldwin told the mayor, and reported that she had turned the matter over to a male sergeant "for immediate attention."[32]

"Men and women," Baldwin declared in her daily log, "should not be allowed to swim together at all." Although she said this in the context of her protective role, it also reflected a general unease with the changes occurring in post-Victorian America. A more relaxed, casual mixing of the sexes during leisure time left traditionalists like the women's police superintendent shaking their heads. The "mixed swim," like the dances and other amusements, soon became popular among young recreation seekers. New styles of bathing costumes added to the problem, especially one-piece swimming suits for women. Although such outfits covered every inch of flesh from the neck to the knees, they exposed bare arms, and allowed a glimpse of the true shape of the female form. But young women, who had begun to swim for exercise, liked being freed from old-style heavy bathing dresses which would have drowned them if they ventured in past their ankles. The need for change in acceptable water attire was obvious to some of the period's reformers, yet rejected vehemently by others.[33]

The denial of ameliorating standards showed plainly in a letter from one Fred Alexander to Mayor Albee. He wrote complaining that a Keystone Films production, *Gussie Rivals Jonah*, was being withheld from exhibition by the city movie censorship board. The writer claimed he was a brother to "the fat man" in the movie, and therefore "personally interested." The reel was "held up on account of one-piece bathing suits being worn by the actresses on Santa Catalina Beach." In California, Alexander related, such swimwear was "considered perfectly proper for bathers at all times." The censorship board, he protested, was "very narrow minded," and apparently oblivious to the current fashion trends on local beaches. His knowledge was based upon consistent observation, he continued, as he "operated the draw on the Morrison Bridge." He invited the mayor to stroll down to the river bank on any warm day. There, the bridge tender asserted, Albee would see "numbers of young women dressed in one-piece bathing suits." Yet, he concluded, he had yet to hear any "criticism with regard to suggestive costumes" from anyone.[34]

The question of bathing attire reflected one of the inherent contradictions of the social hygiene reform agenda. On the one hand, the movement denied any physiological differences in muscular development needs between adolescent boys and girls. Portland recreation reformer Dr. Bertha Stuart stressed that females also needed "abundant and free open-air play to develop muscles, train endurance of the heart, and increase the capacity of

the lungs." Yet, the Victorian reticence of some of her compatriots caused them to reject the very type of clothing which would allow girls to swim or pursue other forms of recreational exercise. More and more young women who were true swimmers appeared on the bathing beaches. The girls of yesterday, who had "paddled in a few inches of water," one news article pointed out, were "vanishing." Young female athletes insisted on having so-called "dresses for water" that were "smart and businesslike in all respects." Rather than exult that the public had taken their exercise advice, however, conflicted reformers instead sniped at the "immoral" clothing that made it possible. Street clothing designed to ease living in the cities also came under fire in the 1910s, especially the infamous "slit skirt."[35]

The slit skirt appeared on American streets before World War I in response to a problem of modern living: the high metal steps of the streetcar. Heavy, ground-length skirts became a genuine hazard when the wearer attempted to board or alight from one of the cars. Soon, clothing designers offered a less voluminous model with a flap or slit at the side which permitted ladies freedom of movement to step up or down more safely and efficiently. But the flash of stocking or ankle thus exposed caused an uproar among moralists. Policewoman Baldwin echoed this discomfort with the new style, as did Mayor Albee, who in 1913 issued an "edict against the wearing of slit skirts upon the public streets." The mayor's pronouncement was partly due to incidents like one involving the daughter "of a prominent businessman." The slit-skirted girl was arrested as she stepped down from a streetcar on 5th Street after an officer spied "a nickel-plated derringer plainly visible through her transparent hose."[36]

The twenty-three-year-old, who was slightly inebriated when appre-hended, said she had concealed the weapon on a dare from a girlfriend. Yet she gave the policeman a false name. When she was taken to Baldwin's office, the policewoman recognized her, and called her family. To protect the girl's relatives, Baldwin refused to give her correct name to the press. But the false name she had given, "Nan Mann," was the actual name of a young stenographer in the Yeon Building, who suffered a great deal of embarrass-ment when newspaper stories implicated her in the incident. The arrestee's mother refused to have anything to do with her, and asked that she be kept in jail as an incorrigible. Baldwin intervened, and after soundly lecturing the young woman for her behavior, arranged for the court to place her on probation to the Catholic Women's League, which promised to keep an eye on her until her family accepted her back. As part of her punishment, the press printed the young woman's real name, and an apology to the real Nan Mann. Although the incident resolved satisfactorily, to Baldwin and others the slit

skirt worn by the girl was indicative of a laxity which went far deeper than mere fashion.[37]

"Some argue," an *Oregonian* piece in late 1913 reported, "that the less women wear, the better for their health. Others see in such signs of the times great social and moral menace." The slit skirt, the above-the-ankle "hobble" skirt, and the thin material of the "x-ray" skirt, Reverend Benjamin Young told the Oregon Congress of Mothers that fall, were symptomatic of "the subtle and dangerous materialism of the age." In the same paper several weeks earlier, Dr. William T. Foster, president of Reed College and head of the Oregon Social Hygiene Society, had denounced such "modern styles of dress" as a "bad influence" on young people. *Oregonian* readers could discern other opinions as well, however. In her popular syndicated column, French actress and social hygiene advocate Sarah Bernhardt urged American women to fight vice and alcohol, yet at the same time asserted that the styles "against which certain severe people rail" were functionally beneficial to female health. The slit skirt prevented injuries, and the lighter dress materials so thoughtlessly castigated as "x-ray" aided ventilation, while the shorter "hobble" skirt would not "pick up the unclean things from the sidewalk, the muck and the spittings," thus avoiding disease. Many in the Rose City denigrated all the hype. The *Oregonian* editors, for example, maintained that too much was being said about woman's dress, which they concluded was "a matter of no importance."[38]

Portland's women and girls, the *Oregonian* declared, should be able to wear what they liked on the streets. "If it pleases them," the paper continued, "it really ought to make very little difference whether police officials like it or not." The editorial proceeded to condemn the city's moralizers. Some local pundits, the essay charged, saw "signs of frightful degeneracy in the slit skirt" simply because it was new. Once the novelty wore off, the editors predicted, everyone would wonder what the flap had been all about. Women were intelligent enough to know when they offended public morals, and "good women" would not dress indecently. "Nothing is immodest," readers were reminded, "except what we have agreed to designate thus." The paper further noted that "society women" had for a long time worn gowns "shockingly immodest in comparison with the slit skirt." Certainly the "bare shoulders of the ballroom" were much worse than the "indicated ankles of the new attire," yet none of the elite ladies had "ever been arrested for displaying them." The reform Puritans, the piece offered, should mind their own business. "Whether we like it or not," the opinion concluded, "the women will work out their own salvation in the matter of dress."[39]

The censorship activities reported here involving Portland's first police-woman are by no means a complete accounting. Yet they impart a sense of how far-reaching such "progressive" attempts were. Alcohol restrictions and dance, movie, literature, and dress censorship were seen as necessary to the standardization and rationalization of modern American social life based on a traditionalist model. In the social hygienists' secular, government-aided interpretation of Protestant religious impulse, self control was advanced as the prized goal for the "new" urban citizen. As one historian wrote of the era, "obedience to the law was critical in the cultivation of self control." This idea of using the police power as a morality-molding agent shows clearly in Baldwin's censorship function. Yet the public, as the *Oregonian* aptly stated in its commentary on women's fashion, continued to work out its "own salvation" regarding cultural standards, in spite of furious suppressive attempts from above.[40]

It is a sad case. The girl is fifteen years old, and is said to be badly diseased. She is known to the city's chauffeurs as "ten-cent Sybil."

—Lola G. Baldwin, February 12, 1912

5

Combating Sexual Delinquency

As young single women moved to Portland seeking work, Baldwin was confronted with a growing "girl problem." Much of the thought on female delinquency remained little changed from the previous century. Although young males were considered "willful lawbreakers" and "governed by reason," females were often described as "malleable," perpetually immature, and emotionally unstable. In persistent Old Testament terms, they were felt to suffer a greater "fall" than males who discarded sexual chastity. Even "betrayed" unwed mothers were believed by some to have "no way back" once they "sinned," and were condemned as much as the deliberate prostitute. Yet, the malleability factor enabled more optimistic reformers to think that at least some could be "rescued" from moral turpitude and rehabilitated. In turn, this thinking allowed the possibility that those with an identified inclination or opportunity for immorality could be prevented from such failure.[1]

In the early twentieth century, as criminology struggled to become "scientific," it still adhered to some of the earlier "fallen woman" ideology, retaining a central belief that sexual deviance was at the heart of all female delinquency. Young women did not have to engage in actual intercourse to be designated "sexually delinquent." Girls who dressed immodestly, wore "male" clothing, used foul language, smoked, drank, or associated with other racial or ethnic groups earned the same label. In a "nature versus nurture"

75

debate which still resonates today, Progressive Era experts argued over whether the root of such behavior was poor social environment or inferior genetics. As a result, several competing explanations for feminine vice existed concurrently, and appear to have been used interchangeably by preventive and corrective agents like Portland's Baldwin.[2]

Although some delinquent girls literally *were* sex offenders, others simply *offended their sex*. Any outward signs of "precocious sexuality" rebuked traditional female moral standards which those like Baldwin hoped to preserve. As government became involved in reform to clean up the city, it was natural that the policewoman, with her determined mission of keeping young women from prostitution and related vice, would play an enhanced role. In step with other emerging female occupations in social work and corrections, Baldwin initiated a specialized, woman-run form of the existing urban vice unit. Unlike the traditional remedial use of the male vice squad, though, Baldwin was among the first to infuse such duty with a preventive ideology. Her department's "chief aim and purpose," as she emphasized in her initial monthly report, was to "*prevent* downfall and crime among women and girls."[3]

The ambiguity among experts as to the cause of female sexual delinquency made for conflicts in adjudication. Some judges, especially those from the early juvenile courts, believed that women or girls, like children, could not be held responsible for immorality, and automatically charged the male offender in carnal cases. Others took the opposite stand. Portland judge Henry McGinn, for example, told Baldwin he would never jail the man, especially if it were his first offense. Other bench officials were more flexible, depending on the evidence. Baldwin's records indicate that she took no absolute position, but relied upon what she believed to be the merits of the case at hand. Yet at times the uncertainty of judicial opinion placed her at odds with the city's court officials.[4]

In 1907, Judge Arthur Frazer of the juvenile court convicted and jailed a married man for "contributing to the delinquency of a minor." The accused man later petitioned Governor George Chamberlain for relief. When he asked Baldwin's advice she advised him to parole the prisoner. As a matter of form, she cited the man's good conduct during time served, and the destitute condition of his family. Her essential reasoning, however, was that the girl's record of "habitual loose character" made *her* culpable. Chamberlain followed the policewoman's recommendation. Once released, the grateful man called on Baldwin, and she provided him with a letter of introduction to prospective employers.[5]

A similar case in early 1909 involved a streetcar conductor arrested for having sex with a minor female. Baldwin discovered that the man had a "good family, and his employer spoke highly of him." The girl, on the other hand, reportedly spent hours loitering in streetcar waiting rooms, and was previously turned in to the policewoman for being "intimate with a middle-sized Greek." After conferring with Baldwin and other police officials, Judge Calvin Gantenbein of the juvenile court dismissed the complaint. Since the carman was the third of his occupation arrested in ten days on similar charges, the judge warned the streetcar companies to keep their men from unnecessary conversations with females. Gantenbein then took legal action against the girl complainant. He declared her a "mentally defective" ward of the court, and had Baldwin transport her to the Catholic-run House of the Good Shepherd detention home. The characterization of sexually delinquent young women as mentally defective was the result of "biological determinism," discussed below.[6]

Although Portland judges began to accept Baldwin's evidence of pathological vice in some girls, she met definite resistance from the juvenile court in Salem. She was called to the state capital as an expert witness in the case of several men indicted for having sex with a number of minor females. The defense argued that the count involving one young woman was invalid because she "was already a [sexually] delinquent girl when the men met her." After a lengthy deliberation in chambers, the judge made a clear ruling, declaring that the state juvenile code specifically protected "the girl who was already a delinquent." The law, he said, "forbade any man using her for illicit purposes while she was yet under age, no matter what her previous conduct had been." One of the girls remarked that she had first been "criminally intimate" with the minister of a church near Portland. Noting this information, the policewoman vowed that she would not rest until she rooted him out. "We do not believe," she penned, "that a man should be attempting to preach the gospel and ruining young girls at the same time without a strong kind of protest."[7]

The early-twentieth-century juvenile codes like Oregon's 1907 law generally reflected a social environmentalist bias. Most provisions assumed that "innocent" young people only turned bad if they were influenced by others. This explains both Judge Frazer and his Salem counterpart's insistence on male culpability. Enforcement efforts concentrated on whoever or whatever encouraged the aberrant behavior, thereby justifying Baldwin's battle against the saloons, roadhouses, dance halls, and other amusements she felt were enticing young people into vice. Yet concurrent with theories of delinquency based on a bad environment, "biological determinists" offered a different

paradigm. Although they rejected earlier scientific insistence that identifiable physical "types" predicted criminality, they offered evidence that intelligence levels were forecasters of delinquency. Whether this held true for female morals offenders was of particular interest to preventive agents like Baldwin. The theory appeared promising by 1910, when mental tests of sexually delinquent female inmates in several eastern institutions showed that one-third to one-half could be classified as "subnormal."[8]

The judge in the streetcar-operator case acknowledged such contemporary scientific opinion when he declared the young woman involved to be "mentally defective." His action reinforced the expert notion that sexually delinquent girls were "feeble minded" and could not control their sexual instincts. By 1910, sophisticated IQ tests were used to screen inmates in many institutions. One version, the Binet Test, was employed by Portland's Reed College psychologist Dr. Eleanor Rowland. She was nationally renowned in her field, and had administered the exams to the inmates in one of the eastern studies. Baldwin was delighted when Reed president and social hygiene advocate William T. Foster offered to have Rowland test Portland's young female inmates. The policewoman declared that it would be very helpful, as her department was "dealing with such a large number of subnormal women and girls." Low scores were either associated with *potential* deviancy, or confirmed it after the fact. Thus, even girls who had not yet committed moral offenses could be institutionalized as a protective measure. On the basis of a mere *tendency* to immorality, courts could place females under indeterminate or permanent custodial care.[9]

In November of 1908, a week after Oregon opened a special institution for its so-called "feeble minded," Baldwin noted that the number of remandants already exceeded capacity. Before assumably reliable testing was available, the determination of mental defect was made by judges and others who were not psychology professionals. Mistakes were made, often in the cases of immigrants who were struggling with the language. Baldwin narrowly averted such an error when a young Russian-Jewish girl named Mollie was reported as "defective" by someone in her neighborhood. With little further investigation, Baldwin asked the juvenile court to make the child a dependent of the state. She did so as a preventive measure, declaring that "the little girl must be cared for, as she would be an easy prey for an evilly disposed person." When Baldwin's assistant Lucy Sargent went to retrieve the child, however, she discovered her to be "a bright girl, anything but feeble minded." The fact that she was stubborn and did not speak English well gave some "an unfavorable impression of her." The girl's family was terrified that the policewoman would take the child away, but Sargent assured them that she "considered her mental condition very good."[10]

Alien males often encountered serious difficulties with enforcement agents. They were assumed to be as bad an influence on young women as the saloon or brothel. Much of the sexual delinquency among young American girls before World War I was laid to immigrant non-Anglo-Saxon males and native blacks, all of whom were believed to have a special taste for white women. As the records of the 1912 Portland Vice Commission show, many more native-born women were involved in the vice trade than immigrants. Such statistics inferred an alarming moral vulnerability in domestic females which made vice prevention all the more necessary. Officials believed that young American girls were being debauched by foreigners or existing racial minorities. Then-popular eugenic theories painted such "outsiders" as genetically inferior and less intelligent than white Anglo-Saxons. This suspected low intelligence translated to a greater propensity for vice or criminal activity, and their sexual instincts were thought to be more acute, more depraved, and less controllable. Prevailing elitist distrust of these ethnics became more intense whenever contact with young white women was threatened.[11]

Suspicions of alien men as sexual predators arose in the 1890s. Immigration restrictionists contended that Chinese men used opium or other exotic drugs to trap young white women into prostitution, an opinion often ratified in the muckraking press of the day. Widely read accounts by English purity advocates Alfred Dyer, W. T. Stead, and William Coote claimed to "expose" a trade in British girls to European, Middle Eastern, and South American brothels. When Stead visited the United States in 1893, he warned that similar conditions existed here. Several years before his tour, Dr. Bessie Cushman of the Michigan Women's Christian Temperance Union (WCTU) had offered a convincing report alleging a traffic in young girls to service lumber camps in the forests of the U. S. and Canada. All of these factors were hot topics among American purity workers, especially those concerned with "girl protection," and those like Baldwin who toiled in "rescue" homes at the time.[12]

Stead published a sensational book entitled *If Christ Came to Chicago* after his stop at the 1893 Columbian Exposition. He took the city's business, religious, and civic leaders to task for tolerating the "disappearance" of young women into commercial brothels specially built to service male visitors to the fair. In lurid detail, he pictured innocent country girls on holiday to the exposition being procured by smooth, swarthy foreigners. Acting on Stead's challenge, the WCTU, the YWCA, the Florence Crittenton Missions, and other institutions intensified efforts to aid young victims of the supposed traffic. Lola Baldwin was heavily involved with the Crittenton and other programs in eastern cities at the time. Nervous purity workers added a new element to the

mix when Southern blacks were enticed to Northern cities by jobs in the expanding industrial sector. Some whites voiced suspicions that these migrant black males would exact belated revenge for centuries of enslavement by seducing young Anglo-Saxon women. Many, like the outspoken and outrageous Madison Grant, believed that blacks possessed "an over-developed sex instinct, premature cessation of intellectual growth, and a tendency to revert to savagery."[13]

Progressive Era moral reformers defended a "color line" which denigrated Asians, non-Anglo-Saxon European immigrants, and native blacks. Breaches of Portland's customary racial etiquette appear frequently in Baldwin's police records, as she was always careful to note the race or ethnicity of her clients. An "American" girl, whose mother had offended the status quo by marrying a Chinese herbalist, was reported as immoral for "associating with Chinamen." An anonymous letter to Baldwin complained that an Italian restaurant owner was recruiting "white women or girls for immoral purposes." The policewoman assessed one young woman as "very dissolute" because she was frequently seen on the streets conversing with "Greeks, Chinese, Japs, and anyone." She took another into custody for being "intimate with a Chinaman." A half-dozen entries documented the surveillance of a person Baldwin's log described as a "good looking Greek" who ran a bootblack stand at 3rd and Alder. The man came under suspicion because he was "very familiar with young white girls" and sometimes shined their shoes for free. Greek restaurants in general were suspected of luring "American women" into prostitution, and the Polish manager of the Omaha Saloon at 16th and Pettygrove reportedly enticed "young white women" into a back room frequented by "Poles, Russians, and Slavs." The most intense scrutiny, however, was reserved for the ultimate cultural taboo, illicit relations between black and white.[14]

Less than 1 percent of Portland's population was of African heritage in the 1910s. Many blacks worked in service jobs for the railroads and hotels, and generally lived quiet existences. Yet, shortly after the turn of the century, a series of unfortunate outside events made them visible beyond their small number. In the northern industrial areas of the country, tensions fathered by economic downturn erupted in violence against blacks who had supposedly encroached on whites' employment prerogatives. A particularly bloody race riot in Springfield, Illinois, in 1908 resulted in the formation of the National Association for the Advancement of Colored People (NAACP). In 1912, black boxing champion Jack Johnson received national attention when he was convicted under the Mann Act of interstate transportation of a white woman for "immoral purposes." Although recent scholarship has shown that the

pugilist was probably innocent, the case caused a sensation at the time. Some whites believed that Jack Johnson epitomized their long-held fears that black men were sexually out of control, and specifically targeted white women. Through newspaper coverage of such stories and outspoken local opinion, Portland became sensitized to what its chapter of the NAACP labeled "the sex problem of the Aryan and the African."[15]

In late 1913, Baldwin helped prosecute a case involving several "white girls and Negroes" taken by police from the St. Francis Club, a private "colored" bar. A seventeen-year-old white girl, reported by the policewoman to be "from an estimable family," went to the club by taxi with an older girlfriend. After an evening of drinking, they apparently agreed to have sex with two black men they had met. The matter was kept out of the newspapers, and Mayor Albee asked Baldwin to keep him closely informed of the case's progress. The policewoman and District Attorney Walter Evans grilled the young women for four hours before they admitted to "illicit relations" and "gross indignities" with the men. Evans then obtained a warrant against the bar's proprietor for selling liquor to the minor girl, and arrested the black men on morals charges. The incensed district attorney further vowed to prosecute "every person connected in any way" with the incident "to the full extent of the law."[16]

The manner in which Baldwin and other Portland authorities responded to the threat of sexual conduct between whites and immigrants or blacks reflected the era's elite cultural consensus. Whether they held environmental or biological determinist views, most reformers saw racial minorities and recent immigrants as a threat to the moral safety of "American" girls. Protective agents like the new policewomen sought desperately to reaffirm customary ethnic and racial hierarchies during a tumultuous period of urban growth and modernization. Middle-class girls who succumbed to the siren call of lower-class amusements were one thing, but those who sought sexual intercourse with the so-called "racially inferior" were quite another. In a time when eugenic-purity enthusiasts like Theodore Roosevelt railed against dilution of the so-called "superior" race, or warned of impending white "race suicide," Baldwin and her cohorts tried to prevent further degeneration of traditional distinctions and moral standards. Convinced that their efforts were well-meaning, such people sought to preserve Anglo-Saxon cultural hegemony as the basis for civilized order *as they defined it.*[17]

In spite of societal watchfulness, sexual innocence still fell by the wayside. If young single women became pregnant, their choices were generally dismal. They could face the stigma of unwed motherhood, or give up their infants for adoption. The desperate often abandoned or even killed their

babies, while others sought abortions. By the late nineteenth century, abortion had been criminalized in most states. Birth control, as far as it existed, was forbidden by a battery of federal morals codes known as the Comstock Laws. As a social hygienist, Baldwin preached an idealized premarital sexual abstinence for both genders. Her casebook tallied frequent evidence to the contrary. Her early work with institutions for unwed mothers clearly affected her later actions as a policewoman and, with the tools at her disposal, she tried to salvage such clients as best she could. With a belief in the redemptive qualities of motherhood, she asserted that pregnant girls should be encouraged to raise their babies. Such tolerance was a departure from the blanket damnation of earlier times. As she told an audience in 1911, the unmarried mother was "usually the innocent girl, as prostitutes rarely become mothers." These were situations, Baldwin insisted, "where earnest and loving care was well repaid."[18]

The policewoman committed those who were reluctant or unable to return to their own families to Portland's homes for unwed mothers. The city's Salvation Army, White Shield, Florence Crittenton, and Louise homes accepted Baldwin's referrals without question. The head policewoman screened the young women as to whether or not they seemed truly "salvageable," and placed them accordingly. The Crittenton asylum, for example, only cared for previously "good" girls, and kept them in residence for six months afterward to learn to care for their babies. It then located "domestic service or some respectable employ" for them, and found suitable care for their infants while they worked. The Louise Home, in contrast, took in girls from so-called "vicious environments." These included the occasional young prostitute who did not abort, as well as pregnant and nonpregnant venereally diseased delinquents. Through watchful medical care and general moral training, the nonsectarian home attempted to reverse unsavory young lifestyles. It averaged twelve new clients a month. In the first half of 1911, for example, it cared for 74 young women, aged 13 to 26, and 29 babies.[19]

Baldwin always insisted on being told the alleged father's identity. Rather than face charges, many males "agreed" to marriage. In some instances, the legitimizing ceremony was followed by a divorce and court-ordered support. In one case a young groom balked after his wedding, which had ben inspired by Baldwin, and attempted to have it annulled. Judge Calvin Gantenbein sided with the women's police, however, and "decided that Mrs. Baldwin did not overstep the bounds of her office in forcing the marriage." He affirmed the legality of the union and ordered the man to pay the girl "$25.00 per month for support."[20]

Baldwin once found herself in personal danger when she pursued a man who had impregnated *two* young women. His menacing uncle twice visited Baldwin and informed her "that she was dealing with dangerous people." He told her outright that if she did not stop pushing the case against his nephew "she might have a bullet put through her head." The plucky Baldwin disregarded his threats and proceeded. He apparently influenced someone, however, as the legal papers in the case mysteriously disappeared from the office of the municipal court. A firm advocate of paternal support, Baldwin later championed a state law mandating such payments.[21]

Unwed motherhood, adoption, or "encouraged" marriage were the only legal solutions to unwed or unwanted pregnancy in Baldwin's day. An 1864 state law declared abortion to be manslaughter, with a prison penalty of one to fifteen years. Despite this prohibition, poor women and girls sought furtive surgeries in the back rooms of boardinghouses, or trusted their luck to dubious remedies like "Famous Sanderson's Root Pills," which were openly advertised to "correct menstrual troubles." If such methods failed, some girls tried suicide. In May of 1908, for instance, Baldwin reported visiting a desperate young pregnant girl who tried to end her life "by taking laudanum." At the other end of the social spectrum, discreet medical abortion was a parlor secret of the higher economic classes, who could afford certain physicians who kept special after-hours appointment books.[22]

It is not possible to determine how prevalent abortion practice was in Portland using Baldwin's records, as only botched operations generally came to her notice. Physical evidence such as uterine laceration or infection nominally proved that an abortion had been performed, but uncooperative patients, families, or witnesses often slowed prosecution. Baldwin reported over two dozen such instances between 1908 and 1912. She pursued two physician brothers a half-dozen times without success. A middle-class mother once admitted that she had procured an abortion from a respected doctor for her daughter, but refused to give his name. Such frustration forced Baldwin put more energy into preventive measures.[23]

The head policewoman began to use decoys to obtain hard evidence against suspected practitioners. Baldwin sent Louise Home superintendent William MacLaren and one of her young probationers to see a "Madame Anna" in the Columbia Building. The girl pretended to be pregnant, while MacLaren posed as her gentleman friend. They asked the woman for help to end the girl's condition. After taking a $25 check from them, the woman gave the girl a prescription for some pills to begin the process. The young woman was told to return for three more special treatments "and the abortion would be accomplished." The woman said she had been in business for twelve years

in Portland, "taking babies all the way from one to eight months." She explained to the girl that, after the procedure, she would give her another nostrum "to prevent pregnancy." Privately, she told the young woman that she offered this last service "because she believed all passionate girls should indulge themselves and get what money they could out of the man." The pair's evidence snared the woman on both state and federal charges.[24]

If possible, Baldwin directly intervened to prevent abortion. In one instance a woman reported that her younger sister, four months pregnant by a city fireman, was planning to abort the child. The fireman had placed the girl in a local boardinghouse, where the landlady arranged for an illegal operation to be performed the next day. Baldwin retrieved the unfortunate girl, then consulted with Judge George Cameron. He informed the city's fire chief of the circumstances. When the chief called the fireman in to his office, he, Baldwin, and the girl's sister persuaded the young man to admit paternity and "agree" to marriage. The fire department head later told Baldwin that he had discovered that another girl, "betrayed" by the same man, had undergone "an abortion which nearly killed her."[25]

The St. Elmo, like certain other boardinghouses, had a reputation for backroom abortion services. The landlady, a woman named "Gertrude," allowed a "Dr. Armstrong" to practice in her personal rooms. She shared in the enterprise, assisting in the operations by administering chloroform to the patients. She had a partner named "Mrs. Dorn," who solicited custom for the business by "keeping her ears open" on the streets. An eighteen-year-old girl turned to Baldwin when she developed side effects from a St. Elmo abortion. She agreed to help the policewoman get the matter before the grand jury. Judge Cameron asked the women's police to find a secure place where the girl might be cared for and "not be tampered with as a witness." She was quietly sequestered in the House of the Good Shepherd while Baldwin's assistant Wilma Chandler presented the evidence to the grand jury. The policewomen succeeded in obtaining an indictment of the man who had impregnated the girl for "seduction under promise of marriage," and against the doctor for performing the illegal procedure.[26]

Shortly after this incident a man came to Baldwin's office from suburban Gresham. He was greatly concerned about his seventeen-year-old daughter. He had just placed the girl in the Mt. Tabor Sanatorium, where she lay seriously ill from an infection after an abortion. The girl, he told Baldwin, "had been living with his sister in Portland, but had been out late at night and auto riding until she was beyond the control of her aunt." The father requested that Baldwin take custody of her as an incorrigible juvenile. The policewoman removed her from the sanatorium and placed her in the House of the Good

Shepherd for treatment. Baldwin was somewhat discouraged when the girl's father gave her the name of the abortionist who had performed the shoddy operation. The doctor he implicated also served as the Italian Consul in Portland, and his diplomatic status made it almost impossible to touch him.[27]

Sympathetic female acquaintances often aided young women who wished to end pregnancies without relatives knowing the circumstances. Such was the case with "Jeanette," a nineteen-year-old Portland resident. She confided her plight to a discreet family friend who referred her to a "Mrs. Smith." This woman charged the girl the at-the-time exorbitant sum of $50 for her abortion services. Unfortunately, the young woman, whose surname was well known in the city, developed an infection afterwards. Becoming frightened, the friend who had suggested the abortionist took Jeanette in to consult with Baldwin. Realizing the seriousness of the problem, the two decided to cooperate with the women's police. After taking both their statements, the policewoman admitted the girl to Multnomah County Hospital for treatment. She then arrested "Mrs. Smith" and had her prosecuted for manslaughter.[28]

Young women who could not afford operative abortions, and those who wanted to prevent pregnancy in the first place, often turned to various remedies advertised in the newspapers. When she and her assistant spotted ads for such merchandise, Baldwin used the federal mail codes to trap the sellers. In one instance, assuming the alias "Hilda Mason," the policewoman answered an *Oregonian* placement hawking "pills for menstruation." She received a letter in reply which "described the tablets and how to use them to prevent pregnancy." The price was given as $1.50 a box. After consulting with the local postal inspector, she sent away for a supply of the pills. When she received the packet, she gave it and all her correspondence to the postal authorities. They subsequently monitored the post office box used for the transactions, and arrested a woman for violating the federal law against such mail-order business.[29]

Baldwin campaigned strenuously against newspaper advertisements for abortive or birth control medications, most of which were worthless. Despite limited initial success she persisted in lobbying the city's dailies to stop accepting such ad copy. With the aid of information supplied by the Portland Social Hygiene Society, she asked the 1909 state legislature to prohibit the advertised sale of "quack female remedies." She testified to the all-male body about the many unfortunate "betrayed country girls and more innocent city girls" who spent hard-earned money on fraudulent products instead of turning to agencies like her own for advice. Newspaper revenue loss proved a sticking point with some lawmakers, but Baldwin persisted, and attested to collaborative promises from the city's dailies. Finally, after she pointed out

that the legislators had approved a similar action which banned the sale of male venereal disease "cures," the medical advertisement bill was amended in her favor. The policewoman soon reported excellent cooperation from the newspapers, and secured subsequent indictments against several parties for "advertising objectionable medicines."[30]

Baldwin's proceedings concerning abortion and birth control must be viewed from the perspective of both her enforcement obligations and her personal beliefs and experience. Abortion was illegal at the time, and she was bound by her policewoman's oath to prevent or prosecute it. For many years, she had worked with institutional homes for unwed mothers who were taught responsibility for their babies and themselves. Progressive Era concern with strengthening the family further reinforced her attitude. Abortion negated the whole philosophy of such programs and ideals. Baldwin had also seen firsthand the results of incompetent operations, whether testifying at the coroner's inquest for a dead fifteen-year-old, or in cases where other young women had been left ill or maimed. The very thought of sexuality without responsibility, of "passionate girls" indulging themselves, was repugnant to Baldwin's social hygiene position of premarital abstinent purity. Many lonely, frightened girls apparently welcomed the policewoman's motherly concern. Baldwin delightedly wrote in her log, for example, that one young woman had named her new baby "*Lola* Violet." Yet her notes also reflected her disappointment when the middle class failed to set a proper example. "Criminal practice suspected," she tersely wrote of one young client with a uterine infection, "but the girl herself the only one to blame. She has not been living right."[31]

Venereal disease among young sexually delinquent females was a serious component of early women's policing. The viral cause of syphilis had been discovered in 1905, and two years later the "Wasserman" blood test became available to detect it. As early as 1908, Baldwin distributed Portland Social Hygiene Society literature on venereal disease through her offices. Alert to the symptoms, and wary of infection, she began to request medical tests for many of the girls who came to her attention. To protect themselves from contamination, the policewomen used an antiseptic wash provided by a local druggist, and handled the girls' clothing with rubber gloves and bichloride of mercury before burning it. By late 1909, Baldwin reported that venereal disease was making "rapid headway" among her clients. The number of what she reported euphemistically as "sick" girls almost doubled from the previous year, and consumed an increasing share of her budget. She believed that habitually contagious girls should be legally committed until cured "for the sake of the community." She reiterated the need for a secure, city-funded

detention facility for such cases after two infected girls she remanded to the Louise Home climbed out a window "five nights in a row" and had illicit relations with several young men who picked them up in an automobile.[32]

As with other classifications of delinquency, Baldwin often made a graded distinction among venereally infected young women. "Agnes," for example, was a young cashier the policewoman described as having been a "good girl" until she was lured out to Fred Merrill's rural roadhouse by a smooth-talking state prison parolee named Wiley. When the girl suspected she had been infected by this man, she turned to the Women's Protective Division for help. Baldwin admitted her to Good Samaritan Hospital for venereal testing, and then placed her in the Louise Home for supervised medical treatment. Baldwin decided that this particular girl was salvageable, but she was less certain about others. She despaired of "Minnie," a young woman repeatedly arrested for vagrancy and found to be diseased. "We have tried in every way to help this girl to a decent life," the policewoman wrote, "and having failed, need to send her where she can not contaminate others." Although reluctant to admit defeat, Baldwin concluded that poor Minnie was "dissolute and diseased, and the good of the community demanded that she be kept in custody."[33]

A frequently infected young woman named "Pearl" similarly resisted all reform attempts by the Women's Protective Division. Between 1909 and 1914, she spent eighteen months in the House of the Good Shepherd, was married twice, gave birth to a baby which the juvenile court took away from her, and was finally sent home to her family. She ran away, returned to the city, and worked as a prostitute in a "cheap lodging house." When Baldwin went to the place to remove the girl she found her "diseased and covered with vermin." Some weeks later, a patrolman arrested her for soliciting in a Greek restaurant. Baldwin discovered that she was still contagious, and claimed to have "good evidence" that the girl was often drunk, and that "she was contributing to the delinquency of five or six boy messengers" who worked from the bicycle shop below the room in which she was living. The officer who arrested her reportedly "took obscene letters from her." The girl's irresponsible behavior seemed impossible to control. For lack of a better solution, Baldwin asked that she be given a stiff jail sentence and compulsory medical treatment.[34]

Baldwin's assessments of the city's diseased girls were usually unquestioned, and even her colleagues turned to her for advice. One policeman reported his uncontrollable stepdaughter, who had become an embarrassment to his family. The policewoman discovered that the girl, barely fifteen years old, was "badly diseased." She further learned that the city's chauffeured

car drivers had nicknamed the poor creature "ten-cent Sybil." She advised the officer to turn the child over to the juvenile court, which ordered detention and medical treatment. Another patrol officer wished to marry a young woman whose venereal medication was being supervised by the Women's Protective Division. When Baldwin checked with the public health authorities, they informed her that the girl was still contagious. The policewoman advised the couple to wait six months, and if the young woman's tests were clear, Baldwin assured them she "would give her consent" to the match.[35]

The Oregon Board of Health agreed to pay for the blood tests she ordered, as well as any medical treatment for girls found to be sick. At the policewoman's request, infected girls could be placed under legal quarantine by state health officials, even if remanded to private institutions. When the arsenic-based drug "Salvarsan 606" became available in 1912 as a treatment for syphilis, the state funded its use for all relevant cases handled by Baldwin's department. The women's police superintendent still insisted, however, that a separate city institution was needed for repeat venereal cases. It was unfair, she maintained, for a basically "good" infected girl to be housed in the same place with repeatedly diseased casual prostitutes like "Minnie," "Pearl," or "ten-cent Sybil." Although Mayor H. R. Albee had a token amount set aside in the 1914 budget as "seed money" for a site purchase, a female venereal detention facility would not be built in the Rose City until 1918.[36]

The venereal disease threat was a powerful symbol of social degeneration for moral reformers in Baldwin's era. Medical reformists among the social hygienists hoped that voluntary adoption of a single standard of premarital sexual abstinence for both sexes would end the "silent infections" many males brought to their marriage beds. Yet increasing sexual activity among the unmarried young convinced such reformers that moralizing alone would not bring about that end. They were forced to begin an unprecedented open discussion of sex and disease which finally put the Victorian "code of silence" to rest. Policewoman Baldwin served as an authorized venereal disease lecturer for the Oregon Social Hygiene Society, utilizing her firsthand knowledge of its horrors among her clientele. The latent deformities, illnesses, and death caused by the villainous germs were, it was feared, lowering eugenic standards among Americans at a time when elites already felt threatened by "inferior" immigrants from other lands. The venereal plague was logically coupled to prostitution, and this linkage helped stimulate the era's repressive war on a combined social evil of sexual vice and disease. By declaring prostitution to be a public health problem rather than strictly a moral issue, social hygienists made it a suitable target for vigorous government interdiction.[37]

Homosexuality also became a concern for post-Victorian public moralists. The age's shifting gender-role paradigms made certain traditionalists nervous, but the idea of female same-sex affinity greatly disturbed many more. There was, as there still is, much debate as to whether the behavior is inborn or learned, and this uncertainty exaggerated moralists' concerns. Cross-dressing was taken as a sign of a tendency to homosexuality, and was labeled "disorderly conduct." Baldwin arrested a number of young women for wearing male attire. It is indicative of the gender-role uncertainty prevalent at the time that what a later age would dismiss as "tomboy" behavior was considered a serious breach of societal order.[38]

Baldwin's most sensational instance of so-called "perversion" involved a woman named "Nell," who used the alias "Harry Livingstone." She landed in the Portland jail on a vagrancy charge in 1912. As "Harry," she had traveled from Spokane, Washington, in the company of a Mrs. Maxwell. Once in the Rose City, the two women reportedly "lived together as man and wife." "Harry" was at first charged with white slavery, as "he" could produce no proof of marriage. Not inclined to invite federal prosecution, Nell confessed her true sex. Spokane authorities provided a remarkable roster of her supposed exploits. Not only, they insisted, had "two girls committed suicide on account of her," she had worked as a "male" bartender in the Washington city, and had a reputation all along the west coast for "consorting with thieves and pickpockets." She had been arrested at various times for "theft, selling liquor to Indians, and wearing male attire." But her main fault, according to the Spokane report, was her "almost insane mania for making love to girls when dressed in men's clothing." Once the vagrancy sentence was completed the pair moved on. Baldwin kept track of them, however, and later noted in her log that the two were in Salem, where Nell was "being supported by the Maxwell woman."[39]

The homophobia shown by Baldwin and her peers was even more marked when their control over incarcerated females seemed threatened. Jail and reformatory staffs blamed overcrowding for lesbian activity which was, as one institution reported, "not an uncommon manifestation" in the 1910s. In early 1914, Baldwin followed up a report that some girls had been smoking cigarettes in the women's quarters of the jail at night. Her interview with the suspects gave insight into what she determined the real problem to be. Separately, she questioned two inmates, "Laura," and "Billy." Although she made a show of pressing the tobacco issue, a mysterious red mark on Laura's neck turned the conversations into a thinly disguised inquisition about sex. After Laura said that Billy had made the mark, she confessed that the two "had been occupying the same bed." Baldwin then confronted Billy. It seemed

"strange," the policewoman probed, "that a girl would suck the neck of another girl." Billy replied that she and Laura were merely playing. "I don't see," the young inmate pointedly concluded, "that there was anything to it at all. Maybe you do."[40]

Criminology experts in Baldwin's era could not agree on a singular cause for female sexual delinquency. Social environmentalists wanted to link all aberrant behavior to conditions they could "fix." The idea of the inherently debauched mental defective appealed to those uneasy about eugenic decline, increased immigration from abroad, and the movement of southern blacks to the northern industrial cities. For a time, feeble-mindedness was used as a convenient explanation for otherwise perplexing cases of recidivism and "perverse incorrigibility." Yet further evaluation of intelligence testing itself revealed flaws which discounted original findings. This helped force a consensus among experts on a "multifactor" assessment of delinquency. By the mid-1910s, they called for broader evaluations of individual cases based on family history, social and economic influences, physical condition, *and* mentality.[41]

Baldwin's appraisals of her young clients were well within the bounds of contemporary thought on female delinquency. She projected an ideal of self control as the key to prevention and rehabilitation in female delinquents. Yet she was pragmatic enough to recognize that if self control failed, social control was the obvious backup. It is also clear from her files that suppression of prostitution dominated her official actions. Her era's absorption with the "girl problem" centered on a changed societal view of the "oldest profession" as not simply an unfortunate lifestyle, but one with serious public health consequences. Prostitution became inseparable from its partner venereal disease. In the years prior to and including World War I, it emerged as the hyper-symbolic enemy of a national crusade. This battle against the social evil assumed a primary significance in Baldwin's policing career.[42]

*The women themselves admit to me
that they cannot carry on their business without fear of molestation, and
that they cannot get new recruits. I also know this, as I have kept a close
check on it.*

—Lola G. Baldwin on vice raids, July 21, 1912

6

Thwarting the "Social Evil"

The social hygiene movement
strongly influenced the way the policewoman idea developed. Gaining
popularity in Oregon after 1905, this organized impulse infused antiprostitution
actions with medical reformism. The Portland Social Hygiene Society, later
expanded as the Oregon Social Hygiene Society, used sex education,
venereal disease information, and the police power to combat the "oldest
profession" and the moral double standard that supported it. Within a decade,
social hygienists almost completely reversed notions that prostitutes were
victims. Urban policewomen like Lola Baldwin played central roles in this
attitudinal transition. As they embraced scientific evidence on the cause,
spread, and consequences of venereal disease, preventive workers and their
political allies battled sexual vice on medical rather than strictly moral or
religious grounds. Through education and legal means, they hoped to inspire
a broad rejection of the traditional justifications of the brothel, the conspiracy
of silence and the double standard.[1]

The "conspiracy of silence" involved a reticence to discuss sexual matters
in other than vague, euphemistic terms. As Portland social hygienist William
T. Foster warned, keeping the young in "a blessed state of innocence" only
produced uninformed or seriously misinformed adults. A formal social
hygiene society was founded in the Rose City in 1908. Across the country,
such groups emphasized the public health dangers of commercialized
prostitution, and advocated preventive sex education. By 1911, the Portland

effort had evolved into a statewide network which sponsored traveling exhibits and lectures. These talks were delivered by respected doctors, clergy, and social welfare workers who disseminated the latest scientific information. In a careful combination of medical fact and old-fashioned morals, both male and female speakers conveyed the horrors of venereal disease, yet imbued sex with a "spiritual" aspect which idealized abstinence until marriage.[2]

As a second goal, social hygienists hoped to eliminate the sexual double standard. Tradition held that "good" women should remain virgins until marriage, but men were not held to the same rule. For some time, medical opinion had indicated a physiological "need" for males to begin having intercourse once they became physically mature. As a result, premarital experience with prostitutes was tacitly accepted as a social necessity. Around the turn of the twentieth century, however, new medical evidence proved that venereal infections thought cured could be passed to future wives and children. Coincidentally or not, doctors also began to reject the notion that healthy males "needed" sex. In a dramatic turnaround, the "social necessity" of paid sex became the "social evil." Reformers preached a single standard of premarital sexual abstinence for both genders and launched a vigorous campaign against the large commercialized vice districts which accompanied urban industrialization.[3]

When Portland hired Baldwin as its first policewoman, she faced a world forged by the double standard. Sexual vice was an entrenched part of the urban landscape. Social hygienists like herself hoped that adoption of a single standard of morals would eventually eradicate prostitution. Without customers, sex as a commodity would have no market. Meanwhile the social evil combined with a rising interest in premarital sex among young people to constitute an important threat to the girls Baldwin had sworn to protect. Urologist L. W. Hyde invited the policewoman to join the Portland Social Hygiene Society in 1908. Such groups formed the organizing base of a movement which, within a decade, would claim credit for the almost-total demise of the commercial "red light district" in the city.[4]

The city's liquor, property, and commercialized vice interests defied the eradication of the lucrative sex trade. The North End vice sector found some hope for survival in one of the competing ideas which divided the reformers, some of whom wished to regulate prostitution in a separate district where the women would be legally subject to medical exams. This idea, which had originated in Europe, had been tried in St. Louis in the 1870s, but later evaluation showed that enforcement had been difficult, corruption and graft endemic, and disease rates only nominally reduced. At the turn of the twentieth century, new research on venereal disease prompted medical

reformists like Portland physician-mayor Dr. Harry Lane to push for total abolition of commercial prostitution. Others believed that rational scientific disease-control methods were all that could be hoped for, despairing of any forseeable end to the demand for commercial sex. At the same time, other officials saw opportunity in restriction, and wanted to tax, license, and regulate the oldest profession to benefit the city's coffers.[5]

Between 1905 and 1909, Mayor Harry Lane led the city's first serious campaign to shut down the North End vice district. As a physician and social hygiene advocate, Lane assigned both moral and physical danger to its notorious dens of iniquity. His effort was handicapped by traditional ties between powerful vice-related property owners, grafting policemen, and curiously sympathetic court and city officials. Even after he had fired the entire police vice squad in 1906, corruption in higher circles stymied the crusading mayor. Payoffs and favors throughout the system gave little incentive for honesty at the patrolman's level. Lane fully endorsed Baldwin's program in 1908 because she had proved a reliable ally in his battle against the city's vice interests during her Travelers' Aid tenure.[6]

The North End district boasted the usual features of western port cities. Merchant seamen, traveling salesmen, loggers, farm hands, and soldiers from nearby Vancouver Barracks strolled the cobbled streets in search of a "good time." Blocks of shanty "cribs," which Baldwin discovered were rented to individual prostitutes "for $15 a week," coexisted with grand bordellos housing dozens of "sporting women." More modest operations like Julius Kutner's Keystone Saloon at 4th and Flanders had connecting doors which led upstairs to small partitioned rooms. Traditionally, these spaces qualified saloons as "hotels," allowing them to circumvent Sunday closing laws. Although barely large enough for a cot and a washstand, they did a brisk short-term rental business. Tony Arnaud's place at 4th and Everett featured much the same attractions, and at nearby Erickson's, Fritz's, and Blazier's saloons, young women who solicited the purchase of drinks for the management could be had for other entertainment as well. Dubious massage parlors, "loosely conducted" rooming houses, suspect ethnic restaurants, and small service businesses rounded out the North End core.[7]

The city's vice district ran on a loose system which nonetheless assured a profit for all involved. The "favorite combination," according to a contemporary survey on vice abatement, was "a saloon, a grill, and a house of prostitution, all in the same building, same block, or immediate vicinity." The saloonman, or more often the brewery which supplied him, rented large quarters from someone representing a wealthy property owner "at arm's length." Agents liked leasing to saloons because the owner could easily "get

big rent without risk of his property being vacant." The barkeeper then sublet part of the ground floor to a grill-restaurant for which he supplied the liquor, and the upper floors to a madam for "a large rent." She recouped her outlay plus a profit from fees charged to her girls and the customers they "rustled and hustled" in conjunction with the management of the saloon and grill downstairs.[8]

Although August Erickson's saloon boasted "the longest bar in the world," the most unusual and flamboyant place in the North End belonged to Fred Fritz around the corner at 2nd and Burnside. Portland vice reformer George Thacher described the operation in an affidavit to the liquor license committee in 1911. Fritz combined a saloon, grill, vaudeville show, and movie theater to lure the drinking crowd. The bar area opened into the lobby of the theater. An upper gallery consisting of eighteen private drinking and dining boxes ran horseshoe-style around the stage. Fritz usually employed a dozen young female entertainers, who divided their time between turns on the stage and drink-selling duties in the gallery. They worked in short flouncy skirts, and hung all over male patrons to entice them into buying beer for an exorbitant dollar a bottle. The girl got a commission of ten cents for the first beer, but fifty cents for each additional. The young woman received a token from the waiter after each sale, upon which she would hike up her skirt with a flourish and deposit the check in her net stocking. She made even more if she could get a customer to buy a pint of "champagne" for five dollars—though this usually proved to be "hard cider charged with gas to make a lot of foam."[9]

Many of the Fritz hostesses, however, solicited more than their nightly commissions. Late in the evening, they would single out a man who still seemed to have money, and tell him that if he bought one more pint of champagne the two could share it later in the girl's room at a nearby lodging house. Certain special customers were entertained on the premises in a gallery booth with a "Private—Keep Out" sign on the door. Portland residents looking for a drink generally avoided Fritz's place as a known "trap." The management solicited its custom, which could average four hundred men an evening, from outlying towns and among business travelers. Fritz distributed advertising cards in the hinterlands, one side of which showed a happy patron flanked by two scantily dressed women. The other side described the wonders of the "largest burlesque show on the West Coast," and said the card was a "complimentary ticket, good for gentlemen only." A sidewalk barker passed out similar free passes in front of the place. Like lambs to the slaughter, lines of hopeful rubes and traveling salesmen filed nightly past a large sign proclaiming: "Refreshments On The Upper Floor. To Make Things Interesting,

Fritz's Theater, Burnside Street
Photograph: Oregon Historical Society (negative OrHi 52278)

We Serve An American Beauty Lunch With Each Drink." Fritz and company were so adept at "the fleece" that it was the rare customer who complained, as one did to Thacher in indignant terms: "Why, all she wants of me is my money!"[10]

Places like Fritz's Theater operated just barely within the law. Nonetheless, Baldwin and others who battled the social evil complained that they "established a commercial demand for prostitutes." Even if a young woman were not a prostitute when she began to work in such a place, the overt familiarity required to make her commission-only pay soon tempted her to cross the line to make more "on the side." Mayor Harry Lane had tried since 1905 to close Fritz down, but he had consistently failed in court. The mayor's hand-picked police captain Philip Bruin told him that it was useless to pursue Fritz for abetting prostitution because he obviously had "a frame up with someone in authority." In investigating the matter, Bruin informed Lane, he had "made many personal enemies amongst the prominent citizens." From the far-reaching influence of the "liquor interests" to a police court which operated a lucrative "fine and release" system of predictable roundups of house prostitutes, there seemed little official impetus to abatement in the Rose City.[11]

The "frame up" Bruin referred to was made clear during Lane's crusade against several saloons which permitted prostitution activities on their upper

floors. An existing city ordinance which prohibited brothels "in connection with saloons" was applied against Erickson's, Blazier's, and a number of other North End bars. Lawyers for the drink establishments easily convinced the court that the charges should be dropped. Their clients, in a literal interpretation of the code, had closed off the doors which led upstairs from the saloon proper. They then constructed sidewalk entrances to new outside stairways, and trade went on as usual. Because the brothels were no longer actually "connected" to the barrooms below, the court considered them in compliance with the city code.[12]

At the time Baldwin began her municipal career, shady international procurers were believed to be at the root of the traffic in women. Federal immigration laws of the period reflected both nativist and social hygienist fears of the damage which might be done to "American home life" by "diseased alien women" placed in U. S. brothels. Immigration statutes enacted in 1903 and 1907 prescribed the arrest and deportation of recent arrivals found to be associated with prostitution. By 1910, federal codes allowed the expulsion of foreigners who even worked in saloons or other places where prostitutes gathered. Immigrant-run restaurants and amusements and fruit, cigar, and bootblack stands were eyed suspiciously as procurement venues.[13]

Because local conditions seemed resistant to change, the new policewoman decided to fight the prostitution trade in the only effective way open to her. Soon after her swearing-in, Baldwin became heavily involved in federal immigration cases. She received authorization from Portland's police chief to aid government investigators and the federal courts. Within her first month of duty, she helped deport a young Japanese woman who had been placed in a Portland brothel "by a Jap who had lured her from Tokio." Several months later, she assisted in the deportations of a young "Russian Jewess" and a Chinese girl. Both had been procured by the son of one of Portland's main "crib" managers for work at his Astoria annex. The immigration bureau kept tabs on these so-called "maques," or pimps, informing Baldwin at one point that it knew of at least forty such men "having headquarters in Portland." Although deportations were normally carried out through Seattle, the policewoman sometimes had to transport aliens much farther. In one instance, she accompanied two Swedish girls to New York City for processing.[14]

Baldwin's encounter with one young woman provided a fitting character-ization of the brothel network she and Mayor Lane hoped to eradicate. Acting on a tip, Baldwin made a late-night visit to "a crib at 86 North 4th street." An informant had reported that the occupant was "less than eighteen, although she claimed to be twenty-two." As a precaution, the policewoman asked her cab driver to stand guard on the street so that prospective customers would

not interrupt the interview. The girl, "Emma," appeared to Baldwin to be "about eighteen." She described her as "a young Jewess, quite pretty, does not look dissipated, says she does not use liquor, smokes sometimes, but is not addicted to it." The girl told the detective that she came from New York, and had only taken the crib "to fill in when other girls were absent." She acknowledged that she was employed by the same man who recruited the two Astoria prostitutes whom Baldwin had helped to deport. She revealed that she had worked for him "in a number of Northwest cities." Her pimp, "Jake," did not fear prosecution, the young woman declared, as he claimed that "the policemen were all his friends, and he could do as he liked."[15]

Like other cities, Portland had a small number of brothels run by racial minorities for their own single men. With the exception of the periodic police roundup and fine applied to prostitutes in general, the minority-run places were left alone—unless, that is, they crossed the city's "color line." Acting on a tip, police raided a brothel run by a "Negress" on Everett Street. Detectives found four white girls employed in the house, a resort for single black railroad service workers who lived at the nearby Golden West Hotel. The idea of white women, even prostitutes, entertaining black men caused an alarm. The madam was arrested and bound over to a grand jury under maximum bail of $1,000. The U. S. Attorney became involved over a rumor that one of the young women was from out of state. If true, that would make her presence in the house a Mann Act violation. (The federal Mann Act, passed in 1910, forbade the interstate transport of women or girls for immoral purposes.) Federal officials backed off when the grand jury dismissed the charge for lack of evidence. In general, the affair aroused much more official hysteria than usually accompanied such prosecutions. After Baldwin convinced two of the white girls to testify, the black proprietess was indicted, tried, and convicted under a state law prohibiting anyone from "operating a bawdy house." The white girls were released uncharged.[16]

The official cooperation shown in the Everett Street case was an anomaly. Collusion between vice operators, city police, and other officials continually plagued abatement efforts. Acknowledging the situation, city councilman and future mayor George L. Baker had pointedly warned Harry Lane that prostitutes would simply scatter throughout town if he closed down the North End. Taking the regulationist position, Baker and others like ex-councilman Fred Merrill urged that the city simply require licensing of brothels and "red light ladies" in a segregated district. In response, hundreds of Lane's supporters from among the city's middle class and small businessmen mounted a petition drive to demonstrate their commitment to the mayor's abolitionist stance. In answer to complaints that police procedures against the

prostitutes were overly harsh, signers asserted that any short term "evil" would be more than offset "by the gain in decency, in social cleanliness and in the purification of the atmosphere in which our families must live."[17]

Lane's persistent police raids convinced at least some prostitutes to depart the North End. Baldwin tracked one girl from a local crib south to Salem. The madam at the capital city brothel where the girl worked told the policewoman that few other Portland prostitutes had come there, as the sheriff met the trains "and did not allow any of them to land." Back in the Rose City, Baldwin discovered that prosecution results were unpredictable and uneven at best. Advocating a single standard of *guilt* for both parties in prostitution cases, she noted "an injustice" in the treatment of a group of people arrested at the Cadillac rooming house. The men were fined $25 and released, Baldwin reported, but the women were assessed $50 and put in jail. The policewoman begged bench officials to take her solicitation arrests more seriously. "It is useless for us to work," she remonstrated, "unless we can obtain convictions." Yet too many of them echoed the opinion of Judge Henry McGinn, who flatly told Baldwin that he "would never send a man to the penitentiary for a carnal crime, especially if it be his first offense."[18]

So-called "loosely conducted" hotels and rooming houses like the Cadillac were perhaps a worse problem than the identifiable brothels. Early in her tenure, Baldwin approached Mayor Lane and the city license committee to see if something could be done to regulate them. Many proprietors gave little attention to the "lascivious cohabitation" of their clientele as long as the room rent was paid. Some hotels did not ask for or verify identification upon registry. Even the city's policemen utilized their discreet hospitality. One, ordered to escort a young woman safely home late at night, took her instead to a hotel where he sexually assaulted her. Certain landladies allowed abortion practice in their buildings as a sideline. Others routinely served alcoholic beverages at their tables without benefit of liquor permits. Baldwin began to keep a detailed list of places she suspected of "harboring girls" who engaged in casual or full-time prostitution. Despite her complaints, the city was predictably slow in pursuing regulation. In the hope of embarrassing the offending lodging houses, Baldwin would publicize their names in the periodic reports she made available to the newspapers.[19]

Discouraged by his uphill battle against the city's vice interests, Harry Lane lost a half-hearted re-election bid in the April 1909 primary. When Portland's next mayor Joseph Simon took office, he and his incoming chief of police offered Baldwin "hearty approval" and instructed her to proceed with her preventive work. This endorsement was significant because the fate of the women's police section had become a political football during the mayor's

race. In January, candidate Allan G. Rushlight, then chair of the city council ways and means committee, had tried to eliminate Baldwin's department by cutting off its funding. The fuss began when the policewoman asked for a $3,000 increase in her budget. In the course of the debate, Rushlight complained about her supposed lack of cooperation with officials. He inferred she was something of a loose cannon who failed to report to the city council regularly. Baldwin in turn charged that the chairman represented various "saloon interests" who were opposed to her antiprostitution work. Indignantly, she declared that her almost-daily reports to the police chief were all that was required of her. Rushlight retaliated by suggesting that the council, which had created her position under an ordinance, had as much right to abolish it.[20]

Mayor Lane, the city's Woman's Club, Women's Union, YWCA, Congress of Mothers, and Social Hygiene Society organized to save the policewoman's job. Woman's Club member and *Evening Telegram* columnist Eleanor F. Baldwin (no relation) urged Portland women to show up at the next city council meeting to prevent "the disgrace of such a backward step." The lobbying campaign succeeded, and Baldwin soon reported that the situation had been "amicably resolved." Yet the Rushlight scare sensitized the women's police advocates to the program's vulnerability. Baldwin's allies decided to avert future political reprisals by making the women's division a permanent section of the city's police organization. The support coalition placed a charter amendment to that effect before municipal voters in the June 1909 election. This was a somewhat risky move, as Portland's women did not yet have the general franchise. Apparently enough wives and daughters were able to convince male voters of the need for women's policing. On the day the Rose City tapped former United States Senator Joseph Simon as mayor, it ratified the women's police amendment by a majority of nearly a thousand votes.[21]

Although Mayor Simon had gained a political reputation in the Senate as "a master of compromise," he presented a rigid position on the social evil. He was a member of the Portland Social Hygiene Society, and its warnings on prostitution and venereal disease clearly affected his vice policy. Simon, fully supported by Baldwin, favored abolition over regulation of prostitution and set out to obliterate the vice district north of Burnside Street that his predecessor had been unable to close. Yet both Simon and the women's police superintendent soon appeared to be challenged for their zeal by reformer Charles N. Crittenton, founder of the Florence Crittenton chain of rescue homes.[22]

When the aging purity crusader spoke at a downtown Portland church in late 1909, local newspaper accounts suggested that he favored segregation

and regulation of prostitution. The next day, Simon invited Crittenton to city hall to debate the issue. Meanwhile, Baldwin sent a letter of support to the mayor, which was also published as part of an *Oregonian* piece on the controversy. As a past board member of several Crittenton homes, the policewoman declared, she could not believe that their founder would advocate regulated sexual vice. Contemporary opinion among social workers, she assured all, was that "segregation" was "simply incubation." At the mayor's office, Crittenton denied that he favored retaining Portland's vice district. What he had intended to convey in his address, he suggested, was a warning to "go slow." If sympathetic efforts were not made to rehabilitate former brothel inmates, he argued, they would eventually resume their old lives elsewhere. Regretting any implication that he had wanted to interfere with city policy, Crittenton insisted that he had simply voiced concern over harsh police-raid treatment of the North End women. Simon assured him that "only humane methods" would be used in the future against suspected prostitutes. Accepting the mayor's response, the frail Crittenton left Portland, and died several weeks later during a lecture stop in San Francisco.[23]

Baldwin retracted her public criticism of Crittenton after he clarified his position, and reiterated her support of Simon's actions. "If the underworld cannot have a wide open town," she wrote, "their next choice is a restricted district, and we have made a splendid start toward defeating their end thus far." The policewoman told the mayor that Crittenton seemed out of touch with recent changes in his own organization. She had visited many of the Crittenton homes across the country, Baldwin informed Simon, and had met with Dr. Kate Waller Barrett, the chain's national manager. As was true in Portland, she said, the homes no longer dealt with prostitutes as a class, but with unwed mothers. Rather than attempt to rehabilitate hardened cases, Dr. Barrett believed it more fruitful to prevent "betrayed" girls from *becoming* prostitutes. Yet Baldwin did agree with Crittenton's suggestion of specialized care for wayward women. As Portland had no municipal facility for reforming them, she hoped at the least for some type of segregated "medical detention" to cure their diseases.[24]

In 1910, a New York grand jury effectively put the long-rumored international white slavery cartel to rest. The panel's six-month inquiry seemed to bear out Baldwin's general observations in the Rose City when it found no conclusive evidence of an extensive organized market in women. However, social hygienist John D. Rockefeller, Jr., the jury's foreman, concluded that a practice of sorts was carried out by persons "acting for their own individual benefit." Although the Rockefeller report punctured the theory of a great "foreign conspiracy," it recognized enough of a problem to

encourage local abatement programs as well as spur the passage of the federal Mann Act. A contemporary survey by Chicago's Law and Order League strongly reiterated social hygiene sentiment against commercialized sex and reaffirmed the threat of venereal disease. As Baldwin forwarded her copies of both the New York and Chicago summaries to Mayor Simon, she noted that her department was "much pleased" with his continued vigilance over the social evil in Portland.[25]

Although simple geography had much to do with it, the Mann Act proved a valuable tool for Baldwin. Many of her prosecutions involved soldiers from Vancouver Barracks, a short ferry ride across the Columbia River in Washington. Rail passage between Portland and Seattle, Spokane, and other Washington cities figured in many other instances. The federal law allowed the policewoman to bypass local judges who had been less than cooperative. Her success rate was further enhanced in 1911 when Oregon's legislature passed a so-called "little Mann Act" which applied the federal criteria to intrastate transportation cases. The state law enabled Baldwin to get some control of the roadhouse "joyriding" problem that persisted outside city limits. Between 1910 and 1912, her log reported eighteen incidents involving the federal and state antitrafficking laws. The strangest of these was her encounter with Nell, the infamous Spokane lesbian described earlier.[26]

Although Baldwin enjoyed success with the new state and federal antitrafficking codes, Mayor Joseph Simon suffered an embarrassing setback. Despite his personal antivice zeal, a grand jury accused his police chief Arthur Cox of "malfeasance in office" for allowing selected bawdy houses immunity from raids. The Portland Municipal Association joined other civic groups in charging that the mayor's apparent naivete had aborted his own efforts to close the vice district. In February 1911, Simon began a furious effort to prove himself. In an *Oregonian* interview, he railed against certain "mysterious persons" who were using the confusion in his administration to advocate referring the regulated vice idea to the voters. "I know of my personal experience," Simon informed the newspaper, "that certain men have tried to have a district of this kind formed for the sole reason that they wanted to make a big graft out of it." For his part, he said, he had always "refused to listen to it." Although the city council apparently rejected the idea of referral, the embattled mayor had already lost all credibility with his political allies. His fellow Republicans refused to support him, and he forfeited his re-election bid a few months later by a two-to-one margin.[27]

Past experience with Mayor-elect Allan G. Rushlight made Baldwin and others suspicious of his commitment to vice reform. In the interim between his election and inauguration, the policewoman joined a growing movement

to explore the possibility of forming a vice commission in the Rose City. Following New York's lead, municipalities across the country had appointed citizen bodies to make thorough statistical surveys of prostitution and venereal disease and provide city officials with recommendations. Episcopalian clergyman Henry R. Talbot, Catholic Father Hugh J. McDevitt, Reverend Delmar H. Trimble of Centenary Methodist Episcopal Church, and Rabbi Jonah Wise represented the city's religious bodies. Physicians Horace M. Patton, Samuel A. Brown, and Margaret N. Quigley added medical legitimacy to the ad hoc committee. Dr. Quigley, Mrs. L. W. Sitton of the school board, and Mrs. A. E. Rockey all were members of the Women's Union. Other males included a juvenile court judge, the superintendent of a private detective agency, a high school principal, the head of the Boys and Girls Aid Society, and the manager of Portland Commons. In concert with these able citizens, policewoman Baldwin hoped to influence the incoming mayor to consider a vice commission.[28]

In one of his first official communications on the North End situation, Mayor Rushlight made a generic speech about opposing a "wide open" town. Although the statement did not rule out some sort of regulation, he seemed amenable to the idea of letting someone else formulate the city's vice policy. Commission boosters seized this opening and began a serious research and lobbying campaign. Baldwin had policewoman Wilma Chandler take notes at the library on the recent voluminous report of the Chicago Vice Commission. The superintendent herself corresponded with Arthur B. Farwell, president of the Chicago Law and Order League, whose group was one of the sponsors of that city's vice probe. Farwell sent Baldwin his encouragement, along with a packet of news clippings about the vice commission's formation and plan of action. The policewoman passed the information on to the local committee.[29]

Activists in Portland agreed to base their effort on the Chicago model. They drafted an enabling ordinance and introduced it to the city council in August 1911. Reverend Henry Talbot, head of the group, urged other local ministers to put pressure on the ways and means committee to appropriate the $3,000 needed to fund the commission. The amount was reasonable, Talbot contended, as the same work had cost $5,000 in Chicago, and $10,000 in New York. Meanwhile, a hesitant Rushlight refused to name the members of the proposed board until it had assured funding. However, Governor Oswald West soon expressed his displeasure over Portland's noncompliance with his own statewide vice crusade. As Rushlight had told the impatient West that he was waiting for a vice commission review before he took any action, he was backed into a corner. On September 24, the mayor bowed to the pressure,

the ways and means committee obligingly found the money, and fifteen commissioners were appointed, policewoman Baldwin among them.[30]

The Portland Vice Commission began its activities in late 1911 with a comprehensive survey of the venereal disease problem. With a third of the city's medical practitioners responding, the commission estimated that venereal cases represented "almost a quarter of the disease" seen by doctors. In January 1912, the panel recommended that infected persons be reported to health officials and legally subjected to treatment. The vice commission, at least a third of whom were members of the Oregon Social Hygiene Society, reserved special praise for that body's venereal disease education efforts. The panel called for the creation of free dispensaries and clinics to be run by the Board of Health, and further proposed that the city pay the cost of venereal isolation wards in existing hospitals until it could build a specialized medical detention facility. Such findings reiterated Baldwin's earlier musings that "some means ought to be devised" to commit diseased girls to curative institutions "for the good of the community."[31]

Meanwhile, in what seemed to be a disingenuously zealous response to the governor's abolition agenda, Rushlight apparently set out to make a point. He began a furious series of raids in the North End, and his wholesale arrests caused an uproar. The courts were overwhelmed; the jails became overstuffed; yet the pursuit continued. Finally, Judge William N. Gatens, to call attention to the absurdity of the situation, began releasing all the prostitutes brought before him. He ranted against the police for "hunting down women who were beyond redemption" while ignoring men who were out to debauch young girls. Although himself a member of the Social Hygiene Society, nothing in his experience, he reported, led him to believe that prostitution could ever be stamped out. He branded the city's police for their shortsightedness, and said they should be putting efforts where they might do some good. The only "really efficient work," Gatens declared, "could be done at the point where the girls verge from the right to the wrong path." The *Oregonian* soon picked up on this theme of preventive policing. The editors could not fathom why so many patrolmen were being utilized at the wrong end of the problem. "One policewoman in Portland has the wayward girls under her charge," the newspaper noted, "yet one girl saved from ruin is worth many scarlet women harassed, blackmailed, and jailed."[32]

Gatens' disgust brought only a brief response from Rushlight, who defended his intentions and said with a straight face that he was "not through yet." The city's police committee chairman John B. Coffey was more sympathetic to Judge Gatens. "There is absolutely no use trying to rid the city of women of the underworld," Coffey admitted, "unless we at the same time

give young girls protection from designing procurers." He agreed with the judge that the void left by the arrested prostitutes would soon be filled by the city's underworld with fresh young recruits. He observed that if the pimps were prosecuted too, they would soon move on, and their women would follow them. "As a matter of fact," Coffey confided, "between the *macquereaux* and the grafting policemen, the women are to be pitied rather than censured and prosecuted."[33]

In the shadow of this argument, the vice commission began its investigation of commercialized prostitution. By July 1912, it became bogged down in the old dispute over whether the profession should be banned or limited to a restricted district. In many ways, the debate seemed deliberately calculated to slow the work of the appointed investigative body. Sources close to Rushlight, for example, made it known that he felt the vice commission had no real authority to institute changes, but only the power to "make reports and recommendations."[34]

Rushlight offered his opinion at a hearing called by the vice commission that a controlled district "would be better than present conditions." Judge Gatens agreed in principle, yet cautioned that such an area would have to be "stringently regulated, with no liquor, or chance for men to live off the earnings of women." The judge had reason to believe that such a plan was plausible, based on future implementation of the commission's venereal control recommendations, and the recent experience of San Francisco. The previous year, as a first stage in a planned "controlled district," that city had opened a municipal clinic for venereal inspection and treatment of prostitutes. The women were examined twice a week and issued compliance cards by the board of health. Only if they failed to register or report for inspection were they subject to arrest. Bay Area businessmen, physicians, and clergy associated with the social hygiene element were very optimistic about the experiment. Currently, the California city was investigating various ways to make such a district work without the possibility of corruption.[35]

Although work pressures had forced Baldwin to resign from the vice commission by this time, she made the effort to voice her opinion at the hearing. Baldwin argued vehemently against both men, stating that she was "unilaterally opposed to any kind of a restricted district." While current conditions were not perfect, she conceded, they were "far better than they ever were." Recent vice raids which some had dismissed as useless, she countered, were in fact having a deleterious effect in the North End. Prostitutes had admitted to the policewoman that they could no longer carry on their trade "for fear of molestation," and procurers complained that they could not "get any new recruits." To her, the medical compromise was no

compromise. Hinting at the possibility of further action by Governor West, who had recently threatened to give her "a free hand" through special state enforcement powers, Baldwin reminded her listeners that "by state law" brothels could not be "recognized or condoned." By the end of the session, Rushlight bowed out of the discussion. He admitted frankly that he did "not really know how the problem should be handled," and deferred the decision to the vice commission.[36]

On August 23, the commission's findings made headlines. Of 547 locations suspected of being prostitution venues, 431 were confirmed to be "immoral" at the least. Of greater significance was the official disclosure of the open secret that many vice-infested buildings were owned by prominent men. With heavy profits from their investments, few seemed to care how the properties were used. Purportedly aghast at this "absence of a keen sense of personal responsibility" among the wealthy, the vice panel made two earnest recommendations. First, not unlike Baldwin's usual practice of publishing the names of lodging houses which harbored prostitutes, it asked for a precedent-setting "tin plate" ordinance, which would require the owners of saloon buildings, hotels, boardinghouses, and other lodging facilities to post their names on their holdings. Second, the panel asked that all commercial housing be inspected and licensed, with strict registration policies. Under continued commission pressure, the city complied with both requests. Within months, somewhat in spite of itself, Portland became the source of a model vice reform that would be copied and praised by other municipalities.[37]

In late 1912, a third vice commission report tackled the "legal and police aspects of the social evil." In one of her many complaints about prostitution conviction rates, Baldwin had confided to a Portland judge that she and her assistants "might as well be seat warmers and clock watchers" for all the support they got in the courts. The commission confirmed her frustrations. Less than 50 percent of almost 1,900 prostitution arrestees had been convicted in the previous eighteen months. Of 216 establishments raided in the same period, not one had been put out of business. In an attempt to overcome this local "failure to get results," the vice panel turned to the state for remedy. Because there were duplications and discrepancies of jurisdiction and law among Oregon's towns and cities, it proposed a uniform statewide abatement code. The committee also asked for a statute mandating a separate, state-level "morals court" in counties of over a hundred thousand people. As only Multnomah County met that criterion, the measure was clearly aimed at Portland. Such tactics were necessary, the report added, "to afford the decent element some relief from present conditions in an orderly and lawful manner." When the next legislature enacted both laws, the Rose City's commercial vice district was legally defunct.[38]

The vice commission uncovered "118 instances" of police graft or similar irregularities during its investigations. Accordingly, it asked that the city review its civil service requirements for law enforcement officers. The panel strongly suggested that more emphasis be placed on "moral qualifications" for duty. In addition, it recommended that all police personnel be instructed in laws of evidence so that cases would no longer be forfeited because of shoddy methods. Furthermore, the department was advised to keep more comprehensive records and statistics. Within the year, the male force was purged from top to bottom. The commission also identified weaknesses in the division of authority and the governing structure of the department. Many of these problems were addressed in 1913, after municipal voters approved a change to the "Galveston Plan" commission form of government.[39]

The Portland Vice Commission was the primary catalyst for change in the city's attitude toward prostitution abatement. The pressure of a strengthening social hygiene movement and a like-minded state legislature and governor bolstered the commission's effectiveness. The Rose City's next mayor, former legislator and active social hygienist H. Russell Albee, had been a significant force in passage of many of the state's antivice laws. Baldwin's women's police section also had a measurable impact on law-enforcement approaches to prostitution and other vice crime. Significantly, the vice commission's third report implied that Baldwin had instituted professional standards fully five years before the panel mandated such reform for the city's male police ranks. Through sheer persistence and the judicious use of state and federal codes, Portland's head policewoman made remarkable progress in overcoming the corruption and lax methods of the local bureaucracies and courts.[40]

Baldwin's own career may be utilized to trace the general change in attitudes about the prostitute. In the late nineteenth century, she had shared Charles Crittenton's "Social Gospel" doctrine that these women were victims who could be morally and occupationally rehabilitated. Her work with the YWCA-supported Travelers' Aid continued to reflect this belief in the possibility of rescue. As a secular policewoman, however, Baldwin's daily experience and Social Hygiene Society-inspired exposure to scientific evidence on the twin social evils of prostitution and venereal disease caused her to doubt whether the problem was that simple. By 1908, the women's police superintendent had discarded Crittenton's strictly moral approach for Mayor Harry Lane's medical-reformist analysis of prostitution as a public health menace. Baldwin used this approach to get results in her police work. Even when she knocked heads with Judge Gatens over the restricted district, the exchange showed the range of belief among reformers who supposedly had the same agenda. Whereas the prostitute was formerly seen as a victim,

the "diseased prostitute" was clearly a victimizer. This change of attitude allowed for harsh abatement without much public outcry, and the substitution of so-called "medical detention" for "fine and release."[41]

Ignoring any contradiction, social hygienists like Baldwin employed both environmentalist and hereditarianist thought to further their goals. Those who sought to eliminate the red-light districts improved the social environment of the cities by removing vice centers. At the same time, they pushed the ideals of eugenics forward by eliminating a source of "race degeneration" caused by the activities of the "feeble-minded" prostitute and the diseases she spread. Although undertones of elitist racism showed plainly in some of the era's rhetoric, many well-intentioned reformers emphasized that a healthier species would benefit all of society. Social hygienists were especially adept at statistically projecting huge dollar-amount savings in medical costs, increased worker productivity, and lessened social welfare expenditures. William T. Foster of the Oregon Social Hygiene Society, for example, estimated that its venereal disease prevention campaign alone meant a $200,000 annual gain in productive labor to the state.[42]

When social hygiene concerns inspired the creation and success of the Portland Vice Commission, Lola Baldwin's faith in its ideals expanded. Citizen interest in vice reform empowered her profession as she alone could not, given the entrenched opposition. Yet the relationship was necessarily symbiotic. The social hygiene agenda could only be fulfilled through increasing degrees of state control. Although Harry Lane and Baldwin quickly embraced the medical model of vice control, it took years for the enforcement apparatus to catch up. While mayors Lane and Simon actively sought abolition, economic interests, remnants of regulationism, and old-fashioned graft prevented its implementation. Eventually, the social hygiene element assumed an ad hoc police power through the vice commission. This allowed it to work around the opposition and mold the city's enforcement institutions to its own purposes. Both the morals court and the medical detention facility recommended by the vice surveyors were aspects of the Progressive Era's "new penology." Portland policewoman Lola Baldwin would become a prominent local and national actor in that movement.[43]

The women of the state have
worked for ten years to get this school, so that delinquent girls may be
given a chance to make useful women in the end.

—Lola G. Baldwin on "Hillcrest," January 31, 1915

7

Women, Politics, and Penology

As sexual morality became a secular, medical, and political concern, Progressive Era reformers sought to update remedial care for female offenders. Many of the private facilities for delinquent girls, like Portland's House of the Good Shepherd, utilized religious philosophies which lagged behind more recent "scientific" corrections ideas. Even some state reform schools operated on the premise of everlasting condemnation for carnal offenses. New emphases on preventive policing, supervision outside of institutions, venereal medical care, and rehabilitation, however, demanded changed policy. As part of this impulse, the National Conference of Charities and Corrections (NCCC) led the way to what one historian describes as a "new penology" for female transgressors.[1]

After 1900, as representatives of the urban settlement movement began to dominate its committees, the NCCC recommended purging state institutions of the belief that regeneration of the "fallen woman" was unlikely. Such old ideas were antagonistic to the rising ideology of progress in all things, and produced little effort at correction beyond cursory moral training and the teaching of simple domestic chores. The NCCC proposed a broader attack on female delinquency. It advanced preventive policing as a means of discouraging offenses, advocated use of supervised probation in lieu of detention, and urged early-release parole policies. Although the ideal was to resocialize young women outside of institutions, reformers recognized that cases of repeated sexual delinquency and disease would need longer medical and rehabilitative detention.[2]

Baldwin had known and supported the work of the NCCC since her "rescue work" days. In 1908, Millie Trumbull, secretary of the Oregon Conference of Charities and Corrections, asked the new policewoman to help plan the group's annual convocation in Portland. The October meeting at the downtown Unitarian church emphasized a growing concern with the "girl problem." A majority of the sessions were directly related to causes of and cures for female delinquency. Blanche Blumauer, president of the Council of Jewish Women, spoke of the work being done for urban girls at its Neighborhood House settlement. Judge Calvin Gantenbein and probation officer Emma Butler discussed the juvenile court program for delinquent girls. Other speakers addressed such issues as the prosecution of domestic physical abuse cases and changes in female reformatories. Policewoman Baldwin was asked to discuss her proposed city ordinance to eliminate females from saloons, and made a number of converts. Her enthused log entries suggest she left the event with a renewed and validated sense of her own urban mission.[3]

Pragmatic reformers like Baldwin and the others at the Charities and Corrections conference devised practical ways to affect the environmental cause of delinquent behavior. While religious "moral suasion" had worked to a certain degree in simpler times, it invariably failed against the profit motive. Although the diversion programs offered by the settlement houses and groups like the YWCA were extremely important, Baldwin recognized that only the police power could effectively counter the problems of modern commercialized vice and questionable amusements. Her earliest writings disclose her belief that the best weapon at her disposal during her Travelers' Aid tenure was the special police power given her by Mayor Lane at the time of the exposition. Lane apparently extended this usually temporary commission without challenge until it was made permanent in 1908. Her reported success under this status provides a plausible reason why she turned to the city for funding rather than seek enhanced private charity.[4]

As an official policewoman, Baldwin expanded the parameters of prevention a hundredfold. As a social feminist and social hygienist, she believed she had the right to use the police power both to reaffirm traditional morals and to combat vice. In her own words, she manipulated the urban environment to "make the path safe for the girl who desired to lead a clean, honest, useful life." After Harry Lane's defeat in 1909, Baldwin immediately tried to assure incoming mayor Joseph Simon of her program's value. The utility of her work, she asserted, had "passed beyond the experimental stage." It had "fully demonstrated," she insisted, that "preventive measures were better than corrective, especially in dealing with young women."[5]

Formal and informal probation, both aims of the new penology, were central to Baldwin's agenda. In 1905, as noted earlier, Portland's juvenile court appointed her a probation officer for "transient girls." She held that unpaid position for the next two years, utilizing a practical oversight plan developed as part of her vice-preventive activities for the exposition. She continued the practice as part of her policewoman's role. She routinely dispensed what she called "after-care" to girls who had been in the courts, or those she felt were in moral danger. She made a special point of knowing where they lived and worked, what amusements they frequented, and who their companions were. Baldwin often visited them at their lodgings, or called them in for informal "motherly" talks to see if she could discern any problems. "An ounce of prevention," she wrote of such girls to Mayor Lane, was "worth a *ton* of cure." She kept the interviews private, yet recorded what she thought important in a confidential file on each girl. She tried, she explained, "not so much to force views upon the girl, but to find some middle ground, and encourage and help her to help herself."[6]

Baldwin believed that "parental" watchfulness deterred recidivism and kept borderline girls from becoming delinquent. She confessed to Mayor Joseph Simon in 1909 that young women needing such further attention were "the heaviest part" of her department's work. Despite this burden, she wrote, she felt she could never deny any girl "a good chance whereby she might be restored and become an honorable and useful member of society." To take some of the burden off herself, she began assigning less serious probation cases to groups like the Catholic Women's League, the Council of Jewish Women, YWCA, various Protestant women's service organizations, the "Big Sister" program, and the city's settlement workers. Sometimes, all a girl needed was a kind, friendly woman to talk to, or a sewing or cooking class to improve her job skills or self-esteem. Attentive "first aid to the tempted," Baldwin contended, was "fully as important as first aid to the injured." In the initial six months of 1909, nearly 50 per cent of the 273 young women who came in contact with her office for the first time for various reasons were placed on the "after-care" list. This was in addition to twelve paroled to her by the courts in the same period. Such figures generally represented the average.[7]

Probation and parole reflected "the principle of overcoming evil by good instead of by coercion," as one eastern prison reformer asserted. From a practical standpoint, such methods offered some relief when improvements to older programs and facilities lagged. In 1912, Governor Oswald West noted that the state's jails and other institutions were outdated, overcrowded, and ineffective. He said that many prisoners had a much better "chance to retrieve

themselves" if released on supervised parole. When political opponents chided him for "sentimentality," he blasted them for refusing to appropriate sufficient funds to modernize the penal system. Until such time as that happened, he intended to use his relief powers when suitable. Like his predecessors George Chamberlain and Frank Benson, West often asked Baldwin's advice on female pardon and parole matters. In November of 1911, for example, he appeared at her Portland office in person "with regard to several pardons" asked by women in the city jail.[8]

Baldwin's section supervised an average of 25 female parolees per year. At times she bargained for parole as a condition of pardon to better oversee those she felt might repeat offenses. When the attorney for a young Portland woman arrested for shoplifting asked for unconditional forgiveness from Governor West, Baldwin escorted the prisoner to the state executive's office in Salem for her hearing. After he interviewed the girl in private, West listened carefully to the policewoman's reservations. He acceded to Baldwin's concerns about recidivism, and granted a pardon on condition that the girl be on parole until she had proved her sincerity. The policewoman subsequently placed the girl as a domestic for a family "in the country near Beaverton."[9]

Baldwin's placement of the girl in the country was a calculated move. The belief that rural or small-town life was beneficial to moral health permeated much of the era's delinquency-reform ideology. Because social feminists like Baldwin hoped to reinvigorate traditional values, they retained a faith in the regenerative powers of the "face-to-face" village. Locations like Hood River especially appealed because they combined rural ambience with tourist hotels, which often provided jobs for the policewoman's paroled referrals. As a plus, removing numbers of delinquent females from the urban "occasion of sin" made Baldwin's city job that much easier. She was quite encouraged after a May 1908 visit to the Mt. Hood Hotel. "We shall probably soon have other places for girls in Hood River and vicinity," she enthused, "as we consider placing girls in outlying towns an important part of our work."[10]

The rural reform school also affirmed the curative powers of the countryside. More hopeful opinion on sexual delinquency suggested that young women were "less resistant to change" than adult female offenders. If separated from temptation and cured of venereal ailments, they might be successfully "re-formed" through intense social modeling. Yet the reform school was still based in the traditional icon of female domesticity. If sexually delinquent girls were kept in custody during their "dangerous" mid-teens, Progressive Era corrections agents hoped they would make good wives and mothers once they matured. To that end, the all-female staff of the state

"industrial home" or "farm colony" provided them with impeccable role models, basic schooling, and courses in domestic science. Between 1910 and 1920, the construction rate for such facilities more than quadrupled over previous decades.[11]

Social hygienist opposition to prostitution and venereal disease helped popularize the updated female delinquency institutions. By 1910, Oregon was one of only a few states which had not yet built a facility for young female morals offenders. As a charter member of the Portland Social Hygiene Society, Baldwin believed that the isolation and medical and rehabilitative "cure" of the sexual delinquent was imperative to the moral and physical health of the whole population. She often complained that the private facilities she utilized for diseased girls were not secure enough, yet the city jail was an abhorrent substitute, and the state juvenile code forbade placing minors there. Portland's women's groups began pushing the idea of a secure facility for sexually delinquent young women in 1905, after the Travelers' Aid brought the girl problem into sharp focus. "Every community," Baldwin declared, "should look forward to the establishment of an industrial home for delinquent girls." It was only in such a facility, she urged, that "proper medical attention, venereal treatment, eg., can be given; thus carrying out reform rather than punishment."[12]

In 1910, Baldwin took vacation time to review the operation of Washington's new Chehalis Training School. Upon her return, she and her women's club and social hygiene allies renewed their perennial fight for a delinquent girls' home with city authorities. As usual, they had little success when the question of cost arose but, rather than be discouraged, they developed an alternative strategy. In many cases such reformatories were funded by the state. Over the succeeding months, Baldwin and her supporters began work on a plan to push the Oregon legislature into funding a facility. This solution was of course also attractive to the city government: it would partially solve Portland's "girl problem" without city funding, since most of the state's young delinquent females were generated by the Rose City.[13]

Baldwin joined a committee for a state detention home formed by ex-District Attorney John Manning, who headed Portland's Associated Charities. The panel included juvenile court probation officer Emma Butler, Aristene N. Felts of the Congress of Mothers, social worker Valentine Pritchard of the People's Institute, and Mrs. Morton Spaulding of the Portland Women's Union. The group met frequently in the policewoman's office. The idea of a state-sponsored home appealed to cost-conscious Portland civic authorities, and Baldwin used this to advantage whenever possible.[14]

In early 1912 Baldwin learned that her mother was ill back in Rochester. With her typical bent for creative financing, she combined a trip to see her mother with a federal deportation assignment to New York City. She also wangled another two weeks of paid leave from Portland officials "to make investigation with regard to institutions for women and girls" in the New York area. She assured the executive board's police committee that the city would benefit, and left no doubt as to who would foot the bill for such a detention home. "Oregon has no state institution for young women," she reminded them, "and we are making a strong effort to have the next legislature make an appropriation for such."[15]

Baldwin's police statistics on female delinquency made her the detention home committee's natural choice for chief lobbyist. In January of 1913, she successfully testified for the industrial school before a house committee. In February, she was invited to speak on the matter from the floor of the state senate before its decisive vote. She recorded the result in red ink in her daily log for February 16: "Senate Bill 136, providing for a State Industrial School for Girls, passed the senate today with 18 votes." The final bill approved by both houses mandated the appointment of a three-woman advisory board for the institution. Governor Oswald West, acting in his capacity as head of the State Board of Control, appointed Baldwin as its head, assisted by Aristene Felts and a woman named Lotta C. Smith.[16]

Baldwin commuted regularly to Salem for planning sessions over the next few months. The Board of Control found suitable land already owned by the state in suburban Salem, and rushed completion of the first buildings so that the facility could open in a limited way by July 15. The statute provided for the commitment of "girls between the ages of 12 and 25 years." These were separated into two classes. Minors under eighteen could be remanded by the juvenile court until they attained their majority. Those between age eighteen and twenty-five convicted in adult court of larceny, vagrancy, or prostitution could be detained for up to three years. These sentences were indeterminate, which meant an inmate might be retained, paroled, or otherwise released at the discretion of the Board of Control. The older ones were usually more serious offenders, and as the industrial school was the only place besides the jail where Baldwin could send them, it seemed imperative that they be given priority. Because the new school could handle only twenty-five inmates initially, Baldwin told Portland Mayor H. Russell Albee that she would "not take any of the younger class" until the facility could be expanded.[16]

The general profile of the young woman committed to the state industrial school was that of a recidivist, chronically venereal, morals offender. The history of eighteen-year-old "Lillian," remanded to the institution in late 1913,

appears typical. The girl first came to Baldwin's attention at age fifteen, when the Boys and Girls Aid Society appealed to the policewoman to take her in hand. Her father was dead, and her mother reportedly was "a fast woman." At that time, Baldwin had described Lillian as "a bold girl with immoral tendencies and an inclination to be dishonest," but she had not actually done anything definably criminal. She was placed for a time as a mother's helper "in an estimable private family," but when she turned eighteen in July 1913 she left that position "and immediately thereafter became immoral." By the end of October of that year, she had been declared incorrigible, and sentenced to the maximum stay at the state industrial school.[18]

Lillian's amazingly rapid decline illustrates why her type was of such concern to Baldwin. After her eighteenth birthday, the girl traveled across the Columbia River to Vancouver, Washington, and lived in a rooming house close to the Vancouver Army Barracks. In August, she was reported to authorities for "consorting with soldiers," one of whom apparently infected her with a venereal disease. She was hospitalized for treatment, but subsequently continued to fraternize, with predictable results. She was jailed for prostitution in mid-October by the local police, who shipped her back to Baldwin in Portland "as they did not want her in Vancouver after she was discharged." Baldwin placed her as a domestic, but she soon slipped out to spend the night in a hotel with a soldier. A week later, her employer brought her back to Baldwin's office, as the woman "believed the girl was venereal." An examination by a State Board of Health physician confirmed that the girl had "a terrible discharge." Convinced that the young woman "would be unable to make an honest living and a moral recovery" without institutional care, Baldwin filed vagrancy charges against her, and asked the court for the maximum three-year sentence to the industrial school.[19]

Lillian was sent off to "Hillcrest," as the industrial school became known. That would have been the end of it if Jean Bennett had not raised a protest. Bennett was a supporter of the radical Industrial Workers of the World (I.W.W.), which was attempting to organize laborers in Portland canning plants. Under arrest herself for public speaking without permit, she had briefly shared a cell with Lillian while the girl was awaiting disposition. Bennett befriended her and convinced her that she was being "railroaded" to what was essentially a "slave labor" farm. The older woman informed the girl that she had the right to refuse to perform *any* unpaid work and that she had not "done enough" to warrant a three-year sentence. Bennett then smuggled her version of Lillian's plight to the *Daily News*. When the chagrined head policewoman discovered this, she berated the paper's editor for printing the letter, and then turned to Mayor Albee for help in damage control. Albee

advised her that it was too late for any action on his part, as Bennett's attorney Isaac Swett reported he was going to "have the case reopened, either on habeas corpus or a writ of review."[20]

Baldwin was rather upset by this turn of events. "Since the I.W.W. women have been in our jails," she complained bitterly to Albee, "it has been simply awful to try to do anything with the women they have come in contact with." She reported that the agitators "put ideas into the heads of the other women which they had never thought of before." Their rhetoric, she continued, had made the other prisoners "unwilling to take our advice and counsel, and turned them against authority of every kind." She begged Albee to use his personal friendship with attorney Swett to persuade him to leave her cases alone. Albee reminded her that neither of them had any recourse if her adversaries took the matter to court, "that being their privilege at all times." Swett and Bennett subsequently requested a hearing before the State Board of Control, which consisted of Governor West, Secretary of State Ben Olcott, and Treasurer Thomas Kay. When the panel met on November 20, it refused to honor the lawyer's argument that young Lillian was being "wrongfully detained."[21]

Bennett and two male I.W.W. members named L. D. Ramsley and E. F. Hale left the Board of Control hearing and proceeded to the State Industrial School. They demanded that matron Esther Hopkins allow them to interview Lillian. Hopkins refused, at which time they intimated in a threatening way that they would force her to do so. The matron again resisted, insisting that she was "not afraid of them." The trio retreated and called on Governor West, telling him that they were philosophically opposed "to all such institutions as the State Industrial School for Girls." West told the *Oregonian* that the I.W.W. committee then informed him point-blank that if the Board of Control did not free the girl "she would be liberated anyway." West said he gathered from their talk that "large numbers of the order might be brought to the Capital City for the purpose of freeing Miss Larkin."[22]

West was actually sympathetic to I.W.W. organizing efforts in some Oregon industries, yet he told the Bennett and her group that he disagreed with them in this case. He informed them that they needed a court order to see Lillian: the girl's mother was permitted to see her, but everyone else was barred. West said that the Board of Control *would* consider further evidence and that he would parole the girl if they could prove in court that she was being held unlawfully. Bennett and her allies lost their appeal in the circuit court, which upheld both the industrial school commitment process and the Board of Control decision not to release the girl. Several weeks later, a disgruntled Bennett attempted a Portland recall drive against Baldwin. Mayor

Albee refused to act on the lengthy petition, however, which charged the policewoman with being "utterly heartless and coldblooded and not a fit person to judge of human flesh and blood." Albee, with considerable support, declared that he "never considered the dismissal or even a reprimand for Mrs. Baldwin on this account."[23]

Hillcrest had to pass a fiery test for its very existence a year later. On January 30, 1915, without consulting the Board of Control, Andrew C. Smith of the legislature's joint ways and means committee moved to abolish the school by not funding it for the next biennium. He contended that per capita costs at the institution were exorbitant, and suggested the inmates could be farmed out to private religious homes like the House of the Good Shepherd "at a much smaller cost." A furious Baldwin countered that Smith had neglected to take start-up costs into consideration. Of course the $50,000 appropriation, divided by fifty inmates, yielded $1,000 per girl. Yet by her calculations, germane costs had been only $20 per month, a sum $4 less than that of keeping a boy at the boys' training school. Smith would not back down: saying that there were at least ten thousand delinquent girls in the state, he asked how it could justify such extravagant quarters for only fifty? As Baldwin gathered herself for a fight, the women's club network rallied around her. By the next day, the legislative committee received countless letters and telegrams of protest from women in Portland, Salem, Eugene, Medford, Ashland, and elsewhere.[24]

"Hillcrest" Home for Girls, founded in 1913
Photograph: Oregon Historical Society (negative CN 013429)

On February 2, a dozen prominent women from the State Federation of Women's Clubs, the Portland Woman's Club, the Council of Jewish Women, the State Congress of Mothers, and other groups stormed the ways and means committee. Aristene Felts, speaking as both Hillcrest board member and head of the Congress of Mothers pointedly objected to Smith's plan. Foremost, she explained, "the state's mothers felt their children should be protected from the class of girls sent to the institution." Hillcrest was "the one place to send girls more than 18 years old." The judges would not put them in jail, so they would be back on the streets as "a menace to other girls." The records of the work, Felts argued, "proved that fifty per cent of the girls were reclaimed." Blanche Blumauer of the Council of Jewish Women said that, although they did certain good, "denominational institutions were not prepared to do the work as thoroughly as the state should be." Smith, a Catholic, countered that Baldwin had stirred "sectarian and religious bigotry" by circulating a list of state appropriations supposedly weighted to Catholic institutions. Speaker Ben Selling angrily squelched that discussion, and defended Baldwin's reputation and her "valuable service for the city of Portland and the state." After that, several less animated speakers sustained the women's lobby, and the legislature expedited monies for the girls' asylum.[25]

Baldwin was relieved and pleased that both her own work and the institution had been legitimized. She was quite proud of the Hillcrest "cottage" program. The school's inmates, she wrote, were "grouped in families, and given the best of industrial training," here referring to "industry" in the traditional sense of "work." Most activities at the school centered on the farming practices typical of the surrounding Willamette Valley. The program relied heavily on home-agriculture pursuits of "dairying, fruit raising, gardening, and poultry raising." About an acre of land was allowed for each girl. If nothing else, the agronomic emphasis encouraged outdoor exercise, and instilled pride of accomplishment in some who had known little of it in their lives. In August of 1915, Baldwin reported proudly to Mayor Albee that the residents had "cultivated and raised fifteen acres of potatoes, besides filling and seeding nearly an acre of lawn, hauling in the leaf mold from the woods themselves." Older inmates had "dug a ditch nearly 400 feet long, threaded pipe, coupled it, and installed faucets to carry water to the poultry houses and the stable." The inmates apparently thrived on this kind of outdoor activity. "The only difficulty," Baldwin remarked, was that "every girl wanted a part in it, and there was not enough ditch digging to go around."[26]

Portland's Mayor Albee, a social hygienist and former state legislator, was one of the home's foremost boosters. He lauded the facility's absorption with rural producer values, and extolled the outdoor work program as "both

healthful and useful." Baldwin and her supporters, he wrote, were "to be congratulated on having put such a project into execution." The mayor was often personally helpful to the inmates and staff. The home's supervising matron Esther Hopkins had pleaded in vain with the legislature for a phonograph to introduce "fine music" to the girls as they tackled sewing or other indoor tasks. When Albee heard of their need, he purchased a machine with his own money, and presented it to the institution. Hopkins sent him a letter signed by the grateful inmates. She added her own thanks, writing that she believed music was "one of the essential things to help people have purer, better thoughts and aspirations." Baldwin also acknowledged the gift, noting that the girls were "delighted with it, as it passes many a dull evening hour."[27]

As the state industrial school regimen demonstrated, many Progressive Era institutional programs looked back to an idealized agrarian past. They tried to deliberately recreate conditions from a time when labor spheres were less defined by gender. Consciously or not, female penal workers like Baldwin, who themselves sought legitimacy in the male marketplace, created self-serving experiments with their charges. By demonstrating that even "defective" females could be made healthy if allowed to pursue tasks defined as "unwomanly" by Victorian culture, such women asserted their own right to compete. Even the controversial Lillian, whom the staff had considered "the least promising girl in the school," was later reported to be "materially improved, happy, and contented." Contrary to the suspicions of critics like Jean Bennett, Baldwin did not simply use the facility as a dumping ground for her failures. She paid close attention to inmate progress, and used paroled release in a great many cases. In 1915, for example, when there were twenty-nine girls in residence, there were an almost equal number of twenty-five on supervised parole.[28]

Facilities like the state industrial school have been described as "anti-institutional institutions." Hillcrest transcended the physical limitations of jail through "family" groupings, parole options, outdoor work, and physical education programs. More importantly, it further faded the sharp sex-role distinctions of Victorian domesticity by including traditional gender-neutral agrarian tasks in its rehabilitative curriculum. Such activities could instill a sense of equality and personal achievement, even though based in a mythic, bucolic past. Such self-esteem enhancement, even if temporary, probably did more good for the inmate than anything else the institution offered. Places like Hillcrest, intended mainly for the reform and moral safekeeping of younger female delinquents, wove together traditional maternal nurture and modern penal theory. Unforeseen circumstances, however, forced Baldwin to accommodate older offenders during most of her years on its board.[29]

Even as the reformatory opened, Baldwin admitted that she had so many older candidates that the institution's planned mission of "saving" younger delinquents had to be deferred. As a social hygienist, she was faced with a dilemma. While hoping to fulfill the school's central purpose of segregating at-risk younger girls from the dangers of urban society, she could not ignore older diseased sexual delinquents who were a health risk to that society. For the time being, the state institution was the only reform option she had available for older transgressors. Ironically, she was left with a population predominantly over eighteen years of age in a school philosophically dedicated to the reform of minor girls.[30]

One of the recommendations of the Portland Vice Commission had been a more "modern, intelligent, and constructive" handling of morals cases. It had requested a specialized court for dealing with "morally deliquent" females over the age of eighteen. It was intended as a replacement for the city police court, with its revolving-door "fine and release" system. The new entity was to be more private and humane. Vice commissioner Rabbi Jonah Wise had assailed the night court as a disgrace. He decried the circus atmosphere, and the "gaping and uncouth" voyeurs who took relish in the "hideous shame of the fallen women." The morals court was designed to complement a proposed medical and reformative facility for prostitutes. Yet, despite the vice commission request and a state mandate, implementation of the court was delayed by voters several times.[31]

Baldwin had advocated a women's morals court long before the vice commission took up the idea. While on a deportation assignment in the east in early 1912, she had investigated New York City's magistrate's court. Her eastern acquaintance Maude E. Miner served as its chief probation officer for women and girls, and the institution was admired by reformers nationwide. On her return, Baldwin continued to keep in touch with her colleague, and actively pushed the idea of a women's court in the Rose City. In a *Sunset* magazine interview several months later, she explained that among the "big things" she desired for female offenders in Portland were the "establishment of a public defender as well as a public prosecutor paid by the city, and a separate municipal court for the cases of women." Over the next year, however, a charter amendment for such a court "failed several times" with the city's voters. Baldwin refused to give up on the idea. She scored a coup when she again met Miner at the NCCC convention in Seattle in July 1913. The New Yorker agreed to come to Portland to confer with officials about separate hearings and other reform procedures for delinquent women.[32]

Baldwin had laid some groundwork for the meeting a month earlier when she submitted a proposal to Mayor-elect Albee. As part of the city's conversion

to a commission form of government, she asked that her department be given broader powers, including "general oversight of all women prisoners on parole or in places of detention." When Miner arrived, Judge John H. Stevenson of the municipal court listened attentively to her argument that women morals offenders needed differential treatment. By September, Stevenson had decided to make Baldwin's police section responsible for all probation and parole duties for women offenders under his jurisdiction. Considering both Miner's pleas and the requirements of the statewide prostitution abatement law passed by the legislature, Stevenson was determined that the city would have a morals court in spite of voter rejection.[33]

By the fall of 1913, the City Attorney's office had endorsed Stevenson's plan to hear the cases of delinquent women in special closed sessions. Mayor Albee was also anxious for the court to be approved in order to ameliorate what he called "the unfortunate woman problem." In early December, Judge Stevenson acted unilaterally. "On Monday afternoon of each week," he announced, "the court will hold a session, which for convenience will be called a morals court." Baldwin was especially pleased because Stevenson assigned all the probation and parole functions for the court session to the women's police. Although the new institution did not have any official standing other than the bench assertion that it existed, the policewoman was confident that it would "carry out the plan of a morals court insofar as was practicable." As expected, no one of consequence protested the innovation. Six months later, again by personal fiat, Stevenson created a court of domestic relations for reviewing spousal complaints.[34]

Judge Stevenson held his morals and domestic relations sessions in a small room near the regular court. His main interest, he claimed, was "relieving witnesses testifying respecting delicate matters from the embarrassment of large and morbid courtroom audiences." This feature was especially important in domestic relations cases. "Women having complaint against their husbands," he explained, frequently held back because they did not wish to air "secret family affairs" in open court. Stevenson dismissed critics who called the sessions a "secret tribune," and denied that they were used "to deprive anyone of a public trial." He maintained that his courtroom was always open "to anyone with any right whatever to be there." The doors were "impliedly closed" only to those whose interests were "purely that of indecent curiosity." By the end of 1914 the judge reached the "very sound conclusion that such a court ought to be created by law." He especially praised "the invaluable assistance rendered to the court by the Women's Protective Division."[35]

The municipal court women's docket greatly increased Baldwin's duties. "Everyone in the department," she told Mayor Albee, worked "to the very

limit." In fact, she had found it "almost impossible to conform to the state law" on women's work hours. As a comparison, the Seattle women's division, which employed more workers, handled only forty court cases in the same month that Portland's processed 78. To improve her hectic schedule, Baldwin examined court procedures and offered suggestions for changes. She asked for a clearer definition of the responsibilities of the jail matron, and for more certain court times for cases the policewomen had to attend. She requested that copies of all arrest reports on women and girls be sent to her well before their hearings. By the end of 1914 she reported a much more workable system. She received the women's docket each morning in time to decide which cases warranted a policewoman's attendance, and which prisoners were candidates for parole, probation, or after care. Her section assisted in 266 court cases in 1914 compred to 95 the previous year. The department's drive for "greater efficiency," moreover, allowed it to supervise 61 parolees compared to 17 in 1913.[36]

The morals court was only part of the vice commission plan to bring treatment of the prostitute class in line with the new penology. Although it first had asked only for a "special venereal disease hospital," that idea was later modified to include reformative detention. Penal reform advocates began to push for a home where prostitutes would be given venereal treatment, mental evaluation, and rehabilitation in lieu of being "fined and released." In March 1913, the city council directed Mayor Rushlight to appoint a panel to study the advisability of such a facility. He named former vice commissioners William MacLaren, George Thacher, and Father Hugh McDevitt, Dr. Sarah Whiteside of the health department, and Oregon Congress of Mothers head Aristene Felts, who served with Baldwin on the state industrial school board and building committee. As a first step, the group drafted a charter amendment to allow for alternative commitment of vice offenders to a detention or industrial home provided by future ordinance. It limited jail time for certain morals crimes to six months, yet allowed an indeterminate sentence of up to two years in the detention home for the same violation. Voters approved the proposal five weeks later by a two-to-one margin.[37]

The second phase was to determine whether such an institution was truly needed. In early May, members of the committee asked Baldwin to accompany them on an inspection of cells the city utilized for women. The tour exposed "a pressing need for suitable quarters for female offenders," as the women's jail space in the police station was deemed "unsuited for the purpose." The city was at the time constructing a new public safety building which would be ready in a few months. The proposed women's area in the new facility was "as good as could be expected in a city jail," but was criticized

for its "close confinement without occupation." Next on the tour was the county lock-up, where those sentenced for periods longer than a few days were kept. There, the panel discovered women arrested for minor offenses held in dim steel cages "intended to provide safekeeping of the most desperate male criminals." The cells were constructed of thick iron bars set three inches apart, with heavy metal horizontal cross-pieces every twelve inches. The group was stunned to find that Portland was, in its words, "confining women in dungeons as a penalty for committing misdemeanors." A replacement structure was planned, but the committee insisted that the county consult with the city on the configuration of the women's area.[38]

In mid-May, concerned about charges of "cruel and unusual punishment" threatened by the Oregon Prisoners' Aid Society, the city council enlarged the advisory panel to ten. New members included Mrs. Henry L. Corbett of the Women's Union and Oregon's Consumer's League, and Millie Trumbull of the juvenile court, Woman's Club, and Prisoners' Aid Society. The group now met weekly, and supplemented its earlier jail visits with data on inmate management provided by Baldwin and others in the city's corrections area. The panel corresponded with the superintendents of detention homes in other states, and reviewed published findings of investigators and social workers concerning institutional reform. They prepared a thorough brief for Rose City authorities "with the view of suggesting certain changes to correct very obvious defects in the treatment of offenders."[39]

The committee's July 1913 final report "urgently" recommended that the city build a separate facility for women accused of morals offenses. The bottom line was that fines or jail did nothing to eradicate prostitution or disease. It was the conviction of the panel that "there should be no plan of punishment whatever of the unfortunate women in the house of detention." Under this philosophy, the women would be "divided into two classes, the abnormal and defective, and the normal." Little could be done with the subnormal ones, "except to cure them of disease and restrain them from being a constant menace to society." The normal women, however, should be "given encouragement to lead respectable lives and training in some form of labor" to make them self-supporting. The basic premise was the same as that for the younger sexual delinquents who were supposed to populate the new state industrial school. Yet there was some hesitancy in applying it to older women.[40]

Other locations had been reluctant to sentence older offenders to long-term rehabilitative detention "because of its being regarded as a punishment." The Portland committee did not view that as a problem, however, in light of documented experience with younger women that effective reform required

"an indeterminate sentence of some years duration." They hoped that this experience, together with expert assertions that the plan was not "punishment," would lull objections. The panel offered the detention home as "a sensible and humane alternative to the fining system, which simply encouraged the dissemination of disease." Furthermore, they insisted, the present method of handling prostitutes was "marked by stupidity and brutality." The members understood that houses of detention would "not abolish prostitution," but suggested that they were an important adjunct to abatement procedures against local premises used for immoral business. As a bonus, other cities had discovered that the threat of long detention caused some prostitutes to move on.[41]

The panel's siting suggestions were consistent with the vogue for rural reformatories. The report declared the home "be established outside of the city, at a distance not exceeding 25 miles, and in close proximity to a railway line." It would require grounds "of at least fifty acres." This was to provide "a certain degree of freedom and healthful exercise of the inmates while attending to gardens and fruit, poultry raising, bee-keeping and such." At a projected $36,550, they envisioned an eleven-building complex, including a fully equipped venereal hospital. The group defended the cost with a bit of irony. It was true, they admitted, that under the old fining system prostitutes had "been a source of revenue to the city treasury to the extent of some $10,000 a year." In that case, the members offered, "it might be estimated that they have already contributed the funds for a place for the care and treatment of their successors."[42]

Despite general agreement on the worth of the project, fiscal reality intervened. In the city's changeover to commission government, outside consultants discovered gross discrepancies in budgeting and accounting procedures. By their reckoning, Portland's finances had been precarious for some time. Although disappointed, the detention home supporters did what they could to alleviate existing conditions. Baldwin deferred placing minors in the new state industrial home so it could accommodate young adult sexual offenders. Mayor Albee authorized the women's police to find a way to teach "industrial pursuits" to idle jailed females. Baldwin persuaded Grace Purse of the Episcopal Social Service League to begin a sewing class for women prisoners. As a bonus, the latter venture eased city finances by turning out inmate clothing at minimal cost. Yet Purse soon complained to the policewoman that the class did nothing to change the basic deficiencies of the jailing system.[43]

In an open endorsement of the detention home idea, Purse told Baldwin that the jail had "little effect, either as a punishment or a corrective." Whatever

incarceration hoped to "achieve as a preventive through fear" was overcome after the first use. Many of those in her sewing class, she pointed out, were "serving a third, fifth, or even thirteenth sentence." When they completed their terms, most returned to the streets and their old immoral associates. Sewing or other busy-work did nothing to encourage them to change. "Some provision," Purse urged, "should be made to prepare them for some *congenial* occupation for their future." Moreover, she asserted, "it would in the end prove much cheaper for the city to work out some such system for them, rather than to pay their board intermittently." Purse decried "the waste in human life" inherent in the nonreformative jail regimen. "No method of correction and instruction," she concluded, would prove effective if it denied what she called "the personal equation."[44]

Meanwhile, the detention home lobby proceeded to boost the idea of the facility. Judge Stevenson lauded the idea of "an industrial farm for the uplift of women of the underworld" in a speech before the annual meeting of the Pacific Coast Rescue and Protection Society. Mayor Albee informed the police commissioner of Dallas, Texas, that "before very long" Portland would have a state-of-the-art place for "unfortunate women." By late fall 1913, interested parties readied a more modest proposal. Albee engineered an appropriation of $15,000 in the 1914 budget so that the municipality might show good faith and at least purchase a site. The mayor expressed his conviction that the city's contribution, embellished by "gifts from public-spirited men and women," would make the home a reality. The success of the project, he enthused, would go far toward proving that Portland could be "cleaned up of its social outcasts, and kept clean of them."[45]

Almost a year later the city bought a forty-acre site near Troutdale for the women's detention facility. Baldwin was delighted and immediately offered the city her expertise and that of her Hillcrest School planning compatriot Aristene Felts. Their committee, the policewoman informed Albee, had "gone into the matter of plans and specifications quite extensively." She asked if the two could show him "photographs and plans," as well as "some very interesting data" secured by Felts on a recent visit to New York's famed Bedford Hills Women's Reformatory. The drawing-board stage went forward optimistically. Western secretary Thomas D. Eliot of the American Social Hygiene Association sent Albee his encouragement from San Francisco. He was glad to see that Portland was to begin "intelligent dealing with the social evil." He was pleased that the city was facing the problem of women "unfit for any normal life without a thorough course of training under indeterminate sentence in an institution of the type of Bedford Reformatory."[46]

Despite planners' enthusiasm, realization of the detention home remained elusive. Although Albee went so far as to entertain suggestions for a superintendent for the proposed institution in mid-1915, no further money was appropriated for the women's reformatory for almost another three years. It was not until January 1918, under Mayor George L. Baker, that the city approved $25,000 for construction and operation of a women's venereal detention facility. Ironically, although policewoman Baldwin was in some ways key to the process, the move was not in fact made in response to local lobbying efforts, but rather as part of compliance with federal wartime venereal disease abatement regulations for cities near military encampments. After hasty construction, "The Cedars," as it was called, began to accommodate "infected and uninfected prostitutes, the former for treatment, and both for an extensive system of rehabilitation."[47]

Much of the new penology aided the era's campaign against prostitution and venereal disease. Baldwin, as "municipal mother," kept a strict eye on young urban women, and actively fought the pitfalls which might entice them into sexual commerce. Her surveillance of probationers and parolees prevented repeat morals offenses. The detention homes she supported were built with the best of social feminist intentions. As the idea of the diseased prostitute took on monstrous proportions, the medical-reformist movement began to dominate corrections measures. Organizations like the Social Hygiene Society convinced the public that both the casual prostitute earning "side money" and the confirmed brothel inmate were equal threats to family life. The effectiveness of this message is clear in the women's clubs' insistence that Hillcrest be sustained to keep sexual delinquents out of circulation. Although official funding lagged, the people seemed willing to approve incarceration measures which would assure, as Mayor Albee suggested, an environment "cleaned up of its social outcasts and kept clean of them." Placing these outcasts out of sight in rural detention played perfectly to such sentiments.[48]

Well-meaning reform of the treatment of prostitutes had a paradoxic dark side. The elimination of the "fine and release" system and its replacement by medical detention and rehabilitation meant prolonged custodial care. The touted humanity of such treatment made it easy for voters to approve long sentences to innocent-sounding "farm colonies," "homes," and "schools." Yet the inseparable association of prostitutes with venereal disease caused the public to inordinately fear the fallen woman it had once seen as a victim. As abatement laws closed the red light districts, detention became a "public health" expedient for disposing of former inmates. As an extension of this trend, the social hygiene element dictated national policy as the country

mobilized to enter World War I. Many prominent social hygienists and women from the ranks of the new penology answered a federal call to fight an enemy as vicious as "the Hun." As officials declared "moral martial law," Portland's Lola Baldwin volunteered for the domestic effort to eliminate the venereal threat to "our boys" training for service in France.

I know you are needed in Portland,
but I am sure you can do a still greater service as our field worker in the
War Department Commission on Training Camp Activities.

—Maude Miner to Lola G. Baldwin, February 8, 1918

8

Defending "Moral Martial Law"

In the period just before World War I, social hygienists across the nation helped frame prostitution abatement laws to facilitate the passing of the red light district. The federal government's "American Plan" of wartime morals training for military personnel and its companion civilian antivice campaign effectively completed the process. The social hygiene agenda had become so influential that abstinence became the watchword for soldiers and sailors traditionally among the brothel's best customers. In 1917 the American Social Hygiene Association and its affiliates fashioned a national wartime morals program under the direction of Secretary of War Newton D. Baker. It provided mass sex education and venereal disease warning for recruits, closed the remaining red light districts, and mandated "moral martial law" within a five-mile radius of any military facility. Part of the effort, under reformer Raymond B. Fosdick's Commission on Training Camp Activities, called for the policing of women and girls who lived or worked in or near such "sanitized zones."[1]

William F. Snow, general secretary of the American Social Hygiene Association and a major in the Medical Reserve Corps, stated the problem succinctly. American boys were being sent to Europe, he wrote, to engage the dual alliance of Germany and Austria-Hungary. Yet while the men were

Note: "moral martial law" is a term coined by the author to describe the federal morals policing efforts in areas surrounding military encampments and facilities during World War I.

in training camps, there was "an even more dangerous and insidious enemy to be fought here at home." He referred, he said, to the "triple alliance of alcohol, prostitution, and venereal diseases." The "lines of defense" against this triad, he continued, included "social measures to diminish sexual temptation, education of soldiers and civilians in regard to venereal diseases, and measures against these diseases." Moreover, he asserted, "war conditions" would accentuate the need for "adequate civil control of prostitution, alcohol, and exposure to infection." He urged all local governments and civilians to do their part to ensure that such snares were eliminated from the areas near encampments.[2]

In September 1917, Commissioner Fosdick appointed New York probation and parole worker Maude E. Miner to head his Committee on Protective Work for Women and Girls. The panel attracted social workers, police, and juvenile reformers, and a host of women's organization representatives. The stellar roster included Mrs. John D. Rockefeller, Jr., Julia Lathrop of Hull House and the National Children's Bureau, penal reformer Martha Falconer of Philadelphia, Ethel S. Dummer, underwriter of the Chicago Psychopathic Institute for Juvenile Offenders, Dr. Katherine Bement Davis of the Bedford Hills Women's Reformatory, and settlement house worker Jane Deeter Rippin. Their major objective was to police "the numbers of girls who left their homes, local or in nearby cities, to hang about the camps."[3]

When Fosdick asked Miner to suggest others experienced in "girl work," she recommended her northwestern compatriot Lola Baldwin. In November of 1917, according to Baldwin, Fosdick approached her about becoming his regional field secretary. In her new capacity, she would initiate and supervise "war emergency" protective morals restrictions and venereal treatment and prevention services in Portland and other northwest cities. Her duties were very similar to her customary policewoman's work, yet her federal mantle would authorize her to ask for whatever local cooperation she deemed necessary. The War Department empowered her to obtain by special ordinance any regulations or facilities germane to the effort. That meant she could finally secure certain moral and medical reforms in Portland that she and others had long advocated.[4]

Secretary of War Baker had sent out letters to all mayors of cities near military facilities. Like other executives, Portland's Mayor George L. Baker was advised that federal authorities would not tolerate vice districts, streetwalkers, or "clandestine prostitutes apt to frequent lodging houses and hotels" near the camps. Portland had officially closed its North End to brothels in 1913, yet Baldwin and others still complained about hotelkeepers who accommodated couples who obviously were not married. The United States

Public Health Service was empowered to obtain local cooperation to monitor venereal disease, distribute warning literature, and provide clinic, hospital, or medical detention care for "those already infected of both sexes." Portland's social hygiene element, including its head policewoman, had been eager for such comprehensive venereal disease control since the vice commission's first report of January 1912. In addition, the tantalizing possibility of a *mandated* detention hospital resurrected a project dear to many Rose City vice reformers.[5]

Late in November 1917, the city amended its public health code to include stringent venereal disease regulations. Doctors were required to report all cases to the health department, giving the person's age, sex, color, marital status and occupation, and the nature, duration, and probable origin of the illness. Druggists were ordered to report the name, sex, and address of anyone attempting to purchase medicine ordinarily used to treat venereal sickness. The city health officer was authorized to investigate and examine anyone suspected of being infectious. The intent of this provision was clear, as it stated that "owing to the prevalence of such disease among prostitutes, all such persons may be considered within the above class." Since prostitution was the "most prolific source of infection," the health officer "and all other officers" were directed to use "every proper means of suppressing the same." The health officer was to quarantine and treat all cases until declared noninfectious. Exposing others to infection became a criminal act, punishable, as was any violation of the code, by a $500 fine, six months in jail, or both.[6]

The ordinance was intentionally framed to provide for the detention of the "diseased prostitute." The health officer was ordered to quarantine victims for treatment, yet that stipulation was not universally applied. The code contained an escape clause which was clearly intended for the "better sort" of patient. "In lieu of isolation," an infected person could post a $1,000 bond, and agree to show up for prescribed medical care. As the ordinance was originally written, anyone could put up such surety and remain at large. Within days, the section was amended to require the subject to swear under oath that he or she was "not a prostitute," and to present a certificate signed by the mayor, the police chief, and a municipal judge attesting to the same.[7]

If the city *assumed* all prostitutes to be diseased, it would have to find a suitable place for them. The venereal disease code directed the city council to approve or provide "buildings for quarantine purposes." It was apparent that the venereal beds in the local hospitals were not secure enough for the type of isolation the city and War Department had in mind. After the health ordinance passed, several cells at the Kelly Butte jail were reserved for

venereal detention use, but they soon proved impractical and inadequate. On January 2, 1918, the city agreed to provide for the construction and operation of a specialized detention home for women on the site purchased during the Albee administration. For Baldwin and her social hygiene friends, it was the realization of a long-held dream. In line with federal suggestions, the city "planned to commit infected and uninfected prostitutes to this home, the former for treatment, and both for an extensive system of rehabilitation." Baldwin wrote to her federal superior Jane Deeter Rippin that "The Cedars," as it was named, would be ready for occupancy by early summer 1918. Portland was the first city in the nation to voluntarily build a wartime venereal isolation center for women. Oregon's U. S. Senator George Chamberlain was so pleased with the Rose City project that it became the prototype for uniform national urban antivenereal programs under the 1918 Chamberlain-Kahn Act.[8]

Although brothel prostitution disappeared from Portland following the 1913 abatement and injunction law, innovative forms of the oldest profession were still in evidence as the war approached. The now-underground sex industry had modernized along with the rest of society. By the mid-1910s, the telephone, private automobile or taxi, and the discreet hotel combined to assure that males "in the know" could still find intimate feminine companionship. As martial mobilization proceeded, however, federal authorities increasingly targeted clandestine sexual commerce. Portland and other military-zone cities cooperated in efforts to suppress the social evil wherever and in whatever form it was discovered.[9]

On the same day the city funded the women's detention home, it strengthened the local hotel and lodging house regulations. All were required to be licensed annually, and only persons of "ascertained good moral character" would be granted permits. To remain in compliance, the licensee could not allow the facility to be used "for the purpose of prostitution, fornication or lewdness, or suffer any lascivious cohabitation, adultery, or other immoral practice." Strict registers were to be kept noting names, room numbers, and times of rental. These books could be inspected at any time by police, health department, or other officials. It became unlawful to register under an assumed name, or for two people of the opposite sex to share a room, unless provably child and parent or documented husband and wife. Violations were punishable to the same jail and fine limits as the venereal disease code.[10]

As part of its cooperation with federal authorities to stem the venereal plague, the city tightened its so-called "public morality and decency" code. It forbade bringing persons together for immoral purposes by any means,

including the telephone, telegraph, private automobile, taxi or other public conveyance. Baldwin had encountered the innovative "call girl" as early as 1911, but the practice multiplied once the red light district was closed. After Oregon's alcohol prohibition law went into effect in 1916, some cab drivers began offering an updated version of the old "joyride." Their so-called "rolling roadhouses" offered bootleg liquor, fast women, and plush, discreetly curtained back seats. The amended code made drivers criminally liable for ferrying couples around the streets in such contraptions.[11]

On the national front, some aspects of the federal morals program ran into unexpected problems. When it was first established, Maude Miner's Committee on Women and Girls assumed it would be preventing the sexual ruin of innocent girls by libidinous recruits. Six months of operational experience, however, showed quite the opposite. A new class of sexual delinquent surfaced. Apparently smitten by so-called "uniformitis," troops of young "charity girls" or "patriotic prostitutes" sought to help the war effort by dispensing free sexual favors to the servicemen. To their dismay, federal social hygiene workers like Baldwin found that such delinquents often outnumbered "good" girls in training camp areas. As a result of this discovery, the government female protective service reorganized its mission, adding a law enforcement component to deal solely with the legal restraint of delinquent women and girls from what it termed "almost unchecked access to the enlisted men."[12]

To facilitate the work of its new morals squads, the federal government divided the country into nine geographic districts. In early 1918, Raymond Fosdick promoted northwest field secretary Lola Baldwin to the job of supervisor of the law enforcement division of the Seventh District, which covered the entire Pacific coast and Arizona. As soon as she cleared up loose ends in Portland, she moved to San Francisco, and set up an office in the Flood Building on Market Street. Within each national district, the reorganization of the Committee on Protective Work for Women and Girls completely relegated protective and recreational activities concerning nondelinquent girls to local women's clubs, settlement houses, YWCAs, girls clubs, and other voluntary groups. Federal law enforcement appointees like Baldwin were to deal exclusively with the legal restraint of sexually delinquent girls and women. Within a five-mile radius of any military facility on the west coast, she and the "fixed post representatives" she appointed had the authority to arrest and detain for an indeterminate period any female even suspected of sexual immorality.[13]

As Baldwin left to assume her wartime duties, Portland's government placed her on honorable leave, and gave her an unexpected parting gift. She

had been arguing without success for years for an increase in the number of Rose City policewomen beyond a stagnant three or four. Her benefactor proved to be a man who had once been part of an attempt to eliminate her section altogether. Mayor George L. Baker, at the urging of Portland's women's clubs, directed the city council to ask for appointment of six additional female officers "as a war emergency." Within a week the city received over sixty-five applications for what the press interchangeably called "policewomen," "feminine patrolmen," or "women policemen." With the war on, Mayor Baker conceded, it was difficult to get men for police service. Therefore he favored "the appointment of women in every position that can be handled by women." Yet it was ironic that the policewomen's service, which had been organized to protect the moral interests of young women, would be substantially expanded for the first time, as the enabling ordinance read, "in order that better protection be afforded the boys serving their country."[14]

The mayor elevated policewoman Wilma Chandler Crounse, who had been Baldwin's assistant since 1909, to replace her as superintendent. But Crouse, having recently married, decided to retire to become a homemaker. As policewoman and nurse Martha Randall had volunteered for overseas medical service, she was also not available. Baker then tapped Abbie Frankel, the president of the Portland Federation of Women's Organizations, to fill Baldwin's position. Frankel suggested a panel of women to screen applicants. The committee included Frankel, policewoman Crounse, the wife of Police Chief Nelson Johnson, Mrs. Sol Blumauer of the Council of Jewish Women, Mrs. John Manning of the Woman's Club, and Mrs. W. C. Alvord and Mrs. William MacMaster of the Women's Union. They chose women with the most experience working with young girls to serve as the six temporary officers.[15]

The federal section governing wartime moral behavior of women and girls was officially placed under the law enforcement division of the War Department Commission on Training Camp Activities in April 1918. After Baldwin was formally confirmed as Seventh District Supervisor, she was authorized to select and appoint "fixed post representatives" who would oversee the extensive "sanitized zones" around military facilities. She supervised their work and made suggestions to stimulate "both the camp and the surrounding community to greater activity along lines which affected the safety of women and of the men in uniform." She coordinated vice suppression efforts by government and private organizations to reduce inefficiency. As the military zones were all declared "dry," Baldwin was expected to "cooperate with and supplement the work of the men in the Section on Vice and Liquor Control." In addition, she was directed to "assist

with social legislation and to collect special data" as requested by her War Department superiors.[16]

As part of Baldwin's assignment, she was expected to salvage as many "borderline girls" as possible given the difficult circumstances. Many of her detainees were the young sex offenders commonly called "charity girls." A large number were runaways with a history of at least one sexual experience, quite often as a kindness to someone in uniform. They had not yet become prostitutes in the commercial sense, and therefore were felt to be more open to reform. It was the supervisor's duty to investigate each girl and turn her over to the local civilian or government agency "best fit to assume care for her." Some young women were released to parental custody after heart-to-heart lectures in which Baldwin or another worker tried to instill "the desire and capacity for self-correction." In many instances, however, the investigator discovered the girl to be incorrigible or suffering from some mental defect. These women and girls were declared to be a "menace and responsibility to the community," and prime candidates for some form of prolonged detention.[17]

Although many of the girls handled by wartime morals agents had arrest records for prostitution, others were detained merely for "loitering around parks, beaches, or the vicinity of training camps, or because they were thought to be diseased, runaways, or incorrigibles." Portland authorities reported to federal officials that they could hold girls simply by "accusing them of being feeble-minded, and consequently a menace to be at large." Nationwide, almost 16,000 young women and girls, "average age twenty," were remanded to jails, detention facilities, institutions for the feeble minded, venereal hospitals, or farm colonies. The study of their case records by the U. S. Children's Bureau produced the first comprehensive national survey of female sexual delinquency. Many were held under indeterminate sentences beyond the duration of the war, as the federal antivenereal campaign persisted through several years of military demobilization. During the war, a total of seventeen venereal detention homes like Portland's The Cedars were constructed through the urging of the federal law enforcement section on women and girls. In the west's Seventh District, Lola Baldwin put her personal stamp on those in Portland, Tacoma, San Diego, and Los Angeles.[18]

Baldwin frequently boasted to her wartime superiors of the achievements of Oregon's girls' industrial school. Its inmates raised and canned small fruits and vegetables for the war effort, she reported, under the expert supervision of "a specialist woman farmer in cooperation with the Oregon Agricultural College." In addition the school maintained "a fine herd of dairy cattle," assuring the young women "an abundance of milk." Although the girls worked outside seasonally, Baldwin asked Washington for funds for "a

covered exercise area, as Oregon has a long rainy season." Compared with other facilities she had visited, she claimed that Hillcrest was "the best institution on the west coast." She always insisted that nothing in the school's program could be construed as "punishment." Yet conditions at other industrial schools were not as rosy. She wrote, for example, of finding "serious trouble at the California State School for Girls at Ventura." She took testimony from a number of young women who said they had been placed in a "no privilege" cottage for forty-five days, during which time they were "fed on bread and water." When they complained, the staff punished them by "turning hoses on them." Baldwin's report brought an investigative visit by renowned penologist Martha Falconer, head of the federal Section on Reformatories and Detention Houses.[19]

While Falconer was on the west coast, Baldwin asked her to help convince San Diego officials to build a female venereal detention home like the one in Portland. The city attorney was against the outlay, intimating to Baldwin that "San Diego did not have the number of women miscreants to warrant such an institution." He seemed "quite surprised" when Baldwin produced records which showed that "five hundred women" had been arrested on morals charges within the city limits during the past year. Most had been fined and released, and the result showed in the numbers of new venereal cases reported. Baldwin asserted that many more would have been taken out of circulation if the judges had had a proper place to send them when they "felt the women would have benefited by such a sentence." She suggested a rural site in nearby "pueblo lands" controlled by the federal government. When Falconer added $10,000 in government appropriations, the "proposition met with the approval of all present." A pleased Baldwin then proceeded to establish a "model farm" where sexually remiss women and girls could be sent for terms in excess of six months.[20]

In her investigation of problems near military installations, Baldwin noted that the uniformed men rarely made advances toward any girl who was "modestly attired and walking as though she had a legitimate errand." It was the "multitude of short skirt silly girls wandering aimlessly about" who were considered the "real menace" by authorities. No matter which west coast city or detention facility she visited, it was rare that Baldwin did not meet at least one girl she already knew. In her very first tour of a San Francisco venereal ward, she overheard a whispered: "For God's sake, don't let Mrs. Baldwin see me!" She turned and discovered a familiar Portland girl. The young woman's husband had just been sent to federal prison for soliciting for her, and she was infected with syphilis. The federal morals supervisor thereafter began a standard practice of photographing detainees to "more easily trace venereal

cases from city to city." The girls used aliases so frequently that name-only records were useless. If the young woman was released, the picture was held in confidence "unless she broke parole."[21]

Many girls were lured to training camp areas by soldiers who promised them marriage as a ploy to obtain sexual favors. Too often the boy shipped out, never having intended to wed in the first place. Agents like Baldwin were then forced to deal with girls who were pregnant, diseased, or in danger of taking up in similar fashion with another soldier in order to survive. Yet at times, as in the case of a young Portland military recruit, the game was worked the other way. A young woman had talked him into marrying her just before he was scheduled to leave for France, but subsequent letters from his family caused him to doubt his wife's fidelity. At the request of his superiors, Baldwin investigated and discovered that the girl was being detained in the Rose City on suspicion of prostitution. The federal policewoman acted to have the man's military pay, which had been going to his wife, diverted to "his aged and needy mother." Military authorities then procured the young man a divorce from what Baldwin described as "a dissolute girl who married him solely for his allotment."[22]

Among the cities in her jurisdiction, Baldwin gave San Francisco "the prize for fast women on its streets and in its cafes." By mid-afternoon, flashy pimps and their "dolls" appeared in the siderooms of the cheap eateries. With the Presidio Army Post right in its midst, the entire city was supposed to be a federally mandated vice-controlled "dry zone." Yet the lascivious element openly lounged about, drank liquor, joked, and talked business with men in uniform. While all this went on, Baldwin reported, "decent people" ate their meals on the other side of the room. In what Baldwin termed "the San Francisco spirit," no one, not even the police, paid any attention. She began eating in the places herself, she wrote, "in order to observe." She recorded "great numbers of mere girls" hanging around who evidently were not working day jobs. Yet when she informed the city's chief of detectives about the illegal drinking and solicitation in the lowbrow restaurants, he flatly told her that such places "did not exist." Eyes opened, she declared to her federal superiors that she "did not have a high regard for the San Francisco police department."[23]

That opinion was compounded one chilly night, when another side of the Barbary Coast revealed itself. Amidst the late evening crowd at 3rd and Market, Baldwin encountered "an American boy" about seventeen who was "powdered, rouged, and perfumed." When she questioned a nearby patrolman about him, he said frankly that up to fifteen such young men congregated there each evening "attracting Greeks for immoral purposes." For a fee of 50¢,

the policeman continued, the boys took customers to their cheap rooms nearby. It was "strange," she wrote, "that policemen should know this condition and not consider it their business." Not long after this incident, her office received a tip about a so-called "Married Woman's Club" which operated in a downtown hotel. When morals agents raided the establishment they discovered "little girls as young as twelve" being used for sexual purposes by older women, although it is unclear from the report if the women were using the girls themselves, or turning them over to men. Baldwin turned the matter over to the juvenile court for prosecution, sadly wiser to the darker side of the human condition.[24]

Less than a week after she inquired about the young male prostitute, Baldwin found herself in a position to show up the entire San Francisco police department. In fact, she scooped private and public investigators throughout the west. On November 1, 1918, the East Side Bank in Portland was robbed of $40,000 in cash and liberty bonds by a young male clerk. The bank offered a $4,000 reward for the capture of the man, Arthur Davis, whose picture was widely circulated to police and private detective agencies up and down the coast. On December 16, an alert Baldwin spotted him on a San Francisco street and apprehended him without incident. She realized she knew his family, and before turning him in, she convinced him to take her to his room to recover the money. Ever wary of the local authorities, she counted it and had the amount verified by a bank before she surrendered it. She eventually received the reward, and distributed it among agencies serving women and girls. "The mere recital of the facts," a Portland newspaper enthused several days later, was "sufficient to establish the great credit due the lady detective."[25]

Baldwin sent reports of lax enforcement problems within her jurisdiction back to Washington. She complained that moral conditions in hotels were getting worse. Many "so-called first class hotels," she penned, were "admitting objectionable people." When Baldwin stopped at the Olympus in Tacoma, she asked for a $2.50 room in order to stretch her $4.99 per diem. The desk clerk told her that he "could rent a room three times over in a night for $2.00," therefore he did not have any for a single customer at the price she wanted. In reporting the matter, she pointed to the "model hotel ordinance" in place in her hometown. She distributed copies of both it and the Portland dance hall code to cities within her federal control, and by request to locales in other parts of the country. "Portland," she boasted to her eastern higher-ups, performed "the best work in the Seventh District."[26]

When hostilities ceased in November 1918, the federal government opted to continue its "moral martial law" in order to safeguard the returning troops. Jane Deeter Rippin, Baldwin's superior in Washington, begged her to stay on

until the War Department no longer required her. She wrote that the need for morals policing would only be intensified as the boys came home again. She informed Baldwin that the Secretary of War had "just detailed fifty more men of the Vice and Liquor Control Section" to help in their postwar efforts. She even hinted that some of their programs might be set up near overseas demobilization centers. Worried that the end of active fighting meant the end of her leave of absence, Baldwin wrote for Mayor Baker's advice. He telegraphed to reassure her that her leave was in force until the formal peace was signed. Relieved, she continued in her position until the national program was dismantled at the end of 1920.[27]

As an important part of her war work, Baldwin monitored court and probation procedures in the cities within her jurisdiction. She had not, she wrote to Washington, "met a single judge who was not interested" in the federal program. Yet she conceded that many of them had "very little idea or understanding" of its antivenereal underpinnings. She had a great deal of trouble with citizen juries in that regard as well. Their attitude was to "give the poor thing a chance," and many panels would "not convict women, even when the evidence was strong in the extreme." Baldwin vehemently rejected the notion that releasing suspect women or girls without medical treatment or correction gave them, or society, "the right kind of chance." Portland's morals court, she noted, had "a fine judge," and she believed that immorality cases there were "absolutely honestly conducted." In San Francisco, on the other hand, the outcome often depended on both the particular judge and "who brought the case." She complained that probation programs were "weak in most cities for lack of sufficiently trained workers." Due to the haste with which the federal program was assembled in some places, she said, some of the local policewomen unfortunately were "not chosen for their fitness."[28]

Although the Portland adult morals court completely accepted the idea of indeterminate medical detention, not all of the city's judicial venues agreed with the premises of federal venereal abatement. By June of 1918 a furious jurisdictional and custodial tug-of-war had developed between the Women's Protective Division, acting in the interests of the federal program, and Judge George Tazewell of the juvenile court. A disgruntled Baldwin wrote to Washington that legal measures were being "employed against us in juvenile courts, especially in Portland." Over the protests of the protective division, Tazewell often released minor female sexual delinquents on their own recognizance, or did not follow up in cases of bail skipping. In Baldwin's estimation, Tazewell's actions directly contradicted health regulations that those "reasonably suspected of being infected," with no statutory regard to age, were subject to medical detention.[29]

This struggle between the juvenile court and the policewomen went back farther than the war years. The titles under which the division operated over time give insight into later difficulties. The section was initiated in 1908 as the "Women's Auxiliary to the Police Department for the Protection of Girls." In 1909, it was incorporated into the police department by charter amendment as the "Women's Auxiliary, Department of Police, Public Safety for Young Women." Under both these names, the section generally cooperated with the juvenile court, although Baldwin disagreed with some judges on the culpability issue. But in 1913, when city departments and courts were reorganized under the commission form of government, Baldwin's section began to switch its emphasis to older women. For the first time, her offices were physically located at police headquarters, and she took on all women's probation and parole work for the municipal court. Although at first she chose the benign-sounding masthead of "Municipal Bureau for Protection of Women," even she admitted that the young female public began linking her with "authority" rather than "advice." By late 1914, the unit officially became the "Department of Public Safety Women's Protective Division."[30]

When juvenile courts were first established in Portland and other cities, they were closely associated with the problem of delinquent boys. Victorian-raised male judges were not yet comfortable in dealing with young girls, especially in cases of sexual delinquency, and Portland's early children's court apparently abdicated that discomfiting responsibility to the policewomen. But when the city's 1913 court reorganization clarified jurisdictional lines, a more self-conscious juvenile court claimed its due. In the past, Baldwin had made ad hoc decisions on whether to turn a minor over to the juvenile court. Her new offices in the police station contained a holding room which she described in print as "very convenient for the detaining of young girls until we can communicate with their parents or send them to the juvenile court." Such arbitrary case disposal seemed a trespass of authority to juvenile court officials, who expected a strict accounting of all minor females who came through the women's division.[31]

The uneasy peace between the policewomen and the juvenile court was shattered by the wartime antidisease regimen. After the venereal detention home opened, Judge Tazewell met with Baldwin's replacement Abbie Frankel and Police Chief Nelson Johnson. The judge thought they reached an understanding on that occasion that "all juvenile girls arrested by police officers should at once be surrendered to the juvenile court." Two months later, however, he found that the policewomen had apparently dispensed with *habeas corpus* in the cases of at least two and possibly more minor female sex offenders. A seventeen-year-old had been held at the venereal

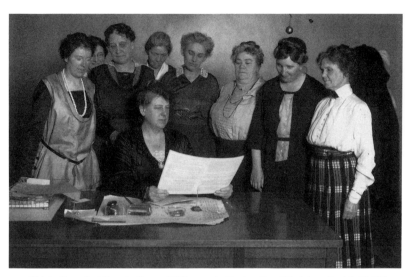

Abbie Frankel (seated) and Women's Protective Division (mid-1918)
Photograph: Oregon Historical Society (negative Journal 290B)

home for forty-one days before Tazewell was notified. A girl of fifteen was similarly detained for fifty-six days "without the matter ever having been taken up by the juvenile court." It was "decidedly against both the letter and spirit of the juvenile law," Tazewell informed Mayor Baker, "for any juvenile to be detained by any police officer." He was especially incensed that minors were being "incarcerated with older offenders" at The Cedars. It was, he concluded, "not improving the morals or the future of any girl to be kept with such women as these young girls have been."[32]

Tazewell accused the policewomen of noncompliance with the state juvenile code. Frankel challenged the judge on his interpretation of the law, noting with emphasis that the statute read "a reputable person *may* file complaint with the Juvenile Court. It does not say must." She and Chief Johnson had come away from the earlier conference with impressions entirely different from Tazewell's. Both insisted to Mayor Baker that the judge had welcomed the policewomen's help with girl cases, as the youth court was "not equipped with sufficient workers to make such investigations." Yet in the judge's mind, the right to investigate evidently did not include the right to detain *during* the investigation. In fact, even keeping a girl for one night in the detention room at headquarters constituted a violation of the law, in his opinion. Tazewell was undeniably correct in this, as the state code specified that minors had to be kept "outside of the enclosure of any jail or police station." The women's protective division was also legally remiss in placing juvenile offenders in the same building with adults.[33]

When Judge Tazewell did not receive what he felt were adequate explanations from the women's department, he dragged the mayor and the chief of police into the battle. He noted that certain boys who had been caught "borrowing" automobiles had mysteriously never come before his bench. One of the offenders was supposedly the "son of one of the city commissioners," and several others were from well-to-do families. The cases were apparently discreetly disposed of by Chief Johnson. It served "no good purpose," the judge observed, to instill in the minds of youth that on the basis of the "social or financial standing of their parents they be immune from being called to account for misdeeds." He accused Mayor Baker of intervening so that one case in particular was handled quietly in the chief's office when it should have been given immediately to the juvenile court. In addition he turned up evidence that four more minor girls were held in the Women's Protective Division detention rooms at police headquarters "from two to five days."[34]

Frankel turned in full explanatory reports for the juvenile girls she had held, and both she and the chief assumed the matter was behind them. But two weeks later, Tazewell complained to Baker of another girl held for several days before surrender to his court. In addition, he charged, the policewomen had denied they had any other minors at the time, when he could prove that they did have at least one in custody. He was so upset that he threatened to "proceed against them for malfeasance of office." Frankel had provided what she believed were reasonable circumstances for holding the girls. She angrily told the chief that if the juvenile court brought up "the malfeasance business" again, she was prepared to "dig up some of the cases which *have* been turned to them, and after four days, found they have not been near the case." In spite of the judge's warning, she told the chief, she still planned to thoroughly investigate each girl whether to give her to the youth court or not. If she carried out "the letter of the law" as Tazewell insisted, Frankel concluded, her section would be "flooding the juvenile court with every girl who came into our department even for a bit of advice."[35]

With the beleaguered mayor acting as intermediary, the heated exchange between the juvenile court and the policewomen dragged on. When Baldwin turned her attention to the flap, she sought help from the federal government, which had appropriated special funds to improve venereal detention facilities. She assisted Portland officials in getting monies to expand capacity at The Cedars. To at least partially assuage Tazewell, she begged similar aid for the state industrial school for girls. She wished to enlarge Hillcrest, she wrote to Washington, "in order that the younger and more hopeful girls might be taken from The Cedars and placed at the state school under longer

sentences, where at the same time they may receive treatment for venereal disease." Although she was very angered by Tazewell's behavior, she used his charges to sweeten the argument for both allotments. At the overcrowded Portland venereal facility, she contended, minors were forced to associate with older prostitutes "under most adverse conditions" in contradiction to the state juvenile code.[36]

As troops began to return stateside to muster out, the federal morals squads persisted in their vigilance. When a triumphant Navy sailed home to its west coast ports, Baldwin and her workers strictly policed vaudeville shows and other amusements likely to attract the returning soldiers and sailors. After Baldwin's agents in San Francisco closed one dance revue and ran its performers out of town, she wired a warning to Mayor Baker that "Purcell's Negro Shimmie Dancers" were on their way north. They were officially "under the ban," she reported, as the government desired only "clean bills" in the coast cities to greet the arriving fleet. At times during demobilization, however, an enforcer more ominous than the government scoured the amusement districts clean. The influenza epidemic which ravaged the nation during the war years brought even the "sporting life" to a standstill. In San Franciso, Baldwin noted, the vice sectors became eerily quiet during the dreaded waves of illness. "Our workers have not much to report," Baldwin said of one such siege, "as all the amusements are closed, the silk-stocking girl has disappeared, and the men have been restricted to camp for weeks at a time."[37]

As the federal morals policing program continued into the postwar years, director Raymond Fosdick often praised the work of the men and women of his Law Enforcement Division. Substantially through their efforts, he wrote, "the red light district has practically ceased to be a feature of American city life." As demobilization proceeded, many of the functions of the Commission on Training Camp Activities were transferred to a new agency, the United States Interdepartmental Social Hygiene Board. Baldwin worked under its aegis in the last months of her federal tenure. After she returned to Portland, she continued to subscribe to its weekly intercity tracing memoranda of the names and descriptions of "women in cases involving moral turpitude." She was promoted twice during her three-year tour of government duty, and was called to Washington D. C. at intervals to advise her superiors. Army Medical Corps colonel Robert Field, who served with her for a time, wrote a gracious tribute to her service after the war. "To Mrs. Baldwin," he penned, "belongs the credit for influencing me and in fact converting me by her words and her quiet effective work to the idea of the value of women officials."[38]

Baldwin's federal position ended in December of 1920. At age sixty, having honorably served her country, she went back to Portland anticipating her old duties as head of a much-expanded women's protective division. Things did not work out quite as she had planned, however. The city welcomed her to her old supervisory job, but she returned to face a new chief, a shake-up in the entire police department, and a downsizing of the women's section. The war emergency over, a cost-conscious city released the extra women it had hired at the behest of the federal morals program. Baldwin's wartime replacement, the tenacious Abbie Frankel, returned to her women's club work. Although Rose City officials graciously acknowledged the senior policewoman's recent importance as a federal agent, the glow did not persist. She soon found herself in a *status quo ante* position as the supervisor of four workers in Portland instead of four hundred spread over the west coast.[39]

The wartime "red light scare" was one of the hallmarks of social hygiene influence on American society during the Progressive Era. By employing coercive state practices to combat the "diseased prostitute," the federal women's law enforcement section enabled Raymond Fosdick and others to claim that the commercial vice district had been eliminated. In the name of public health, if nothing else, much of the streetwalking element was locked away for the duration. As a bonus to the social hygienists, the antivenereal campaign in both civilian and military arenas frightened or coerced at least some males into practicing a single standard of sexual behavior. Whether they were soldiers whose pay was docked while they were infected, or private citizens who went through the embarrassment of being reported to health officials by their doctors and druggists, the message got through to a certain percentage.[40]

Through federally sanctioned wartime tactics, female policing agents like Baldwin helped foster a change in law enforcement and public attitudes toward the prostitute. Nationwide, under martial law health regulations, they arrested 35,000 women and girls on suspicion of immorality and held them without due process for extensive periods. They later claimed to have prevented an "estimated 259,524 cases" of venereal disease by this process. It was calculated to cost eleven cents to prevent a sexual encounter by incarceration, but seven dollars to medically treat one infected man. No men were ever prosecuted for using prostitutes, although military personnel were subject to pay and promotion penalties if they became diseased, and infected civilian men were required by law to seek medical attention. In neither case were the men detained. Because the government continued its morals policing well after the war, the stereotype of the criminalized prostitute became ingrained in the minds of enforcement agents and the public,

overcoming lingering prewar depictions of prostitutes as unwilling white slaves or victims of male lust. Postwar America tagged such women as diseased sexual deviants who victimized men and their innocent families and deserved incarceration.[41]

The national venereal incarceration program has been described as an expedient of "self-preservation," accepted as a "wartime consensus" in order to to protect soldiers. There was only token opposition in the United States to this aspect of federal "moral martial law." Even the clergy, many of whom were active members of the social hygiene element, failed to "criticize policies that seriously curtailed the civil liberties of women and denied them their personal liberties as well." Portland's Judge George Tazewell was one of only a few who complained of the process while it was going on. Maude Miner resigned as head of the government committee in protest after it changed its mission from protecting girls to protecting soldiers through coercive detention of young women. Dr. Kate Bushnell of the WCTU, who had pioneered white slavery investigations in the late nineteenth century, organized a demonstration in Oakland, California, in July of 1918. She publicly derided both the lack of *habeas corpus* proceedings and the dreadful compulsory medical examinations forced upon the suspected women against their will under the Chamberlain-Kahn Act. The government, in this case in the person of Seventh District Supervisor Lola Baldwin, officially "ignored such protest."[42]

Recent historians have characterized the wartime federal morals program and its detention component as part of the darker side of Progressive Era reform. Several have pointed to its complicity in the criminalization of the individual prostitute and the move away from condemnation of the environmental factors which caused her to adopt the life in the first place. One researcher noted that European reformers were appalled at the "narrow and draconian" aspects of the American Plan of venereal control, and absolutely refused its implementation in postwar demobilization zones on the Continent. Yet Baldwin retained her faith in the "public health" detention program, and maintained as much of it as possible in Portland when she returned. She assigned one of her policewomen exclusively to venereal cases, and had her appointed as a deputy state health officer. In 1921 she reported "988 persons held for the health department." Of this number, 440 were found to be infected, 243 of them females. A third of these were sent to The Cedars, which, to the end of her tenure, Baldwin insisted was "one of the most efficient and best conducted institutions of its kind in the country."[43]

From a pragmatic career standpoint, Baldwin used the national wartime popularity of the social hygiene agenda to obtain needed local institutions. Her federal position helped her to further the status and numbers of women

vice officers. Although the increases were only temporary in many instances, it may be argued that the enhanced visibility of women police during the war era made them more acceptable later on. In retrospect, it is certain that Baldwin considered her wartime federal appointment years among her best. Although she tried to preserve the elements of the national venereal program in the Rose City after her return, she never again experienced the undisputed power she wielded as overseer of the west coast's "moral martial law."[44]

*I remember with what a feeling of
responsibility I assumed the task of organizing such a department as it was
the first effort of any city to attach women to police service.*

—Lola G. Baldwin, February 6, 1922

9

Toward a New Profession

Abraham Flexner, educator, re-
former, and officer of the American Social Hygiene Association, was a
featured speaker at the 1915 National Conference of Charities and Corrections
convention in Baltimore. He informed the gathered "social workers" and
others, including policewomen, that they needed to combat a growing
perception that they were merely facilitators who parceled clients out to
established experts. In his view, a true profession had to proceed from
altruistic motives yet be essentially intellectual in character. Its practitioners
had to "initiate activities for which they were directly and personally
responsible" with an aim of practical results. The avocation, he continued,
had to "center on expertise or knowledge that was not accessible to the
general public," and use techniques based on specialized training. Moreover,
a profession should express what he called "self awareness" through an
organization of its own. The speech proved a turning point. As the
convocation ended, many of the diverse groups who functioned under the
social work umbrella determined to prove that their specialties were more
than mere occupations.[1]

Early police histories assert that the organization of the International
Association of Policewomen at the 1915 Baltimore conference was the point
at which the policewoman movement became self aware. Yet that assump-
tion dismisses the foundations laid by first policewoman Lola Baldwin.
Through her contacts in the fields of social service, women's organizations,
and penology, the word about her police program spread steadily after its

inception in 1908. Baldwin proved an effective evangelist who insisted from the beginning that police work was a legitimate career for women interested in protecting their own sex. She had used this social feminist sense of mission as a bargaining chip in her effort to convince the city to pay for her vice policing. Her warning that other cities had asked her for reports apprised local officials that they stood on the threshold of acclaim if they made the right decision. If Portland chose to fund her agenda, she insisted, it would "be known from East to West as the city which believes in protecting and cherishing pure, sweet, young womanhood."[2]

A review of Baldwin's proselytizing and the way she organized her work in Portland is essential to an understanding of her impact on the growth of the policewomen's field. Even in the first year of her municipal status she reached out beyond the borders of Oregon to explain the need for women's police work. In May of 1908, she wrote to Edward T. Devine, one of the nation's foremost advocates of a social hygiene partnership with government to suppress "vice in all its repulsive and seductive forms." Baldwin gave him the details of her program in Portland, and asked that a subscription to his newsletter *Charities and Commons* be sent to her office "to be used in the work of this department." Several years later, when Devine changed the name of his publication to *The Survey* it became the national forum of the social hygiene movement.[3]

The YWCA network brought a substantial amount of mail to the Portland policewoman because of the Travelers' Aid connection. In September 1908, Mary Betts of the Sacramento, California, YWCA wrote asking particulars of the municipal "girl work." When Baldwin spoke at the Conference of Charities and Corrections meeting in Portland in October of that year, her expository remarks brought questions from cities throughout the northwest. YWCA representatives from Bellingham, Washington, asked her to repeat her talk there immediately after the conference. She had to decline because she was busy with the pressing needs of another neighboring city, Seattle. That municipality was preparing to host the Alaska-Yukon Exposition, and Baldwin's experience with Portland's recent world's fair made her the region's most sought-after consultant on preventive vice policing.[4]

Seattle Travelers' Aid and police officials asked Baldwin to organize a vice preventive plan for its approaching exhibition. She took several days off from her duties to talk with interested people in both that city and nearby Tacoma. She provided reports of her program and illustrated its application and success. She justified her extended stay to Rose City officials by reason of the good will and positive publicity it would bring. Oregon's largest town, she wrote in October 1908, could take justifiable pride in being "the first city to

have inaugurated the work under the Police Department." Other municipalities, she reiterated, had "been watching with interest the outcome of the work in Portland." As there was nothing of the kind being done in Seattle, it was only proper that she take time to see that it was "inaugurated at once" if any good was to be done during the fair. The Seattle female-protective element was so impressed that it telegraphed Baldwin in early December for a copy of the Portland women's police ordinance. By the end of the year, as *Evening Telegram* columnist Eleanor F. Baldwin reported, parties in six states had made similar requests for facts "with evident intention of following Portland's example."[5]

In January 1909, Mrs. Londo Fletcher of Berkeley,California, a worker for the juvenile court in San Francisco, wrote to Baldwin "very much interested in what Portland was doing." In early February, the policewoman noted a letter from a "Miss McCorkle of Richmond, Virginia, asking for details about starting protective work there." On February 9, Mrs. Winfield Smith of the Seattle Woman's Club telephoned Baldwin to inform her that the city council had passed a women's police ordinance based on the one in the Rose City. The Portland program would be adopted by Seattle almost without change. "We are particularly pleased with this," Baldwin enthused, "as it is the outcome of a plan we have cherished for some time." She felt even more strongly about it several weeks later, after she toured the dance halls and saloons of the Seattle vice district with a YWCA official. In almost every place they entered, the two women "were solicited and stared at in the most flagrant manner." Seattle, she emphasized, "certainly *needs* protective work."[6]

Within a month of Seattle's decision to employ women police officers, Baldwin noted that Tacoma's mayor had appointed "Miss Beardsley," a former Travelers' Aid agent, "to do similar work in that city to what we are doing here." After less than a year, the Portland policewoman influenced at least two other northwest cities into hiring female vice officers, and requests for information continued to come in. Grace Fisher of the Oakland, California, YWCA corresponded with Baldwin, "asking full particulars of the municipal work for women and girls in the city of Portland." The policewoman reportedly "sent her a long letter giving details." In September of 1909, Baldwin received a letter from Boston which proved to be one of the most prestigious inquiries yet encountered. A. M. Gilman, secretary of the forward-looking "Boston 1915" Exposition, asked that she send an exhibit explaining her work for inclusion in the city's upcoming municipal "progress fair."[7]

A contingent of prominent New England businessmen and reformers planned the "Boston 1915" exhibition with an eye toward the "civic and social rejuvenation" of the city. Men like Edward Filene, Louis Brandeis, and Richard

Cabot hoped to stage an affair "of real interest to the people, the everyday folks who don't care a toothpick about statistics and deep sentences." One popular exhibit, for example, consisted of a full-sized model of a healthy apartment, replete with windows, running water, and a bathroom. Across from it stood another display depicting a typical run-down flat. The whole exposition was designed so that average citizen and social worker alike could understand the purpose of the improvements being suggested for urban health. It would include, Baldwin informed Portland's Mayor Joseph Simon, "the best done anywhere in the world along the lines of civic betterment." The Boston committee asked that her police work be shown, she continued proudly, "because Portland was the first city in the United States to place a woman as a regularly appointed officer."[8]

In order that her submission "might not seem too personal," Baldwin decided to ask "sixteen representative men to state their opinions of the value of the work." She received what she termed "very satisfactory" replies from the police chief, district attorney, and several local judges, but, as her mailing deadline approached, she discovered that the mayor had not responded. When Simon explained that he was unsure of exactly what she wanted, the policewoman gave him copies of some of the letters she had already gathered. She reminded him that the completion of the packet was essential because the Massachusetts city reportedly was seriously "contemplating the establishment of such a department." Simon provided an apt description of her importance and duties for those attending the Commonwealth city's civic exposition. "In the investigation of lodging houses, dance halls, cafes, picture shows, etc.," he wrote in part, the municipal policewoman was "especially valuable, her work acting as a preventive of bad results in many instances."[9]

Baldwin elicited local patronage for the policewoman idea by lecturing before civic groups and other interested organizations. In July 1908 she spoke about her work at the summer Chautauqua program in Oregon City. Later that year, she briefed Portland's state legislators on her activities as she lobbied them for protective laws and appropriations. Over the next year, she made addresses to many of the city's major reform groups. In January 1909 she assisted Dr. L. W. Hyde of the Portland Social Hygiene Society in a lecture on "the social evil" before the membership of the YMCA. The next month, the Portland Social Science Club asked her to talk on conditions in the dance halls. In the spring, she spoke before the WCTU about the enforcement of the new "women in saloons" ordinance. In the fall the Portland Civic Institute invited her to be a featured speaker at its annual convocation. Over the next few years, she responded to invitations from the YWCA, the Travelers' Aid, the People's Institute, the Ministerial Association, the Commercial Club, and the

League of Oregon Municipalities. This last association had held its meeting in Eugene, and under Baldwin's guidance, that city soon added a women's division to its police department. All of these contacts broadened her support network, and cemented relations with social reformers of both sexes.[10]

In the summer of 1911, Mayor Allan Rushlight received a letter from J. T. Donegan, supervisor of the Central City Mission in Vancouver, British Columbia. "We have heard," he wrote, "of the splendid work which your city is doing through the Municipal Department of Public Safety for Young Women." He asked Rushlight to allow Baldwin to come north to speak "in the interest of work for girls" to the mission's women's auxiliary and the membership of the Vancouver YWCA. As a sweetener, he said the Canadians would "consider it a privilege to pay all expenses that may be incurred." In light of his former attitude about Baldwin's work, Rushlight replied with unusual enthusiasm. "I am thoroughly in sympathy with such work," the mayor penned, "and am of the opinion that the Coast Cities might all cooperate in this line." When he informed Baldwin that she was "at liberty" to accept the invitation, she graciously acknowledged his gesture. "We feel very much gratified that the work in Portland has received such favorable notice," she wrote to city hall, "and thank you for giving permission for leave of absence."[11]

Baldwin's first international foray was a resounding success. The vice reform element in Vancouver received her with open arms. Like Portland a few years earlier, the city was experiencing unprecedented growth and was becoming concerned about the moral safety of young women moving there to find work. Reformers wanted to establish a municipal protective service while the city was young, so that it could be expanded as the need required. Baldwin reportedly "touched the hearts of everyone in her audiences by her graphic descriptions of what was taking place day after day in the larger coast cities." The Portland policewoman especially warned her hearers that the young workers most likely to run into trouble were middle class. Poorer girls were usually more streetwise, she explained, and the upper classes, who did not have to work, were "chaperoned and shielded from the dangers and pitfalls of the business girl's life." Her subject was so compelling that extra talks had to be scheduled. When she left, the Vancouver, B. C. *Chronicle* reported, those who had heard her had nothing but praise for what many referred to as the "noble woman from the United States."[12]

Several days after Baldwin's return to Portland, Mayor Rushlight received a long letter from Donegan. Interspersed with his profuse thanks to the Rose City executive were descriptive insights into some of the ways Baldwin convinced others of the value of women as vice officers. "Deploring the lack

of such a work," the Canadian reform advocate wrote, "she drew attention
to the splendid institutions which Vancouver boasts for the benefit of its men."
The American policewoman, Donegan said, had made the most earnest
appeal for protecting girls that he had "ever been privileged to hear."
Baldwin's visit, he claimed, had "given an impetus to protective work in
Vancouver that nothing else could have." As a "result of her appeals and the
valuable information she imparted," he concluded, Vancouver was preparing
to institute a municipal women's protective police service "on lines similar to
those in vogue in Portland." Some months later, "Miss Miller and Mrs. Harris,"
the first policewoman candidates in any Canadian city, came to the Rose City
for training under their United States' counterparts.[13]

Although an often-cited 1925 history of women's policing implies so, the
professional association formed by Los Angeles policewoman Alice Stebbins
Wells at the 1915 Baltimore NCCC convention was not the prototype. It merely
added "international" to the title of a formal professional group which had
existed since 1912. In Portland on November 2 of that year, Lola Baldwin was
"selected to head the first organization of women police ever formed in the
United States." Over forty participants representing police departments, social
service agencies, and women's organizations from Portland, Salem, Eugene,
Seattle, Tacoma, Yakima, Spokane, San Francisco, Oakland, Sacramento, and
several smaller cities had traveled at Baldwin's invitation to a three-day
convocation at city hall. The national social hygiene journal *The Survey*
thereafter reported "considerable interest in the first conference of women
police officers held recently in Portland, Oregon." It somewhat pointedly
related to its eastern subscribers that a valuable idea supporting "the steady
progress of women toward active citizenship and public service" had first
been developed on the west coast.[14]

Portland police chief and Oregon Social Hygiene Society member Enoch
Slover told the assembly that he fully believed that only the appointment of
women officers could solve the problem of urban vice. He said that if he
assigned fifty men to burglary detail, they would "come back better and
wiser." But if the same men were put on sexual immorality cases, the chances
were that "within thirty days half of them would have fallen for the paint and
powder and beguiling ways of the women who prey on man's weakness."
Additionally, he reported to assuage certain critics, hiring women did not
necessarily make policing more expensive. The most recent per capita
estimates of cost of protection in Chicago, Philadelphia, St. Louis, and New
York ranged from $2.13 to $3.50, the chief remarked, whereas in Portland it
was only $1.09. The conferees generally concluded that policewomen would
work harder than men "to protect and save," and would "think less of

punishment" in handling those who were "destroying themselves and others through vice." There was blanket agreement with Slover's comments that women would do "better work than men in cleaning up the vice conditions in a city." The gathered female protective workers declared in summation that a minimum of one woman should be hired "for every twenty-five policemen."[15]

Baldwin reported that the organization would take the temporary title of Pacific Northwest Association of Women Engaged in Police Work and Girl Protection. The principals voted to effect nationwide status at the 1913 annual convention of the NCCC in Seattle the next summer, the first time that conference was to be held on the west coast. The new group declared as its main purpose to "bring about a system of cooperation among the women police and the women's clubs engaged in girl protection work." The initial Portland meeting worked out an information-sharing plan which included a special telegraphic code for tracing young women and the replication of programs which strengthened the protection of lone girls in the cities. The next summer, as Baldwin reported to Mayor H. R. Albee on her activities at the Seattle congress, she reflected with pride on the meeting of the new "National Organization of Women in Police Service," of which she was chosen first president. "The fact that seventeen cities now have women in police service," she informed the mayor, "certainly has proven that Portland acted wisely in inaugurating the movement."[16]

Over the next few years, Baldwin fielded inquiries about starting police-woman programs from cities large and small. In the years just before World War I, Salt Lake City, South Bend, Hartford, and St. Louis all asked for details of Portland's women's police plan. Baldwin made a good many converts when she attended meetings of state and national reform groups. She was appointed a delegate to the National Prison Congress several times by Governor Oswald West, the first time for its 1911 conference in Omaha. When the penal association met in San Francisco in October 1915, Baldwin was again asked to represent Oregon. The trip was an extremely busy one for her, as the new Western Conference of Social Workers held its first meeting in the Bay Area at the same time. Both coincided with the grand Panama-Pacific Exposition, planned to celebrate the interoceanic canal and show off a glittering San Francisco, rebuilt from the 1906 earthquake. Baldwin's report of the event was so remarkable that it deserves detailed attention.[17]

Her trip did not begin auspiciously, for soon after she boarded a coastal steamer for the voyage south, the ocean turned on her. "I struck the roughest passage the Northern Pacific S. S. Company had encountered in their 36 trips this year," she wrote to Mayor Albee from her hotel in Oakland. Not wishing to repeat the "awful sea sickness everyone suffered coming down," she

vowed to return by rail. She expressed her gratitude to the mayor for giving her two weeks of leave to attend the "two great conferences." She assured him, however, that she was not spending her time in sightseeing at the exposition. "I have not missed a session thus far of either conference," she penned, "and have notes which I can use later in our work." The Prison Congress, she continued, was "full of helpful things, and they have been greatly interested in what Portland is doing and planning." The San Francisco Travelers' Aid, YWCA, and Civic League, moreover, were all anxious that she should "give them some suggestions as to continuing their work after the fair." Everyone seemed greatly interested in the policewoman idea. Baldwin told Albee that she felt Portland was featured so prominently "for the reason that it was the first city in the United States to inaugurate such a work."[18]

Early in the first week of her California stay, Baldwin and other delegates endured a frightening natural phenomenon. "On the night of the 7th, while in conference in one of the large churches," she wrote, "something occurred not on the program—viz.—the most severe earthquake since the great disaster." When the shaking began, Baldwin was attending a city planning lecture in a room darkened to show lantern slides, so that "quite a panic resulted." Although people "quieted after a time," she reported, "the meeting was spoiled." All the theaters and other buildings were "exited immediately, and the awful roar was even worse than the quake itself." Many fainted from the strain, she wrote, and at the Hotel Oakland where she was staying "people who had retired came into the parlor in their night clothes." She counted thirteen aftershocks "between 9:30 pm and morning, but most were very light." Nonetheless, "the streets were crowded with those who felt safer in the open, and both in Oakland and S. F. people walked the streets all night."[19]

The irony of a quake spoiling the celebration of San Francisco's rebirth was not lost on those like Baldwin who experienced it, nor on local boosters, who apparently tried to hush it up. "Many tourists," the policewoman wrote to Mayor Albee several days later, "left by rail and boat next day." There was "anxiety even among the Californians," she emphasized, "while *panic* prevailed among delegates and fair visitors." Incredibly, in spite of all the excitement, she penned, "not a mention of any kind appeared in any daily paper next day." She decided to stick it out, however, and remained to the end of the conferences. The vagaries of nature aside, Baldwin returned home with "new ideas and renewed enthusiasm." While in San Francisco and Oakland, she reported, she had made "six addresses on the Portland work." In addition, she truly regretted having to turn down an "urgent invitation" from Mrs. Phoebe Hearst. The prominent social hygienist and charter officer of the General Federation of Women's Clubs wanted Baldwin to stay longer

to tell the San Francisco chief of police and other officials more about the Rose City policewomen.[20]

Baldwin's own constant public insistence that Portland had been first to hire women, plus her pioneering efforts to form a policewomen's association to regularize procedures show a self-conscious desire to establish professional credentials. Yet there was another aspect important to the idea of profession for Baldwin: access to the same wages, support staff, technology, and other accommodations enjoyed by her male counterparts. From the day she took office until the day she retired, she fought for the deserved rewards of her job status.[21]

Salary and personnel increases were contended matters during most of Baldwin's tenure. When the city approved the women's police ordinance in 1908, it agreed to hire one "female detective" and a "clerk." To the chagrin of male detectives, however, Baldwin received a captain's salary, since she was heading a department. The discrepancy came back to haunt her the next year, when what she called the "liquor interests" on the city council tried to eliminate her section. The policewoman was fortunate to have enough support from women's organizations and the male-only voting franchise to get the service incorporated into the city charter in mid-1909. Baldwin remained the lone ranked female officer until July of 1910, when her clerk Wilma Chandler was "advanced to a position as police officer" under civil service rules. Chandler was a 1907 graduate of Pacific University in Forest Grove, Oregon. Baldwin begged for Chandler's promotion because her caseload had increased dramatically with the passage of the Mann Act. The two were still expected to handle both office and outside work, however. Baldwin eventually closed the office for part of the day, explaining to officials that she had no other choice if the city did not hire a new clerk. In January 1911 the civil service board finally provided the policewomen with a secretary.[22]

Baldwin pressed her luck in late 1911, hoping to obtain still another woman officer. She said that the city's rapid population growth was far outstripping her abilities to deal with female crime. In addition, she explained that she now had Oregon's "little Mann Act" prosecutions to contend with as well. "The business of this office in regard to court cases," she wrote in her annual report for 1911, "is increasing to such an extent that it practically takes the full time of one person." Therefore, she hinted broadly, her section was "eagerly looking forward" to at least "one extra helper in the near future." The city council's police committee did provide another body, but not a woman. Instead, it gave Baldwin the loan of a male officer, provided one were available, at any time she felt it necessary. Although it was not exactly what she had in mind, she accepted the police committee's offer.[23]

As she did with other concessions won from the city, Baldwin zealously guarded her "right" to this part-time male help. In June of 1912 the police committee tried to withdraw the officer. Baldwin responded swiftly, and asked Chief Enoch Slover to intercede on the policewomen's behalf. She told him that it was difficult to convince the police oversight board that she needed the extra help. Because her offices were outside of headquarters, she contended, the panel understood very little of her work. She needed the officer who had been assigned to her "in getting a line on conditions throughout the city with regard to girls." The policewomen "kept him busy constantly," she wrote, with his most important investigative duty performed late at night. "While I believe there are some things women can do better than men in this work," she coyly conceded to her chief, "there are other things which demand the attention of a man." She concluded her plea with the hope that her section would "not be crippled by cutting down its help." With the chief's input, the police committee capitulated, and she retained the intermittent aid of a male officer.[24]

Baldwin did not give up the idea of another permanent policewoman, however, and began to lobby in the interests of a protegee, Martha Randall. An eastern-born medical nurse, Randall had succeeded Baldwin as the YWCA Travelers' Aid head in Portland. When the city of Eugene added a women's section to its police department, Baldwin recommended Randall as its supervisor. In late 1913, when the Rose City policewoman discovered that the new public safety building was to include a "finely equipped emergency hospital," she immediately thought of the Eugene women's police director. "Since it will be necessary to have a trained nurse in attendance," she wrote to Mayor Albee, "I beg to make the following recommendation." As she was about to take on all the women's parole work for the municipal court, it was "imperative," Baldwin said, that she have more help. In view of the current need for a city nurse, she offered Randall as the perfect choice, suggesting that the young woman might share time between police and clinic duties.[25]

With the increase of her workload late in 1913, Baldwin had hoped to have $500 added to her operating funds for the next fiscal period. Her budget had remained at $1,200 since 1909. The added money would help defray the cost of Randall's position. In the previous year, she told Mayor Albee, her section's activities had grown by 82 per cent, and it was only with "the greatest difficulty and sometimes to the detriment of the work" that she had kept within the appropriation. In times of financial stress, she proudly reminded the mayor, "no other department could make a better showing of economy" than the women's police service. Yet even her well-known frugality could not produce extra funds which were simply not available. The scheme for an added

policewoman had to remain on hold, but not without frequent reminders from Baldwin. In the late winter of 1914, Mayor Albee requested that Baldwin keep her office open in the evening. She said it was impossible. Although her work had "greatly increased," she reiterated, she still had "no more help than before."[26]

By June 1914 Baldwin had discovered a way to bring Randall on board. She and Judge Stevenson worked out a deal whereby some extra funds from his appropriation could be combined with monies squeezed from the policewomen's operating budget to pay for a "temporary worker." Baldwin justified the move because the uniformed male officer she had been using was called back for Rose Festival duty. Moving swiftly, the policewoman begged Mayor Albee to place Randall in the position. He did so, but only named her vaguely as a "temporary assistant." Baldwin realized she had not been specific enough in her request and immediately contacted Albee, sending along a file of recommendation letters concerning Randall. Baldwin wanted the young woman appointed with full police powers, since she would be required to "serve warrants and perform other duties of an officer of this department." She got her wish and, for the summer at least, Martha Randall had a job in the Portland Women's Protective Division.[27]

By the end of summer, Baldwin was exploring a way to make her temporary officer a permanent fixture. She discussed with the police chief and captain of vice detectives whether it would be better to again detail a man to help out, or keep Randall. Both men agreed that Randall was a prized acquisition, since, as Baldwin had pointed out a year earlier, she could also be utilized in the emergency clinic. Baldwin came prepared, and mentioned that there was enough money left in the police salary budget to keep Randall under her present status until the first of the year. At that time, it would be clear whether sufficient future monies were available; if so, Randall could take the civil service exam. Baldwin's reasoning totally convinced her male police cohorts, and with their endorsement she laid the matter before the mayor. The next day, Albee wrote to her in agreement. "Since there are sufficient funds in the police budget," he penned, "this plan is most satisfactory to me." The newest Portland policewoman was worked into the subsequent budget and made permanent under civil service. The nurse-policewoman aided her mentor faithfully. When Baldwin retired in 1922, she lobbied to have Randall named as her successor.[28]

Over her supervisory career, Baldwin paid strict attention to her workers' wages. When policewoman Wilma Chandler passed her third anniversary without receiving the usual raise, her boss pursued the matter with the ways and means committee of the city council. Backed by the mayor, police chief,

and head of the civil service board, Baldwin demanded the increase. The deserving Chandler, she wrote, had been "invaluable to the work of the department, never flinching under the most trying circumstances." The young woman had "come to the third year of her police service, at which time the men receive $100 per month automatically." Baldwin asked that amount be paid to her assistant from then on. "If a woman performs her duty as an officer as faithfully as a man," the head policewoman concluded, "she should be entitled to the same remuneration." At the same time, Baldwin obtained a $15 raise for her stenographer, Elizabeth Moorad, whom she described as "a widow with a child to support." True to this standard, one of the last requests the women's police head made at her retirement in 1922 was that her staff be allowed overtime pay.[29]

The matter of office space and equipment at times proved a challenge. Simple things like paper supplies were easily obtained, but Baldwin often had to beg and cajole for even the simplest technology necessary to her job. It was a minor triumph when the chief granted her a flashlight, but she eventually had to ask a private donor, Henrietta Failing of the Women's Union, for funds to purchase a camera. Even then, certain city officials griped about "extrava gance" when she charged film development costs to her expense account. Baldwin utilized photographs of girls as evidence and often as a way of keeping track of those who regularly assumed aliases. When she apprehended one young morphine addict, for example, she took pictures of her fresh needle marks for later court use. If one of her clients turned up missing, or if a family brought in a picture of a runaway, the head policewoman would have the photographs converted to lantern slides which were then displayed at intermission in movie theaters throughout the area.[30]

For the first four years of her police service, Baldwin utilized her original office space at the YWCA. The organization initially allowed her to use its general telephone, but after a few months it became obvious that her call volume was too great to allow this to continue. In late August of 1908 Baldwin wrote to the city auditor of the urgent need for a separate phone, but his office kept putting her requisition off. In late October, she finally went to the phone company in person to research the cost and particulars of obtaining service, and turned an itemized request in to the auditor. In spite of doing the groundwork herself, it was still another four months before the city bureaucracy authorized her to order "an automatic phone for the Women's Auxiliary." She was at last assured that girls could reach her office without hindrance and in confidence. On one significant occasion, Baldwin used her communications equipment to further gender rights. In the spring of 1913, when Portland women were about to exercise the franchise for the first time,

the policewoman loaned her telephone to the Women's Civic Progress Club to help facilitate voter registration.[31]

Baldwin's greatest technological coup concerned what had become the ultimate symbol of the police profession by the 1910s: the patrol car. The need for rapid mobility, especially at night, had plagued the policewoman from the beginning. She had to make official visits via streetcar, or by expensive taxi or hired carriage late in the evening. Portland had purchased its first patrol car and three motorcycles in 1912. The next year the city acquired another utility vehicle and four additional motorcycles. The section that used a car was charged $5 each time it did so. Baldwin, unusual for her sex at the time, knew how to drive, and took advantage of this service in emergencies. This cost the policewomen's budget dearly, but the convenience and time saved were undeniable. Both the utilitarian and prestige aspects were tantalizing, and Baldwin began to lobby for an automobile for the exclusive use of the policewomen. "The heaviest part of our work is our outside investigations," she wrote to Mayor Albee and the city commission in August 1913, "of which we made fifty in the month of July." The policewomen's beat included "everything within the city limits," she continued, so the men could well imagine how hard the women's job was "without the use of an auto."[32]

Having planted the seed with officials, Baldwin schemed to make her dream a reality. For the next year she quietly worked on a plan of action. In September 1914, she was finally ready to broach it to Mayor Albee. She wrote to him about the current financial downturn, and how it had thrown great numbers of young women out of work and into moral temptation. Through expansion, she reminded the mayor, the city now covered "53.46 square miles of territory, to every point of which our duties carry us." Each call was urgent, she said, yet the policewomen spent "much valuable time in going out to bring in girls." Therefore, Baldwin announced, she wished to "ask for a small four-passenger automobile" which the women could drive themselves. She qualified the request by stating that they did not want the car for their own pleasure or convenience, but rather that they might "save time and render more efficient service." She then played her ace. "We have planned for this expense," she said, "and by the closest economy have saved enough from our appropriation to purchase such a machine."[33]

Although the mayor and police chief had no objection to the idea, it still had to proceed through proper channels. Albee gave the letter to the city auditor, asking that the item be presented at the next regular council meeting. The auditor's office, however, took its time pricing out the car. When it suggested that Baldwin did not have enough money on hand for the purchase, she did her own shopping. Within a short time, she presented a bid

herself to the city council. She had "figured it out very closely" she insisted, and would "have enough to buy a Ford car and equip it, including a self starter." Her total, moreover, was "well within the $650 appropriation," which would "eliminate the possibility of discussion." In addition, as she had "gotten better prices" than the city purchasing agent, she included a request for upgraded shock absorbers. She did not intend to show anyone up, she explained, but wished only to expedite the approval process as the policewomen were "anxious to have the machine this winter during the bad weather." Her persistence and frugality won out. The city's motor equipment report for 1914 included "1 Ford 1914 Model five-passenger Touring Car for exclusive use in the Women's Protective Division."[34]

Baldwin was pleased with her acquisition, and soon taught policewoman Martha Randall to operate the car so that it could be used without waiting for a male driver if Baldwin were not available. The car proved a great improvement to the division's work for the municipal court. As many of their parolees worked during the daytime, the vehicle allowed the policewomen to visit them regularly at their homes or lodgings in the evening. As the summer approached, the women were better able to patrol the river beaches, parks, and other amusements. Although the machine was a welcome boon to the policewomen, it apparently aroused some jealousy among the male foot patrol. Someone badly sabotaged the vehicle while it was parked in the police department garage. As Baldwin described the incident, "the brakebeams were bent up so that they were useless, the oilcups filled with sawdust and shavings, the radiator battered in and water put in the gasoline." Regretfully, she reported having "constant trouble" with the auto from then on. The ignition became balky, and it often required "ten to thirty minutes of cranking" to start the car.[35]

Over time, the male officers got used to policewomen who could drive patrol cars. They eventually incorporated Baldwin's skills in their own stakeout work. On one memorable day in 1918, she played an integral role in a "bootleg sting" operation on the east side. As part of the plan, officers camouflaged two police cars to look like private autos. A male detective used one vehicle to pick up a suspected bootlegger named Fred Pincus, whom he had befriended for the purpose of making a substantial buy. Baldwin followed the pair in the second car, which concealed three other officers under a blanket in the back seat. She parked near the booze merchant's East Madison Street home, and waited for a prearranged sign from the first detective that the bargain had been completed. She then alerted her passengers, who converged on the house and helped place the man under arrest. The caravan then proceeded to police headquarters, although part of

Baldwin's cargo now included "a case of quart bottles of whisky" for the evidence locker.[36]

Technology such as the automobile was important to the professional self-image of the women's police, yet so were proper office accommodations. In mid-1912, when the YWCA was no longer able to rent space to Baldwin because of its own needs, she had to find other quarters. There was no room for her at the police station, and even if there had been, she was still reluctant to have her work so closely identified with the men's department. The head policewoman dickered with the manager of the Merchants' Trust Building at 6th and Washington until she obtained two rooms "at $37.50 per month, including heat, light, and janitor service." On June 26, the policewomen moved to their new home. Within a short time, however, they realized that they would need a waiting room. The bargain-conscious Baldwin persuaded the manager to rent her a third small room across the hall at only ten dollars a month extra. The new offices were physically much closer to police headquarters, and the move away from the YWCA proved to be an important transitional one for the women's division.[37]

In 1913, Baldwin reluctantly altered her traditional opposition to being housed in police headquarters when an outside civic consultant recommended the revocation of her police department status. The city had contracted with the New York-based Bureau of Municipal Research to change its government structure over to the commission format. Among other things, the consultants suggested that the women's section be removed from the police department and placed under the municipal court. When Baldwin heard of the proposal, she immediately protested. She was informed by the Municipal Research representative that her objection was too late, as the draft plan had already been made. The head policewoman responded quickly to the crisis, and pleaded with Mayor Albee to remain under the department of public safety. Baldwin complained that the consultant, "not knowing of the work," had made an arbitrary decision. "The more I think of placing the women's work under the municipal court," she wrote, "the more objectionable it seems."[38]

In a logical move to incorporate all police functions under one roof, the city was constructing a new centralized public safety building. Yet, acknowledging Baldwin's historical attitude, no provision had been made for her in the complex when the plans were drawn up. Now, however, with the consultant arguing for her *actual* separation from the police department, it had become dangerous to insist that her section "be divorced as far as possible" from it, yet be under it "in fact." As a pragmatic measure, she was forced to abandon the idea of distance, developing an "urgent need" to be

Police headquarters at 2nd and Oak, built in 1913
Photograph: Oregon Historical Society (negative OrHi 77943)

accommodated in the new municipal center. The "temporary quarters" she occupied were suddenly "far too small," and she complained of "a loss of a large amount of time and effort in going back and forth." She pointed out the city's architectural "error," and demanded to be included. On December 10, 1913, she moved to the third floor of the new public safety headquarters on Oak Street. For the first time in its history, the women's protective division was physically wedded to the police department.[39]

An examination of Baldwin's career begs to answer social reform critic Abraham Flexner's 1915 challenge to attendees of the National Conference of Charities and Corrections meeting in Baltimore to prove professional status. As developed by Portland's premier female vice officer, the occupation of "policewoman" met most or all of his criteria. She was motivated by an altruistic sense that young working women needed protection from the moral pitfalls of the commercial city. Her program was based in a social feminist intellectual certainty that women were different from men, and that it was society's *civic* duty to provide a "clean path" for them. There was never any question that the policewoman's plan was initiated in the expectation of practical results in the community. Baldwin parlayed her experience into a

distinct expertise on "girl work" which she shared with other men and women interested in establishing similar policing venues. Most of the activities she pursued were subsequently replicated in other locations with little change. She was the undeniable force behind the calling's drive for recognition through first a regional and later a national professional association.[40]

The early policewoman's job included a great deal of "social work," yet it must not be assumed that her tasks were any less dangerous than those of male officers. In the course of her public career, Baldwin was threatened with a "bullet through the head" by a relative of a man she had prosecuted for seduction. Another man, whose estranged wife went to Baldwin for protection from him, attempted to poison Baldwin with a gift of strychnine-laced tea. A stray bullet fired by the angry mother-in-law of a bigamist narrowly missed the policewoman as she sat in a Portland courtroom. For several months one winter, she was stalked by a team of "down and out class" men who shadowed her every move. Each time she investigated vice cases, she was open to the possibility of violent behavior. Despite many near-misses, her only duty-related injury came in a rather conventional manner. Although it sidelined her for several months, the only harm she ever sustained while on the job came from an automobile accident in Arizona while she was a federal agent during World War I.[41]

Any suggestion that Baldwin's task was minimal because she merely *added* women to an established profession is misplaced. She and the women's organizations who supported her faced the formidable task of reconciling the public and the state to the idea of a female in a traditionally male occupational role. Her records are unambiguous in the assertion that she felt of herself and her policewomen as a legitimate class of municipal worker. That she did as much as she possibly could to spread her new occupation to other areas affirms this. In addition, her unblinking insistence on the same benefits and equipment as her male counterparts can only be marveled at. In later years, Baldwin modestly stated that she had earned the respect of her male colleagues "by being a woman doing woman's work." Yet this disclaimer almost trivializes the strength of character which so clearly shows in an examination of her actions at the time. She fully understood the rules of the game, and played it as toughly as any of her male associates. Her record belies her later testament that her success was due to a supposed belief that "women should never undertake to do work which men can do better."[42]

She couldn't be bought; she couldn't be influenced, and she couldn't be intimidated.

—Elizabeth Moorad on Lola G. Baldwin, June 11, 1950

10

Epilogue

On May 1, 1922, sixty-two-year-old Lola Greene Baldwin officially resigned her commission. She had influenced local, regional, and national women's policing activities for seventeen years, fourteen of them as a paid municipal officer. Her writings at the time of her retirement indicate a certain weariness of spirit which seemed compounded by societal changes around her. She appeared to have a difficult time readjusting to postwar civilian duty once she shed her federal authority. As if her years of vigilance had had no effect whatever, the "Ragtime Era" had slipped unhindered into the "Jazz Age." The removal of wartime restrictions bared a Portland with drastically transformed social and cultural mores. In late 1921, for example, Baldwin publicly condemned a popular new custom of dance hall weddings. She openly criticized Judge William N. Gatens of the circuit court for conducting such ceremonies. Gatens promptly rebuffed her objections, and insisted that he and most others "believed such marriages were proper." He intimated that the head policewoman was somewhat out of touch with modern views of acceptable behavior.[1]

Compelled somehow to explain the reasons for the moral relaxation around her, Baldwin shared her feelings in her 1921 annual report. She was "forced to admit," she wrote, that conditions had worsened perceptibly since the war. The policewoman partly blamed a reaction to the lifting of restraints put in place by federal mandate, yet cited other reasons as well. She complained that high wartime wages "did not benefit the home life, nor make for thrift and industry as might have been expected." To her dismay, a nation on the threshold of the "Roaring Twenties" had exchanged thrift for

consumption. Baldwin particularly disparaged the young "flapper" in her short skirts, bobbed hair, and facial makeup. This new type, she grieved, made a "poor substitute for the modest beautiful young American girl of yesterday." The flashy clothes which had identified the prewar "bad" girl now filled almost every young woman's closet. Youth delinquency was on the rise, she continued, and the dreaded triangle of "liquor, automobiles, and dancing" appeared in most cases. She saw this primarily as "the results of too much freedom and a general lowering of standards in the American home." Until the discipline in the family improved, she warned, neither the policewomen nor the social agencies would be able to cope with the situation.[2]

Appalled that the demeanor her generation associated with the prostitute had become the norm, Baldwin lashed out at the example set by the "new woman." She scorned smoking as perhaps the most insidious behavior effected by postwar female culture. "This habit," the policewoman remonstrated, "which once would have ostracized any woman and classified her with the underworld is now in common use among women and girls who would have us believe they are decent." The "mannish" addiction had invaded the "schools, colleges, and social functions" and was even "openly practiced by some professional women." Baldwin claimed to have caught girls as young as six trying to smoke "as they had observed their elders doing." Resurrecting another issue, she rejected a move by the high schools to sponsor dances for student recreation. The public schools were "the bulwark of our national home life," she insisted, and no activities should be permitted there "to which thousands object upon the grounds of moral menace to children." Somewhat at a loss, the policewoman appeared to confuse what she termed a "sadly declining" state of postwar morality with society's attempt to define a modern set of mores. Disillusioned by the pyrrhic results of her stringent social control efforts, Baldwin elected to retire a few weeks after submitting her report to city officials and local newspapers.[3]

Baldwin's difficulty in accepting the postwar change in public moral behavior stands in marked contrast to certain of her contemporaries. Theater impresario and perennial municipal officeholder George L. Baker opposed the policewoman in her early years because of her censorship role, yet fully embraced much of her program by the time he became Portland's mayor in 1917. He converted to the social hygiene ethic based on its convincing arguments about venereal disease. By the time he assumed the Rose City's highest elective office, he was an active member of the Oregon Social Hygiene Society. During the war, he became an enthused ambassador for the federal antivice campaign in the northwest. Unlike Baldwin, however, he was able to accommodate himself to postwar cultural reality. This flexibility assured his

periodic re-election for a full decade after Baldwin retired. As with the long career of Denver's Judge Ben Lindsey, this ability to adapt allowed some progressives to transcend the postwar disillusionment which entrapped many of their cohort. Baker's intimate understanding and optimistic view of the entertainment needs of society precluded the type of blanket condemnation engaged in by traditional moralists like Baldwin.[4]

Over her active career, Baldwin maintained unusually good working relationships with her male superiors and counterparts. The major exception was Mayor Simon's chief Arthur Cox, whose involvement with the liquor and prostitution underworld led to his own dismissal. Yet even Cox agreed with her about the dangerous dance halls. She worked well with Mayor Lane's police chief Carl Gritzmacher, but prevailing vice conditions stymied their success. Although Mayor Rushlight was at times difficult himself, his chief Enoch Slover cooperated fully with the WPD, as did Mayor Albee's appointment, John Clark. George Baker's choice, Nelson Johnson, had a special interest in the women's division, as his wife became an officer when Baldwin was absent during World War I. Baldwin's last chief, Leon Jenkins, whom Baker appointed in 1920, had served amicably with the policewomen on vice details for a number of years. Baldwin was generally satisfied with the character and performance of the male officers her department worked with, although she had trouble in the early years with a few "morally unfit" patrolmen who pursued young women while on duty. Exhibiting loyalty to those she approved of, however, she at least twice testified at police internal investigations. The first occasion was in 1913, when she characterized an officer accused of using too much force in an arrest as "always professional and trustworthy" in her experience. The second instance occurred during World War I, when a patrolman was accused by unnamed individuals of "being drunk on duty and 'pro-Hun'." Baldwin and officer Wilma Crounse testified that they had "never smelled any liquor on him, or heard any word against him."[5]

When Baldwin stepped down, the city handed her responsibilities over to Martha Randall, a Portland policewoman since 1913. Although Baldwin told one reporter that she was simply "going home," she did not retire to seclusion. She assisted her husband LeGrand and sons Pierre and Myron in the family's new commercial bakery venture, but she remained on the executive board of the Hillcrest School as well, and continued to lecture on venereal diseases and vice for the Oregon Social Hygiene Society. Ever concerned with delinquency problems, she traveled frequently in the 1920s to lecture on the preventive work she had fostered, and encouraged the formation of new women's police divisions. During the same period, she served on the Oregon

Parole Board. She was appointed to several terms as western representative on the National Committee on Prisons and Prison Labor in the late 1920s and early 1930s. These activities reaffirmed her faith in social control as practiced in settings unaffected by the interwar cultural reformation. The prison labor board implemented a conservative occupational agenda for women's institutions which was reminiscent of Baldwin's regimen for Oregon's Hillcrest. Over the years, she closely monitored the status of the Portland Women's Protective Division, and authored numerous newspaper letters and opinion pieces when her vision for the department was challenged.[6]

In 1929, Baldwin was involved in a serious automobile accident which exacerbated her older injuries from the World War I period. As a result, she curtailed most of her outside travel, yet remained active on the Portland front. In the mid-1930s, she lobbied hard with her successor Martha Randall to keep the WPD from becoming a casualty of the Depression-era mindset that women were usurping men's jobs. In 1938 her husband LeGrand became seriously ill, forcing his retirement from the bakery business. His wife's schedule slowed even more as she nursed him until his death in July 1941. Never one to dwell on misfortune, the ex-policewoman resumed where she had left off when her husband's health failed. In October 1941, the old menace of "liquor, automobiles, and dancing" resurrected the fire in Baldwin. When Prohibition ended, Portland's dance hall code was relaxed to allow beer to be sold as a concession, and now some proprietors were pushing for hard liquor as well. Citing the fact that youth from outside the city drove into Portland for the dances, Baldwin shared her dread of the probable consequences in a letter to the *Oregonian*. "Let us not get too modern and too broadminded," she concluded in true social feminist form, "but protect our homes and our young people, for this is a time when clear heads and steady hands are needed."[7]

Baldwin was always concerned with the pristine reputation the WPD had maintained since its inception. Whenever the WPD, or policewomen in general, were made to appear less than noble, she complained loudly and persistently. In 1951, she wrote a letter to the editors of *The Saturday Evening Post* disparaging an expose it had run in its July 7 issue. The article in question described calculated cruelty on the part of policewomen and jail matrons toward young female delinquents in institutions. Baldwin defended her profession, saying that "never in her experience" had she encountered "any such thing." In early 1954, a Portland writer turned an interview with WPD Captain Elizabeth Brown into a television script without her knowledge. The play was bought by the "Man Behind the Badge" program. When it aired in Portland as an episode titled "Help Wanted, Female," the original story was

hardly recognizable. Brown was portrayed as a uniformed officer, played by the glamorous Norma Crane. The fictionalized captain was shown using her feminine wiles rather than her brain to track down a man who was luring young women to their deaths under the guise of employing them as maids. Baldwin was distressed by the undue publicity brought to the WPD, as well as the story, which she described as "very poor, full of lies, and entirely changed by the script writers."[8]

Baldwin's successor Martha Randall retired from service in 1941. She was replaced by Captain Elizabeth Moorad, who had been a member of the Women's Protective Division since before World War I. Moorad presided over a predictable temporary expansion of the WPD for World War II vice control, and the division's acquisition of male juvenile work. She retired due to ill health in 1952, and was succeeded by Captain Elizabeth Brown. Brown was the first head of the division without a direct link to Baldwin's original group of policewomen. Decades younger than her predecessors, with an advanced degree in Education and Psychology from Oregon State University, Brown was apparently perceived as a threat by some in the city police hierarchy. As a result, in an eighteen-month period between late 1952 and early 1954, the civil service board attempted to institute several changes in the women's division which seemed intended to devalue it. The board altered the entry requirements for the policewomen's service by eliminating the four-year college degree in favor of a simple high school diploma. Under proposed "realignment" of titles within the Police Bureau, it suggested that the women's division head should be demoted in rank from captain to lieutenant. Chief Jim Purcell added to the ferment when he insisted that it was time for the policewomen to work in uniform. All three moves infuriated the nonagenarian Baldwin, who mobilized her women's organization allies to preserve the integrity of the police unit she had created almost a half-century earlier.[9]

Although the two branches of the police service had coexisted for four decades, the more highly educated women officers only became targets once the last of Baldwin's "old guard" retired. Captain Brown was the unwitting victim of the generalized conservative backlash of the 1950s which challenged both ambitious women and liberal elite control over social problems. For example, one woman officer who worked in the division at the time recalled certain patrolmen referring to the policewomen as "damned social workers." Brown worked within channels to prove that the changes would be detrimental to the public image and integrity of her section, yet she could only go so far without worry of reprisal. Baldwin had no such fears to contend with. She prodded the Federation of Women's Organizations to pass resolutions condemning the proposed actions, and urged its seventy-odd

member groups to write to the civil service panel in protest. Baldwin herself penned a guest editorial for the *Oregon Journal* which laid the issues before the public.[10]

Baldwin told *Journal* readers that she and the Federation of Women's Organizations, which had "faithfully supported the WPD ever since its birth," were "highly indignant" over the situation. She spoke, she insisted, "for the women of the city," who felt that "one or two individuals" had taken it upon themselves to make "drastic" and "arbitrary" changes in the women's division without consulting the female public. The proposed rank devaluation, plus the less stringent job qualifications, Baldwin complained, "seriously lowered the standard of workers" in the policewomen's unit. The uniform issue, which Baldwin had resisted for the entire life of the WPD, suggested "a radical departure from the ideals of the work." She and her clubwoman supporters had argued since 1908 that the policewomen needed to be inconspicuous in their line of service, both to ensure cooperation and limit embarrassment to girls or their families. She further noted that this latter change would cost the city a considerable amount at a time when budgets were supposedly strained. She begged city officials to convene hearings in the matter so that all sides might be heard. "The women of Portland," she concluded, "believe that the price in efficiency is too great to pay for a bit of glamour by an organization which was born and reared on faith, prayer, and courage."[11]

The Federation of Women's Organizations sent an official letter of protest to the civil service board, as did the YWCA, the League of Women Voters, and numerous smaller organizations and individuals. Their protestations forced the eventual reversal of both the rank question and the lowered standards. As Chief Purcell conceded in a letter to Baldwin, he felt that "the reconsideration of the actions was brought about largely through your efforts and the efforts of others who shared interest in the problem." Yet Purcell persisted in his desire to put the women in uniform. Mayor Fred Peterson joined the chief in urging the professional garb, saying that the women's organizations were themselves devaluing the policewomen by not allowing them "the dignity of the uniform." He even hinted that his proposal for pay equity in the police bureau might hinge on the acceptance of the clothing change. Although Baldwin and others on the outside continued to protest the idea, Captain Brown was placed in an awkward position.[12]

Chief Purcell envisioned a military-style uniform for his policewomen, and arranged for a fashion show by representatives of the women's service branches. When he ordered Captain Brown to send one of her women to approve his choice, she detailed officer Sybil Plumlee. The chief favored a Navy WAVE outfit that the policewoman gamely modeled for her superior.

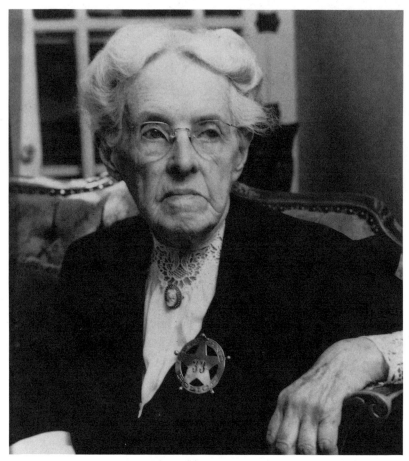

Lola Baldwin at age 94
Photograph: Al Monner, Oregon Historical Society (negative CN 000045)

According to Plumlee, the uniform fitted her very badly, and its wooly bulk made free movement difficult. Unfortunately, Purcell had invited press photographers, and Plumlee appeared in unflattering glory in the evening papers. The stir the picture caused effectively put an end to the chief's suggestion. He then told Captain Brown that if his selection was so inappropriate she should come up with a better one. She submitted some ideas to one of her officers who was also a talented artist. The result was a proposal for a simple blue serge suit with a white blouse and black tie. Purcell turned the sketch over to a local tailoring house, and Brown and the women resigned themselves to a future in uniform. "After all," Brown told an *Oregon Journal* reporter, "principally, we're interested in the work we do, not the superficial problem of dress."[13]

The situation resolved unexpectedly when the prototype arrived from the tailor. When the officer it was ostensibly made for tried the uniform on, the gathered policewomen stared in dismay. According to Plumlee, it looked worse than the Navy outfit she had modeled. "It fit just terribly," she recalled, "probably because it was made by a men's tailor, who apparently had no idea how to fit a woman." Brown was furious that her design had been botched, and she gave her sanction to a renewed campaign by Baldwin and the women's organizations which finally laid the idea to rest. Officer Plumlee, who said she "would not have minded a uniform" to aid her limited clothing budget, nonetheless admitted that the confidentiality of plain clothes work "allowed us policewomen to resolve many domestic disputes without resorting to arrest." With a certain irony, it was not until the early 1970s, at the instigation of some of the policewomen themselves, that Portland's female officers finally donned blue uniforms.[14]

Quite obviously, Lola Greene Baldwin never truly retired from "girl work." She maintained the alliances she had forged with women's organizations which, like her own work, were rooted in the twentieth century's *first* woman's movement. She raised her voice, and her pen, whenever the ideals she stood for were challenged. Her newspaper letters and opinion pieces reminded Portland that she was ever alert, despite her advanced age. She discovered that her ideas were often recycled by others who had no consciousness of their origin until she pointed it out. In 1956, for example, she informed the *Oregonian* that a "pilot program" for female delinquency prevention in the high schools it had reported on was identical to one she had begun before World War I. She was frequently feted by local service clubs, and the Federation of Women's Organizations honored her by including her in its biographical anthology of distinguished Oregon women. The nation's pioneer municipal policewoman continued to be an activist conscience for traditional morality in the Rose City until her death on June 22, 1957 at the age of ninety-seven.[15]

The long-enduring "female dominion" of social feminist ideals over municipal women's policing in Portland was itself short-lived after Baldwin's demise. Women's groups continued to dictate policy involving the service and demeanor of the Rose City's policewomen throughout the bulk of the 1960s. The relationship broke down late in that decade, however, when a "new" women's movement began to seek true sex equity in the workplace. For over sixty years, the Women's Protective Division had always been treated as a "separate but equal" branch of the police bureau. In 1969, Officer Penny Orazetti asked for a transfer to another division and was refused. Other policewomen subsequently applied for positions in different sections, and

were also denied. Believing that "separate but equal" was as abhorrent to gender as it was to race, Orazetti and several women officers sued the Bureau of Police in 1973 under Title VII of the Civil Rights Act of 1964 and Oregon's 1972 Sex Discrimination Guidelines.[16]

The suit demanded full access and equity based on the fact that the women had been engaged in "ordinary police practices" for many years. Just like the men, they investigated crimes, made arrests, went on patrol, transported hostile persons, and calmed disturbances. The only difference was that they were "arbitrarily restricted to one division, and denied the experience of patrol in a marked car." As an immediate concession, women were assigned to uniformed patrol duty in July 1973. The remainder of the action was settled after five years of negotiations, and the resulting conciliation agreement caused the *de facto* dissolution of the Women's Protective Division as a separate unit of the police bureau. Women officers thenceforth enjoyed the same pay, work rules, and rights of transfer as their male counterparts. In an interesting postscript, Penny Orazetti Harrington, who instigated the policewomen's lawsuit, was sworn in on January 24, 1985 as the first fully empowered female police chief of a large U. S. city.[17]

11

Conclusions

The evidence in this work confirms Lola Greene Baldwin as the first female police agent hired under civil service in the United States. By the 1920s, however, her primacy was ignored in two important police histories that are often cited by more recent authors. Both Elmer D. Graper and Chloe Owings credited the policewoman idea to Alice Stebbins Wells, a theological seminary graduate who petitioned the mayor of Los Angeles to hire her in September of 1910. Many of the "firsts" attributed to Wells are easily discredited by an examination of Baldwin's ample records. Graper and Owings rely heavily on a 1914 article by famed social reform critic and writer Maud Darwin. Darwin based her piece, "Policewomen: Their Work in America," almost solely upon an interview with Wells, who neglected to mention any American women's policing activity previous to her own appointment. In turn, many current police histories use Graper and Owings as primary sources, perpetuating the historiographical error.[1]

Alice Wells herself wrote magazine items on policing in the 1910s, often shading history in her own favor. In one piece, she asserted that when her position was placed under civil service in 1911, the required test was "the first of its kind," ignoring the fact that Lola Baldwin passed a specialized "female detective" civil service exam in early 1908. Similarly, a 1911 article by Clara M. Greening in *Sunset* magazine touted Los Angeles protective worker Wells as "Policewoman Number One." It is very plausible that Louise Bryant's 1912 *Sunset* piece on Lola Baldwin was written to set the record straight. The Portland journalist's ending statement was absolutely clear on that point. Bryant emphasized that Baldwin was the "first woman in the United States to be regularly appointed under civil service," and that she had "worn a police badge for over seven years." The correction probably had little effect beyond the west coast, however, as the California-based *Sunset* was essentially a regional journal.[2]

It is possible that the apparent historiographical discrepancy had much to do with professional image. After Abraham Flexner's 1915 attack on their status, social workers, including the early policewomen, became sensitive to

the issue of more stringent educational and training qualifications. Owings' description of the proposed professionalization platform written by the policewomen assembled in Baltimore in 1915 shows this clearly. One of the points emphasized was the need for specific college-level course work for women in the profession. As it turned out, Hartford Seminary graduate Alice Wells organized the first such class on "women police and their work" for a summer session at the University of California at Los Angeles in 1918. Although she was a trained teacher, Portland's Lola Baldwin had no undergraduate degree. As she freely admitted, everything she knew and passed on about policing she "learned by doing." Baldwin, of course, was "grandmothered in" in Portland, but subsequent Rose City policewomen were required to have college training and relevant social work experience. Under prevailing circumstances, it became a status and image expedient by the 1920s to label the college-trained Wells as progenitor in place of Baldwin.[3]

It is plausible that there was some quiet agreement between Baldwin and the policewomen's professional organization on this matter. As far as can be determined, she remained publicly silent on the issue, something quite unusual for the historically self-promoting Oregonian. Significantly, the profession's own bulletin never denigrated Baldwin's accomplishments. Although the definition of the "full-fledged policewoman" included Wells-inspired college course work by the 1920s, the female law enforcement officers association kept Baldwin's name in reverence. In August 1927, for example, Helen D. Pidgeon, executive secretary of the International Association of Policewomen, referred to Baldwin alone as "the pioneer woman in our service." As the organization prepared to celebrate its anniversary in 1929, it purposely planned to meet in San Francisco, midway between Portland and Los Angeles. For that occasion, national officials expressed their hope that both Baldwin and Wells would "be present to receive our gratitude for their pioneer service."[4]

The emergence of the professional policewoman idea begs broader explanation beyond a suggestion of its being simply a branch of social work. Sociologists Robert Liebman and Michael Polen describe police professionalization as the end result of shifts in responsibility for law enforcement or crime prevention. Over time, they argue, the burden of policing transferred from part-time volunteers or vigilantes to full-time agents paid by private sources or the state. In light of this thesis, Baldwin can be seen as the principal transition figure of the American policewomen's movement. In the late nineteenth century, she worked as a volunteer investigator for institutional homes for prostitutes, unwed mothers, and delinquent girls. She later translated that resume into paid preventive and investigative work for

the Travelers' Aid Association. When she and her supporters convinced Portland to hire her as the nation's first policewoman, she turned privately funded female vice prevention work into a paid government activity.[5]

Historian Don Kirschner portrays the Baldwin type of woman reform professional as one trying to escape a "do-gooder" image. Although the Travelers' Aid paid Baldwin to coordinate its activities, it relied mainly on "society matron" volunteers whom many in the working class viewed as moralistic busybodies. In contrast, Kirschner argues, professionals were respected for being "not only well-intentioned, but ... practical, detached, scientific, and generally right." At a certain point in what Kirschner describes as the "drift toward professionalism," Baldwin began to apprehend "a sense of special identity" in her activities. By developing standards and procedures such as her cross-referenced case data system, periodic statistical reports, preventive policing, and "after care" probation plan, she exuded what Kirschner terms "both the image and the reality of professionalism." The language of Baldwin's 1907 lobbying report to the city indicated that she distinctly perceived of herself as a policewoman of three years standing. She reiterated this identification in 1913 when she overruled the outside municipal research consultant who tried to place her section under the municipal court.[6]

Middle-class interest in preserving traditional female purity played a central role in the emergence of the women's police. As David J. Pivar and others have documented, many Americans feared the apparent changes in moral values which accompanied urbanization. For some, the source of anxiety lay in corrupting "democratized" amusements. Others decried the moral decadence of the "new" immigrants, a perception enhanced by the social hygiene-inspired specter of an Anglo-Saxon race decimated by venereal disease and "inferior" bloodlines. Many of these concerns found focus in the campaign to solve the "girl problem." Through their own convictions, and bolstered by pressure from the emerging social feminist "female dominion," Baldwin mentors like Harry Lane, Joseph Simon, H. Russell Albee, George Chamberlain, and Oswald West came to believe that female influence through the state was necessary. Women were crucial to an envisioned "parental" government which would assure the reiteration of traditional values through timely intervention. When a combination of social and moral problems mushroomed into a perceived and well-publicized crisis, taxpayers became willing to pay for women's vice policing.[7]

The Progressive Era presented a classic window of opportunity for Baldwin's energies. During this period of extensive reform and restructuring in American life, traditionally empowered men became more receptive to the idea of women as legitimate agents of the state. Liebman and Polen have

suggested that desire for political power partly motivated those who sought control over policing. Through her authorship of social control measures regulating the lives of young urban females, and with the backing of united women's interest groups, Baldwin assumed elements of such power five years before Oregon women gained suffrage in 1912. Once they obtained the vote, Portland's women generally championed those officials who helped their special causes. In late 1914, for example, Mayor H. Russell Albee barely survived a recall attempt. In a post-election letter to Baldwin, he claimed that much of the credit for the positive outcome was "due to the women of Portland, who supported this administration well."[8]

Progressive Era professional women like Baldwin were required to perform a delicate balancing act between customary male and female roles. As she gained a foothold in a public sphere traditionally dominated by men, the first policewoman was especially vulnerable to the particular tensions and ambiguities of the post-Victorian age. On the one hand, as a social feminist, Baldwin based her police work on the idea that females were somehow different and in need of state protection. Unlike radical feminists who wanted total sex equity, she championed suffrage only as a way for women to determine their own legal destiny. She clearly reconciled many of the gender prejudices of the times via her professional status. She appeared to treat her work arena as a "separate but equal" refuge which existed outside traditional sex classification. Within the structure of her profession, she felt free to demand the same deference, salary, equipment, and office accommodations as her male cohorts, while at the same time insisting that she was "just a woman doing a woman's job." In the same way, her official role and its presumed expertise gave her premature entry into the city and state political and legislative process.[9]

Baldwin's career embodied many of the anomalies of the Progressive Era. Her role in creating a new field for women and in demanding the same professional treatment as her male counterparts suggests a feminist gender equality model. Yet, she confined the types of cases her section handled within the police bureau to those concerning females and children. This allowed her to be effective, yet not antagonize anyone who might think she or her policewomen desired to usurp male investigative prerogatives. Although she is correctly classified as a social feminist, she distanced herself from some of her cohort by refusing to endorse an absolutist position on such issues as the liquor question, where, rather than put her energies into the eradication of saloons, she preferred to concentrate on banning women from them. Along with the Consumers' League and settlement matriarch Jane Addams, she championed a legislated "living wage" and maximum hours for

women as a way of keeping them from vice to earn extra money. Yet she despised local I.W.W. sympathizers who sought the same goal by radical means. Although she opened up police work to a few middle-class women, she closed off employment opportunities for many more of her sisters in the working class. Her neo-Victorian moral judgementalism and protective social control ordinances eliminated female access to a variety of urban amusement jobs because of potential ties to the vice trade. In much of her work, her obsession with sexual propriety blurred ideological lines. This is best exemplified by her endorsement of and participation in sex and venereal disease education in a period which exhibited a lingering reticence to discuss such matters.[10]

Peggy Pascoe's work exploring the evolution of female moral authority proves helpful in evaluating the paradoxes of Baldwin's career. Pascoe describes three complex cultural changes which paved the way to modernism in the early twentieth century. First, a transformation of the Victorian gender system induced a shift from the idolization of the female to an acknowledgment of her passion. Second, a decline in the cultural authority of Anglo-Protestant evangelicalism in a time of growing secular consumerism made traditionalist "church women" moral reformers appear as examples of "self-denial, repression, or religious fanaticism." Third, the rise of an anthropological "cultural relativism" challenged older racial hierarchies by suggesting that no culture was more valuable or moral than any other. Since these notions continued to coexist with their opposites for some time, the Progressive Era reformer remained trapped by cultural incongruities.[11]

In Pascoe's model, the nineteenth century had assigned moral authority to the pious woman. This notion carried forward to the twentieth century and persisted in Protestant evangelical efforts like the YWCA. When Baldwin's work was sponsored by that organization, she tended to mirror its moral perception of prostitutes as unwilling victims. But when she accepted municipal funding and the backing of secular, nonpartisan women's interest groups, she was freed to make individual judgements based on "scientific" evidence of female passion and her personal casework experience. She had enough common sense, however, that she could act on both the "white slave myth" and the idea of female sexual culpability at the same time without thinking it odd in any way. Later, her full absorption of the scientific social hygiene ethic allowed her to embrace the wartime characterization of prostitutes as criminal victimizers, yet still talk of "saving" sexually delinquent girls out at Hillcrest.[12]

Despite a popular infatuation during the 1910s with sociology and anthropology and their intriguing cultural theories, Baldwin resisted a change

in her traditionalist attitudes. Imprisoned by certain aspects of Victorianism, she failed to comprehend the evolving mores of urban industrialism. The policewoman could only perceive casual dating and mixed-sex amusements, for example, through the lens of chaperoned courtship. It seemed far beyond her understanding that unchaperoned girls could "have fun" and yet remain "good." Notions of racial hierarchy forced her to disparage the Negro music and dances which the working and middle classes embraced for leisure-time rejuvenation. As greater numbers of urban citizens accepted the presence of the democratized nightlife, the head morals officer persistently equated the amusement sector with vice. She could not apprehend that what Eric Schneider refers to as a "shift in the dominant culture" was demolishing the Victorian pedestal, destroying old class barriers, and repudiating Anglo-Saxon moral hegemony.[13]

Perhaps nothing more clearly indicates the moral rigidity of social feminists like Baldwin than their attempts to censor popular culture. As Paula Fass has observed in her study of the period's youth, Baldwin was correct in her assertion that family influence was waning. As a traditionalist, Baldwin relied on a vision of an idealized past as a touchstone for modernizing society. When the policewoman saw "old conventions and styles questioned," as Fass suggests, she "assumed there was no morality and no order." Although Baldwin sensed a truth, her limited vision rendered her unable to process it as part of a change in cultural dynamics. Especially in youth entertainment choices, as Fass and others like Kathy Peiss and Joanne Meyerowitz suggest, peer groups began exercising control over individuals. Exiled by their own children, parents became more willing to abdicate to the state the control they felt slipping away. Baldwin encountered this phenomenon when the Mothers' Congress demanded more rigorous youth curfew control. She simply berated the women for their lack of parental authority, failing to see a fundamental change at work.[14]

Baldwin's hard-headed militance was her greatest strength and, paradoxically, her greatest weakness. As Robert H. Wiebe has argued, many Progressive Era social control reform professionals were deluded into believing that everyone shared their goals. This assumption, Wiebe has concluded, led them "to trample sensibilities without regard for the resentment that was accumulating about them." Baldwin failed to perceive this, for example, when I. W. W. sympathizers attempted to have her recalled from office over what they claimed was her "railroading" of a young woman into the Hillcrest School. Baldwin's authoritarian use of police power embodied the most coercive elements of the expertise so honored by Progressive Era reformers. The apex of her influence occurred during World War I, when she

had absolute discretion over the lives of thousands of young women. She appeared most comfortable functioning within a military hierarchy under conditions of national emergency. Once cut off from martial law powers, Baldwin experienced a pessimism and despair shared by other traditionalists in the postwar era, and she retired rather than be destroyed by it.[15]

The policewomen's movement began at a time when the nation was undergoing convulsive changes. A new urban society mix was in the process of defining both a popular culture and moral standard to meet its needs. It was opposed by a coalition of reformers of both genders bent on curbing public expressions of sexuality and other excess. Whether they were social feminists, progressives, social hygienists, or social workers, many had an underlying aim of preserving the female purity standards associated with an earlier ethic. Baldwin and many of her supporters could be termed "antimodern modernists." Amid the emergence of industrialism and consumerism, they used "modern" expert, rational, bureaucratic methods to resist modern cultural mores. It has been suggested that the Progressive era's unifying spirit lay in just such a belief that small-community values could be made relevant to a world of large-scale organization. Baldwin's actions and words fully validate this view.[16]

Baldwin's agenda wedded Progressive Era principles of social feminism, social hygiene, social welfare, and preventive policing. Historian Joanne Meyerowitz argues that the repressive social control invested in protective programs like Baldwin's was misplaced, as working girls evolved their own survival strategies to cope with urban temptations. Meyerowitz contends, as the *Oregonian* editors suggested in Baldwin's day, that young women *did* "work out their own destiny" in terms of moral standards. Yet Don Kirschner reminds us that to condemn the era's reformers because they sought to institute a relatively harsh form of social control is to miss the point. Especially with the alarming social hygiene evidence on venereal disease, they faced what to them was a very real crisis in the cities. The democratic sensuality of ragtime culture evoked a rapid response among keepers of the social order whose basic reference point was the face-to-face society of the small town of the past. The goal of their repression was restoration of an elusive "community." They merely wished to adapt traditional values to modern urban conditions. As part of this "quest to reintegrate a fragmented society," Baldwin did her best to infuse her job and her constituency with the ideals of female purity that had been customary in the past.[17]

Numerous historians, including J. Stanley Lemons, Karen Blair, Robyn Muncy, and Mina Carson, have shown how social feminists came to dominate the Progressive Era women's movement. Whether they were settlement

workers, clubwomen, or female professional pioneers like Portland's Baldwin, they embodied a compromise between an occupation-restricted past and a new world of women's opportunity in the public sphere. Retaining the traditional image of "woman's work," Baldwin evolved a protective and preventive policing agenda based on gender difference and female weakness, rather than radical feminist concepts of sexual equality. Like the urban settlement workers, Baldwin translated the role of female purifier of the home into service as an "urban housekeeper." As William L. O'Neill suggests, this rationale allowed middle-class women like herself to pursue selected outside careers, keep their domestic image, yet at the same time transcend it. By adopting just such a female nurturing posture, Lola Baldwin broke down most objections to her inclusion in the male bastion of police work.[18]

Although Baldwin established her profession at the beginning of the twentieth century, many of the problems she addressed are hauntingly familiar as that century comes to a close. The venereal disease scare of the Progressive Era had many parallels to the current panic about AIDS and other sexually transmitted diseases. The resultant dance between public health authorities and conservative anti-education and anti-immigration forces would not have surprised the first policewoman, nor would the cry for a return to "family values." The argument about the root cause of youth delinquency remains as fundamentally unresolved as it was early in this century. With sophisticated DNA research techniques, scientists are again investigating the possibility of genetic links to certain types of criminal behavior. The conservative militancy Baldwin expressed in her antivice campaign mirrors the country's present "get tough" antidrug and violence policies and the growing crusade for abstinence as the only safe sex. Liberal therapeutic corrections measures are bowing to a cry for harsh repression from citizens who feel unsafe in their own homes. "Three strikes and you're out" sentencing policies echo the social hygienists' plea for "three strikes and you're sterilized." The list could continue, but the point is clear: history may not repeat itself, but the basic response to social crises arguably does.

Academic dissection of Lola Baldwin's actions aside, her extraordinary achievement as a pioneer in a new field for women must be given full recognition. When Portland first hired her, the city's entrenched vice interests, both within and without the government, fought her efforts at every turn. Given those difficult circumstances, it is remarkable that she was able to keep the policewoman idea alive past its infancy. On countless occasions, only her pragmatic sense of compromise and the unflagging support of the city's women's clubs, social service agencies, and social hygiene element preserved her position. We must not forget that Baldwin generally acted according to

the social consensus of her time. Critical scholarly opinions of her rigid moral reasonings fade as contemporary society wrestles with strikingly similar issues.

Lola Greene Baldwin's true legacy survives in the thousands of women who have followed in her professional footsteps. Although Baldwin herself would probably have preferred they remain "separate but equal," the complete integration of women into modern law enforcement is a living monument to the efforts of Portland's pioneering female "cop." Her belief in the need for women police, although originally based in the idea of feminine difference, was the founding impulse of a legitimate and well-respected career path. In the continuum of the development of the contemporary female line officer, Baldwin's early activities often seem quaint and overly moralistic. Yet her strength of character, insistence on relative employment equality, and strict standards of investigation and professional behavior reserve an honored place for her in both law enforcement and women's history. As retired Officer Sybil Plumlee remarked: "In some ways, the old Women's Protective Division *was* archaic, but on balance we did a lot of good." Portland's "Municipal Mother," as journalist Louise Bryant so aptly named her in 1912, should be remembered with genuine respect, and given her due as the nation's premier urban policewoman.

Appendix

Selected Statistical Data, 1908-1914[1]

	1908	1909	1910	1911	1912	1913	1914	(Totals)
New girls[2]	497	460	411	356	648	653	731	3756
Venereal cases	62	111	38	50	60	71	53	445
Insane	—	—	14	21	13	11	24	83
Runaway/missing	—	—	17	50	74	83	111	335
Sexual vice investigations	365	732	201	307	431	658	604	3298
"Pitfall" investigations	43	126	85	91	56	—	—	401
Lodginghouse investigations	44	70	32	53	48	—	—	247
"After-care"	346	295	120	94	105	164	155	1279
On parole	11	26	8	20	26	20	61	172
Transportation furnished	40	34	15	16	9	17	—	131
Meals furnished	482	861	467	570	490	581	469	3920
Lodgings furnished	119	323	108	147	228	271	143	1339
Sent to institutions	—	40	101	102	133	120	134	630
Interviews	918	1913	3120	2263	2753	2422	2432	15821
Court cases	—	—	—	—	—	114	266	380
Office expenses ($)	303	669	685	734	692	557	484	4124

1. Compiled from several documents in LGB File, PPHS.
2. Baldwin described this category as "girls who have not come in contact with this department before in any way." Rest of data may include carryover clients from previous years.

Notes

Introduction

1. "Lindsey Praises Women," *Oregonian*, 25 February, 1911, p. 1; Louise de Koven Bowen, "Women Police," *Survey* 30, (April 1913), 64-65; Raymond B. Fosdick, *American Police Systems* (1920; reprint, Montclair, NJ: Patterson-Smith, 1969), pp. 376-77.

2. "$3,000 From City to Travelers' Aid," *Oregonian*, 24 December, 1907, p. 11; "Annual Report of the Portland Civil Service Commission for 1908," in *Mayor's Message and Municipal Reports for 1908*, Box 27, 17-06-02, Portland Archives and Records Center [hereinafter PARC]; Portland Police Department Women's Protective Division Daily Activity Reports [hereinafter WPD/DAR], 1 April, 1908, Portland Police Historical Society [hereinafter PPHS]; *Portland Ordinances 17410* and *17411*, 12 February, 1908, copies in Portland Mayor's Office Correspondence [hereinafter MOC], 1908, Box 12, File 12/3, 15-07-34/3, PARC.

3. William L. O'Neill, *The Progressive Years: America Comes of Age* (New York: Harper and Row, 1975), pp. 80-83; Karen J. Blair, *The Clubwoman as Feminist: True Womanhood Redefined, 1868-1914* (New York: Holmes and Meier, 1980), pp. 117-19; Mina Carson, *Settlement Folk: Social Thought and the American Settlement Movement, 1885-1930* (Chicago: University of Chicago Press, 1990), pp. 196-98.

4. Blair, *Clubwoman as Feminist*, pp. 117-19; see Robyn Muncy, *Creating a Female Dominion in American Reform, 1890-1935* (New York: Oxford University Press, 1991).

5. For an overview of the urban moral safety issue, see John D'Emilio and Estelle B. Freedman, *Intimate Matters: A History of Sexuality in America* (New York: Harper and Row, 1988), pp. 150-56, 203-15. Patterns of female employment influx in Portland were similar to those experienced in Chicago, another market-industrial city; see Joanne J. Meyerowitz, *Women Adrift: Independent Wage Earners in Chicago*, 1880-1930 (Chicago: University of Chicago Press, 1988).

6. For a comprehensive look at social-feminist-endorsed "female to female" preventive, protective, and corrective actions during the Progressive Era, see Estelle B. Freedman, *Their Sisters' Keepers: Women's Prison Reform in America, 1830-1930* (Ann Arbor, MI: University of Michigan Press, 1981), Part 3, "The Progressive Approach, 1900-1920," pp. 107-57.

7. Clyde Griffen, "The Progressive Ethos," in Stanley Coben and Lorman Ratner, eds. *The Development of an American Culture* (New York: St. Martins, 1983); Lola G. Baldwin records, PARC, PPHS, *passim*; Louise Bryant, "A Municipal Mother," *Sunset*, 29 (September 1912), 290-93.

8. Joiell Cox, "Bows of White Ribbon," in Helen K. Smith, ed., *With Her Own Wings* (Portland, OR: Beattie, 1974), pp. 209-11; Ruth B. Moynihan, *Rebel For Rights: Abigail Scott Duniway* (New Haven: Yale University Press, 1983), pp. 142, 212.

9. Anna H. Pogue, "Millie Reid Trumbull," and Agnes Holt, "Sarah A. Evans," in Smith, ed., *With Her Own Wings*, pp. 227-28, 229-30; Eleanor F. Baldwin, "The Woman's Point of View," *Evening Telegram*, various dates; Louise Bryant, "Portland Pioneer in Municipal Work for Women," *Oregonian*, 14 January, 1912, sec. 5, p. 5; Bryant, "Municipal Mother," *Sunset*.

10. W.T. Gardner to Mayor Albee, MOC 1915, Box 33, File 33/3, 15-07-21/2, PARC; "Hall's Name Changed," *Oregonian*, 11 February, 1915, p. 9.

11. Katherine V. Gibson, "The People's Institute," in Smith, ed., *With Her Own Wings*, pp. 224-26.

12. Helen Smith, "Pioneer Jewish Women," in Smith, ed., *With Her Own Wings*, pp. 219-23; Steven Lowenstein, *The Jews of Oregon*, 1850-1950 (Portland: Jewish Historical Society of Oregon, 1987), pp. 138-43.

13. Elizabeth Moorad and Wilma Crounse, "Lola G. Baldwin," and Julia Hobday, "Jessie M. Honeyman," in Smith, ed., *With Her Own Wings*, pp. 231-34, 235-37; Meyerowitz, *Women Adrift*, pp. 48-53.

14. WPD/DAR 3 October 1908, 3 March, 16 June, 1909, 13 September, 1913.

15. For the roots and purpose of the social hygiene impulse see David J. Pivar, *Purity Crusade: Sexual Morality and Social Control, 1868-1900* (Westport, CT: Greenwood, 1973), pp. 238-45, 275-76.

16. E. Kimbark MacColl, *Merchants, Money, and Power: The Portland Establishment, 1843-1913* (Portland: Georgian Press, 1988), pp. 382, 389; Pivar, *Purity Crusade*, pp. 243-45.

17. WPD/DAR 8 August 1908; "Pioneer Experiences," *Social Hygiene* 5, 4 (October 1919), 585; "Anti-Vice Body Outlines Work," *Oregonian*, 21 September, 1911, p. 4.

Chapter 1

1. Chief Charles H. Hunt "To the Editor," 24 May, 1905, copy in Council Documents 1905, Box 85, File 85/10, 19-04-19/1, Portland Archives and Records Center [hereinafter PARC]. Attendance at the exposition totaled 2,460,000. *Report of the Lewis and Clark Exposition Commission* (Salem: State Printer, 1906), p. 21. For an overview of the world's fair, see Carl Abbott, *The Great Extravaganza: Portland and the Lewis and Clark Exposition* (Portland: Oregon Historical Society, 1981), all, p. 54 for description of special police. For a retrospective on the economic and political ramifications of the fair, see E. Kimbark MacColl, *Merchants, Money, and Power: The Portland Establishment, 1843-1913*, (Portland: Georgian Press, 1988), pp. 383-86.

2. Ellen M. Ewing, "Lola G. Baldwin - No. 1 Policewoman," *Oregonian,*
 Northwest Living Magazine, 11 June, 1950, pp. 10, 14. For several views of
 the "white slave" question in the Progressive Era, see Mary de Young,
 "Help, I'm Being Held Captive!: The White Slave Fairy Tale of the Progres-
 sive Era," *Journal of American Culture* 6 (1983): 96-99, also David J. Pivar,
 Purity Crusade: Sexual Morality and Social Control, 1868-1900 (Westport,
 CT: Greenwood, 1973), pp. 176-77, and Frederick K. Grittner, *White*
 Slavery: Myth, Ideology, and American Law (New York: Garland, 1990),
 all. For a romanticized portrait of Baldwin see Elizabeth Moorad and
 Wilma Crounse, "Lola. G. Baldwin," in Helen K. Smith, ed., *With Her Own*
 Wings: Historical Sketches, Reminiscences, and Anecdotes of Pioneer
 Women, 2nd ed (Portland: Beattie, 1974), pp. 231-34. For the original
 purpose and scope of the Travelers' Aid program for the fair see "Its Work
 Needed," *Oregonian,* 16 April, 1905, p. 10, and "Women Unite to Save
 Womankind," *Oregon Journal,* 16 April 1905, copy in Women's Protective
 Division [hereinafter WPD] Scrapbook, Portland Police Historical Society
 [hereinafter PPHS], also "For the Travelers' Aid," *Oregonian,* 11 June, 1905,
 p. 9. Baldwin reminisced about the dangers of the world's fairs to an
 audience in Vancouver, British Columbia, in September 1911. Of those
 eleven hundred missing girls, she said "only one was found afterwards,
 and she was discovered in Portland two years later." See "In the Course of
 Social Service," Vancouver, B.C. *Chronicle,* 22 September 1911, copy in
 WPD Scrapbook, PPHS.

3. Rolla J. Crick, "Nation's First Women's Police Unit," *Oregonian,* 28 March,
 1954, p. 8a; Ewing, *Oregonian,* NWL Mag., 11 June, 1950, pp. 10, 14; Otto
 Wilson, *Fifty Years' Work With Girls: The Life of Dr. Kate Waller Barrett*
 (1933, reprint, New York: Arno, 1974), p. 174. For background on Jessie
 Honeyman, see Julia Hobday, "Jessie M. Honeyman," in Smith, ed., *With*
 Her Own Wings, pp. 235-37. For the Chicago YWCA roots of the Travelers'
 Aid, see Joanne J. Meyerowitz, *Women Adrift: Independent Wage Earners*
 in Chicago, 1880-1930 (Chicago: University of Chicago Press, 1988), pp.
 48-52. For a contemporary description of the proposed preventive work,
 see "Will Close Up Massage Shops," *Oregonian,* 21 May, 1905, p. 8.

4. "Its Work Needed," *Oregonian,* 16 April, 1905, p. 10.

5. Around the year 1920, Baldwin provided a rather complete biographical
 history as part of a Federal Civil Service exam. See questions 19 and 20,
 Federal Civil Service Form 2118 [hereinafter FCS/2118], copy in LGB File,
 PPHS; Paul E. Johnson, *A Shopkeeper's Millennium: Society and Revivals in*
 Rochester, New York, 1815-1837 (New York: Hill and Wang, 1978), p. 118.

6. FCS/2118, LGB File, PPHS; Louise Aaron, "Mrs. Baldwin Feted on 88th
 Birthday," *Oregon Journal,* 31 January, 1948, p. 1.

7. FCS/2118, LGB File, PPHS; "Baker's Rites Set Tuesday," *Oregonian,* 8 July,
 1941, p. 11.

8. FCS/2118, LGB File, PPHS. For the history of the proclivity of western New
 York women to engage in slave abolitionism and the later "new abolition-
 ism" of the antiprostitution movement, see Mary P. Ryan, *Cradle of the*
 Middle Class: The Family in Oneida County, New York, 1790-1865 (New

York: Cambridge University Press, 1981), also Johnson, *A Shopkeeper's Millennium*, and James B. Stewart, *Holy Warriors: The Abolitionists and American Slavery* (New York: Hill and Wang, 1976).

9. *Oregonian*, 8 July, 1941, p. 11. In later life, Lola Baldwin referred to having worked for "Woolworth's" when she first arrived in Portland in 1904. This is technically incorrect. She was employed by her husband at E. P. Charlton. Charlton's *became* the Portland Woolworth's in about 1912, after a merger between the two chains. Godfrey M. Lebhar, *Chain Stores in America, 1859-1962* (New York: Chain Store Publishing Co., 1963), pp. 38-39.

10. *Oregonian*, 16 April, 1905, p. 10; Ewing, *Oregonian NWL Mag.*, 11 June, 1950, pp. 10, 14; Crick, *Oregonian,* 28 March 1954, p. 8a; *Oregon Journal* 16 April, 1905; "Home for Working Girls," *Oregonian*, 10 June, 1905, p. 9.

11. For a map with descriptions of the amusement and culinary offerings along "The Trail," see Abbott, *Great Extravaganza*, p. 26. For a description of the YWCA pavilion at the fair, see Belle W. Cooke, "Where Women Work Wonders," *Sunset* 15 (June 1905), 480-82.

12. *Oregonian*, 16 April, 1905, p. 10; *Oregonian*, 21 May, 1905, p. 8.

13. *Oregonian*, 21 May, 1905, p. 8.

14. Anna Holm Pogue, "Millie Reid Trumbull," in Smith, ed., *With Her Own Wings*, pp. 227-28; Allan W. East, "The Genesis and Early Development of a Juvenile Court: Multnomah County, Oregon," Ph.D. diss., University of Oregon, 1939, p. 44n; "Juvenile Court First Session," *Oregonian*, 10 June, 1905, p. 5; LGB "Commission of Probation Officer for Juvenile Court," 10 June, 1905, copy in LGB File PPHS; FCS/2118, LGB File PPHS.

15. Abbott, *Great Extravaganza*, p. 3; *Oregonian*, 21 May, 1905. p. 8.

16. FCS/2118, LGB File PPHS; "For Travelers' Aid," *Oregonian*, 13 August, 1905, p. 14.

17. "For a Clean Town," *Oregonian*, 9 July, 1905, p. 11; Mayor Harry Lane to LGB, 17 July, 27 September, 1905, copies in Mayor's Office Correspondence [hereinafter MOC], 1905, Box 1, File 1/2, 15-07-31/1, PARC; Letter, LGB to Harry Lane, 14 July, 1905, copy in MOC 1905, Box 1, File 1/2, 15-07-31/1, PARC.

18. *Oregonian*, 13 August, 1905, p. 14; Louise Bryant, "Portland Pioneer in Municipal Protective Work for Women, *Oregonian*, 14 January, 1912, Sec. 5, p. 5.

19. "For Travelers' Aid," *Oregonian*, 20 October, 1905, p. 14. Sections 2076 [enacted in 1864], 2077 [1905], 2082 [1895] of Oregon law variously covered seduction, fornication, procurement, and the taking away of minor females for any purpose without parental consent. *Lord's Oregon Laws*, Vol. 1 (Salem: State Printer, 1909), pp. 923-25.

20. "Girls Are In Need," *Oregonian*, 25 October, 1905, p. 10. For additional information on the earlier YWCA Travelers' Aid work, see Meyerowitz, *Women Adrift*, pp. 48-52.

21. LGB to Mayor Lane, 30 December 1905, copy in MOC 1905, Box 1, File 1/2, 15-07-31/1, PARC.

22. *Oregonian*, 25 October, 1905, p. 10; LGB to Harry Lane, 30 December, 1905.

23. LGB to Harry Lane, 30 December, 1905; "Travelers' Aid is Disbanded," *Oregonian*, 26 January, 1906, p. 14; "Travelers' Aid Will Celebrate Golden Jubilee," *Oregonian*, 17 April, 1955, sec. 3, p. 9. For Rabbi Wise's optimism for the interdenominational effort see *Oregonian*, 16 April, 1905, p. 10; LGB Travelers' Aid Funding Request, December 1907, copy in MOC 1908, Box 13, File 13/7, 15-07-25, PARC, LGB Travelers' Aid Work Synopsis, 1905-1907, copy in MOC 1907, Box 8, File 8/17, 15-07-34/1, PARC.

24. Travelers' Aid Work Synopsis, 1905-1907; YWCA Travelers' Aid 1907 Activity Log [partial], copy in MOC 1908, Box 11, File 11/2, 15-07-33/3, PARC.

25. FCS/2118, LGB File PPHS; Travelers' Aid Work Synopsis 1905-1907; Travelers' Aid Funding Request, December 1907; LGB Report of the San Francisco Relief Fund, copy in MOC 1908, Box 11, File 11/3, 15-07-33/3, PARC.

26. Travelers' Aid Work Synopsis, 1905-1907; Travelers' Aid Funding Request, December 1907.

27. For a more detailed portrait of Dr. Harry Lane see MacColl, *Merchants*, pp. 372-97.

28. For further information on Dr. Esther Pohl Lovejoy, see MacColl, *Merchants*, pp. 382, 389. For a portrait of Sarah Evans see Agnes Holt, "Sarah A. Evans," in Smith, ed., *With Her Own Wings*, pp. 229-30. For an overview of the medical alarm over prostitution see John C. Burnham, "The Progressive Era Revolution in American Attitudes Toward Sex," *Journal of American History* 59 (1973): 886, 892-95, and John D'Emilio and Estelle B. Freedman, *Intimate Matters: A History of Sexuality in America*, (New York: Harper and Row, 1988), p. 204. Harry Lane and his wife served as hosts to the medical convention he wooed to the Rose City that summer. See "Doctors Will Visit Portland," *Oregonian*, 9 July, 1905, p. 8.

29. For Lane's troubles with the vice element, see MacColl, *Merchants*, pp. 391-92. Utilizing Portland Blue Book club lists, the author has determined that over half of the prominent families identified by MacColl (p. 437) as associated with vice properties by the Vice Commission in 1912 had female representatives in either the Woman's Club, Women's Union, or Council of Jewish Women.

30. Captain P. Bruin to Chief Gritzmacher, 2 July, 1906, copy in MOC 1906, Box 5, File 5/3, 15-07-31/3, PARC; Captain P. Bruin to Mayor Lane, 17 January, 1908, copy in MOC 1908, Box 12, File 12/3, 15-07-34/3, PARC. Ewing, *Oregonian, NWL Mag.*, 11 June, 1950, pp. 10, 14; MacColl, *Merchants*, pp. 391-92.

31. Travelers Aid Funding Request, December 1907.

32. *Ibid.*; LGB to Mayor Lane, 1 December, 1907.

33. Travelers' Aid Funding Request, December 1907.

34. *Ibid.*

35. *Ibid.*

36. "$3,000 From City to Travelers' Aid," *Oregonian*, 24 December, 1907, p. 11; *Portland Ordinances 17410* and *17411*, copies in MOC 1908, Box 12, File 12/3, 15-07-34/3, PARC. The "dog pound" story finally came out in print in 1912, when the national social hygiene movement journal *Survey* ran a piece on the early development of the policewoman idea. "Western Women as Police Officers," *Survey* 29 (December 21, 1912), 346.

37. "Votes Money to YWCA," *Oregonian*, 13 February, 1908, p. 5; LGB to Mayor and City Council, 8 February, 1908, copy in MOC 1908, Box 13, File 13/7, 15-07-25, PARC.

38. *Portland Ordinances 17410* and *17411*; *Oregonian*, 13 February, 1908, p. 5; Civil Service Commission to LGB, 11 March, 1908, copy in LGB file, PPHS; Women's Protective Division Daily Activity Reports [hereinafter WPD/DAR], 1 April, 1908, PPHS.

39. WPD/DAR 1 April, 1908; LGB to Mayor Lane, 1 December, 1907; LGB to Chief of Police, 1 May, 1908, MOC 1908. Box 12, File 12/3, 15-07-34/3, PARC.

40. LGB to Chief of Police, 1 May, 1908; Samuel Walker, *A Critical History of Police Reform: The Emergence of Professionalism* (Lexington, MA: D. C. Heath, 1977), p. 86.

41. Travelers' Aid Funding Request, December 1907; LGB to Chief of Police, 1 May, 1908; Louise Bryant, "A Municipal Mother," *Sunset* 29 (September 1912), 290-93.

42. Travelers' Aid Funding Request, December 1907.

43. LGB to Chief of Police, 1 May, 1908.

44. *Ibid.*; WPD/DAR 13-18, 20, 24-5 April, 1908.

Chapter 2

1. LGB to Mayor Harry Lane, 1 December, 1907, copy in Mayor's Office Correspondence [hereinafter MOC], 1908, Box 13, File 13/7, 15-07-25, Portland Archives and Records Center [hereinafter PARC]; Women's Protective Division [hereinafter WPD] Scrapbook, "Uniforms," and File, "Conciliation Agreement," Portland Police Historical Society [hereinafter PPHS].

2. LGB to Chief Gritzmacher and Captain Baty, 1 May, 1908, copy in MOC 1908, Box 12, File 12/3, 15-07-34/3, PARC.

3. Jane Addams, *A New Conscience and an Ancient Evil* (New York: Macmillan, 1912), p. 56. In 1911, Baldwin explained her Portland police work in depth to civic improvement boosters in Vancouver, British Columbia. "In the Cause of Social Service," Vancouver, B. C. *Chronicle*, 22 September, 1911, WPD Scrapbook, PPHS.

4. Louise Bryant, "Portland Pioneer in Municipal Protective Work for Women," *Oregonian*, 14 January, 1912, Sec. 5, p. 5; Louise Bryant, "A Municipal Mother," *Sunset* 29 (September 1912), 290-93.

5. Vancouver, B. C. *Chronicle*, 22 September, 1911. For other such instances of suicide in discouraged working girls, see Joanne J. Meyerowitz, *Women Adrift: Independent Wage Earners in Chicago, 1880-1930* (Chicago: University of Chicago Press, 1988), pp. 28, 39.

6. John D'Emilio and Estelle B. Freedman, *Intimate Matters: A History of Sexuality in America* (New York: Harper and Row, 1988), pp. 195-210. For a contemporary assessment of the dangers to employed girls in the cities, see Addams, *New Conscience, passim*; Women's Protective Division Daily Activity Reports [hereinafter WPD/DAR], 11 April, 7 May, 1908. For a confirmation of the mainstream nature of Dr. Esther Pohl Lovejoy's views on moral weakness in this type of girl, see Peter L. Tylor, "'Denied the Power to Choose the Good': Sexuality and Mental Defect in American Medical Practice, 1850-1920," *Journal of Social History* 10 (June 1977), 472-89.

7. The stated purpose of the Oregon law of 1903 was "to regulate and limit the amount of hours of employment of females in any mechanical or merchantile establishment, laundry, hotel, or restaurant." It also required employers to provide seats for females. *General Laws of Oregon, 1903*, pp. 148-49. For a general overview of the context of the *Muller* case, see Gordon B. Dodds, *Oregon: A History* (New York: W. W. Norton, 1977), pp. 180-82. For a constitutional historian's discussion of the various appeals in the *Muller* case and the "Brandeis brief," see Melvin I. Urofsky, *A March of Liberty: A Constitutional History of the United States* (New York: Alfred A. Knopf, 1988), p. 551.

8. WPD/DAR 6, 7 May, 12 December, 1908, 1 December, 1909.

9. LGB FCS-2118, p. 5; Addams, *New Conscience*, Chapter 3.

10. WPD/DAR 30 May and 1 June, 1910, 15 March, 1911, 17 October, 1912, 21 July, and 6 August, 1913; LGB to Mayor Joseph Simon, 13 April, 1911, copy in MOC 1911, Box 24, File 24/6, 15-07-28/3, PARC; Addams, *New Conscience*, pp. 213-14.

11. Addams, *New Conscience*, pp. 71-72.

12. WPD/DAR 11 May, 14 August, 1908, 14 February, 1910; D'Emilio and Freedman, *Intimate Matters*, pp. 208-10.

13. WPD/DAR 26 August, 1908; "Chinese Obey Law, " *Oregonian*, 24 August, 1908, p. 14. For an overview of Harry Lane's battle against the restaurants and grilles with so-called "boxes," see E. Kimbark MacColl, *Merchants, Money, and Power: The Portland Establishment, 1843-1913* (Portland, OR: Georgian Press, 1988), pp. 391-92. The Travelers' Aid held a young girl taken from one of the booths at Richards' Grille in protective custody until the trial, but the results were less than gratifying for Harry Lane. "Tom Richards is Not Guilty," *Oregonian*, 18 January, 1906, p. 8, and letters, Travelers' Aid to Mayor Lane, 4 February, 1906, and Mayor Lane to Travelers' Aid, 6 February, 1906, copies in MOC 1906, Box 3, File 3/5, 15-07-31/2, PARC.

14. WPD/DAR 16 March, 1909.

15. WPD/DAR 8 November, 1910.

16. LGB to R. H. Brown, 31 August, 1909, copy in MOC 1911-12, Box 24, File 24/6, 15-07-28/3, PARC; WPD/DAR 30 November, 1, 7 December, 1908 .

17. WPD/DAR 11 February, 15 March, 26 May, 1 June, 1909.

18. LGB to R. H. Brown, 31 August, 1909; WPD/DAR 26 July, 1909.

19. WPD/DAR: 19, 26, 28 May, 1, 2 June, 1909; "Will Close Up Massage Shops," *Oregonian*, 21 May, 1905, p. 8.

20. WPD/DAR: 26 May, 1, 18 June, 1909.

21. LGB Six Month Report to Mayor Simon, 1 July, 1909, copy in MOC 1911, Box 24, File 24/6, 15-07-28/3, PARC; LGB to Mayor Albee, 3 July, 1913, copy in MOC 1913, Box 61, File 61/1, 15-07-01/1, PARC; WPD/DAR: 21, 22, 29 June, 5 July, 1 909 .

22. LGB to License Committee, 20 June, 1912, copy in Council Documents 1912, Box 117, File 117/9, 19-04-08/2, PARC.

23. LGB to License Committee, 20 June, 1912; Vice Commission to Mayor and City Council, June, 1912, copy in Council Documents 1912, Box 117, File 117/9, 19-04-08/2, PARC.

24. LGB to Chief Gritzmacher and Captain Baty, 1 May, 1908, copy in MOC 1908, Box 12, File 12/3, 15-07-34/3, PARC; "Many Girls Aided," *Oregonian*, 14 October, 1908, p. 16; WPD/DAR 1 August, 1910; LGB to Mayor Allan Rushlight, 13 March, 1912, copy in Council Documents 1912, Box 121, File 121/6, 19-04-09/2, PARC; Bryant, "Municipal Mother," *Sunset*, 292.

25. WPD/DAR 27 January, 1912; Bryant, "Municipal Mother," *Sunset*, 292.

26. WPD/DAR 24 August, 1911, 29 January, 1912.

27. WPD/DAR 26 May, 1908, 19 May, 1909; Clifford G. Roe, *The Prodigal Daughter: The White Slave Evil and the Remedy* (Chicago: L. W. Walter, 1911), p. 182.

28. Portland Vice Commission to City Auditor, 5 April, 1912, copy in MOC 1912, Box 25, File 25/21, 15-07-19/1, PARC; WPD/DAR 28 May, 2, 22 June, 26 July, 1909.

29. WPD/DAR 22 June, 26 July, 1909; LGB Annual Report for 1911, in *Mayor's Message and Annual Reports for 1911*, pp. 538-39, Box 27, 17-06-02, PARC; Oregon's 1907 law which governed the "age of consent" forbade minors from being in places where others engaged in lewd behavior which might lead to sexual intercourse. *General Laws of Oregon, 1907*, Chapter 91, pp. 154-55.

30. LGB to Mayor [Rushlight] and City Council, 12 March, 1912, copy in Council Documents 1912, Box 121, File 121/6, 19-04-09/2, PARC.

31. Portland Vice Commission to City Auditor, 5 April, 1912; Baldwin's influence on the formation of the vice commission is more fully documented in Chapter 6 of this work. The ordinance Baldwin and the vice investigators championed also banned females from working as business attractions in pool rooms, bowling alleys, saloons, or cigar stands "located immediately adjacent to saloons." *Portland Ordinance 25477*, 26 June, 1912, copy in Council Documents 1912, Box 120, File 120/2, 19-04-10/1, PARC.

32. Portland Vice Commission to City Auditor, 5 April 1912 .

33. *Ibid.*

34. *Ibid.*

35. *Ibid.*; D'Emilio and Freedman, *Intimate Matters*, pp. 214-15.

36. Portland Vice Commission to City Auditors, 5 April, 1912.

37. *Ibid.*

38. *Ibid.*

39. *Ibid.*

40. Urofsky, *March of Liberty*, p. 551.

41. David J. Pivar provides an excellent synthesis of the urban purity impulse. David J. Pivar, *Purity Crusade: Sexual Morality and Social Control, 1868-1900* (Westport, CT: Greenwood Press, 1973), pp. 166-275. Baldwin reported that the city's population had increased from 161,000 at the time of the fair to 235,000 by 1911. WPD/DAR 15 December, 1911.

Chapter 3

1. Kathy Peiss, *Cheap Amusements: Working Women and Leisure in Turn-of-the-Century New York* (Philadelphia: Temple University Press, 1988), pp. 5, 6, 45; Lewis Erenberg, *Steppin' Out: New York Night Life and the Transformation of American Culture* (Chicago: University of Chicago Press, 1984), pp. xiv, 5, 6, 61; Lary May, *Screening Out the Past: Mass Culture and the Motion Picture Industry* (New York: Oxford University Press, 1980), p. 38. The best contemporary look at the problem of young working women and dance halls and other amusements is Belle Linder Israels, "The Way of the Girl," *Survey* 22 (July 1909), 486-97.

2. Women's Protective Division Daily Activity Reports [hereinafter WPD/DAR] entries on Portland amusements, various dates, 1908-1913.

3. Peiss, *Cheap Amusements*, pp. 5, 6; May, *Screening*, p. 46; Erenberg, *Steppin' Out*, pp. 5, 6, 66.

4. Erenberg, *Steppin' Out*, pp. xii, 5, 6, 64; LGB to Harry Lane, 25 November, 1908, copy in Mayor's Office Correspondence [hereinafter MOC], 1908, Box 12, File 12/3, 15-07-34/3, Portland Archives and Records Center [hereinafter PARC]; "Dance Halls Evil," *Oregonian*, 28 February, 1910, p. 16; WPD/DAR, 22 June, 1909.

5. Report of Committee on Health and Police, 9 March, 1910, copy in Council Documents 1910, Box 107, File 107/12, 19-04-15/2, PARC; Peiss, *Cheap Amusements*, p. 96; May, *Screening*, p. 49; John D'Emilio and Estelle B. Freedman, *Intimate Matters: A History of Sexuality in America* (New York: Harper and Row, 1988), pp. 130, 195, 199, 208; "Many Girls Aided," *Oregonian*, 14 October, 1908, p. 16; WPD/DAR 22 June 1909; LGB Annual Report 1909, copy in MOC 1909, Box 24, File 24/6, 15-07-28/3, PARC; *Oregonian,* 28 February, 1910, p. 16; Deposition "State vs. Wroten" (Club Saloon), copy in Council Documents 1908, Box 99, File 99/6, 19-04-13/1, PARC; LGB to Harry Lane, 25 November, 1908.

6. Peiss, *Cheap Amusements*, pp. 45, 100-104; Erenberg, *Steppin' Out*, pp. 73-74, 151-55; D'Emilio and Freedman, *Intimate Matters*, p. 196; *Oregonian*, 28 February, 1910, p. 16; WPD/DAR 2 November, 1910; Report of Committee on Health and Police, 9 March, 1910; "Mayor Unable to Close Dance Hall," *Oregonian*, 22 February, 1910, p. 20.

7. Report of Committee on Health and Police, 9 March, 1910; Erenberg, *Steppin' Out*, pp. 63, 64, 81; Peiss, *Cheap Amusements*, pp. 45, 88-89; D'Emilio and Freedman, *Intimate Matters*, pp. 130, 195, 199, 208.

8. May, *Screening*, p. 49; Peiss, *Cheap Amusements*, p. 95; Chief Gritzmacher to Mayor Lane, 27 May, 1909, copy in MOC 1909, Box 17, File 17/5, 15-07-25, PARC; *Oregonian*, 28 February, 1910, p. 16.

9. WPD/DAR 13, 16, 23, 25 June, 1908, 25 February, 1909; LGB to Chief Gritzmacher, 1 June, 1908, copy in MOC 1908, Box 12, File 12/3, 15-07-34/3, PARC; *Oregonian*, 28 February, 1910, p. 16. LGB to Mayor Simon, 26 January, 1910, copy in MOC 1911, Box 24, File 24/6, 15-07-28/3, PARC.

10. *Oregonian*, 22 February, 1910, p. 20; "Mayor to Raid Dances," *Oregonian*, 23 February, 1910, p. 11; "Dance Hall is Closed," *Oregonian*, 24 February, 1910, p. 4.

11. *Oregonian*, 22 February, 1910, p. 20.

12. *Ibid.*; *Oregonian*, 23 February, 1910, p. 11.

13. *Ibid.*; *Oregonian*, 24 February, 1910, p. 4.

14. "Mother of 4 Sentenced," *Oregonian*, 26 February, 1910, p. 12.

15. *Oregonian*, 24 February, 1910, p. 4.

16. "Mayor is Opposed by Mrs. Baldwin," *Oregonian*, 27 February, 1910, Sec. 1, p. 10.

17. "Dance Halls Evil," *Oregonian*, 28 February, 1910, p. 16.

18. *Ibid.*

19. *Oregonian*, 28 February, 1910, p. 16; "Amendment to dance hall licensing regulations," 26 January, 1910, copy in Council Documents 1910, Box 107, File 107/12, 19-04-15/2, PARC.

20. *Oregonian*, 28 February, 1910, p. 16.

21. *Ibid.*

22. *Ibid.*

23. "Mrs. Baldwin to be Reprimanded," *Oregonian*, 1 March, 1910, p. 10.

24. "Inquiry is Due Today," *Oregonian*, 3 March, 1910, p. 12.

25. "In Place of Dancehalls?," *Oregonian*, editorial, 1 March, 1910, p. 6; *Oregonian*, 28 February, 1910, p. 16.

26. *Oregonian*, 1 March, 1910, p. 10; "Expenses of Mrs. Baldwin Held Up," *Oregonian*, 2 March, 1910, p. 12. *Oregonian*, 3 March 1910, p. 12. The expenses were, of course, legitimate. With a camera bought for her by Women's Union member and Women's Protective Division booster Henrietta Failing, Baldwin photographed girls for evidence. In September of 1908, for example, she recorded the needle marks on a morphine addict's arms, lest they heal and fade by the time of her hearing. WPD/DAR 22 July, 3, 7 September, 1908. In the case of the questionable rail

fares, Baldwin took the train on official police business, such as her extradition trip to Seattle. The women's police department also furnished transportation home for an average of two to four runaways a month. In 1909, fares were paid for 34 such girls. "Report for 1909," LGB to Mayor Simon, 26 January, 1909.

27. *Oregonian*, 2 March, 1910, p. 12; LGB, Six Month's Report to Mayor Simon, 11 July, 1910, copy in MOC 1911, Box 24, File 24/6, 15-07-28/3, PARC.

28. A copy of Grant's proposed ordinance was debated by the city council Committee on Health and Police in early March 1910, but was shelved until someone came up with a better one. "Report of Committee on Health and Police," 9 March, 1910, copy in Council Documents 1910, Box 107, File 107/12, 19-04-15/2, PARC; Baldwin enumerated her objections to Grant's proposal at the time it appeared. *Oregonian*, 28 February, 1910, p. 16.

29. Sixty-nine of the city's prominent men who lived in the Portland Heights area signed a petition against the building of the dance hall in early 1909. It is clearly marked "Placed On File," with no indication of any further action to be taken. "Remonstrance Against Building Dance Hall or Road-house on Portland Heights," copy in Council Documents 1909, Box 102, File 102/7, 19-04-14/1, PARC.

30. *Ibid.*; the problem at Council Crest between the Pavilion and its neighbors was described by the hall's lessee two years later when he reapplied to the city for a license. A. Du Champ to License Committee, 3 September, 1912, copy in Council Documents 1912, Box 119, File 119/11, 19-04-14/1, PARC.

31. A. Du Champ to License Committee, 3 September, 1912; "Dance Hall to Go," *Oregonian*, 26 May, 1910, p. 4.

32. LGB "Six Month's Report to Mayor Simon," 11 July, 1910; A. Du Champ to License Committee, 3 September, 1912; "Annual Report of the Municipal Department of Public Safety for Young Women, 1910," copy in MOC 1911, Box 24, File 24/6, 15-07-28/3, PARC.

33. WPD/DAR 23 September, 16 October, and 15 December, 1911. Ex-city councilman Fred Merrill had chronic difficulties with the policewoman over his downtown dance hall and the notorious roadhouse he operated east of the city limits. See Fred Merrill to Mayor Lane, 19 November, 1908, copy in MOC 1908, Box 10, File 10/9, 15-07-34/2, PARC, and LGB to Mayor Lane, 25 November, 1908, copy in MOC 1908, Box 12, File 12/3, 15-07-34/3, PARC.

34. WPD/DAR 4 January, 1912; "Portland to Ban Public Dances," *Oregonian*, 5 January, 1912, p. 12. In a *Sunset* magazine feature about the Rose City's policewoman, Louise Bryant used the battle against the dance halls as the "best illustration" of Baldwin's policies. Louise Bryant, "A Municipal Mother," *Sunset* 29 (September 1912), 291; Baldwin's annual summary for 1911 prematurely reported the early 1912 dance hall ban because she compiled her previous year's statistics *after* the events of the first week of January 1912. She could not resist, it seems, including such an exciting victory, although it technically belonged in the following year's report.

"Annual Report for 1911 of Municipal Department of Public Safety for Young Women," copy in Mayor's Message and Annual Reports, 1911," Box 27, 17-06-02, PARC.

35. WPD/DAR 31 January, 1912.

36. WPD/DAR 13 April, 24 June, 28 July,1912.

37. WPD/DAR 29 June, 1912.; A. Du Champ to License Committee, 3 September, 1912.

38. "Dance Bill is Proposed," *Oregonian*, 15 November, 1912, p. 15; "Dance Curb Favored," *Oregonian*, 26 November, 1912, p. 4; LGB to Mayor Albee, 11 February, 1914, copy in MOC 1914, Box 61, File 61/1, 15-07-01/1, PARC.

39. *Oregonian*, 15 November, 1912, p. 15; WPD/DAR 19, 21 November, 1912.

40. *Oregonian*, 26 November, 1912, p. 4; "Dance Law Displeases," *Oregonian*, 26 November, 1912, p. 18.

41. "Dance Ban Changed," *Oregonian*, 6 December, 1912, p. 17; "Public Dancing is Regulated by Act," *Oregonian*, 27 March, 1913, p. 20.

42. *Portland Ordinance 27553*, 13 August, 1913, copy in MOC 1916, Box 38, File "Dance Matters," 15-07-14/1, PARC; LGB to Mayor Albee, 11 February, 1914.

43. LGB to Mayor Albee, 11 February, 1914.

44. *Portland Ordinance 34790*, 4 December, 1918, copy in Council Ordinances, 34250-35700 (1918-19), File 135, 05-01-55, PARC; LGB to Mayor George Baker, 16 March, 1922, copy in MOC 1922, Box 38, File "Dance Matters," 15-07-14/1, PARC; "Drastic Dance Law Asked in New York," *Oregonian*, 13 March, 1922, p. 4.

45. Erenberg, *Steppin' Out*, pp. xii, 63; Peiss, *Cheap Amusements*, p. 162; May, *Screening*, p. 46. With a certain degree of hypocrisy, elite Portlanders bypassed the new code when it came to their own infatuation with the Tango. The exotic Latin American dance, the sensuous movements of which would certainly have banned it from the public halls, took the upper class by storm in the prewar years. The so-called "Tango Tea" was devised as a subterfuge by which the city's pedigreed citizens could indulge in the craze without raising eyebrows. In late 1913, both the Multnomah Hotel and the Portland Hotel arranged private dance exhibitions and lessons combined with late-afternoon light refreshments for the "smart set." Limited to a dozen couples, the affairs were by invitation only and, as the *Oregonian* reported, "confined to the society people." See "Tango Teas to be Given in Portland," *Oregonian*, 22 November, 1913, p. 12.

46. Jane Addams, *A New Conscience and an Ancient Evil* (New York: Macmillan, 1912), p. 106; Louise de Koven Bowen, "Dance Halls," *Survey* 26 (June 3, 1911), 383-87; Foster was a nationally known social hygienist and president of Portland's Reed College. He disparaged the dance halls in his introductory chapter to an edited collection of papers read at a Social Hygiene Society conference in 1913. William T. Foster, ed., *The Social Emergency: Studies in Sex Hygiene and Morals* (Boston: Houghton-Mifflin,

1914), p. 19. Peiss's research shows that in early twentieth-century New York, fully eighty per cent of the dance halls were near or connected to saloons, and many were bankrolled by brewers. Peiss, *Cheap Amusements*, p. 95. For a recent journal treatment of Progressive Era dance regulation, especially in Chicago and New York, see Elisabeth I. Perry, "The General Motherhood of the Commonwealth: Dance Hall Reform in the Progressive Era," *American Quarterly* 37 (Winter 1985), 719-33.

Chapter 4

1. For examples of the "pitfall" problem see "Many Girls Aided," *Oregonian*, 14 October, 1908, p. 16, and LGB "Report for August 1908," copy in Council Documents 1908, Box 101, File 101/1, 19-04-13/2, Portland Archives and Records Center [hereinafter PARC].

2. Lewis Erenberg, *Steppin' Out: New York Nightlife and the Transformation of American Culture* (Chicago: University of Chicago Press, 1984), pp. 67, 69, 177-78, 194; Kathy Peiss, *Cheap Amusements: Working Women and Leisure In Turn-of-the-Century New York* (Philadelphia: Temple University Press, 1986), pp. 144-45.

3. Women's Protective Division Daily Activity Reports [hereinafter WPD/DAR], 2 November, 1910; "Act is Protested," *Oregonian*, 5 November, 1910, p. 5; "Singer's Act is Abruptly Ended," *Oregonian*, 6 November, 1910, sec. 1, p. 12; Erenberg, *Steppin' Out*, p. 193.

4. "Singer's Ire is Up," *Oregonian*, 7 November, 1910, p. 12; "Tucker Case Dropped," *Oregonian*, 8 November, 1910, p. 9.

5. *Ibid.*

6. *Ibid.*; LGB to Mayor Simon, 10 January, 1911, copy in Mayor's Office Correspondence [hereinafter MOC], 1911-12, Box 24, File 24/6, 15-07-28/3, PARC.

7. *Ibid.*; Fred Fritz's Saloon and Theater at Second and Burnside had a long reputation for salacious entertainment. In early 1910, for example, Baldwin received complaints that "a troupe of fast women calling themselves 'The Dollies'" were amusing the crowd with "obnoxious" dance routines. WPD/DAR 31 January, 1910; LGB to Mayor Simon, 10 January, 1910.

8. *Oregonian*, 6 November, 1910, p. 12; Erenberg, *Steppin' Out*, pp. 187-97.

9. The "Dance of Death" program, like Sophie Tucker, was booked by the Pantages Theater. WPD/DAR 13 March, 1913; "Policewomen's Reports on Shimmie Dancing," copies in MOC 1919, Box 38, File "Dance Matters," 15-07-14/1, PARC.

10. "First Moving Pictures in Portland," *Oregonian*, 5 August, 1897, p. 10; Erenberg, *Steppin' Out*, pp. 69, 70; Lary May, *Screening Out the Past: The Birth of Mass Culture and the Motion Picture Industry* (New York: Oxford University Press, 1980), pp. 26, 27; Robert Sklar, *Movie-Made America: A Cultural History of American Movies* (New York: Vintage Press, 1976), pp. 4, 5.

11. WPD/DAR 27 April 1908, 19 May, 28 August, 9 November, 1909, 22 February, 1910, 11 March, 1911.

12. WPD/DAR 11 March, 23 September, 1911; Mayor H. R. Albee to L. L. Lewis, 5 March, 1914, copy in MOC 1914, Box 30, File 30/7, 15-07-20/3, PARC; "Municipal Board of Review" entry, *Card-file/Historical Index*, 2012-10 2/2, PARC.

13. "Children and the City Streets at Night," Oregon Social Hygiene Society Report, copy in MOC, 1914, Box 31, File 31/8, 15-07-21/1, PARC; Oregon Congress of Mothers and Parent-Teacher Associations to Mayor Albee, 27 March,1914, copy in MOC 1914, Box 31, File 31/8, 15-07-21/1, PARC; Mayor Albee to C. Lindsay, 13 November, 1914, copy in MOC 1914, Box 30, File 30/8, 15-07-20/3, PARC; LGB Quarterly Report, 1 January to 1 April, 1911, copy in MOC 1911, Box 24, File 24/6, 15-07-28/3, PARC; LGB to Mayor Baker and Chief, 6 February, 1922, copy in LGB file PPHS.

14. Erenberg, *Steppin Out*, p. 72; May, *Screening*, p. 59; "Children and the City Streets at Night"; WPD/DAR 20 February, 4 September, 1913; Hollywood turned out a spate of moral warning films in the silent era. For a synopsis of their content and purpose, see Kevin Brownlow, *Behind the Mask of Innocence* (New York: Alfred A. Knopf, 1990), especially chapters 1 through 5.

15. Baldwin's observations were confirmed several years later by sociologist Howard B. Woolston. A quarter of his sample of young early twentieth-century prostitutes implicated alcohol in their moral downfalls. Howard B. Woolston, *Prostitution in the United States* (1921, reprint, Montclair, NJ: Patterson-Smith, 1969), p. 70.; LGB Report of Women's Auxiliary, August 1908, copy in Council Documents 1908, Box 101, File 101/1, 19-04-13/2, PARC; "The Protection of Women," unidentified newsclipping, copy in MOC 1908, Box 12, File 12/3, 15-04-34/3, PARC; LGB Six Month Report to Mayor Simon, 1 July, 1909; WPD/DAR 3 July, 1908.

16. LeGrand Baldwin ran unsuccessfully for the state senate in 1910, although he "polled the highest vote ever given to a Party Prohibitionist in Multnomah County." In 1912, he sought the Third District U. S. congressional seat with the same backing and similar negative results. *Oregon State Voters' Pamphlet for 1912* (Salem: State Printer, 1912), p. 37. Premier Oregon suffragist Abigail Scott Duniway diverged from the ideology which wedded suffrage and prohibition in many states. She calculated that it would be easier to reconcile men to suffrage if they were not simultaneously threatened with alcohol prohibition. *After* the vote was obtained, Duniway asserted, women could approve prohibition at the polls. She was proved correct on both counts. Oregon women gained suffrage in 1912, and were given credit for the passage of statewide alcohol prohibition in 1913. Other states which insisted upon combining suffrage and prohibition were retarded in their efforts for several more years. Ruth B. Moynihan, *Rebel for Rights: Abigail Scott Duniway* (New Haven: Yale University Press, 1983), pp. 212-19; *General Laws of Oregon*, 1907, pp. 39-47, 154-55.

17. LGB to Chief Gritzmacher, 1 June, 1908, and LGB to Mayor Lane, 25 November, 1908, copies in MOC 1908, Box 12, File 12/3, 15-07-34/3, PARC; WPD/DAR: 11 May, 3, 7, 18, 22 July, 10, 25 August, 1908.

18. Transcript "State vs. Wroten," copy in Council Documents 1908, Box 99, File 99/6, 19-04-13/1, PARC. The transcript of the Club Cafe proceedings cost Baldwin's office $18, an incredible sum when one considers that her entire monthly expenditures at that time ran between $60 and $80. She justified the amount by saying that "if ... we are able to revoke the license of such a place, the money could not be expended in a better way." WPD/DAR 26 August, 8, 14, 21, 22, 23, 24 September, 1908, 16 March, 1909.

19. WPD/DAR 16 March, 13 April, 18 June 1909, 15 December, 1911.

20. Early-twentieth-century sociologist Howard B. Woolston called the chauffeured automobiles "rolling roadhouses," and similarly deplored the "odious reputation" of motorcycles. Woolston, *Prostitution*, pp. 153-54; Baldwin reported numerous incidents of automobiles used to transport girls to roadhouses, etc. WPD/DAR 7, 19 June, 29 August 1909, 30, 31 March, 1910, 16 April, 18 June, 1912.

21. LGB Six Months' Report to Mayor Simon, 1 July, 1909, copy MOC 1911, Box 24, File 24/6, 15-07-28/3, PARC; WPD/DAR 18 June, 1909, 7 October, 1912; LGB to Mayor Albee, 27 February, 1915, and Mayor Simon to LGB, 1 March, 1915, copies in MOC 1915, Box 61, File 61/2, 15-07-01/1, PARC.

22. WPD/DAR 17 July, 1908, 25 August, 1910, 11 March, 1911. For a synthesis of the age's drive for censorship, see David J. Pivar, *Purity Crusade: Sexual Morality and Social Control*, 1868-1900 (Westport, CT: Greenwood Press, 1973), pp. 232-38.

23. WPD/DAR 11-21 September, 5, 15 October, 1908.

24. *Ibid.*

25. WPD/DAR 1-15 August, 4 September, 1909; LGB to Frank E. Watkins, 4 September, 1909, and circulars, "Portland Introducing Bureau," "Guarantee Bureau," copies in Council Documents 1909, Box 106, File 106/6, 19-04-16/1, PARC.

26. LGB to Frank E. Watkins, 4 September, 1909; L. B. Osborne to City Council, 6 September, 1909, copy in Council Documents 1909, Box 106, File 106/6, 19-04-16/1, PARC; LGB to Mayor Simon, 18 September, 1909, copy in MOC 1911, Box 24, File 24/6, 15-07-28/3, PARC.

27. Brochure of "Portland Introducing Bureau"; WPD/DAR 4, 22 September, 1909; "Report of the Committee on Health and Police," 17 September, 1909, copy in Council Documents 1909, Box 102, File 102/7, 19-04-14/1, PARC.

28. LGB to Mayor Simon, 15 May, 1911, copy in MOC 1911, Box 24, File 24/6, 15-07-28/3, PARC.

29. *Ibid.*; LGB to Mayor Albee, 21 August, 1913, copy in MOC 1913, Box 61, File 61/1, 15-07-01/1, PARC.

30. E. Kimbark MacColl, *Merchants, Money, and Power: The Portland Establishment, 1843-1913* (Portland: Georgian Press, 1988), p. 400; Pivar, *Purity Crusade*, p. 239.

31. LGB to Mayor Albee, 30 September, 1913, copy in MOC 1913, Box 61, File 61/1, 15-07-01/1, PARC.

32. *Ibid.*

33. WPD/DAR 27 September, 1913.

34. Fred Alexander to Mayor Albee, 24 May, 1915, copy in MOC 1915, Box 33, File 33/2, 15-07-21/2, PARC.

35. "Tight Dress Craze," *Oregonian*, 28 September, 1913, Sec. 1, p. 12. For an excellent primary source review of the social hygienists' attitude toward exercise for young females, see Dr. Bertha Stuart, "Teaching Phases for Girls," in William T. Foster, ed, *The Social Emergency: Studies in Sex Hygiene and Morals* (New York: Houghton Mifflin, 1914), pp. 154-67.

36. Albee's "edict" was discussed by a constituent, Robert G. Duncan, in a letter which instructed the mayor to consider another censorship problem, performance "tango" dancing at the Multnomah Hotel's Arcadian Garden Cafe. "If," Duncan told Albee, "we are liable to throw cat fits at the sight of a slit skirt, there might be danger of going into convulsions while trying to follow the contortions of the cabaret performers and swallow a wienerwurst at the same time." Robert G. Duncan to Mayor Albee, 25 October, 1913, copy in MOC 1913, Box 26, File 28/8, 15-07-20/1, PARC; "Girl's Silk Hose is Poor Gun Holster," *Oregonian*, 28 September, 1913, Sec. 1, p. 1.

37. *Oregonian*, 28 September, 1913, Sec. 1, p. 1, WPD/DAR 29 September, 1913; "Bad Motive is Alleged," *Oregonian*, 29 September, 1913, p. 7; "Nan Mann, Ann Maney," *Oregonian*, 30 September, 1913, p. 11.

38. "X-Ray Skirts Grilled," *Oregonian*, 1 October, 1913, p. 2; "Mrs Felts to Head Mother's Congress," *Oregonian*, 25 October, 1913, p. 12; "Able Teachers of Sex Hygiene Few," *Oregonian*, 8 October, 1913, p. 8; "Bernhardt Urges American Women to Fight Drink and Vice," *Oregonian*, 5 October, 1913, Sec. 3, p. 6; "Women's Dress," *Oregonian* editorial, 22 September, 1913, p. 6.

39. *Oregonian*, editorial, 22 September, 1913, p. 6.

40. Pivar, *Purity Crusade*, pp. 261-63.

Chapter 5

1. Steven Schlossman and Stephanie Wallach, "The Crime of Precocious Sexuality: Female Juvenile Delinquency in the Progressive Era," *Harvard Educational Review*, 48 (February 1978): 69-72; LGB to Mayor Lane, 30 December, 1905, copy in Mayor's Office Correspondence [hereinafter MOC], 1905, Box 1, File 1/2, 15-07-31/1, Portland Archives and Records Center [hereinafter PARC]; Barbara Meil Hobson, *Uneasy Virtue: The Politics of Prostitution and the American Reform Tradition* (New York: Basic Books, 1987), pp. 110, 125, 136. For a perspective on changing attitudes toward unwed mothers, see Joan Jacobs Brumberg, "'Ruined' Girls: Changing Community Responses to Illegitimacy in Upstate New York, 1890-1920," *Journal of Social History* 18 (Winter 1984), 247-72. For a detailed discussion of the genetic question and sexual delinquency, see Mark H. Haller, *Eugenics: Hereditarian Attitudes in American Thought* (New Brunswick, NJ: Rutgers University Press, 1984), Chapters 7-9.

2. Hobson, *Uneasy Virtue*, p. 136.

3. Schlossman and Wallach, "Precocious Sexuality,"*Harvard Ed. Rev.*, 72-77; Estelle B. Freedman, *Their Sisters' Keepers: Women's Prison Reform in America, 1830-1930* (Ann Arbor, MI: University of Michigan Press, 1981), pp. 127-31; Samuel Walker, *A Critical History of Police Reform: The Emergence of Professionalism* (Lexington, MA: D. C. Heath, 1977), pp. 85-86; LGB to Chief of Police, 1 May, 1908, copy in MOC 1908, Box 12, File 12/3, 15-07-34/3, PARC.

4. Women's Protective Division Daily Activity Reports [hereinafter WPD/DAR], 15 December, 1911 (LGB report to Chief E. A. Slover, October and November 1911).

5. WPD/DAR 5, 7, 16, 27 November, 1908. Frazer could not defend his opinion due to his untimely death in the interim. For a discussion of the change in attitudes about male culpability, see Eric C. Schneider, *In the Web of Class: Delinquents and Reformers in Boston, 1810s-1930s* (New York: New York University Press, 1992), pp. 72-74. In another such incident, Baldwin testified for the defendant in a rape case, reporting that she was familiar with the girl's family history, and thus believed the man "innocent of the assault." WPD/DAR 6 January, 1912.

6. WPD/DAR 30 November, 1908, 4 February, 1909; Schlossman and Wallach, "Precocious Sexuality," *Harvard Ed. Rev.*, 80.

7. WPD/DAR 8 April, 1909; Portland Juvenile Judge W. N. Gatens, for example, accepted the possibility of female culpability. Yet he couched his observations in a way which also blamed parents for the problem. "I regret to say," Gatens remarked in 1911, "it is true that the girls go half way in suggesting indiscretions. Such a girl usually exhibits a dearth of parental teaching." "Old Folks Blamed," *Oregonian*, 13 December, 1911, p. 14.

8. Freedman, *Sisters' Keepers*, pp. 116-21. For the text of Oregon's Juvenile Control Act, see *General Laws of Oregon 1907*, Chapter 34, pp. 39-47. Schneider, *Web of Class*, p. 89. More than 50 per cent of the inmates in roughly contemporary testing samples in Ohio, New York, and Massachusetts were declared "feeble minded," that is, having tested mental ages of less than twelve years. Haller, *Eugenics*, pp. 100-104.

9. LGB to Mayor Albee, 11 March, 1914, and Mayor Albee to LGB, 13 March, 1914, copies in MOC 1914, Box 61, File 61/1, 15-07-01/1, PARC. Alarming mental testing results prompted eugenics enthusiasts to push for laws mandating sterilization of the "feeble-minded" sexual delinquent. Freedman, *Sisters' Keepers*, p. 116. In 1913, the Oregon legislature passed a sterilization law aimed at both the feeble-minded sexual delinquent and the criminal "three-time loser." It failed in a voters' referendum that year, but eventually passed in a revised form in 1917. For the extent of such state-by-state sterilization mandates, see Haller, *Eugenics*, pp. 4, 6, 57, 74, and Chapter 9.

10. WPD/DAR 30 November, 1908, 13 January, 1909. For Oregon's provision of a "Home for the Feeble-minded," see *General Laws of Oregon 1907*, Chapter 84, p. 144.

11. Of 1,504 women arrested on morals charges between January 1911 and June 1912, approximately 60 percent of those whose background was recorded were reported as "American," 12 percent "Negro," and a cumulative 6 percent identifiable as Eastern or Southern European. *Third Report of the Portland Vice Commission, December 1912*, pp. 95-97; John D'Emilio and Estelle B. Freedman, *Intimate Matters: A History of Sexuality in America* (New York: Harper and Row, 1988), p. 215; Haller, *Eugenics*, pp. 54-55, 144; Frederick K. Grittner, *White Slavery: Myth, Ideology, and American Law* (New York: Garland, 1990), p. 130.

12. Grittner, *White Slavery*, pp. 39-52.

13. *Ibid.*, pp. 43-6; Haller, *Eugenics*, pp. 54-5.

14. WPD/DAR: 11 May, 18 April,1908, 24, 29 March, 1911, 27 January, 6 March, 30 June, 25 November, 4 December, 1912, 7 February, 1913; LGB to Mayor Albee, 7 February, 1914, copy in MOC 1914, Box 61, File 61/1, 15-07-01/1, PARC; D'Emilio and Freedman, *Intimate Matters*, p. 215.

15. Oregon's 1910 census reported that 1,492 "Negroes" lived in the state, most in Portland, which had a population of 207,000 at the time. E. Kimbark MacColl, *The Shaping of a City: Business and Politics in Portland, Oregon, 1885-1915* (Portland, OR: Georgian Press, 1975), p. 393. In 1915, Portland's NAACP estimated 2,500 African-Americans in a general urban population of about 250,000. Portland Chapter NAACP to Mayor Albee, 12 July, 1915, copy in MOC 1915, Box 49, File 49/5, 15-07-07/1, PARC. David W. Noble, *The Progressive Mind, 1890-1917*, (Minneapolis: Burgess, 1981), pp. 127-28. Boxer Jack Johnson's recent biographer obtained records through the Freedom of Information Act on how federal prosecutors, apparently outraged at the fighter's blatant and public preference for white women, pursued him relentlessly until they put together a convincing enough case to send him to prison. Grittner, *White Slavery*, pp. 101-102; D'Emilio and Freedman, *Intimate Matters*, pp. 202-203.

16. The St. Francis Club incident did not appear in the *Oregonian* during the time period involved. It may be assumed that this represented a conscious decision on the part of the newspaper voice of the civic elite, since the daughter of a prominent family was implicated. Baldwin discussed the case in full in a private report to Mayor Albee after it was reconciled. LGB to Mayor Albee, 26 November, 1913, copy in MOC 1913, Box 61, File 61/1, 15-07-01/1, PARC.

17. D'Emilio and Freedman, *Intimate Matters*, pp. 203, 215.

18. WPD/DAR 12 May, 16 November, 1908; The policewoman made these remarks to a Canadian audience in 1911. "In the Cause of Social Service," Vancouver, B. C. *Chronicle*, 22 September, 1911, WPD Scrapbook, PPHS. Baldwin's remarks about unwed mothers were typical of a softening of former attitudes which condemned such women as forever morally unredeemable. Kate Waller Barrett, head of the National Florence Crittenton Missions, voiced this sentiment well in 1910. "If we cannot have that trinity God intended—husband, wife, child—," she wrote, "we can have the other trinity—mother, child, home—which has a mighty potency in it for good." Quoted in Susan Tiffin, *In Whose Best Interest?: Child*

Welfare Reform in the Progressive Era (Westport, CT: Greenwood, 1982), pp. 171-72; For the change in attitude about the possibility of moral regeneration in unwed mothers, see Brumberg, "'Ruined' Girls," *Jour. Soc. Hist.* 18, 247-72.

19. WPD/DAR 4 August, 28 September, 14 October, 18 December, 1908, 1 February, 1911; W. T. Gardner to H. R. Albee, 13 November, 1913, copy in MOC 1915, Box 33, File 33/2, 15-07-21/2, PARC; "Louise Home" fundraising brochure (1911), copy in MOC 1913, Box 28, File 28/3, 15-07-20/2, PARC.

20. WPD/DAR 13 August,1908, 5 September to 17 October, 1909.

21. WPD/DAR 23, 24 July, 1908.

22. WPD/DAR 15 May, 23 July, 1908, 6, 15 January, 24 February, 23 March, 9 June, 26 July, 1 August, 24 October, 1909, 28 January, 22 February, 15 July, 2, 15 September, 15 October, 1910, 26 August 1911, 20 August, 12, 17 October, 1912. For the Oregon abortion statute, see *Lord's Oregon Laws*, Section 1900, p. 862.

23. WPD/DAR 13 January, 15 September, 1910, 17 October, 1912. Although it cannot be proven conclusively which were legitimate trained physicians, Baldwin's records report the names of numerous "doctors" who performed abortions. Among the identified surnames: Courtney, Von Falkenstein, Atwood (two brothers), McCormick, Pierce, Walker, Armstrong, Candiani, McKay, Watts, Mallory, King, and Ausplund. WPD/DAR 1908-1912, *passim.*

24. WPD/DAR 9 June, 1909.

25. WPD/DAR 24-31 October, 20 November, 1909.

26. WPD/DAR 2 September, 1910.

27. The Italian Consul's name was Dr. Candiani. WPD/DAR 15 September, 1910.

28. Jeanette Ladd entries, WPD/DAR 12, 13, 14 August, 1913.

29. WPD/DAR 15 October, 1910.

30. WPD/DAR 15 January, 2, 3 February, 1909, 5 October, 1910; *General Laws of Oregon*, 1909, p. 229; LGB Annual Report for 1910, copy in MOC 1911-12, Box 24, File 24/6, 15-07-28/3, PARC.

31. Tiffin, *Whose Interest?*, pp. 171-72; WPD/DAR 23 July, 1908, 6 January, 24 February, 26 July, 1909, 15 September, 1910, 20 August, 1912.

32. William T. Foster, ed. *The Social Emergency: Studies in Sex Hygiene and Morals* (Boston: Houghton-Mifflin, 1914), pp. 37-39. Head of the Oregon Social Hygiene Society and president of Portland's Reed College, Foster was well known in national social hygiene circles. "Case History of Lillian Larkin," 13 November, 1913, copy in MOC 1913, Box 61, File 61/1, 15-07-01/1, PARC, also WPD/DAR 5 October, 1908, 7 June, 19 July, 15, 29 August, 1909; Baldwin reported that instances of "sick" [her term for venereal] girls almost doubled from 1908 to 1909. In 1908 she recorded 62, but that number increased to 111 in 1909. "Cumulative Statistics, 1908-1914," LGB File, Portland Police Historical Society [hereinafter PPHS].

33. WPD/DAR 21 July, 29 August, 1909.

34. LGB to Mayor Albee, 20 February, 1914, copy in MOC 1914, Box 61, File 61/1, 15-07-01/1, PARC. Baldwin had been dealing with "Pearl" since 1909. WPD/DAR 10 June, 1909.

35. WPD/DAR 12 February and 8 June, 1912.

36. WPD/DAR 15 December, 1911, 12 February, 22 June, 1912; W. T. Gardner, Boys and Girls Aid Society of Oregon, to Mayor H. R. Albee, 12 November, 1913, copy in MOC 1915, Box 33, File 33/3, 15-07-21/2, PARC; "Albee Eager for Detention Home," *Oregonian*, 17 November, 1913, p. 14; LGB to Albee, 15 September, 1914, and Albee to LGB, 16 September, 1914, copies in MOC 1914, Box 61, File 61/2, 15-07-01/1, PARC.

37. D'Emilio and Freedman, *Intimate Matters*, pp. 203-12; Pivar, *Purity Crusade*, pp. 259, 272-73; John C. Burnham, *Paths into American Culture: Psychology, Medicine, and Morals* (Philadelphia: Temple University Press, 1988), pp. 150-69; Foster, *Social Emergency*, pp. 5-12; *Five Years Work in Oregon* (Portland: Oregon Social Hygiene Society, 1916), p. 47.

38. WPD/DAR 8 November, 1910, and 24 August, 1911.

39. WPD/DAR 19 June and 19 August, 1912.

40. Freedman, *Sisters' Keepers*, pp. 138-41; LGB to Chief Clark, 12 March, 1914, copy in MOC 1914, Box 61, File 61/1, 15-07-01/1, PARC.

41. Freedman, *Sisters' Keepers*, pp. 109-31; Haller, *Eugenics*, pp. 105-106.

42. LGB Files, *passim*; Freedman, *Sisters' Keepers*, p. 119-20, 139, 141.

Chapter 6

1. William T. Foster, *The Social Emergency: Studies in Sex Hygiene and Morals* (Boston: Houghton-Mifflin, 1914), pp. 5-12; David W. Noble, *The Progressive Mind, 1870-1917* (Minneapolis: Burgess, 1981), p. 85. For an extended discussion of the social hygiene medical-reformist influence on Progressive Era campaigns against the twin social evils of prostitution and venereal disease, see John C. Burnham, *Paths into American Culture: Psychology, Medicine, and Morals* (Philadelphia: Temple University Press, 1988), chapters 7-14.

2. Foster, *Social Emergency*, pp. 5-12; John C. Burnham, "The Progressive Era Revolution in American Attitudes Toward Sex," *Journal of American History* 59 (1973), 884-85.

3. Foster, *Social Emergency*, pp. 13-24; Burnham, "Progressive Attitudes," *Jour. Am. Hist.*, p. 886; John D'Emilio and Estelle B. Freedman, *Intimate Matters: A History of Sexuality in America* (New York: Harper and Row, 1988), pp. 206-208; "Anti-Vice Body Outlines Labors," *Oregonian*, 21 September, 1911, p.4.

4. *Oregonian*, 21 September, 1911, p. 4; Women's Protective Division Daily Activity Reports [hereinafter WPD/DAR], 8 August, 29 September, 5 October, 1908, 15, 16 January, 1909, 6 November, 15 December, 1911; Raymond B. Fosdick, "The Annual Report of the Commission on Training Camp Activities," *Social Hygiene* 5, no. 2 (April 1919), 267.

5. For the result of the St. Louis medical regulation experiment and the social hygiene push for complete abolition, see Burnham, *Paths*, pp. 138-48, 150-66, also Barbara Meil Hobson, *Uneasy Virtue: The Politics of Prostitution and the American Reform Tradition* (New York: Basic Books, 1987), pp. 139-61.

6. E. Kimbark MacColl, *Merchants, Money, and Power: The Portland Establishment, 1843-1913* (Portland, OR: Georgian Press, 1988), pp. 372-97; "Will Close Up Massage Shops," *Oregonian*, 21 May, 1905, p. 8.

7. Portland District Attorney to James B. Reynolds, 15 April, 1914, copy in Mayor's Office Correspondence [hereinafter MOC], 1914, Box 29, File 29/9, 15-07-19/3, Portland Archives and Records Center [hereinafter PARC]; MacColl, *Merchants*, p. 392; Captain Bruin to Chief Gritzmacher, 2 July, 1906, copy in MOC 1906, Box 5, File 5/3, 15-07-31/3, PARC; Howard B. Woolston, *Prostitution in the United States* (1921, reprint, Montclair NJ: Patterson-Smith, 1969), p. 104n; "Pitfalls for Girls," *Oregonian*, 5 March, 1907, p. 11; WPD/DAR 13 April, 7 October, 1908.

8. "Report of Committee on Detention Home, etc.," 19 July, 1913, copy in Council Documents 1913, Box 128, File 128/1, 19-04-02/1, PARC.

9. This detailed observation of the scene at Fred Fritz's entertainment complex is from an affidavit submitted as evidence to the liquor license committee regarding the establishment's permit renewal in 1911. "Affidavit of George A. Thacher Relative to Fritz' Theater," 5 October, 1911, copy in Council Documents 1911, Box 114, File 114/9, 19-04-08/1, PARC.

10. *Ibid.*

11. Captain P. Bruin to Chief of Police, 2 July, 1906, copy in MOC 1906, Box 5, File 5/13, 15-07-31/3, PARC; Captain P. Bruin to Mayor Lane, 17 January, 1908, copy in MOC 1908, Box 12, File 12/3, 15-07-34/3, PARC.

12. Captain P. Bruin to Mayor Lane, 17 January, 1908.

13. Ruth Rosen, *The Lost Sisterhood: Prostitution in America, 1900-1918* (Baltimore: Johns Hopkins University Press, 1982), xi-xiv; D'Emilio and Freedman, *Intimate Matters*, pp. 209-10.

14. LGB Six Month Report to Mayor Simon, 1 July, 1909, copy in MOC 1911, Box 24, File 24/6, 15-07-28/3, PARC; D'Emilio and Freedman, *Intimate Matters*, pp. 209-10; LGB Federal Civil Service Form 2118 [hereinafter FCS/2118], LGB file Portland Police Historical Society [hereinafter PPHS]; LGB Annual Report for 1910, copy in MOC 1911, Box 24, File 24/6, 15-07-28/3, PARC; WPD/DAR 13-25 April, 7 September, 1908, 16, 29 June, 1909, 13 January, 1912.

15. WPD/DAR 7 September, 1908.

16. WPD/DAR 1, 6, 19 November, 5, 6, 7 December, 1912, 6, 18 January, 1913.

17. Captain P. Bruin to Mayor Lane, 17 January, 1908, copy in MOC 1908, Box 12, File 12/3, 15-07-34/3, PARC; WPD/DAR 13 April, 1909. Antiprostitution petitions to Mayor Lane [numerous], September 1908, copies in MOC 1908, Box 12, File 12/3, 15-07-34/3, PARC. Although MacColl has suggested that the merchants who signed these antiprostitution remonstrances were

primarily concerned with improving conditions near their businesses, the actual petition letters made no mention of this and were very carefully couched in "social hygiene" language. MacColl, *Merchants*, p. 392; Rosen, *Lost Sisterhood,* pp. 14-19; David J. Pivar, *Purity Crusade: Sexual Morality and Social Control, 1868-1900* (Westport, CT: Greenwood, 1973), p. 154.

18. WPD/DAR: 7 December, 1908, 27 January, 13 April, 1909, 15 December, 1911.

19. WPD/DAR 23 June, 1908, 1, 17 February, 24-31 October, 1909, 2 September, 1910, 20 October, 1, 15 December, 1911, 31 January, 20 June, 1912; "Moral Conditions Decried by Jurors," *Oregon Journal,* 4 May, 1912, p. 2; "Hotel Keepers Given Blame," *Oregon Journal,* 5 May, 1912, Sec. 2, p. 5; *Second Report of the Portland Vice Commission,* August 1912, p. 75.

20. MacColl, *Merchants,* pp. 419-20; WPD/DAR 5 July, 1909; "Provide $267,745 for Police Work," *Oregonian,* 21 January, 1909, p. 10.

21. Eleanor F. Baldwin, "A Chance for Women to Help," *Oregon Journal,* 12 January, 1909, WPD Scrapbook, PPHS; MacColl, *Merchants,* pp. 418, 432-34; LGB Six Month Report to Mayor Simon, 1 July, 1909; WPD/DAR 1, 9, 13, 14, 15, 27 January, 1, 10, 19 February, 1, 9 March, 1909; "Charter Changes Number Twelve," *Oregonian,* 9 June, 1909, p. 18.

22. MacColl, *Merchants,* p. 418; Rosen, *Lost Sisterhood,* pp. 14-19; Pivar, *Purity Crusade,* p. 154; "Bad Zone Best Plan," *Oregonian,* 27 October 1909, p. 4.

23. *Oregonian,* 27 October, 1909, p.4; LGB to Mayor Simon, 28 October, 1909, copy in MOC 1911, Box 24, File 24/6, 15-07-28/3, PARC; "Mayor Stands by Pact on Boxing," *Oregonian,* 28 October, 1909, p. 16; "Agrees With Mayor Simon," *Oregonian,* 29 October, 1909, p. 20; "Calls on Mayor Simon," *Oregonian,* 29 October, 1909, p. 20.; Otto Wilson, *Life of Dr. Kate Waller Barrett* (1933, reprint, New York: Arno, 1974), p. 178.

24. LGB to Mayor Simon, 28 October, 1909; Estelle B. Freedman, *Their Sisters' Keepers: Women's Prison Reform in America, 1830-1930* (Ann Arbor, MI: University of Michigan Press, 1981), p. 127.

25. *Chicago Law and Order League Report,* and *1910 New York Grand Jury White Slave Traffic Report,* with cover letter LGB to Mayor Simon, 27 February, 1911, copies in MOC 1911, Box 24, File 24/6, 15-07-28/3, PARC; D'Emilio and Freedman, *Intimate Matters,* p. 210.

26. For Oregon's "little Mann Act" see *General Laws of Oregon, 1911,* Chapter 68, pp. 107-108; WPD/DAR 12 October, 20 November, 1910, 25 March, 15, 25 June, 26 July, 19 August, 17 October, 1911, 13 January, 8 February, 16 April, 4, 13, 18, 19 June, 18 July, 19 November, 16, 18, 19 December, 1912.

27. "Bad Lands Are Fought," *Oregonian,* 25 February, 1911, p. 12; MacColl, *Merchants,* pp. 433-34.

28. Warren M. Blankenship, "Progressives and the Progressive Party in Oregon, 1906-1916," Ph.D. diss., History, 1966, University of Oregon (Ann Arbor, MI: University Microfilms, 1979), p. 233; Rosen, *Lost Sisterhood,* pp. 14-15.

29. "Badland Not to be Segregated," *Oregonian,* 6 July, 1911, p. 12; WPD/DAR 24 July, 1911.

30. "Vice Commission Asked," *Oregonian*, 23 August, 1911, p. 11; "Social Evil is Study," *Oregonian*, 28 August, 1911, p. 11; "15 to Down Vice," *Oregonian*, 30 August, 1911, p. 11; "Rushlight Names Vice Commission," *Oregonian*, 24 September, 1911, sec. 2, p. 22.

31. "Vice Report Made," *Oregonian*, 10 January, 1912, p. 12; *Portland Vice Commission First Report*, January 1912, pp. 4-6; WPD/DAR 21 July, 1 September, 1909.

32. "Judge Censures Police," *Oregonian*, 13 December, 1911, p. 14; "Young Girls and the Law," *Oregonian* editorial, 13 December, 1911, p. 10.

33. *Oregonian*, 13 December, 1911, p. 14.

34. "Citizens Baffled by Vice Problem," *Oregonian*, 21 July, 1912, p. 18.

35. *Oregonian*, 21 July, 1912, p. 18. Although the San Francisco experiment began in optimism, it later was found to have been effectively controlled by the city's vice interests. See Burnham, *Paths*, p. 149, and Hobson, *Uneasy Virtue*, pp. 147-49.

36. LGB to Chief Slover, 26 June, 1912, copy in Council Documents 1912, Box 122, File 122/3, 19-04-10/2, PARC; *Oregonian*, 21 July, 1912, p. 18.

37. "Portland Immoral, Vice Probers Say," *Oregonian*, 23 August, 1912, pp. 1, 4, 6; MacColl, *Merchants*, pp. 534-38; *Portland Vice Commission Second Report*, August 1912, pp. 71-75.

38. WPD/DAR: 13 April, 1909, 15 December, 1911; *Portland Vice Commission Third Report*, December 1912, pp. 84-108. For a contemporary assessment of the abatement code question, see Bascom Johnson, "The Injunction and Abatement Law," *Social Hygiene* 1, no. 2 (March 1915): 231-56.

39. *Third Report*, pp. 109-15. In 1913, Portland approved a change in the basic form of city government. Voters adopted the "Galveston Plan," first tried in Galveston, Texas. The plan was designed to reduce the chances of municipal corruption through payoffs or other influence in several ways. The office of mayor became a full-time position. Four full-time paid city commissioners, elected at large, replaced the fifteen part-time city councilmen who had represented specific geographical wards. The mayor and each commissioner would have equal legislative vote, with the veto eliminated. All elected offices would be nonpartisan. The mayor would assign each commissioner the administration of a major department of city government, while he or she would assume control of the police bureau. In addition, municipal court judge would become a full-time position. MacColl, *Merchants*, pp. 445-49.

40. MacColl, *Merchants*, pp. 436-38, 448; *Third Report*, passim.

41. LGB files, *passim.*

42. Mark H. Haller, *Eugenics: Hereditarian Attitudes in American Thought* (New Brunswick, NJ: Rutgers University Press, 1984), pp. 53-4, 79-81, 100-103, 144; Hobson, *Uneasy Virtue*, pp. 190-94; *Five Years Work in Oregon* (Portland: Oregon Social Hygiene Society, 1916), p. 48.

43. Freedman, *Sisters' Keepers*, pp. 126-42.

Chapter 7

1. Don S. Kirschner, *The Paradox of Professionalism: Reform and Public Service in Urban America, 1900-1940* (New York: Greenwood, 1986), p. 2; Steven Schlossman and Stephanie Wallach, "The Crime of Precocious Sexuality: Female Juvenile Delinquency in the Progressive Era," *Harvard Educational Review* 48, 1 (February 1978), 69-70; W. T. Gardner to H. R. Albee, 13 November, 1913, copy in Mayor's Office Correspondence [hereinafter MOC], 1915, Box 33, File 33/3, 15-07-21/2, Portland Archives and Records Center [hereinafter PARC].

2. Estelle B. Freedman, *Their Sisters' Keepers: Women's Prison Reform in America, 1830-1930* (Ann Arbor, MI: University of Michigan Press, 1981), pp. 109-42; Robyn Muncy, *Creating a Female Dominion in American Reform, 1890-1935* (New York: Oxford University Press, 1991), pp. 34, 40, 41.

3. Women's Protective Division Daily Activity Reports [hereinafter WPD/DAR] 12, 13 October, 1908; Isabel C. Barrows, "The Pacific Coast," *Charities and Commons* 21 (December 1908), 365-68.

4. The YWCA Travelers' Aid reflected what Peggy Pascoe refers to as a "home mission" reform orientation. This religiously motivated stance relied on "moral suasion," both to keep girls on the right path, and to prompt civic authorities to use the police power to enact and enforce laws which would perpetuate Victorian morality ideas. Peggy Pascoe, *Relations of Rescue: The Search for Female Moral Authority in the West, 1874-1939* (New York: Oxford, 1990), pp. 185-86.

5. LGB Six Months' Report to Mayor Simon, 1 July, 1909, copy in MOC 1911-12, Box 24, File 24/6, 15-07-28/3, PARC; Peggy Pascoe argues that a net loss of moral authority among women reformers occurred when government began to enact public morality standards. This was undoubtedly true for some religiously motivated women who resisted change and became increasingly marginalized as a result, but social feminists like Lola Baldwin saw no contradiction at all in using "modern" methods against "modern" vice. Pascoe, *Relations of Rescue*, pp. 185-86, 192, 198, 212.

6. The "after-care" philosophy was embedded in Baldwin's Travelers' Aid plan, whose purpose was "to protect girls who come to the city, know where they live, where they work and under what conditions, know their temptations and allurements," etc. LGB "Travelers' Aid Work Synopsis," October 1907; LGB to Mayor Lane, 8 February, 1908, copy in MOC 1908, Box 13, File 13/7, 15-07-25, PARC, and LGB "Annual Report for 1911," in *Mayor's Message and Annual Reports, 1911*, p. 538, Box 27, 17-06-02, PARC.

7. For New Yorker Maude Miner's nationally recognized probation and parole work, see Maude E. Miner, "Two Weeks in a Night Court," *Survey* 22 (May 8, 1909), 229-34, also "Probation for Girls Who Err," *Survey* 23 (December 11, 1909), 349-50. Baldwin regularly referred to her "after-care" program in her reports to municipal authorities. LGB to Chief of Police, 1 May, 1908, copy in MOC 1908, Box 12, File 12/3, 15-07-34/3, PARC; LGB to Mayor

Simon, 1 July, 1909, copy in MOC 1911, Box 24, File 24/6, 15-07-28/3, PARC; WPD/DAR, 16 June, 1909, 1 April, 1913; LGB "Report for October and November 1911," part of WPD/DAR 15 December, 1911.

8. Freedman, *Sisters' Keepers*, pp. 131-32; "Probation for Girls," *Survey* 23, 350; "Parole System is Defended," *Oregonian*, 17 January, 1912, p. 6; WPD/DAR 17 October, 4 November, 1909, 1 November, 1911.

9. "Comparative Statistical Report, 1908-1914," [Appendix] compiled from documents in LGB File, Portland Police Historical Society; WPD/DAR 10, 12, 18, 29 March, 1913.

10. WPD/DAR 18 May, 1908.

11. Schlossman and Wallach, "Precocious Sexuality," *Harvard Ed. Rev.*, 75-78; Susan Tiffin, *In Whose Best Interest?: Child Welfare Reform In the Progressive Era* (Westport, CT: Greenwood, 1983), p. 61. The mid-teens were considered especially "dangerous" because contemporary studies showed that a great percentage of young prostitutes had entered the life between the ages of sixteen and eighteen. Jane Addams, *A New Conscience and an Ancient Evil* (New York: MacMillan, 1912), pp. 193-94, and Howard B. Woolston, *Prostitution in the United States* (1921, reprint, Montclair, NJ: Patterson-Smith, 1969), pp. 41-44. From an average of less than five per decade from 1850 to 1910, the number of newly constructed female detention homes soared to 23 for the years 1910 to 1920. Schlossman and Wallach, "Precocious Sexuality," *Harvard Ed. Rev.*, 70.

12. Schlossman and Wallach, "Precocious Sexuality," *Harvard Ed. Rev.*, 90-91; WPD/DAR 7 June, 19 July, 1909, 31 March, 1910, 4 June, 1912.

13. WPD/DAR 15 September, 1910; "Mrs. Lola G. Baldwin Heads Police Matron League," Scrapbook Number 10, p. 116, Oregon Historical Center.

14. WPD/DAR 18 December, 1912.

15. LGB to Police Committee of the Executive Board, 31 January, 1912, copy in Council Documents 1912, Box 122, File 122/3, 19-04-10/2, PARC.

16. WPD/DAR 15 January, 16 February, 1 May, 1913. Although a 1950 retrospective on Baldwin's career claimed there was "violent opposition" in the legislature to the industrial school, contemporary coverage contradicts this. Possibly the elderly Baldwin, or her interviewer, confused the situation surrounding the founding of the school in 1913 with the heated funding debate in the 1915 legislature described later in this chapter. Ellen M. Ewing, "Lola G. Baldwin - No. 1 Policewoman," *Oregonian, Northwest Living Magazine*, 11 June, 1950, pp. 10, 14. Although Baldwin and Felts were well-known figures, the author has been unable to learn any further details on Lotta C. Smith.

17. WPD/DAR 1, 7, 23 May, 5, 11 June, 1913. For the law governing the Oregon State Industrial School for Girls, see *General Laws of Oregon 1913*, Chapter 153, pp. 268-70; "Girls' Home to be Fit," *Oregonian*, 7 March, 1913, p. 2; LGB to Mayor H. R. Albee, 15 July, 1913, copy in MOC 1913, Box 61, File 61/1, 15-07-01/1, PARC.

18. LGB to Mayor Albee, 11 November, 1913, copy in MOC 1913, Box 61, File 61/1, 15-07-01/1, PARC; Esther M. Hopkins, Superintendent State Industrial

School for Girls, to Mayor Albee, 16 December, 1913, copy in MOC 1913. Box 27, File 27/2, 15-07-19/2, PARC; and "Lillian Larkin Case Facts," MOC 1914, Box 30, File 30/2, 15-07-21/1, PARC.

19. "Lillian Larkin Case Facts," MOC 1914, Box 30, File 30/2, 15-07-21/1, PARC.

20. LGB to Mayor Albee, 11 November, 1913; Bennett's arrest was part of the I. W. W. "free speech" tactic to draw attention to the cannery issue. She and others purposely made public speeches in support of the strikers without obtaining city permits. Their objective was to be arrested and clog the legal system until authorities gave in to their demands. Mayor Albee to LGB, 12 November, 1913, copy in MOC 1913, Box 61, File 61/1, 15-07-01/1, PARC.

21. Mayor Albee to LGB, 12 November, 1913, copy in MOC 1913, Box 61, File 61/1, 15-07-01/1, PARC. "Girl's Freedom Denied," *Oregonian*, 21 November, 1913, p. 12.

22. "I. W. W. Threaten to Set Girl Free," *Oregonian*, 22 November, 1913, pp. 1, 14.

23. "Mother in Tears Sees Larkin Girl," *Oregonian*, 23 November, 1913, sec. 1, p. 6; "Move to Free Girl On," *Oregonian*, 25 November, 1913, p. 15; "Mrs. Baldwin is Mark," *Oregonian*, 16 December, 1913, p. 10; "Mrs. Baldwin's Work," *Portland Evening Telegram*, editorial, 17 December, 1913, p. 6; Esther Hopkins to Mayor Albee, 16 December, 1913, Mayor Albee to Esther Hopkins, 19 December, 1913, copies in MOC 1913, Box 27, File 27/2, 15-07-19/2, PARC; Jean Bennett to Mayor Albee [additional petition signatures], 20 December, 1913, copy in MOC 1913, Box 26, File 26/4, 15-07-20/1, PARC; Mayor Albee to Allan R. Joy, 26 December, 1913, copy in MOC 1913, Box 27, File 27/3, 15-07-19/2, PARC.

24. "State Funds Slashed," *Oregonian*, 30 January, 1915, p. 13; "Women Up in Arms," *Oregonian*, 31 January, 1915, sec. 1, p. 6; "Consolidation Act is Subject Today," *Oregonian*, 1 February, 1915, pp. 1, 5.

25. "Women Plead for School for Girls," *Oregonian*, 2 February, 1915, p. 5. "Fiery Fight Waged Over Girls' School," *Oregonian*, 10 February, 1915, p. 4; "Girls' School Bill Is In," *Oregonian*, 11 February, 1915, p. 4.

26. "Aid is Given Many," *Oregonian*, 14 December, 1913, p. 13; *General Laws of Oregon 1913*, Chapter 153, pp. 268-70; Margaret Reeves, *Training Schools for Delinquent Girls* (New York: Russell Sage Foundation, 1929), pp. 57, 121; LGB to Mayor Albee, 2 August, 1915, copy in MOC 1915, Box 61, File 61/3, 15-07-01/1, PARC.

27. Mayor Albee to LGB, 3 August, 1915, copy in MOC 1915, Box 61, File 61/3, 15-07-01/1, PARC; Esther M. Hopkins to Mayor Albee, 7 July, 1915, copy in MOC 1915, Box 33, File 33/7, 15-07-21/2, PARC; LGB to Mayor Albee, 2 August, 1915.

28. Freedman, *Sisters' Keepers*, p. 130; Esther M. Hopkins to Mayor Albee, 16 December, 1913, copy in MOC 1913, Box 27, File 27/2, 15-07-19/2, PARC; LGB to Albee, 11 November, 1913, copy in MOC 1913, Box 61, File 61/1,15-07-01/1, PARC; LGB to Albee, 2 August, 1915; LGB to Mayor Albee, 22 January, 1915, copy in MOC 1915, Box 61, File 61/2, 15-07-01/1, PARC.

Effie Creswell, age twenty-one, was a notable exception to the early success rate at the industrial school. In late 1913 Baldwin turned her in to Salem police for attempted homicide after she was caught putting strychnine in the tea and coffee intended for consumption by staff and inmates. See "Woman Attempts to Poison 14 Girls," *Oregonian*, 28 October, 1913, p. 12.

29. Freedman, *Sisters' Keepers*, pp. 130-37. For the specifics on staffing and overall purpose of Oregon's Hillcrest, see *General Laws of Oregon 1913*, Chapter 153, pp. 268-70.

30. Barbara M. Hobson, *Uneasy Virtue: The Politics of Prostitution and the American Reform Tradition* (New York: Basic Books, 1987), p. 160; Freedman, *Sisters' Keepers*, pp. 128-30.

31. *Third Report of the Portland Vice Commission*, December 1912, pp. 105-8; "Rabbi Says Police Court Is Disgrace," *Oregonian*, 25 February, 1911, p. 12.

32. WPD/DAR 8 February, 1912; Louise Bryant, "A Municipal Mother," *Sunset* 29 (September 1912), 292-93; Maude E. Miner, "Reformatory Girls," *Charities and Commons* 17, (February 1907), 903-19; Miner, "Night Court," *Survey* 22, 229-34; LGB to Mayor and City Commissioners, 24 July, 1913, copy in MOC 1913, Box 61, File 61/1, 15-07-01/1, PARC; WPD/DAR 26 July, 1913.

33. LGB to Mayor-elect Albee, 24 June, 1913, copy in MOC 1913, Box 61, File 61/1, 15-07-01/1, PARC; LGB to Mayor and Commissioners, 24 July, 1913; LGB to Mayor Albee, 3 October, 1913, copy in MOC 1913, Box 61, File 61/1, 15-07-01/1, PARC; WPD/DAR 7 October, 1913; "Morals Court Set," *Oregonian*, 13 December, 1913, p. 10. For a review of the requirements and success of the Oregon Prostitution Abatement and Injunction law, see Bascom Johnson, "The Injunction and Abatement Law," *Social Hygiene* 1, 2 (March 1915), Table opp. 232, 254.

34. "Aid is Given Many," *Oregonian*, 14 December, 1913, p. 13; Mayor Albee to Commissioner Blaylock, 29 September, 1913, copy in MOC 1913, Box 26, File 26/ 3, 15-07-20/1, PARC; *Oregonian*, 13 December, 1913, p. 10; "Municipal Court Annual Report for 1914," in *Mayor's Message and Annual Reports 1914*, pp. 45-6, Box 27, 17-06-02, PARC.

35. "Municipal Court Annual Report for 1914," p. 45.

36. "Women's Protective Division Annual Report for 1914, in *Mayor's Message and Annual Reports 1914*, pp. 19-20, Box 27, 17-06-02, PARC; LGB to Mayor Albee, 24 February, 1914, and LGB to Mayor Albee, 20 February, 1914, copies in MOC 1914, Box 61, File 61/1. 15-07-01/1, PARC.

37. "Vice Report Made," *Oregonian*, 10 January, 1912, p. 12; Freedman, *Sisters' Keepers*, pp. 130-42; "Report of Detention Home Committee," 19 July, 1913, and A. G. Rushlight to City Council, 21 April, 1913, copies in Council Documents 1913, Box 128, File 128/1, 19-04-02/1, PARC.

38. WPD/DAR 2 May, 1913; Oregon Prisoners' Aid Society to Mayor and City Council, 19 April, 1913, and Detention Home Committee to Mayor and City Council, 10 May, 1913, copies in Council Documents 1913, Box 128, File 128/1, 19-04-02/1, PARC.

39. The wealthy Mrs. Henry L. Corbett was a tireless "rights" worker. She was very active in the women's suffrage campaign of 1912, and pushed for a minimum wage law for Oregon in 1913. E. Kimbark MacColl, *Merchants, Money, and Power. The Portland Establishment 1843-1913* (Portland: Georgian Press, 1988), p. 444; "Report of Detention Home Committee," p. 2.

40. Report of Detention Home Committee, pp. 2-4.

41. *Ibid.*, pp. 4-5.

42. *Ibid.*, pp. 5-8; LGB to Mayor and City Commissioners, 24 July, 1913, copy in MOC 1913, Box 61, File 61/1, 15-07-01/1, PARC.

43. MacColl, *Merchants*, p. 486; LGB to Mayor Albee, 3 October, 1913, and 9 March, 1914, copies in MOC 1913-14, Box 61, File 61/1. 15-07-01/1, PARC.

44. Grace B. Purse to LGB, 4 March, 1914, copy in MOC 1914, Box 61, File 61/1, 15-07-01/1. PARC.

45. "Ideas Offered for Society's Reform," *Oregonian*, 1 October, 1913, p. 14; "Albee Eager for Detention Home," *Oregonian*, 17 November, 1913, p. 14; Mayor Albee to Police Commissioner L. Blaylock, 29 September, 1913, copy in MOC 1913, Box 26, File 26/3, 15-07-20/1, PARC.

46. LGB to Mayor Albee, 15 September, 1914, copy in MOC 1914, Box 61, File 61/2, 15 07 01/1, PARC; Freedman, *Sisters' Keepers,* pp. 109-42; Thomas D. Eliot to Mayor Albee, 27 March, 1915, copy in MOC 1915, Box 33, File 33/13, 15-07-21/2, PARC.

47. LGB to Mayor Albee, 7 July, 1915, and Mayor Albee to LGB, 8 July, 1915, copies in MOC 1915, Box 61, File 61/3, 15-07-01/1, PARC; *Portland Ordinance 33646*, "Detention Home for Women," 2 January, 1918, copy in Council Ordinances, File 95, 05-01-54, PARC; Mayor George Baker to Committee for Civilian Cooperation in Combating Venereal Diseases, 12 March, 1918, copy in MOC 1918, Box 68, File 68/7, 15-07-04/1, PARC.

48. LGB Files, *passim.*

Chapter 8

1. Joseph Mayer, "The Passing of the Red Light District," *Social Hygiene* 4, 2 (April 1918), 197-209; Paul B. Johnson, "Social Hygiene and the War," *Social Hygiene* 4, 1 (January 1918), 91-137; Frank P. Stockbridge, "Single Men in Barracks," *World's Work* 35, (March 1918), 502-507; Jane Deeter Rippin, "Social Hygiene and the War: Work with Women and Girls," *Social Hygiene* 5, 1 (January 1919), 125-27.

2. William F. Snow, "The Four Great Lines of Defense," *Social Hygiene Bulletin* 5, 3 (March 1918), 3, 4, 6.

3. Winthrop D. Lane, "Girls and Khaki: Some Practical Measures of Protection for Young Women in Time of War," *Survey* 39, (December 1917), 236-40; "Miss Miner Discusses Plans, etc.," *Social Hygiene Bulletin* 5, 3 (March 1918), 3-4. Baldwin had been handling promiscuous girls and the soldiers

from Vancouver Barracks since 1905. In 1913, she was apprised by the headmaster of Hill Military Academy in Portland of an even younger epidemic of "uniformitis." He said that young girls congregated in the street outside the private boys school, trying to get the cadets' attention. Several boys had already been "reprimanded for breaking the rules and sneaking out with the girls." Women's Protective Division Daily Activity Reports [hereinafter WPD/DAR], 24 April, 1913. Other reformers understood the problem as well. Jane Addams, for example, warned her readers in 1912 about the morally dangerous mix of young girls and military encampments. Jane Addams, *A New Conscience and an Ancient Evil* (New York: MacMillan and Co., 1912), pp. 200-203; Barbara M. Hobson, *Uneasy Virtue: The Politics of Prostitution and the American Reform Tradition* (New York: Basic Books, 1987), pp. 171-72.

4. Hobson, *Uneasy Virtue*, p. 175; "Mrs. Lola Baldwin Enters War Work," *Oregonian*, 9 February, 1918, p. 9; Katherine B. Davis, "Social Hygiene and the War: Women's Part in Social Hygiene," *Social Hygiene* 4, 4 (October 1918), 532-33; Rippin, "Work with Women and Girls," *Social Hygiene*, 126-27; Stockbridge, "Single Men," *Worlds Work*, *passim*.

5. Stockbridge, "Single Men," *Worlds Work*, 507; "Vice Report is Made," *Oregonian*, 10 January, 1912, p. 12. For the effect of the closing of Portland's red light area, see Bascom Johnson, "The Injunction and Abatement Law," *Social Hygiene* 1, 2 (March 1915), 254.

6. *Portland Ordinance 33510*, "Suppression of Venereal Diseases," 23 November, 1917, copy in Council Ordinances 1917-18, Box 32821-34249, File 91, 05-01-54, Portland Archives and Records Center [hereinafter PARC].

7. *Portland Ordinance 33511*, "Amending Ordinance 33510," 27 November, 1917, copy in Council Ordinances 1917-18, Box 32821-34249, File 91, 05-01-54, PARC.

8. *Portland Ordinance 33510*, 23 November, 1917; "Home is Nearly Ready," *Oregonian*, 28 November, 1917, p. 20; "Home for Women Will Be Rushed," *Oregonian*, 31 December, 1917, p. 9; *Portland Ordinance 33646*, "Detention Home for Women," 2 January, 1918, copy in Council Ordinances 1917-18, Box 32821-34249, File 95, 05-01-54, PARC; Mayor Baker to Committee on Civilian Cooperation in Combating Venereal Diseases, 12 March, 1918, copy in Mayor's Office Correspondence [hereinafter MOC], 1918, Box 68, File 68/7, 15-07-04/1, PARC; "Girls to be Aided," *Oregonian*, 17 February, 1918, p. 18; "Many Women Flee," *Oregonian*, 4 March, 1918, p. 9; LGB to Jane Deeter Rippin, 2 May, 1918, copy in LGB File, Portland Police Historical Society [hereinafter PPHS]; "Cedars Now Open," *Oregonian*, 11 August, 1918, Sec. 1, p. 12. For description and enforcement of the Chamberlain-Kahn Act, see Hobson, *Uneasy Virtue*, pp. 176-78.

9. Johnson, "Injunction and Abatement," *Social Hygiene*, 254; Stockbridge, "Single Men," *World's Work*, 506-507.

10. "Control is Up Today," *Oregonian*, 2 January, 1918, p. 11; *Portland Ordinance 33649*, "Regulation of Rooming Houses, Hotels, etc.," 2 January, 1918, copy in Council Ordinances 1917-18, Box 32821-34249, File 95, 05-01-54, PARC.

11. *Portland Ordinance 33853*, "Public Morality and Decency, Amendment," 27 February, 1918, copy in Council Documents 1917-18, Box 32821-34249, File 102, 05-01-54, PARC; Stockbridge, "Single Men," *World's Work*, 506-507. For an early example of a "call girl," see WPD/DAR 15 June, 1911. For a contemporary description of the "rolling roadhouses," see Howard B. Woolston, *Prostitution in the United States* (1921, reprint, Montclair, N.J.: Patterson-Smith, 1969), p. 153.

12. Rippin, "Women and Girls," *Social Hygiene*, 125-36; Ruth Rosen, *The Lost Sisterhood: Prostitution in America, 1900-1918* (Baltimore: Johns-Hopkins University Press, 1982), p. 35.

13. "Federal Position is Given Mrs. Baldwin," *Portland Evening Telegram*, 9 February, 1918, p. 17; "Mrs. Lola Baldwin Called for War Work," *Oregonian*, 7 February, 1918, p. 9; "Police Matron Gets Fosdick Commission," *Oregon Journal*, 9 February, 1918, p. 7; Rippin, "Women and Girls," *Social Hygiene*, 125-36; M. C. Greegor to LGB, 10 August, 1918, copy in LGB file, PPHS. For the authority given to federal morals officers like Baldwin, see David J. Pivar, "Cleansing the Nation: The War on Prostitution, 1917-1921," *Prologue* 12 (Spring 1980), 33, and Rosen, *Lost Sisterhood*, p. 35.

14. "Policewomen May Be Put on Force," Oregonian, 10 February, 1918, sec. 1, p. 6; *Portland Ordinance 33950*, "Appointments to Women's Protective Division," 27 March, 1918, copy in Council Ordinances 1917-18, Box 32821-34249, File 105, 05-01-54, PARC; "Mayor Urges Policewomen," *Oregonian*, 26 March, 1918, p. 8; "Club Woman Is Named," *Oregonian*, 31 March, 1918, Sec. 1, p. 11; "Fair Applicants Seek Police Jobs," *Oregonian*, 6 April, 1918, p. 1; "Six Policewomen Will Guard Girls," *Oregonian*, 9 April, 1918, p. 16.

15. "Six Policewomen Will Guard Girls," *Oregonian*, 9 April, 1918, p. 16.

16. Rippin, "Women and Girls," *Social Hygiene*, 126-27; War Department to LGB, 10 August, 1918, copy in LGB File PPHS; LGB Federal Civil Service Form 2118, LGB File PPHS [hereinafter LBG FCS/211, PPHS].

17. Rippin, "Women and Girls," *Social Hygiene*, 126-28.

18. *Ibid.*, 135; LGB FCS/2118, PPHS; LGB Report of 7th District for December 1918, copy in LGB File, PPHS; Mayor Baker to Committee for Civilian Cooperation in Combating Venereal Diseases, copy in MOC 1918, Box 68, File 68/7, 15-07-04/1, PARC; Susan Tiffin, *In Whose Best Interest?: Child Welfare Reform in the Progressive Era* (Westport, CT: Greenwood, 1982), p. 242.

19. LGB "Report of Seventh District for December 1918," and LGB "Weekly Report of Seventh District, 27 January to 3 February, 1919," copies in LGB File PPHS.

20. "Weekly Report of Seventh District, 27 January to 3 February, 1919."

21. LGB "Report of Seventh District, December 1918"; LGB to Jane Deeter Rippin, 2 May, 1918, copy in LGB File, PPHS.

22. "Miss Miner Discusses Plans, etc.," *Social Hygiene Bulletin*, 3; LGB to Jane Deeter Rippin, 2 May, 1918.

23. LGB to Jane Deeter Rippin, 2 May, 1918; "Liquor Law Strict," *Oregonian*, 23 February, 1918, p. 18; "Anti-Liquor Regulations Made More Drastic," *Social Hygiene Bulletin* 5, 3 (March 1918), 1.

24. "Report of Seventh District, December 1918."

25. "Report on Bank Robber Case," LGB File PPHS; "Policewoman Traps Youth Accused of $35,000 Theft," *San Francisco Bulletin*, 17 December 1918, p. 1; "Woman Captures Daring Bank Robber," *Portland Evening Telegram*, 17 December, 1918, p. 1; "The Lady Detective," *Portland Evening Telegram*, editorial, 19 December, 1918, p. 6.

26. "Report of Seventh District, December 1918."

27. Jane Deeter Rippin to LGB, 5 December, 1918, copy in MOC, 1918, Box 45, File 45/14/ 15-07-15/2, PARC; Raymond B. Fosdick, "Annual Report of the Commission on Training Camp Activities 1919," *Social Hygiene* 5, no. 2 (April 1919): 267.

28. "Report of Seventh District, December 1918."

29. *Ibid.*; Judge George Tazewell to Mayor George Baker, 18 September, 1918, copy in MOC 1918, Box 62, File 62/15, 15-07-02/1, PARC; *Portland Ordinance 33510*, "Suppression of Venereal Diseases," 23 November, 1917.

30. For the changes in titles for the women's division over time, see correspondence letterheads, LGB Files, *passim*.

31. Eric C. Schneider, *In the Web of Class: Delinquents and Reformers in Boston, 1810s - 1930s* (New York: New York University Press, 1992), pp. 159-64. Baldwin described the detention room and its purpose in her annual report for 1914. "Women's Protective Division Annual Report," in *Mayor's Message and Annual Reports 1914*, pp. 19-20, Box 27, 17-06-02, PARC; LGB to Chief Clark, 20 April, 1914, copy in MOC 1914, Box 55, File 55/8, 15-07-09/1, PARC.

32. Judge Tazewell to Mayor Baker, 18 September, 1918.

33. G. J. Frankel to Chief Johnson, 21 September, 1918, and Chief Johnson to Mayor Baker, 5 October, 1918, copies in MOC 1918, Box 62, File 62/15, 15-07-02/1, PARC. For juvenile code on detention of minors, see *General Laws of Oregon 1907*, pp. 45-46.

34. Tazewell to Baker, 21 December, 1918, copy in MOC 1918, Box 62, File 62/15, 15-07-02/1, PARC.

35. Frankel to Johnson, 27 December, 1918, copy in MOC 1918, Box 62, File 62/15, 15-07-02/01, PARC; Tazewell to Baker, 9 January, 1919; Frankel to Johnson, and Moorad to Johnson, 17 January, 1919, copies in MOC 1919, Box 62, File 62/16, 15-07-02/1, PARC.

36. LGB to Jane Deeter Rippin, 14 December, 1918, copy in LGB File, PPHS.

37. "Women Police to Censor," *Oregonian*, 20 April, 1918, Sec. 1, p. 1; LGB to Mayor Baker, 6 August, 1919, copy in MOC 1919, Box 38, File "Dance Matters," 15-07-14/1, PARC; "Report of Seventh District for December 1918."

38. Fosdick, "Annual Report 1919," *Social Hygiene*, 265-68; Colonel Fields' note appears in "Experience Record of Lola G. Baldwin," copy in LGB File, PPHS; LGB to Mayor and Chief, 6 February, 1922, also LGB FCS/2118, PPHS.

39. "Lola Baldwin Will Take Old Police Job," *Portland Evening Telegram*, 6 December, 1920, p. 3; "Big Shakeup Due in Police Bureau," *Oregonian*, 6 December, 1920, pp. 1, 5.

40. John D'Emilio and Estelle B. Freedman, *Intimate Matters: A History of Sexuality in America* (New York: Harper and Row, 1988), pp. 211-15; Rosen, *Lost Sisterhood*, pp. 35-37; Stockbridge, "Single Men," *World's Work*, 506; and Mayor Baker to Committee on Civilian Cooperation in Combating Venereal Diseases, 27 March, 1918.

41. D'Emilio and Freedman, *Intimate Matters*, pp. 210-15; Rosen, *Lost Sisterhood*, pp. 35-40; Pivar, "Cleansing Nation," *Prologue*, 29-40; Estelle B. Freedman, *Their Sisters' Keepers, Women's Prison Reform in America, 1830-1930* (Ann Arbor, MI: University of Michigan Press, 1981), pp. 146-49; Hobson, *Uneasy Virtue*, pp. 171-83.

42. Pivar, "Cleansing Nation," *Prologue*, 34-36; Hobson, *Uneasy Virtue*, pp. 170-76; LGB to Mayor and Chief, 6 February, 1922.

43. Rosen, *Lost Sisterhood*, pp. 35-38; Pivar, "Cleansing Nation," *Prologue*, 33-40; LGB to Mayor and Chief, 6 February, 1922.

44. Baldwin found an ally in Mayor George L. Baker, who told a meeting of northwest civic officials that the best way to eliminate sexual vice was "to get at the source by providing policewomen." "Drive Launched to Stop Social Evil," *Oregonian*, 24 April, 1918, p. 13. Raymond Fosdick pushed for policewomen in urban enforcement departments after the war. In 1922 he recommended that the city of Cleveland hire ten women, as he believed that they could "perform work of the highest order, often in a way that cannot be equalled by men." Raymond B. Fosdick, et. al., *Criminal Justice in Cleveland: Cleveland Foundation Reports*, Roscoe Pound and Felix Frankfurter, eds. (1922, reprint, Montclair, NJ: Patterson-Smith, 1968), p. 77.

Chapter 9

1. Don. S. Kirschner, *The Paradox of Professionalism: Reform and Public Service in Urban America, 1900-1940* (New York: Greenwood Press, 1986), p. 54.

2. Elmer D. Graper, *American Police Administration* (1921, reprint, 1969, Montclair, NJ: Patterson-Smith), p. 232; Chloe Owings, *Women Police: A Study of the Development and Status of the Women Police Movement* (1925, reprint, 1969, Montclair, NJ: Patterson-Smith), pp. 104-105; LGB to Mayor Lane, 8 February, 1908, copy in Mayor's Office Correspondence [hereinafter MOC], 1908, Box 13, File 13/7, 15-07-25, Portland Archives and Records Center [hereinafter PARC].

3. David J. Pivar, *Purity Crusade: Sexual Morality and Social Control, 1868-1900* (Westport, CT: Greenwood Press, 1973), pp. 268-69; Women's Protective Division Daily Activity Reports [hereinafter WPD/DAR], 21 May, 1908.

4. WPD/DAR 25 September, 12, 13, 15, 28 October, 1908.

5. WPD/DAR 15 October, 1 December, 1908; Eleanor F. Baldwin [no relation], "The Woman's Point of View," *Portland Evening Telegram*, 12 January, 1909, p. 7.

6. WPD/DAR 5 January, 9, 11 February, 8 March, 1909.

7. WPD/DAR 1 May, 17 August, "combined report" 5 September to 17 October, 1909.

8. Paul U. Kellogg, "Boston-1915," *Survey* 23 (December 1909), 328-34; WPD/DAR 30 November, 1909; Kirschner, *Paradox*, pp. 65-66; LGB to Mayor Simon, 20 September, 1909, copy in MOC 1911, Box 24, File 24/6, 15-07-28/3, PARC.

9. WPD/DAR "combined report" 5 September to 17 October, 1909; LGB to Mayor Simon, 15 October, 1909, and Mayor Simon to LGB, 19 October, 1909, copies in MOC 1911, Box 24, File 24/6, 15-07-28/3, PARC.

10. WPD/DAR 6 June, 5 December, 1908, 15 January, 16 February, 27 May, 9 November, 1909, 20 September, 2 October, 6 November, 1911, 1 March, 1912, 14 May, 1913.

11. J. T. Donegan to Mayor Rushlight, 17 August, 1911, copy in MOC 1911, Box 24, File 24/3, 15-07-28/3, PARC; Mayor Rushlight to J. T. Donegan, 22 August, 1911, and LGB to Rushlight, 23 August, 1911, copies in MOC 1911, Box 23 File 23/4, 15-07-27/3, PARC.

12. WPD/DAR 22 September, 1911; "In the Cause of Social Service," Vancouver, B. C. *Chronicle*, 22 September, 1911, WPD Scrapbook, Portland Police Historical Society [hereinafter PPHS].

13. J. T. Donegan to Mayor Rushlight, 25 September, 1911, copy in Council Documents 1911, Box 116, File 116/6, 19-04-08/2, PARC; WPD/DAR 1 June, 1912. For corroboration of Vancouver as first Canadian city with policewomen, see Owings, *Women Police*, p. 62.

14. Owings ignores earlier policewomen's organizations, and places the events stemming from the 1915 Baltimore meeting under the assumptive subtitle "The Women Police Organize." According to Owings, it was not until 1915 that the policewomen felt need of "an association through which they might cooperate for the development of their work." Owings, *Women Police*, pp. 104-5; "Western Women as Police Officers," *Survey* 29 (December 1912), 345-47; "Mrs. Lola G. Baldwin Heads Police Matron League," Scrapbook 10, p. 116, Oregon Historical Center.

15. "Western Women," *Survey* 29, 346.

16. *Ibid.*; "Baldwin Heads League," Scrapbook 10, OHC; WPD/DAR 29 October, 1912; LGB to Mayor Albee, 7 June, 1913, and 24 June, 1913, copies in MOC 1913, Box 61, File 61/1, 15-07-01/1, PARC.

17. WPD/DAR 21 February, 1913; C. Rein to Mayor Albee, 21 January, 1914, copy in MOC 1914, Box 31, File 31/6, 15-07-21/1, PARC; LGB to W. H.

Warren, 12 September, 1914, copy in MOC 1914, Box 61, File 61/2, 15-07-01/1, PARC; LGB to Mayor Albee, 21 September, 1915, copy in MOC 1915, Box 61, File 61/3, 15-07-01/1, PARC; WPD/DAR 18 September, 1911.

18. LGB to Mayor Albee, 21 September and 12 October, 1915, copies in MOC 1915, Box 61, File 61/3, 15-07-01/1, PARC.

19. LGB to Mayor Albee, 12 October, 1915.

20. *Ibid.*; LGB to Mayor Albee, 11 November, 1915, copy in MOC 1915, Box 61, File 61/1, 15-07-01/1, PARC; Karen J. Blair, *The Clubwoman as Feminist: True Womanhood Redefined, 1868-1914* (New York: Holmes and Meier, 1980), pp. 90, 95.

21. Kirschner, *Paradox*, pp. 54, 63-64, 182-83.

22. *Portland Ordinances 17410* and *17411*, "Women Police," 12 February, 1908, copies in MOC 1908, Box 12, File12/3, 15-07-34/3, PARC; LGB to H. W. Wallace, 21 November, 1912, copy in Council Documents 1913, 19-04-01/1, PARC; LGB Annual Report for 1910, and LGB Quarterly Report, 1 January to 1 April, 1911, copies in MOC 1911, Box 24, File 24/6, 15-07-28/3, PARC.

23. LGB Annual Report 1911, in *Mayor's Message and Annual Reports 1911*, pp. 538-39, Box 27, 17-06-02, PARC.

24. LGB to Chief Slover, 21 June, 1912, copy in Council Documents 1912, Box 122, File 122/3, 19-04-10/2, PARC.

25. LGB to Mayor Albee, 18 November, 1913, copy in MOC 1913, Box 61, File 61/1, 15-07-01/1, PARC.

26. LGB to Mayor Albee, 3 October, 1913, and 24 February, 1914, copies in MOC 1913-14, Box 61, File 61/1, 15-07-01/1, PARC.

27. LGB to Mayor Albee, 10 and 15 June, 1914, also Mayor Albee to LGB 16 June, 1914, copies in MOC 1914, Box 61, File 61/1, 15-07-01/1, PARC; Mayor Albee to M. Randall, 10 and 16 June, 1914, copies in MOC 1914, Box 31, File 31/6, 15-07-21/1, PARC.

28. LGB to Mayor Albee, 2 September, 1914, and Mayor Albee to LGB, 3 September, 1914, copies in MOC 1914, Box 61, File 61/1, 15-07-01/1, PARC.

29. LGB to H. W. Wallace, 21 November, 1912 [re. Chandler], and same [re. Moorad], copies in Council Documents 1913, Box 127, File 127/10, 19-04-01/1, PARC; LGB to Mayor and Chief, 6 February, 1922, copy in LGB File, PPHS. Baldwin's influence in pay equity lasted at least until the Depression of the 1930s, when wages for both genders were altered downward. An outside consultant noted that women's salaries for particular ranks had been slashed proportionately more than men's, and recommended they be equalized. They were not, and the WPD itself was lucky to survive criticism that the women were usurping men's jobs. See August Vollmer, *Survey of the Portland Police Bureau* (Portland, OR: City of Portland, 1934), p. 38.

30. WPD/DAR 1 April, 22 July, 18, 27, 28 August, 4 September, 1908, 4 September, 1913.

31. WPD/DAR 27 August, 31 October, 1908, 20 February, 1909, and 8 April, 1913.

32. WPD/DAR 7 September, 1908; Report of Chief of Police for 1913, *Mayor's Message and Annual Reports 1913*, pp. 111-12, Box 27, 17-06-02, PARC; LGB to Mayor and Commissioners, 20 August, 1913, and LGB to Mayor Albee, 20 September, 1913, copies in MOC 1913, Box 61, File 61/1, 15-07-01/1, PARC.

33. LGB to Mayor Albee, 25 September, 1914, copy in Council Documents 1914, Box 132, File 132/7, 19-04-02/3, PARC.

34. Mayor Albee to LGB, 26 September, 1914, copy in MOC 1914, Box 61, File 61/2, 15-07-01/1, PARC; LGB to Mayor Albee, 2, 24 November, 1914, copies in MOC 1914, Box 61, File 61/2, 15-07-01/1, PARC; Report of Bureau of Police for 1914, *Mayor's Message and Annual Reports 1914*, p. 109, Box 27, 17-O6-O2, PARC.

35. LGB to Mayor Albee, 20 March and 4 May, 1915, copies in MOC 1915, Box 61, File 61/2, 15-07-01/1, PARC; LGB to Mayor Albee, 29 November, 1915, copy in MOC 1915, Box 61, File 61/3, 15-07-01/1, PARC.

36. "Police Guile Wins," *Oregonian*, 8 January, 1918, p. 9.

37. WPD/DAR 26 June, 1912; LGB to O. C. Bortzmeyer, 22 June, 1912, LGB to Chief Slover, 22 June, 1912, and LGB to John Coffey, 28 August, 1912, copies in Council Documents 1912, Box 122, File 122/3, 19-04-10/2, PARC; LGB to John Coffey, 6 September, 1912, copy in Council Documents 1912, Box 121, File 121/3, 19-04-09/2, PARC.

38. WPD/DAR 30 June, 1913, and LGB to Mayor Albee, 30 June, 1913, Box 61, File 61/1, 15-07-01/1, PARC.

39. LGB to Mayor Albee, 24, 30 June, and 30 July, 1913, copies in MOC 1913, Box 61, File 61/1, 15-07-01/1, PARC; "Police Move into New Home on Oak," *Oregonian*, 10 December, 1913, p. 6.

40. Kirschner, *Paradox*, p. 54; LGB Files, *passim.*

41. WPD/DAR 15 May, 23, 24 July, 7 September, 1908, 9 February, 9 June, 1, 5 September, 1909, 13 June, 1912; LGB to Mayor Albee , 28 December, 1914, copy in MOC 1914 , Box 61, File 61/2, 15-07-01/1, PARC; "Mrs. Frankel May Quit," *Oregonian*, 2 June, 1920, p. 16.

42. LGB Files, *passim*; Ellen M. Ewing, "Lola G. Baldwin—No. 1 Police-woman," *Oregonian, Northwest Living Magazine*, 11 June, 1950, pp. 10, 14.

Chapter 10

1. "Lola G. Baldwin Quits Police Job," *Oregonian*, 30 April, 1922, p. 16; "Public Weddings Rapped," *Oregonian*, 6 November, 1921, sec 1. p. 10.

2. "Flappers Flit to Doom, Says Chief of Police Bureau," *Oregon Journal*, 6 February, 1922, copy in LGB File Portland Police Historical Society [hereinafter PPHS]; Joanne J. Meyerowitz, *Women Adrift: Independent*

Wage Earners in Chicago, 1880-1930 (Chicago: University of Chicago Press, 1988), pp. 124-26; LGB to Mayor and Chief, 6 February, 1922, copy in LGB File PPHS.

3. LGB to Mayor and Chief, 6 February, 1922, copy in LGB File PPHS. For a recent study of 1920s youth, see Paula S. Fass, *The Damned and the Beautiful: American Youth in the 1920s* (New York: Oxford University Press, 1977).

4. *Oregon Social Hygiene Society Fourth Annual Report, 1914-15*, p. 9; "Drive Launched to Stop Social Evil," *Oregonian*, 24 April, 1918, p. 13; Fass, *Damned*, pp. 16-17. For a portrait of Judge Lindsey, see Charles Larsen, *The Good Fight: The Life and Times of Ben B. Lindsey* (Chicago: Quadrangle Books, 1972).

5. LGB Files, *passim*; Women's Protective Division Daily Activity Reports [hereinafter WPD/DAR], 13 January, 1910, 20 October, 1911, 7 August, 1913; "Harms Case Will be Decided Today," *Oregonian*, 23 January, 1918, p. 12; "Exoneration Given to Captain Harms," *Oregonian*, 24 January, 1918, p. 18.

6. *Oregonian*, 30 April, 1922, p. 16; Ellen M. Ewing, "Lola G. Baldwin—No. 1 Policewoman," *Oregonian Northwest Living Magazine*, 11 June, 1950, pp. 10, 14; Estelle B. Freedman, *Their Sisters' Keepers: Women's Prison Reform in America, 1830-1930* (Ann Arbor, MI: University of Michigan Press, 1981), p. 149.

7. "Two Birthdays, Golden Wedding Celebrated," *Oregonian*, 30 December, 1934, Women's Protective Division [hereinafter WPD] Scrapbook, PPHS; "Baker's Rites Set," *Oregonian*, 8 July, 1941, p. 11; LGB to *Oregonian*, 25 October, 1941, copy in LGB File PPHS.

8. LGB to *Saturday Evening Post*, 8 August, 1951, copy in LGB File PPHS. The story she objected to was "The Case of Anne Milton, Ex-Convict," by John B. Martin, which appeared in *The Saturday Evening Post*, 7 July, 1951, pp. 28-31, 70-72. The *Oregonian* column "Behind the Mike," 26 March, 1954, described the upcoming "Man Behind the Badge" episode. Copy, with Baldwin's comments scrawled in margins, in LGB File PPHS.

9. Rolla J. Crick, "Nation's First Women's Police Unit," *Oregon Journal*, 28 March, 1954, p. 8A; "Women Protest Reduction in Police Captain's Rank," *Oregonian*, 10 January, 1954, copy in LGB File PPHS; Lola G. Baldwin, "Our Policewomen," (guest editorial), *Oregon Journal*, 12 May, 1953, copy in LGB File PPHS.

10. Baldwin, "Our Policewomen"; Officer Sybil Plumlee (ret.), interview with author, 10 August, 1994.

11. Baldwin, "Our Policewomen."

12. "Women Protest Reduction," *Oregonian*, 10 January, 1954; "YW Doubts Uniform Plan," *Oregon Journal*, 26 April, 1953, copy in LGB File PPHS; "League of Women Voters Attacks Protective Division Shift," *Oregonian*, 12 January, 1954, copy in LGB File PPHS; Chief Jim Purcell to Lola G. Baldwin, 27 January, 1954, copy in LGB File PPHS.

13. Sybil Plumlee, interview 10 August, 1994; Rolla J. Crick, "Women Police Need Name With Uniform," *Oregon Journal*, 16 April, 1953.

14. Sybil Plumlee, interview 10 August, 1994.

15. See Helen K. Smith, ed., *With Her Own Wings* (Portland: Beattie, 1974), 231-34; Lola G. Baldwin to Editor, *Oregonian*, 3 April, 1956, typed copy in LGB File PPHS; "City's First Policewoman, 97, Dies," *Oregon Journal*, 24 June, 1957, p. 6; "Death Takes Mrs. Baldwin," *Oregonian*, 24 June, 1957, p. 13.

16. See Robyn Muncy, *Creating a Female Dominion in American Reform, 1890-1935* (New York: Oxford University Press, 1991); "Conciliation Agreement File," WPD File, PPHS.

17. "Conciliation Agreement File," WPD File, PPHS; Harrington was dismissed from her position in June of 1986 after city and departmental criticism of her management style and other issues.

Chapter 11

1. Elmer D. Graper, *American Police Administration* (1921, reprint, Montclair, NJ: Patterson-Smith, 1969), pp. 227-32. Chloe Owings' 1925 history of the policewoman's movement was commissioned by the International Association of Policewomen. Chloe Owings, *Women Police: A Study of the Development and Status of the Policewomen Movement* (1925, reprint, Montclair, NJ: Patterson-Smith, 1969), pp 100-106; Maud Darwin, "Policewomen: Their Work in America," *The Nineteenth Century and After* 75, (June 1914), 1371-77.

2. Clara M. Greening, "Policewoman Number One," *Sunset* 27 (September 1911), 304-306; Louise Bryant, "A Municipal Mother," *Sunset* 29 (September 1912), 290-93; Alice Stebbins Wells, "Women on the Police Force," *American City* 8 (April 1913), 401.

3. Owings, *Women Police*, pp 102-3, 191-93, 197, 271. Portland, like many cities, later expected its female police candidates to have "four years of college or equivalent, majoring in sociology." *The Portland Police Department: Its Purpose and Functions* (Portland Police Department, 1940, not paged).

4. Helen D. Pidgeon, "Service in the Field,"*Policewomen's International Bulletin* 4 (April 1927), 3; Alice A. Winter, "The Policewoman of Policewomen,"*Policewomen's International Bulletin* 6 (September 1930), 12; "Notes," *Policewomen's International Bulletin* 5 (April 1929), 2.

5. Robert Liebman and Michael Polen, "Perspectives on Policing in Nineteenth-Century America," *Social Science History* 2, 3 (Spring 1978): 352-59.

6. Don S. Kirschner, *The Paradox of Professionalism: Reform and Public Service in Urban America, 1900-1940* (New York: Greenwood Press, 1986), pp. 53-55.

7. David J. Pivar, *Purity Crusade: Sexual Morality and Social Control, 1868-1900* (Westport, CT: Greenwood Press, 1973), pp. 176-77, 255-77; John D'Emilio and Estelle B. Freedman, *Intimate Matters: A History of Sexuality in America* (New York: Harper and Row, 1988), pp. 214-15.

8. Liebman and Polen, "Perspectives," *Social Science History*, p. 356; Women's Protective Division Daily Activity Reports [hereinafter WPD/DAR]: 8, 9 April, 1913; H. R. Albee to LGB, 29 October, 1914, copy in Mayor's Office Correspondence [hereinafter MOC], 1914, Box 61, File 61/1, 15-07-Ol/1, Portland Archives and Reports Center [hereinafter PARC].

9. Kirschner, *Paradox*, xi.

10. LGB files, *passim*.

11. Peggy Pascoe, *Relations of Rescue: The Search for Female Moral Authority in the American West, 1874-1939* (New York: Oxford University Press, 1990), pp. 185-212.

12. *Ibid.*, pp. 192, 198. The national General Federation of Women's Clubs encouraged its state affiliates "to follow its policy of avoiding all discussion of religion and politics." Karen J. Blair, *The Clubwoman as Feminist: True Womanhood Redefined, 1868-1914* (New York: Holmes and Meier, 1980), p. 97.

13. Pascoe, *Relations*, p. 198; Pivar, *Purity Crusade*, p. 261; Paula S. Fass, *The Damned and the Beautiful: American Youth in the 1920s* (New York: Oxford University Press, 1977), p. 15; Eric C. Schneider, *In the Web of Class: Delinquents and Reformers in Boston, 1810s-1930s* (New York: New York University Press, 1992), pp. 163-64.

14. Fass, *Damned*, pp. 15, 25, 93-95; Kathy Peiss, *Cheap Amusements: Working Women and Leisure in Turn-of-the-Century New York* (Philadelphia: Temple University Press, 1986), p. 179; Joanne J. Meyerowitz, *Women Adrift: Independent Wage Earners in Chicago, 1880-1930* (Chicago: University of Chicago Press, 1988), pp. 92, 107-18, 140.

15. Robert H. Wiebe, *The Search For Order, 1877-1920* (New York: Hill and Wang, 1967), p. 212; David J. Pivar, "Cleansing the Nation: The War on Prostitution, 1917-21," *Prologue* 12 (Spring 1980), 33.

16. Clyde Griffen, "The Progressive Ethos," in *The Development of an American Culture*, Stanley Coben and Lorman Ratner, eds. (New York: St. Martins, 1983), pp. 144-45, 175, 177.

17. Meyerowitz, *Women Adrift*, pp. 140-42; Kirschner, *Paradox*, pp. 180-81.

18. J. Stanley Lemons, *The Woman Citizen: Social Feminism in the 1920s* (Urbana, IL: University of Illinois Press, 1973), *passim*; Blair, *Clubwoman*, *passim*; Robyn Muncy, *Creating a Female Dominion in American Reform, 1890-1935* (New York: Oxford University Press, 1991), *passim*; Mina Carson, *Settlement Folk: Social Thought and the American Settlement Movement*, 1885-1930 (Chicago: University of Chicago Press, 1990), *passim*; William L. O'Neill, *The Progressive Years: America Comes of Age* (New York: Harper and Row, 1975), pp. 180-81.

Bibliography

Primary Sources

Archives

Oregon Historical Center:
Reports of Portland Vice Commission, 1912-1913
Polk's City of Portland Directories, 1904-1914
Oregon Historical Scrapbooks

Portland Archives and Records Center:
Portland Mayor's Office Correspondence, 1904-1922
Portland City Council Documents, 1904-1922
City of Portland Annual Reports, 1904-1916
Portland City Ordinances, 1908-1918

Portland Police Historical Society:
Women's Protective Division Daily Activity Reports, 1908-1913
Lola G. Baldwin Miscellaneous Correspondence
Women's Protective Division Files and Scrapbooks

Newspapers

Oregonian, 1905-1957
Portland Evening Telegram, 1905-1922
Oregon Journal, 1905-1957

Books, Articles, Reports

Addams, Jane. *A New Conscience and an Ancient Evil.* New York: Macmillan Co., 1912.

———. "Some Reflections on the Failure of the Modern City to Provide Recreation for Young Girls," *Charities and Commons* 21 (December 1908): 365-68.

"Anti-Liquor Regulations Made More Drastic." *Social Hygiene Bulletin* 5, no. 3 (March 1918): 1.

Barrett, Kate Waller. *Some Practical Suggestions on the Conduct of a Rescue Home.* 1903; reprint, New York: Arno, 1974.

Barrows, Isabel C. "The Pacific Coast," *Charities and Commons* 21 (November 1908): 305-307.

Bowen, Louise de Koven. "Dance Halls." *Survey* 26 (June 1911): 383-87.

———. "Women Police." *Survey* 30 (April 12, 1913): 64-65.

Bryant, Louise. "A Municipal Mother." *Sunset* 29 (September 1912): 290-93.

Calahane, Cornelius F. *The Policeman.* 1923; reprint, New York: Arno, 1970.

Cooke, Belle W. "Where Women Work Wonders." *Sunset* 15 (June 1905), 477-82.

Daggett, Mabel P. "The City as a Mother." *World's Work* 25 (November 1912): 17.

Darwin, Maud. "Policewomen: Their Work in America." *The Nineteenth Century and After* 75 (June 1914): 1371-77.

Davis, Katherine B. "Social Hygiene and the War: Woman's Part in Social Hygiene." *Social Hygiene* 4, no. 4 (October 1918): 525-60.

Five Years' Work in Oregon. Portland, OR: Oregon Social Hygiene Society, 1916.

Fosdick, Raymond B. "The Annual Report of the Commission on Training Camp Activities." *Social Hygiene* 5, no. 2 (April 1919): 265-68.

———. *American Police Systems.* 1920. Reprint. Montclair, NJ: Patterson-Smith, 1969.

——— et al. *Criminal Justice in Cleveland: Cleveland Foundation Reports.* Edited by Roscoe Pound and Felix Frankfurter. 1922; reprint, Montclair NJ: Patterson-Smith, 1968.

Foster, William T. ed. *The Social Emergency: Studies in Sex Hygiene and Morals.* Boston: Houghton-Mifflin, 1914.

General Laws of Oregon, Vols. 1903-1913. Salem: State of Oregon.

Graper, Elmer D. *American Police Administration.* 1921; reprint, Montclair, NJ: Patterson-Smith, 1969.

Greening, Clara M. "Policewoman Number One." *Sunset* 27 (September 1911): 304-306.

Israels, Belle Linder. "The Way of the Girl," *Survey* 22 (July 1909): 486-97.

Johnson, Bascom. "The Injunction and Abatement Law." *Social Hygiene* 1, no. 2 (March 1915): 231-256.

Johnson, Paul B. "Social Hygiene and the War." *Social Hygiene* 4, no. 1 (January 1918): 91-137.

Kellogg, Paul U. "Boston-1915" *Survey* 23, (December 1909): 328-34.

Lane, Winthrop D. "Girls and Khaki: Some Practical Measures of Protection for Young Women in Time of War." *Survey* 39 (December 1917): 236-40.

Mayer, Joseph. "The Passing of the Red Light District: Vice Investigations and Results." *Social Hygiene* 4, no. 2 (April 1918): 197-209.

Miner, Maude E. "Two Weeks in a Night Court." *Survey* 22 (May 1909): 229-34.

————. "Reformatory Girls," *Charities and Commons* 17 (February 1907): 903-19.

"Miss Miner Discusses Plans, etc." *Social Hygiene Bulletin* 5, no. 3 (March 1918): 3-4.

Owings, Chloe. *Women Police: A Study of the Development and Status of the Women Police Movement.* 1925; reprint, Montclair, N.J.: Patterson-Smith, 1969.

Pidgeon, Helen D. "Service in the Field." *Policewomen's International Bulletin* 4 (April 1927): 3.

"Pioneer Experiences." *Social Hygiene* 4, no. 4 (October 1919): 567-89.

Portland Blue Book, 1913-1914. Portland, OR: R. L. Polk, 1913.

"Probation for Girls Who Err." *The Survey* 23 (December 11, 1909): 349-50.

Reeves, Margaret. *Training Schools for Delinquent Girls.* New York: Russell Sage Foundation, 1929.

Report of the Lewis and Clark Exposition Commission. Salem, OR: State Printer, 1906.

Rippin, Jane D. "Social Hygiene and the War: Work with Women and Girls." *Social Hygiene* 5, no. 1 (January 1919): 125-36.

Roe, Clifford G. *The Prodigal Daughter: The White Slave Evil and the Remedy.* Chicago: L. W. Walter Co., 1911.

Smith, B. H. "Policewoman." *Good Housekeeping* 52 (March 1911): 296-98.

State Wide Extension: Fourth Annual Report of the Oregon Social Hygiene Society. Portland, OR: Oregon Social Hygiene Society, 1915.

Stockbridge, Frank P. "Single Men in Barracks." *World's Work* 35 (March 1918): 502-507.

Snow, William F. "The Four Great Lines of Defense." *Social Hygiene Bulletin* 5, no. 3 (March 1918): 3-7.

"To Rehabilitate Prostitutes in Portland." *Survey* 31 (November 1913): 176.

Vollmer, August. *Survey of the Portland Police Bureau.* Portland, OR: City of Portland, 1934.

Wells, Alice S. "Women on the Police Force." *American City* 8 (April 1913): 401.

"Western Women as Police Officers." *Survey* 29 (December 1913): 345-47.

Winter, Alice A. "The Policewoman of Policewomen." *Policewomen's International Bulletin* 5 (April 1929): 2.

Woolston, Howard B. *Prostitution in the United States.* 1921; reprint, Montclair, NJ: Patterson-Smith, 1969.

Secondary Sources

Books and Articles

Abbott, Carl. *The Great Extravaganza: Portland and the Lewis and Clark Exposition.* Portland, OR: Oregon Historical Society Press, 1981.

Blair, Karen J. *The Clubwoman as Feminist: True Womanhood Redefined, 1868-1914.* New York: Holmes and Meier, 1980.

Blankenship, Warren M. "Progressives and the Progressive Party in Oregon." Ph.D. diss., University of Oregon, 1966.

Brownlow, Kevin. *Behind the Mask of Innocence.* New York: Alfred A. Knopf, 1990.

Brumberg, Joan J. "'Ruined' Girls: Changing Community Responses to Illegitimacy in Upstate New York, 1890-1920." *Journal of Social History* 18 (Winter 1984): 247-72.

Burnham, John C. *Paths into American Culture: Psychology, Medicine, and Morals.* Philadelphia: Temple University Press, 1988.

————."The Progressive Era Revolution in American Attitudes Toward Sex." *Journal of American History* 59 (1973): 885-908.

Caiden, Gerald E. *Police Revitalization.* Lexington, MA: D. C. Heath,1977.

Carson, Mina. *Settlement Folk: Social Thought and the American Settlement Movement, 1885-1930.* Chicago: University of Chicago Press, 1990.

Davis, Allen F. *Spearheads for Reform: The Social Settlements and the Progressive Movement, 1890-1914.* New York: Oxford University Press, 1967.

D'Emilio, John, and Estelle B. Freedman. *Intimate Matters: A History of Sexuality in America.* New York: Harper and Row, 1988.

de Young, Mary. "Help, I'm Being Held Captive!: The White Slave Fairy Tale of the Progressive Era." *Journal of American Culture* 6, 1 (Spring 1983): 96-99.

Dodds, Gordon B. *Oregon: A History.* New York: W. W. Norton, 1977.

East, Allan W. "The Genesis and Development of a Juvenile Court: Multnomah County, Oregon." Ph.D. diss., University of Oregon, 1939.

Erenberg, Lewis A. *Steppin' Out: New York Nightlife and the Transformation of American Culture*. Chicago: University of Chicago Press, 1984.

Fass, Paula S. *The Damned and the Beautiful: American Youth in the 1920s*. New York: Oxford University Press, 1977.

Flink, James J. *The Automobile Age*. Cambridge, MA: Massachusetts Institute of Technology Press, 1990.

Freedman, Estelle B. *Their Sisters' Keepers: Women's Prison Reform in America, 1830-1930*. Ann Arbor, MI: University of Michigan Press, 1981.

Griffen, Clyde. "The Progressive Ethos," in *The Development of an American Culture*, Stanley Coben and Lorman Ratner, eds. New York: St. Martins Press, 1983.

Grittner, Frederick K. *White Slavery: Myth, Ideology, and American Law*. New York: Garland Press, 1990.

Haller, Mark H. *Eugenics: Hereditarian Attitudes in American Thought*. New Brunswick, NJ: Rutgers University Press, 1984.

Hobson, Barbara M. *Uneasy Virtue: The Politics of Prostitution and the American Reform Tradition*. New York: Basic Books, 1987.

Horne, Peter. *Women in Law Enforcement*. Springfield, IL: Charles C. Thomas, 1980.

Johnson, Paul E. *A Shopkeeper's Millennium: Society and Revivals in Rochester, New York*, 1815-1837. New York: Hill and Wang, 1978.

Kirschner, Don S. *The Paradox of Professionalism: Reform and Public Service in Urban America, 1900-1940*. New York: Greenwood Press, 1986.

Larsen, Charles. *The Good Fight: The Life and Times of Ben B. Lindsey*. Chicago: Quadrangle Books, 1972.

Lebhar, Godfrey M. *Chain Stores in America, 1859-1962*. New York: Chain Store Publishing Co., 1963.

Lemons, J. Stanley. *The Woman Citizen: Social Feminism in the 1920s*. Urbana, IL: University of Illinois Press, 1973.

Liebman, Robert, and Michael Polen. "Perspectives on Policing in Nineteenth-Century America." *Social Science History* 2, 3 (Spring 1978): 346-60.

Lowenstein, Steven. *The Jews of Oregon, 1850-1950*. Portland, OR: Jewish Historical Society of Portland, 1987.

Lubove, Roy. "The Progressives and the Prostitute." *The Historian* 24 (May 1962): 308-30.

————. *The Professional Altruist: The Emergence of Social Work as a Career, 1880-1930*. Cambridge, MA: Harvard University Press, 1965.

May, Elaine Tyler. *Great Expectations: Marriage and Divorce in Post-Victorian America*. Chicago: University of Chicago Press, 1980.

May, Lary. *Screening Out the Past: The Birth of Mass Culture and the Motion Picture Industry*. New York: Oxford University Press, 1980.

MacColl, E. Kimbark. *The Shaping of a City: Business and Politics in Portland, Oregon, 1885-1915*. Portland, OR: Georgian Press, 1976.

———, with Harry H. Stein. *Merchants, Money, and Power: The Portland Establishment, 1843-1913*. Portland, OR: Georgian Press, 1988.

Martin, Susan E. *Breaking and Entering: Policewomen on Patrol*. Berkeley and Los Angeles: University of California Press, 1980.

Meyerowitz, Joanne J. *Women Adrift: Independent Wage Earners in Chicago, 1880-1930*. Chicago: University of Chicago Press, 1988.

Moynihan, Ruth B. *Rebel for Rights: Abigail Scott Duniway*. New Haven: Yale University Press, 1983.

Muncy, Robyn. *Creating a Female Dominion in American Reform, 1890-1935*. New York: Oxford University Press, 1991.

Noble, David W. *The Progressive Mind, 1890-1917*. Revised edition, Minneapolis: Burgess, 1981.

O'Neill, William L. *Everyone Was Brave: The Rise and Fall of Feminism in America*. Chicago: Quadrangle Books, 1969.

———. *The Progressive Years: America Comes of Age*. New York: Harper and Row, 1975.

Pascoe, Peggy. *Relations of Rescue: The Search for Female Moral Authority in the American West, 1874-1939*. New York: Oxford University Press, 1990.

Peiss, Kathy. *Cheap Amusements: Working Women and Leisure in Turn-of-the-Century New York*. Philadelphia: Temple University Press, 1986.

Perry, Elisabeth I. "The General Motherhood of the Commonwealth: Dance Hall Reform in the Progressive Era." *American Quarterly* 37 (Winter 1985): 719-33.

Pivar, David J. *Purity Crusade: Sexual Morality and Social Control, 1868-1900*. Westport, CT: Greenwood Press, 1973.

———. "Cleansing the Nation: The War on Prostitution,1917-1921." *Prologue* 12 (Spring 1980): 29-40.

Ryan, Mary P. *Cradle of the Middle Class: The Family in Oneida County, New York, 1790-1865*. New York: Cambridge University Press, 1981.

Roby, Pamela A. "Politics and Prostitution: A Case Study of the Formulation, Enforcement, and Judicial Administration of the New York State Laws on Prostitution." Ph.D. diss., New York University, 1971.

Rosen, Ruth. *The Lost Sisterhood: Prostitution in America, 1900-1918*. Baltimore: Johns-Hopkins University Press, 1982.

Rosenberg, Rosalind. *Beyond Separate Spheres: Intellectual Roots of Modern Feminism*. New Haven: Yale University Press, 1982.

Schlossman, Steven, and Stephanie Wallach. "The Crime of Precocious Sexuality: Female Juvenile Delinquency in the Progressive Era." *Harvard Educational Review* 48 (February 1978): 65-94.

Schneider, Eric C. *In the Web of Class: Delinquents and Reformers in Boston, 1880s-1930s.* New York: New York University Press, 1992.

Sklar, Robert. *Movie-Made America: A Cultural History of American Movies.* New York: Vintage Press, 1976.

Smith, Elizabeth S. *Breakthrough: Women in Law Enforcement.* New York: Walker and Co., 1982.

Smith, Helen K., ed. *With Her Own Wings: Historical Sketches, Reminiscences, and Anecdotes of Pioneer Women.* 2d ed. Portland, OR: Beattie, 1974.

Stewart, James B. *Holy Warriors: The Abolitionists and American Slavery.* New York: Hill and Wang, 1976.

Tiffin, Susan. *In Whose Best Interest?: Child Welfare Reform In the Progressive Era.* Westport, CT: Greenwood-Press, 1982.

Tylor, Peter L. "'Denied the Power to Choose the Good.' Sexuality and Mental Defect in American Medical Practice, 1850-1920." *Journal of Social History* 10 (June 1977): 472-89.

Urofsky, Melvin I. *A March of Liberty: A Constitutional History of the United States.* New York: Alfred A. Knopf, 1988.

Walker, Samuel. *A Critical History of Police Reform: The Emergence of Professionalism.* Lexington, MA: D. C. Heath, 1977.

———. *Popular Justice: A History of American Criminal Justice.* New York: Oxford University Press, 1980.

———. *The Police in America.* New York: McGraw-Hill, 1983.

Wiebe, Robert H. *The Search for Order, 1877-1920.* New York: Hill and Wang, 1967.

Wilson, Otto. *Fifty Years Work With Girls: The Life of Dr. Kate Waller Barrett.* 1933; reprint, New York: Arno, 1974.

Index